The Best of LIFE

TIME-LIFE BOOKS, INC.
ALEXANDRIA, VIRGINIA

"To see life; to see the world; to eyewitness great events; to watch the faces of the poor and the gestures of the proud; to see strange things—machines, armies, multitudes, shadows in the jungle and on the moon; to see man's work—his paintings, towers and discoveries; to see things thousands of miles away, things hidden behind walls and within rooms, things dangerous to come to; the women that men love and many children; to see and to take pleasure in seeing; to see and be amazed; to see and be instructed."

—from Henry R. Luce's prospectus for LIFE, 1936

Life Magazine

Founder: Henry R. Luce 1898-1967

Editor-in-Chief: Hedley Donovan
Chairman of the Board: Andrew Heiskell
President: James R. Shepley
Chairman, Executive Committee: James A. Linen
Group Vice President, Magazines: Arthur W. Keylor

Vice Chairman: Roy E. Larsen

The Best of Life

Editor: DAVID E. SCHERMAN
Art Director: ROBERT CLIVE
Staff Writer: Frank K. Kappler
Researchers: Anne Fitzpatrick, Lucy Voulgaris
Copyreader: Barbara Fuller
Designers: Albert Ketchum, Lou Valentino,
Bernard Waber, Sanae Yamazaki
Editorial Production: Joyce Pelto, David Young

The editors wish to acknowledge the special contribution of Doris O'Neil, Chief of the TIME-LIFE Picture Collection, without whose foresight and planning publication of this book would not have been possible.

Valuable assistance also was given by the following LIFE writers, reporters and artists: Barbara Baker, Mathilde Camacho, Thomas Flaherty, Ann Guerin, Martin Hanish, Anne Hollister, Adrian Hope, Bonnie Johnson, Joseph Kastner, Edward Kern, John Neary, Joan Nierenberg.

Library of Congress Cataloging-in-Publication Data

The Best of Life.

 Reprint. Originally published: New York: Time-Life Books, c1973.
 1. Life (Chicago, Ill.) 2. Photography, Journalistic.
I. Scherman, David Edward, 1916- II. Kappler, Frank K. III. Life (Chicago, Ill.)
[TR820.B477 1986] 779'.990982 86-12390
ISBN 0-517-61940-7

h g f e d c

CONTENTS

INTRODUCTION

First cover

LIFE Magazine embraced little more than a single generation, a span of 36 years from November 1936 to December 1972. Yet it is impossible to think of any magazine in any period of time that had such extraordinary impact on its readers. LIFE brought the world home to them in a way that they had never seen or experienced before. "Experienced" is the crucial word. A great picture is not merely seen; it demands an emotional response. LIFE created such responses countless times for millions of readers.

Henry Luce certainly did not invent picture journalism with LIFE. Prior to 1936 other magazines and newspapers were already printing pictures in increasing volume. But a popular, big-page, inexpensive magazine devoted to the photograph had never existed before.

Most magazines are built around editors and writers, but LIFE was built around photographers. Their professional skill and unquenchable enterprise were at the heart of LIFE's success. Being a LIFE photographer was the most glamorous job in the profession, and it attracted the best in the world. To support the photographers, who were the front-line troops and the stars, LIFE assembled a conglomeration of special talents and trained them to meet the magazine's many special needs: reporters who could help the photographer line up his story, writers who could cram the necessary information into text-blocks and short captions, picture editors, assignment editors, art directors and department editors. All of them were aimed in one direction: pictures, pictures, pictures.

The result was a cultural explosion. This book is a record of it.

Right after the closing of LIFE was announced, Senior Editor David Scherman came to me, since I was the last managing editor, and described his idea for this book. His qualifications to be editor of *The Best of LIFE* are unique. He is the only staff member who was on LIFE both the week it began and the week it ended. As the only man who had been both a staff photographer and a senior editor, he knew how to take pictures, judge pictures and assemble pictures into coherent form.

For this book, Scherman and his team of LIFE staff members *(page 2)* went through all the bound volumes of the magazine, looking at all 1,864 issues. We agreed from the beginning that this volume should not be a formal history of our times, although a lot of history is in it. We did not want to assemble in chronological order the important events and famous people, although there are many

BURT GLINN

WILLIAM J. SUMITS

Founder Henry Robinson Luce confers with correspondents at the 1964 G.O.P. Convention.

Grey Villet	Edward Clark	Loomis Dean	Joe Scherschel	
Hank Walker	Dmitri Kessel	N. R. Farbman	Yale Joel	
James Whitmore	Paul Schutzer	Walter Sanders	Michael Rougier	Nina Lee

All photographers then on the magazine's staff assembled in New York City in 1960 for the group portrait above. But many others, before and after, were on the staff and contributed their talents. Those who had

of those here too. We had a different criterion, expressed in the title. We simply wanted the best pictures that had appeared in LIFE over 36 years, and these range from history-stamped moments to the happy inanities of the Miscellany page.

Pictures came to LIFE from everywhere—mostly from staff photographers and the many freelance photographers who worked on assignment for the magazine, but also from wire services, archive collections and readers. The only kind of photograph we wanted to avoid in this book was the "point picture"—the kind that merely proves a point or establishes a fact or a face.

You will find things missing. LIFE published thousands of articles and historic memoirs. The great writers and great public figures of this generation were eager to have their words in LIFE (Winston Churchill alone published 46 articles in the magazine), but you will find none of them here. This book celebrates photographers, not writers. LIFE was first and always devoted to pictures, and so is this book.

We have left out the many educational series: *The World We Live In, The Epic of Man, The World's Great Religions,* the histories of Greece and Rome, *The Human Body.* They have decorated classroom walls for the last 20 years, but they do not fit the proportions of this book.

We have left out the great works of art that appeared in LIFE. The magazine published many of the world's most important paintings, by old masters and new artists. But this book celebrates photographs, not paintings.

One more thing is missing from this book. I am sure we have left out one or more of your favorite pictures, images that you remember from those 36 years of LIFE. If so, you have company, for we have left out hundreds of our own favorites: vivid action, stunning portraits, gorgeous scenery, historic figures, beautiful women, great news events, heartbreaking moments, crazy antics. We could have created a whole book for each of the chapter categories.

In view of what *is* here, however, no apologies are offered. This book is a selection from more than 18 million images in LIFE's Picture Collection, the largest indexed treasury of its kind in the world. Choosing the best of these was a nightmare—and a privilege. The result is of course incomplete. It is also, we think, superb.

Ralph Graves

Wayman	Robert W. Kelley	J. R. Eyerman	Ralph Crane	Leonard McCombe	Howard Sochurek	Wallace Kirkland	Mark Kauffman	George Silk
Dominis	Gordon Parks		James Burke	Andreas Feininger	Fritz Goro	Allan Grant	Eliot Elisofon	Frank J. Scherschel
Stackpole	Alfred Eisenstaedt	Margaret Bourke-White	Thomas McAvoy		Carl Mydans	Albert Fenn	Ralph Morse	Francis Miller

already moved on and therefore were not present: Jack Birns, Horace Bristol, Larry Burrows (he returned in 1961), Cornell Capa, Robert Capa, Myron Davis, Paul Dorsey, David Douglas Duncan, Johnny Florea, Her- bert Gehr, Arthur Griffin, Marie Hansen, Rex Hardy Jr., Bernard Hoffman, Martha Holmes, George Lacks, Bob Landry, W. H. Lane, Tony Linck, Hansel Mieth, John Phillips, Hart Preston, George Rodger, Eric Schaal, David E. Scherman, Sam Shere, William Shrout, George Skadding, Ian Smith, W. Eugene Smith, Charles Steinheimer, George Strock, William Sumits, William Vandivert, Hans Wild and Jack Wilkes. Those who later joined LIFE: Carlo Bavagnoli, Bill Eppridge, Henry Groskinsky, John Loengard, Michael Mauney, Vernon Merritt III, John Olson, Charles Phillips, Bill Ray, Co Rentmeester, Arthur Rickerby and John Shearer.

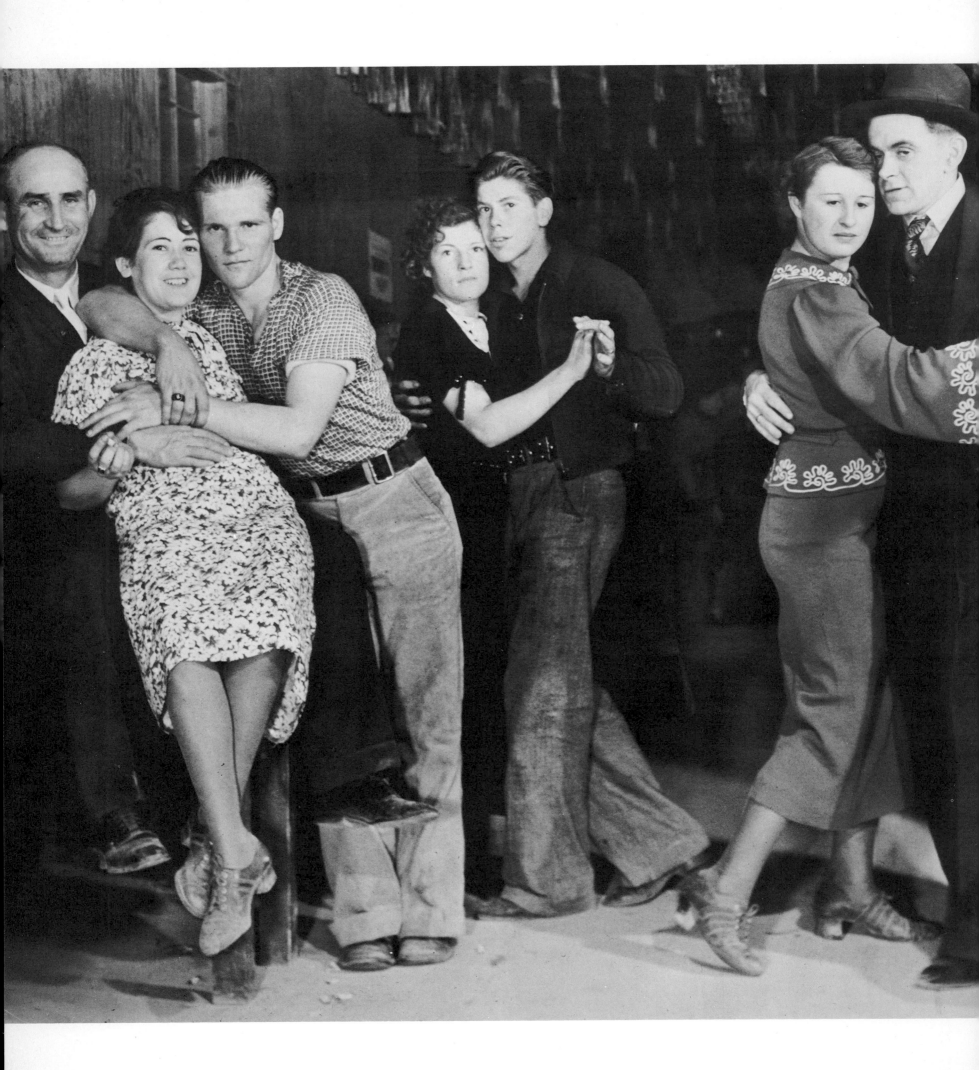

6

THE MOMENT PRESERVED

A selection of the photographs from LIFE that convey the spirit of an eventful era

The major contribution of the camera in this century has been to preserve for all time the memorable moments of contemporary history. During its 36 years of existence, LIFE recorded these moments week by week.

In the process it often presented more than merely a frozen moment; it offered the very essence of the era. And it did so from the outset: the photograph at left, of dance-hall girls entertaining dam workers in a saloon on a Saturday night near Fort Peck, Mont., was the lead-off picture in the major story of the first issue of LIFE. It captured and encapsulated a moment in history when the calloused construction workers on a PWA project could quit their week's labors, wash the cement powder out of their hair and spend Saturday night at a local dance hall.

Of the many thousands of such classic photographs published in LIFE, 57 are reprinted in this section. Taken together they comprise an eloquent and graphic treasury of our times.

In a saloon near Fort Peck, Mont., dam builders spend a Saturday evening with taxi dancers.

MARGARET BOURKE-WHITE

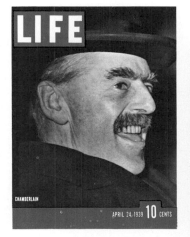

Neville Chamberlain

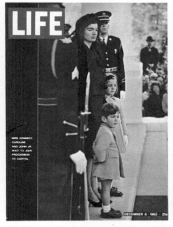

Mourning Kennedy family

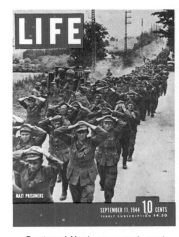

Captured Nazis near war's end

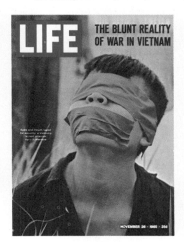

A Viet Cong prisoner

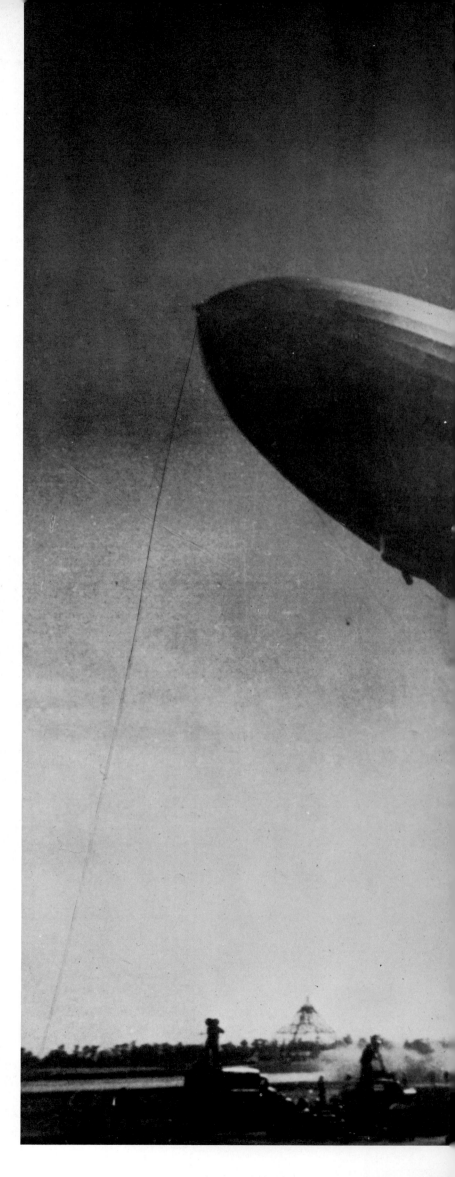

Louisville, February 1937 The social and economic ironies of Depression America seem to be summed up in this frequently reprinted picture of a bread line in front of a billboard advertising that all was well. Actually the people were victims of a flood.

MARGARET BOURKE-WHITE

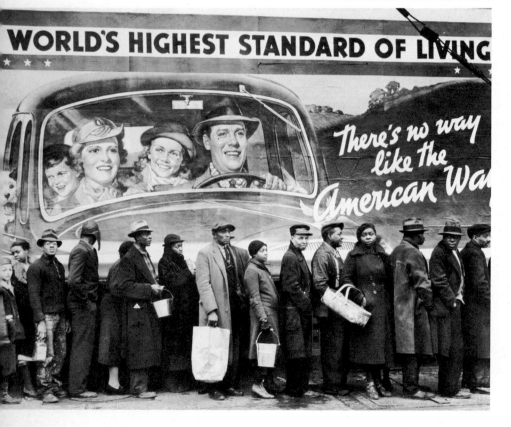

Lakehurst, N.J., May 6, 1937 At exactly 7:23 p.m. the German dirigible *Hindenburg,* docking after its first ocean crossing of the season, bursts into flames, killing 36, before the cameras of a score of press photographers. At least four of them snapped their shutters at the same moment and got pictures identical with this one.

SAM SHERE

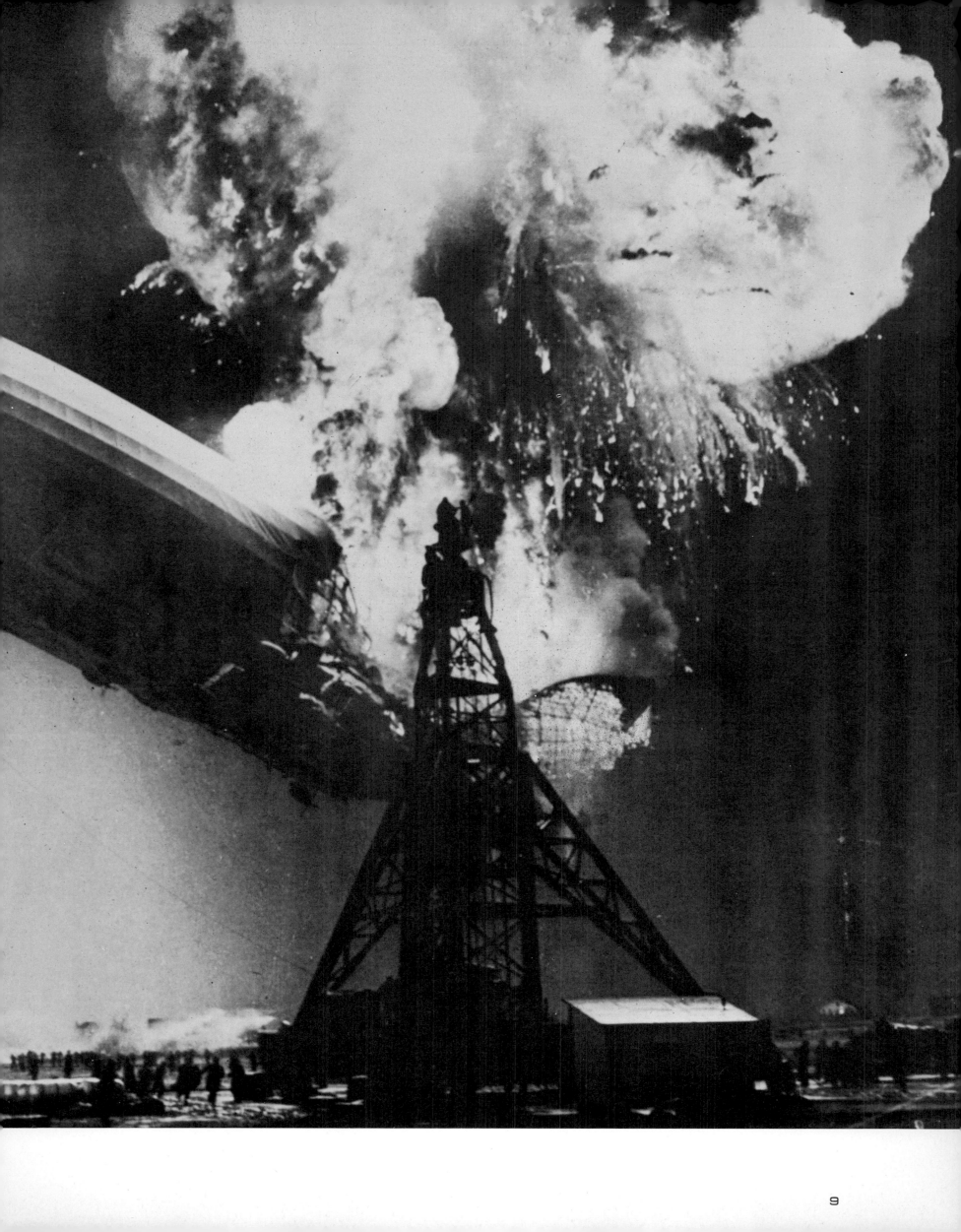

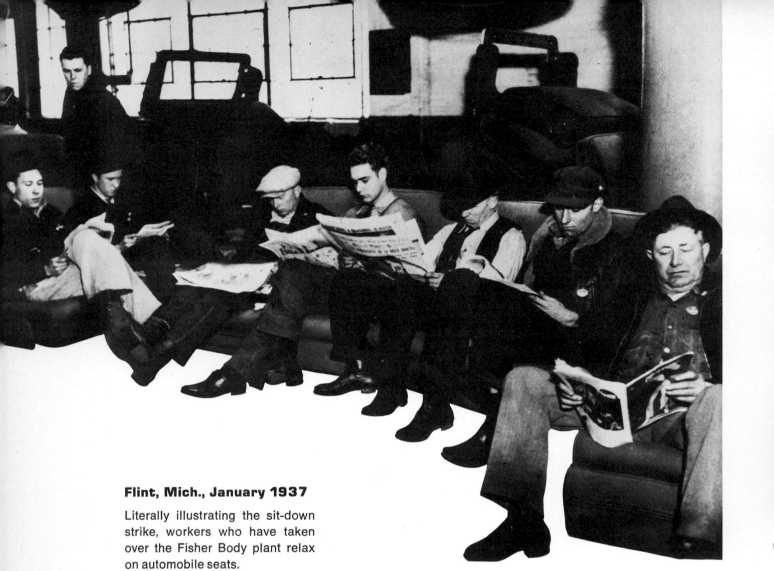

Flint, Mich., January 1937

Literally illustrating the sit-down strike, workers who have taken over the Fisher Body plant relax on automobile seats.

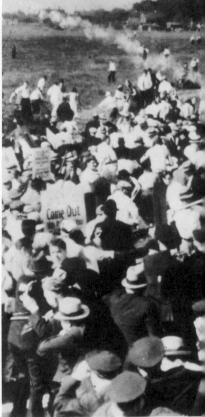

Chicago, May 30, 1937

A historic Memorial Day battle is joined as police frantically try to hold off an army of striking steelworkers advancing on the Republic Steel Corporation plant.

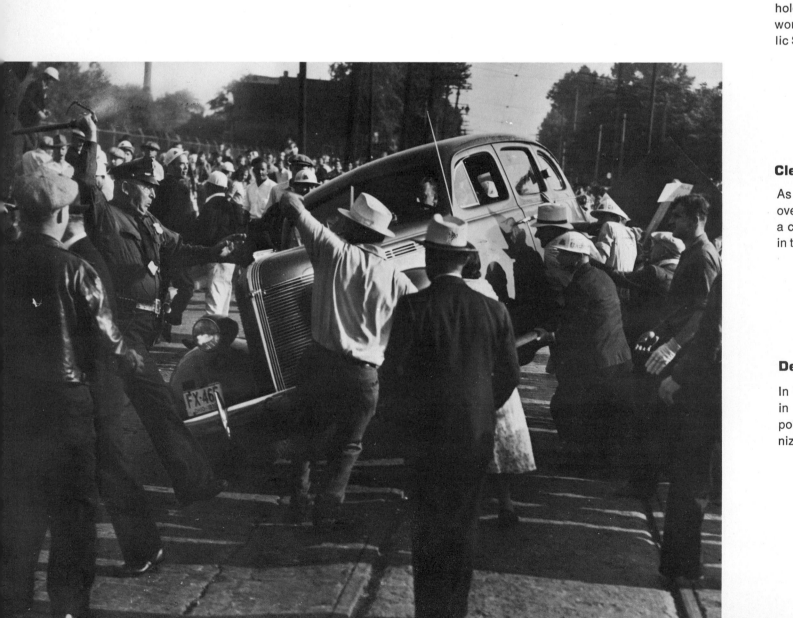

Cleveland, August 1939

As United Auto Workers try to overturn the car of a nonstriker, a club-wielding policeman wades in to drive them off.

Dearborn, Mich., May 1937

In a picture that became famous in labor history, Ford company police gang up on a U.A.W. organizer at Ford's River Rouge plant.

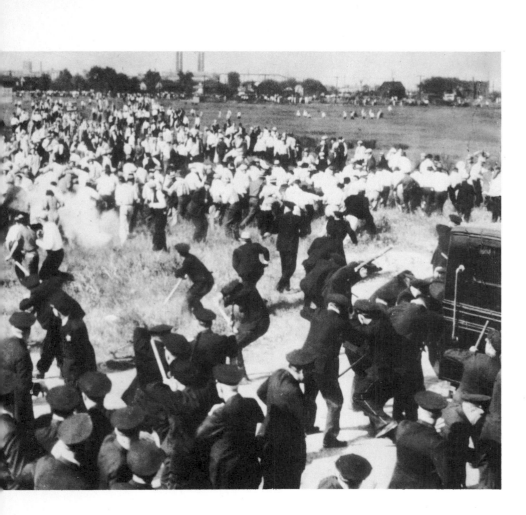

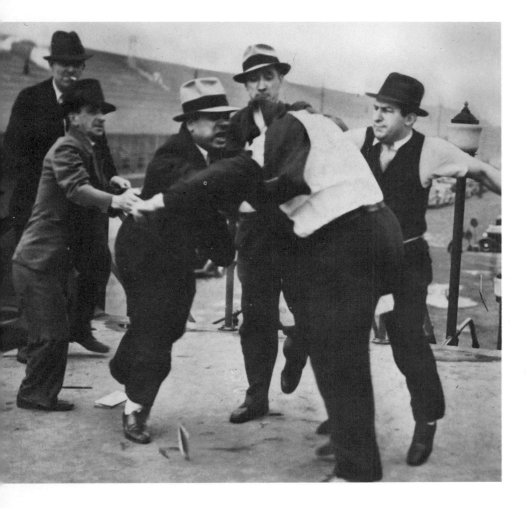

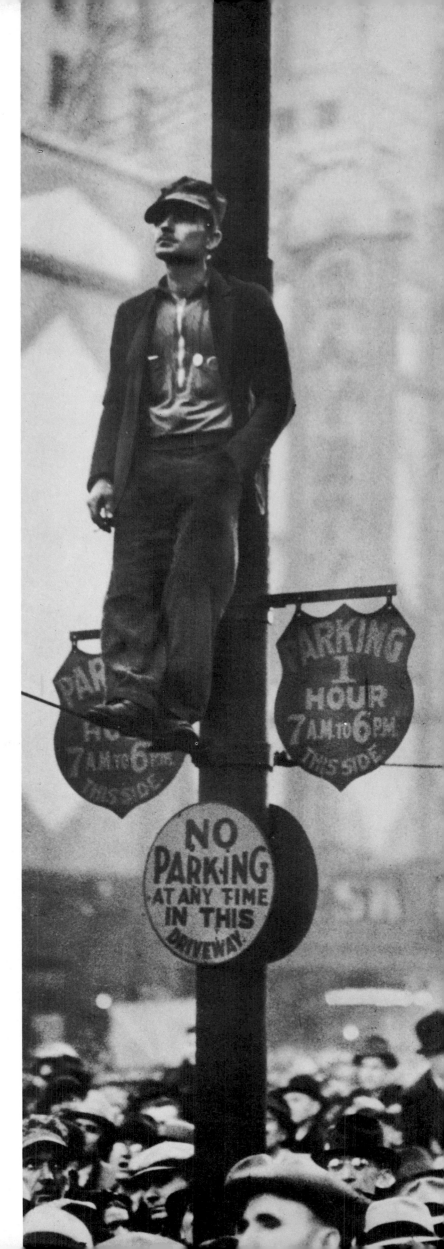

Detroit, March 23, 1937

From his private perch a union
man watches a mass demonstra-
tion by labor in Cadillac Square.

WILLIAM VANDIVERT

Newark, N.J., June 4, 1938

Norman Thomas, the perennial Socialist Presidential candidate, is pelted with rotten eggs during a speech attacking the perennial boss rule of Mayor Frank ("I am the Law") Hague in Jersey City.

RALPH MORGAN

Elwood, Ind., Aug. 17, 1940

In what is not a movie scene but a news photograph that LIFE's editors praised as the greatest campaign picture ever made, G.O.P. candidate Wendell Willkie rides into his hometown to make his acceptance speech.

JOHN D. COLLINS

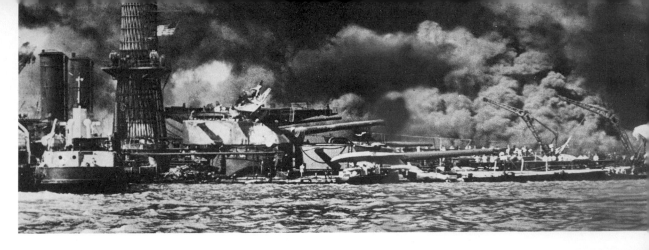

Pearl Harbor, Dec. 7, 1941

It was a year after Pearl Harbor before pictures of the attack were made public. This one shows the *Arizona* burning as men watch from the *West Virginia (left)*.

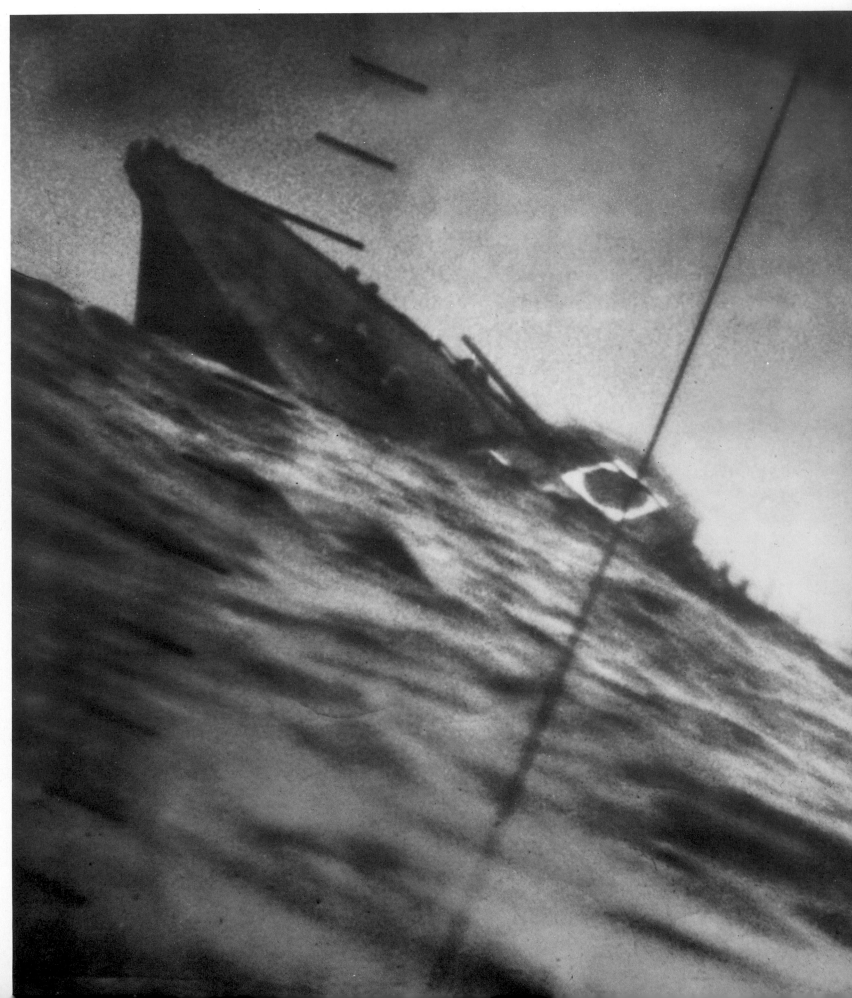

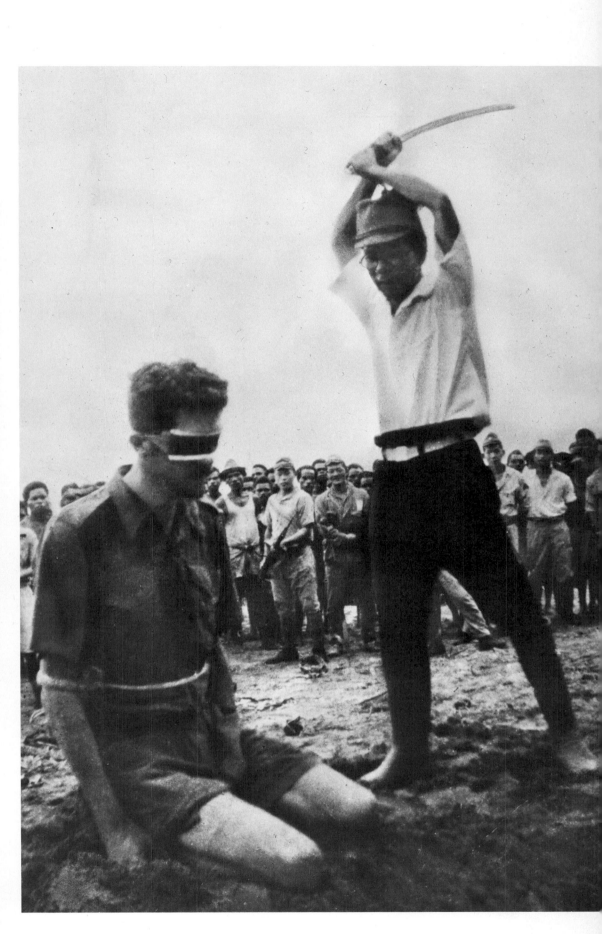

The Pacific, July 1942

After half a year of bad news, the U.S. Navy released this dramatic photograph of a Japanese destroyer taken through the periscope of the sub that sank it.

The Pacific, 1945

This Japanese snapshot of an officer about to behead an Australian flier was passed hand to hand by GIs in the Pacific, and finally reached LIFE near war's end.

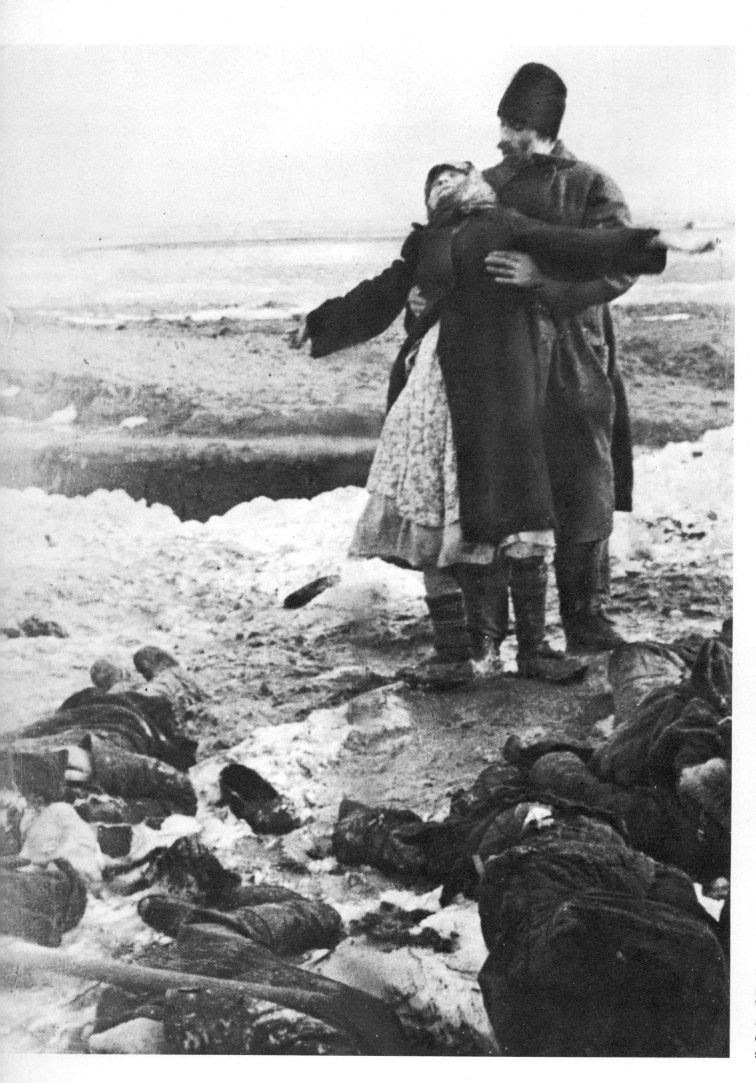

Russia, 1942

A Russian supports his fainting wife at the moment when she discovers their son among a pile of guerrillas executed by the Nazi Army. This picture, among the first from Europe's eastern front, impressed Americans with what LIFE's caption called the "family anguish in Russia, where the war is being fought in every home."

Marseilles, February 1941

In what became one of the most poignantly memorable pictures of World War II, a Frenchman weeps as poilus carry the flags of defeated regiments to the docks to be sent away for safekeeping.

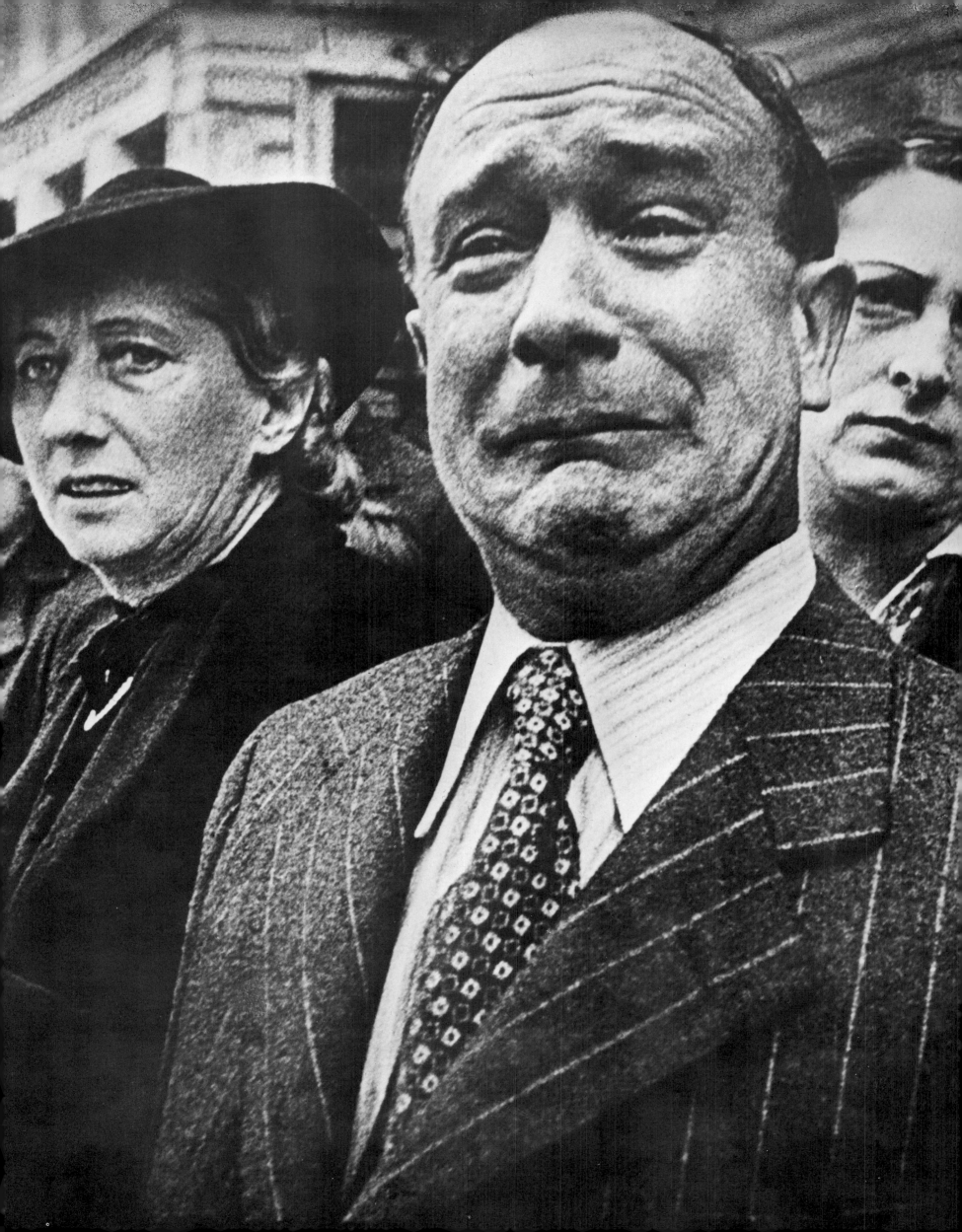

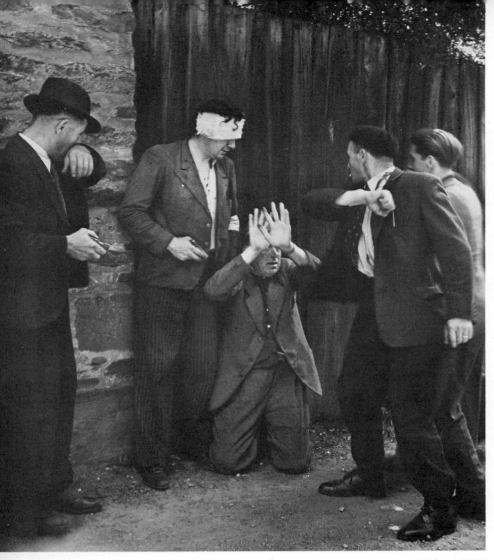

Brittany, August 1944 Four French patriots, fresh from the liberation of Rennes, gang up on a collaborationist who kneels to plead for mercy and tries to shield his face.

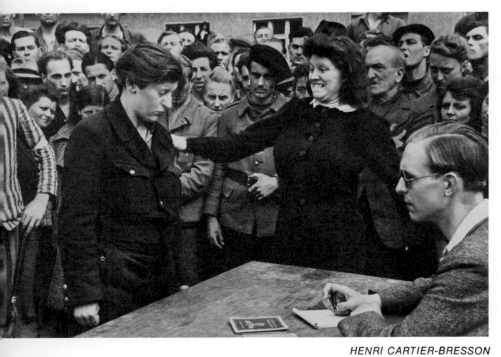

Dessau, 1945 With a sweeping gesture of contempt, a campmate identifies a Gestapo informer who has tried to mingle with other refugees and is on the verge of being released.

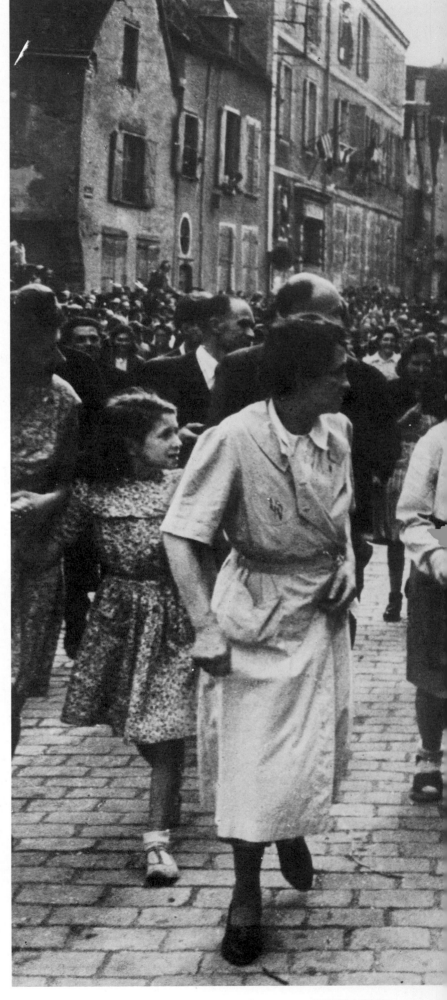

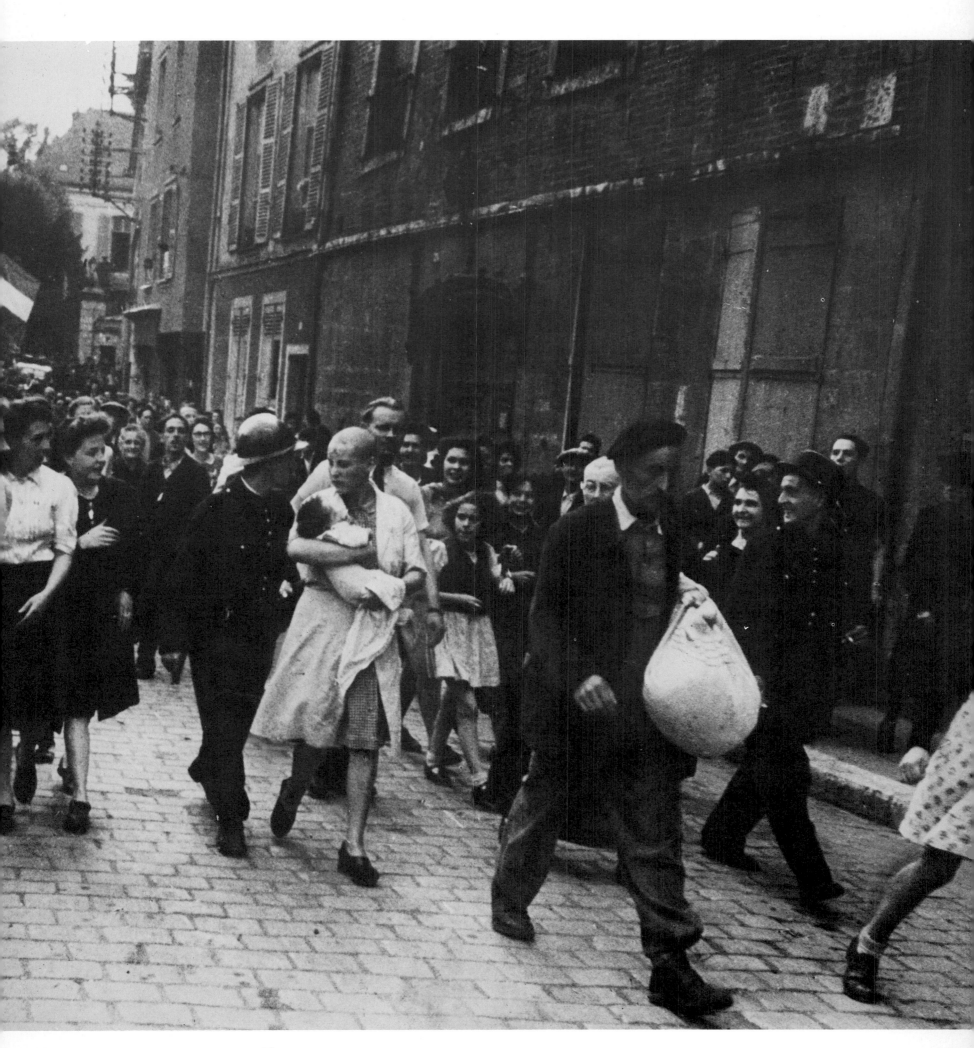

Chartres, August 1944 The shame of a female collabora-
tionist, shorn in punishment, is
reflected in the face of this moth-
er as she carries her German-
fathered child through the streets
to the taunts of her neighbors.

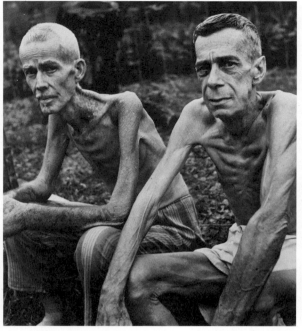

CARL MYDANS

Manila, February 1945

Returning after the recapture of Manila to the camp where he had been imprisoned, Mydans found these two emaciated comrades.

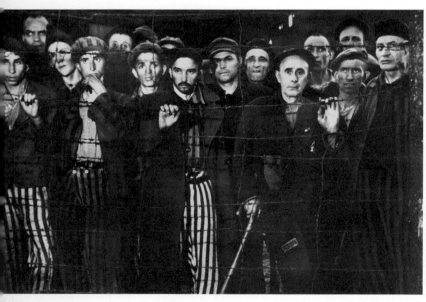

MARGARET BOURKE-WHITE

Buchenwald, April 1945

A liberation-day picture shows prisoners staring dully at their rescuers, still unable to comprehend that freedom has come.

Nordhausen, April 1945

Slain slave laborers at a V-bomb factory are stacked in the anonymity of mass death.

JOHNNY FLOREA

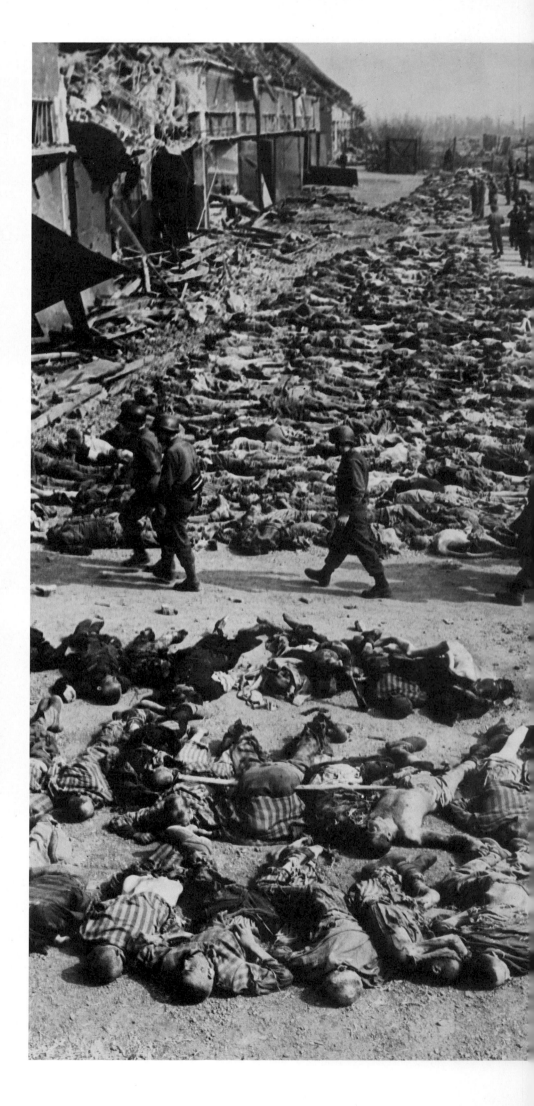

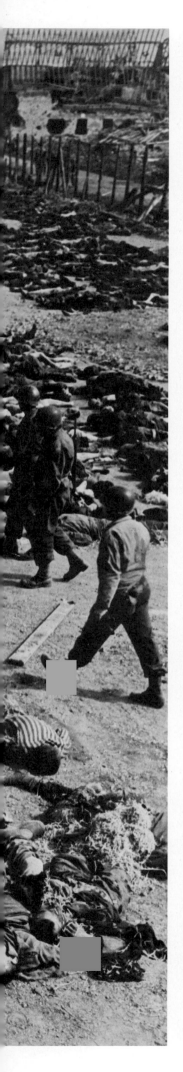

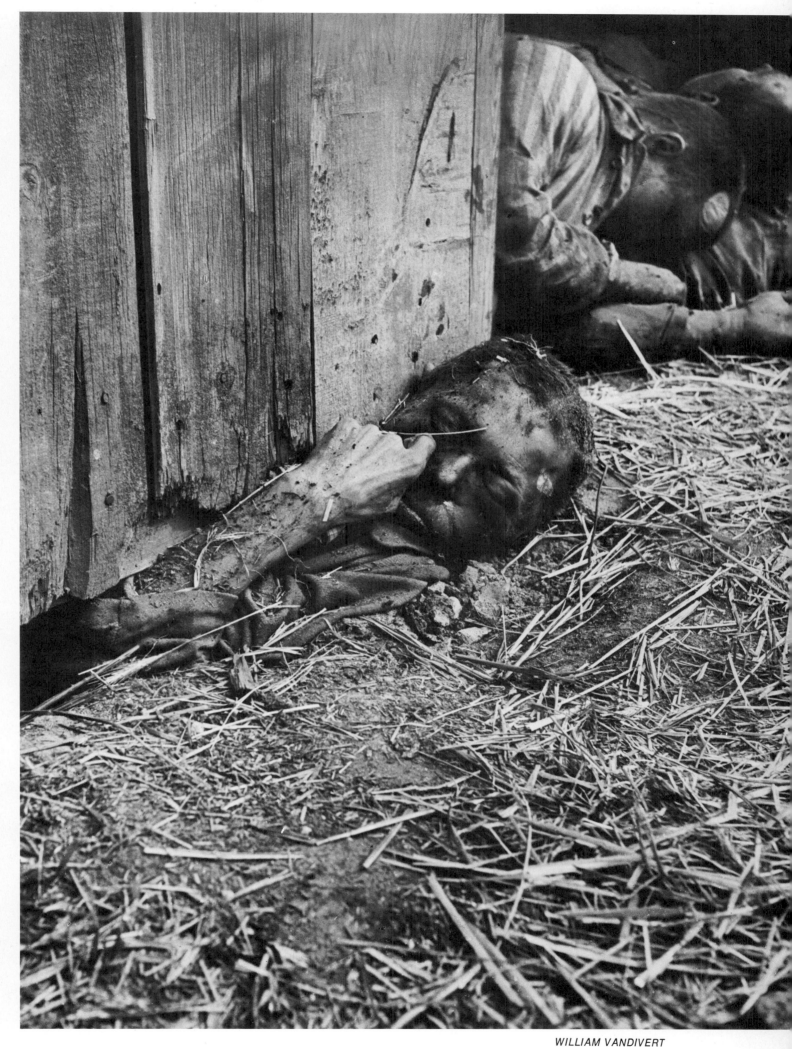

Berlin, April 1945 Driven by a fierce will to live, this political prisoner was just able to squeeze his head and an arm under the door of a prison building before being killed in a fire set by his German captors.

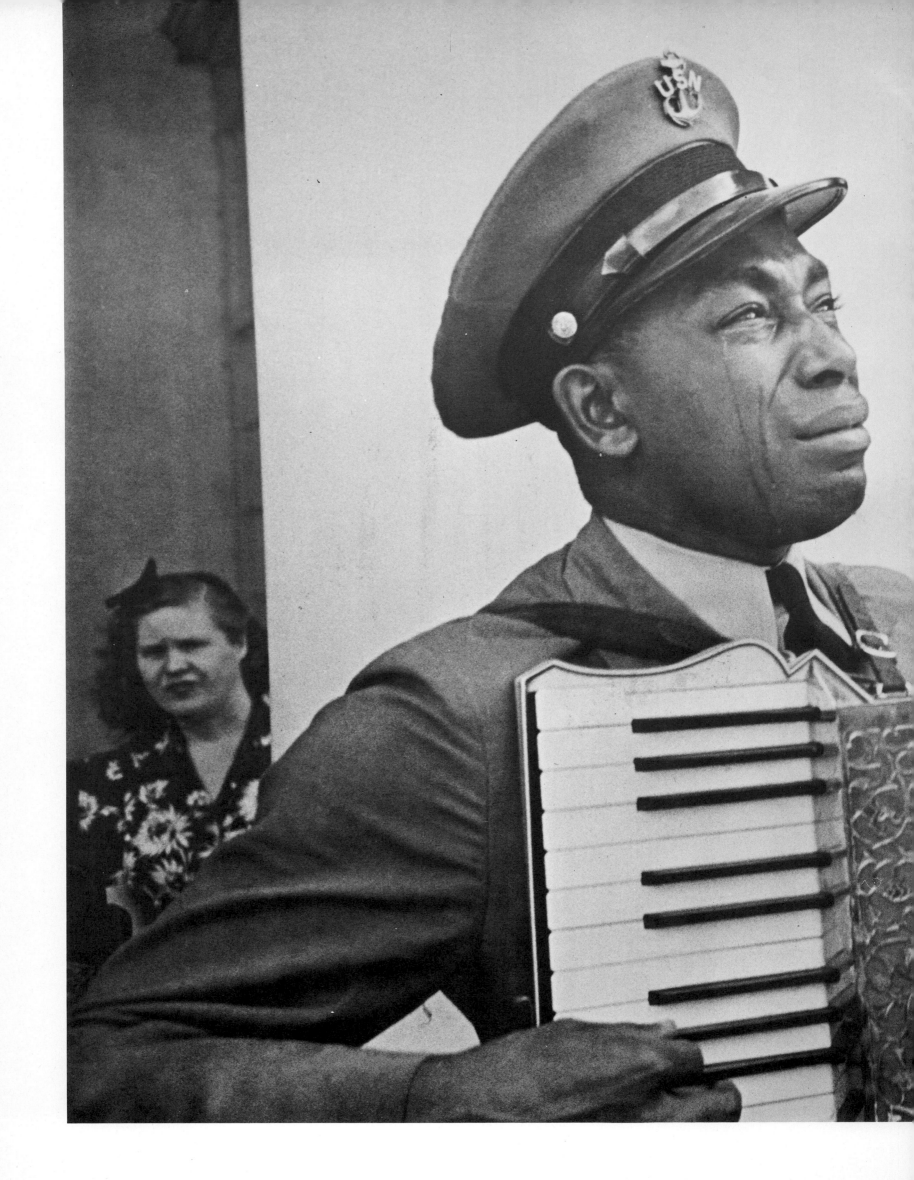

April 13, 1945 As F.D.R.'s body is carried to the train at Warm Springs on the day after his death, C.P.O. Graham Jackson plays *Goin' Home,* his tear-stained face symbolizing the nation's sorrow.

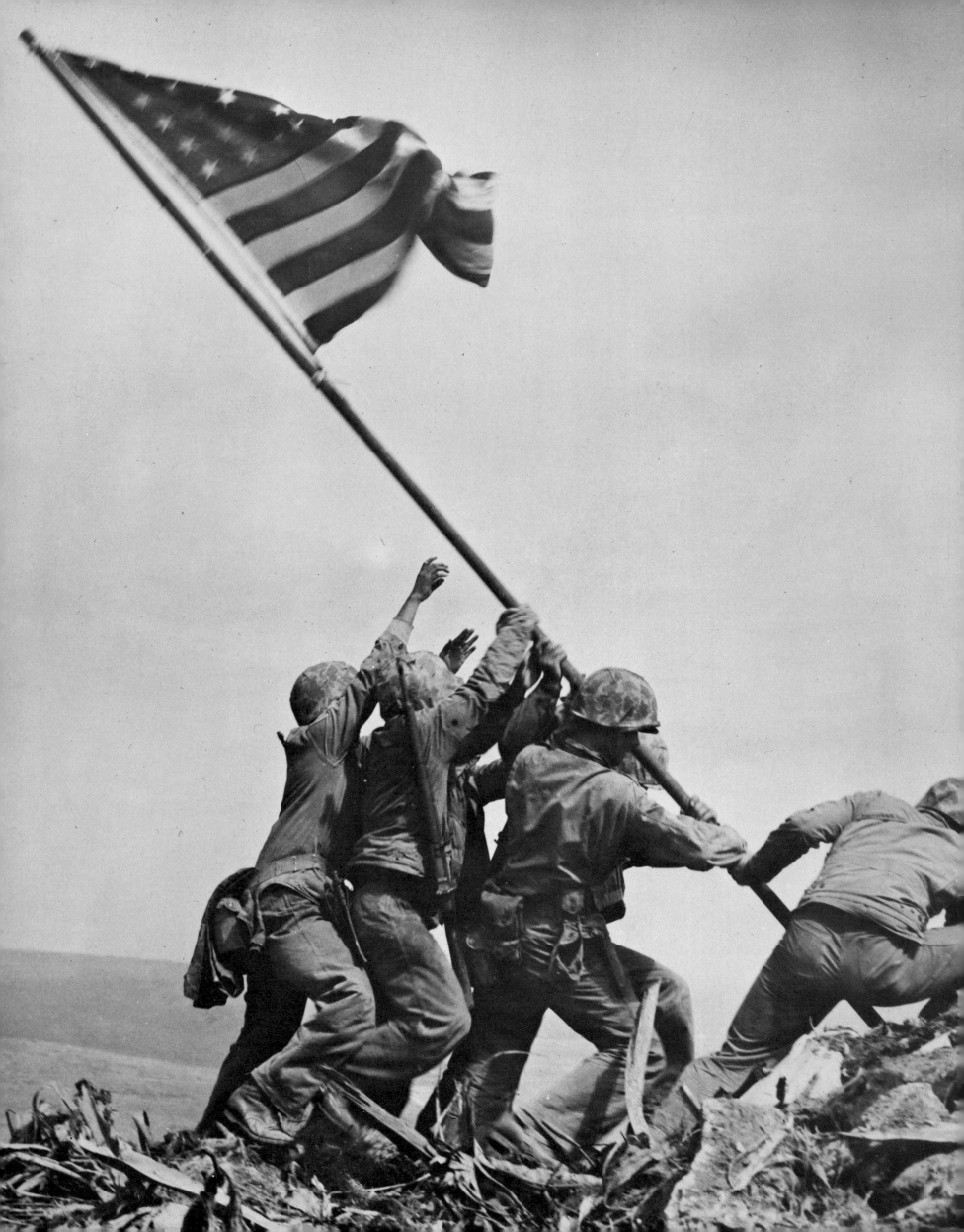

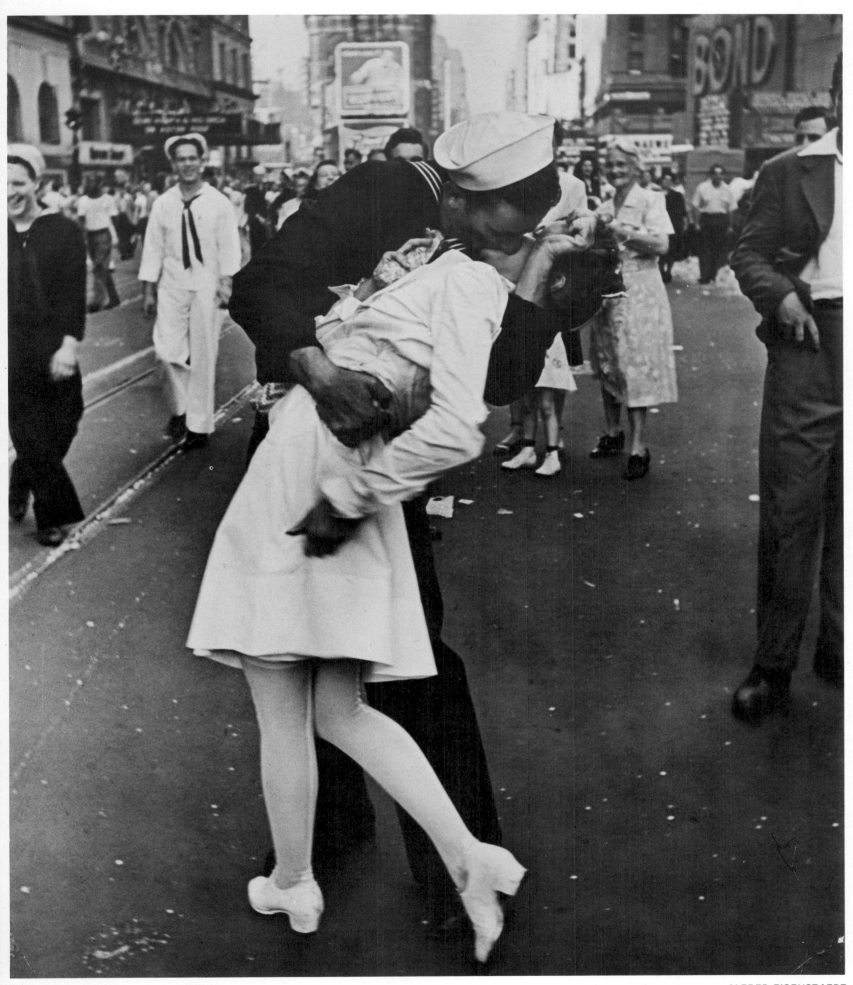

ALFRED EISENSTAEDT

Iwo Jima, Feb. 23, 1945

New York, Aug. 14, 1945

This sculpture-like classic actually showed the second flag-raising to celebrate the recapture of the island from the Japanese. The first, earlier in the day, had been filmed by a Marine sergeant.

On V-J Day, Eisenstaedt caught this sailor and girl who summed up the nation's victory spree.

JOE ROSENTHAL

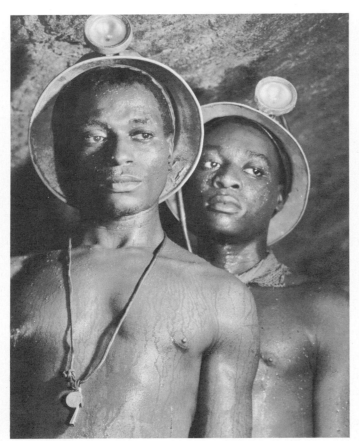

MARGARET BOURKE-WHITE

Johannesburg, March 1950

Two gold miners, eyes empty of hope, sweat in the 95° heat of a tunnel a mile under the Union of South Africa's biggest city. The nation's racial policy of apartheid was new at the time.

The Punjab, October 1947

A procession of Sikhs stretches like a classic frieze across the Indian landscape as they flee east, abandoning homes absorbed into Pakistan during the political division of the subcontinent.

MARGARET BOURKE-WHITE

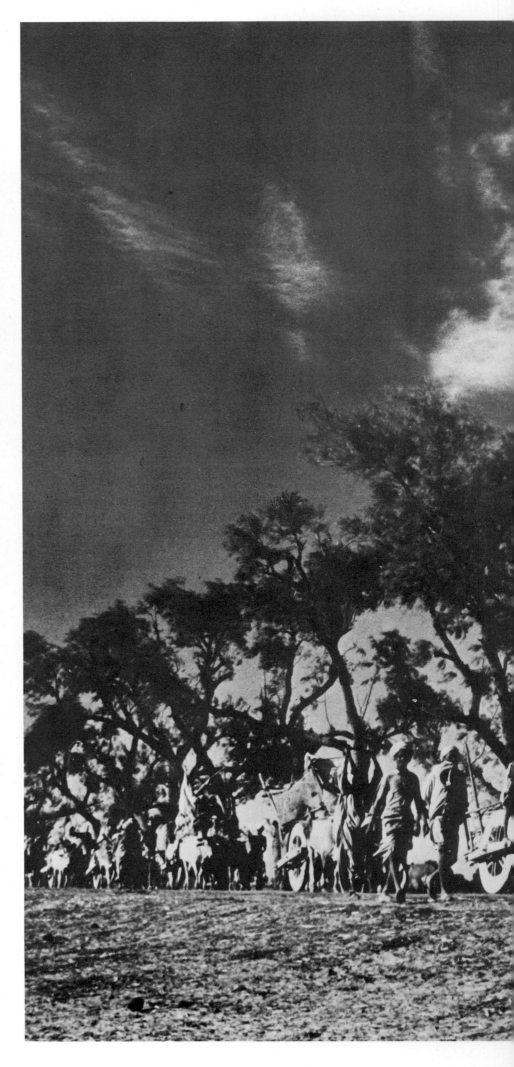

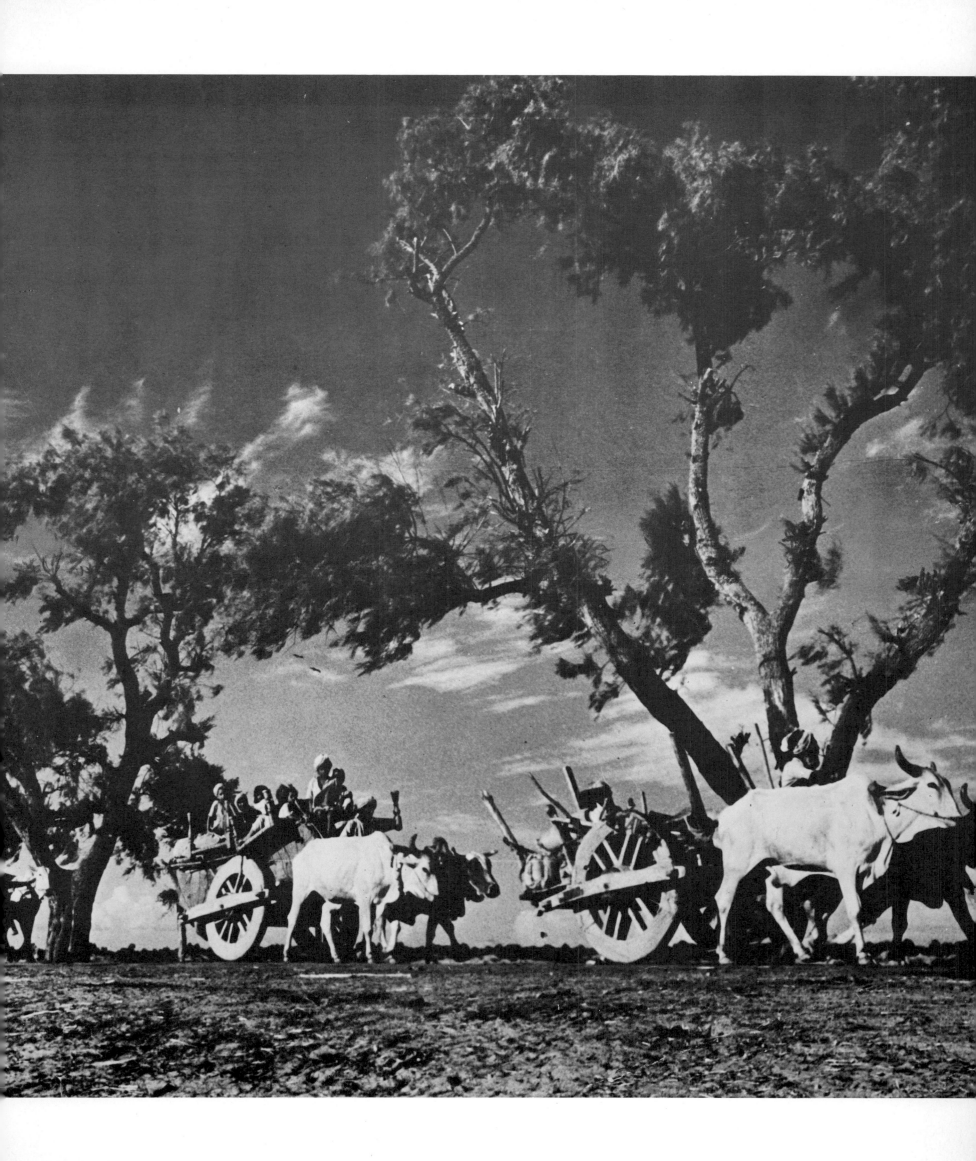

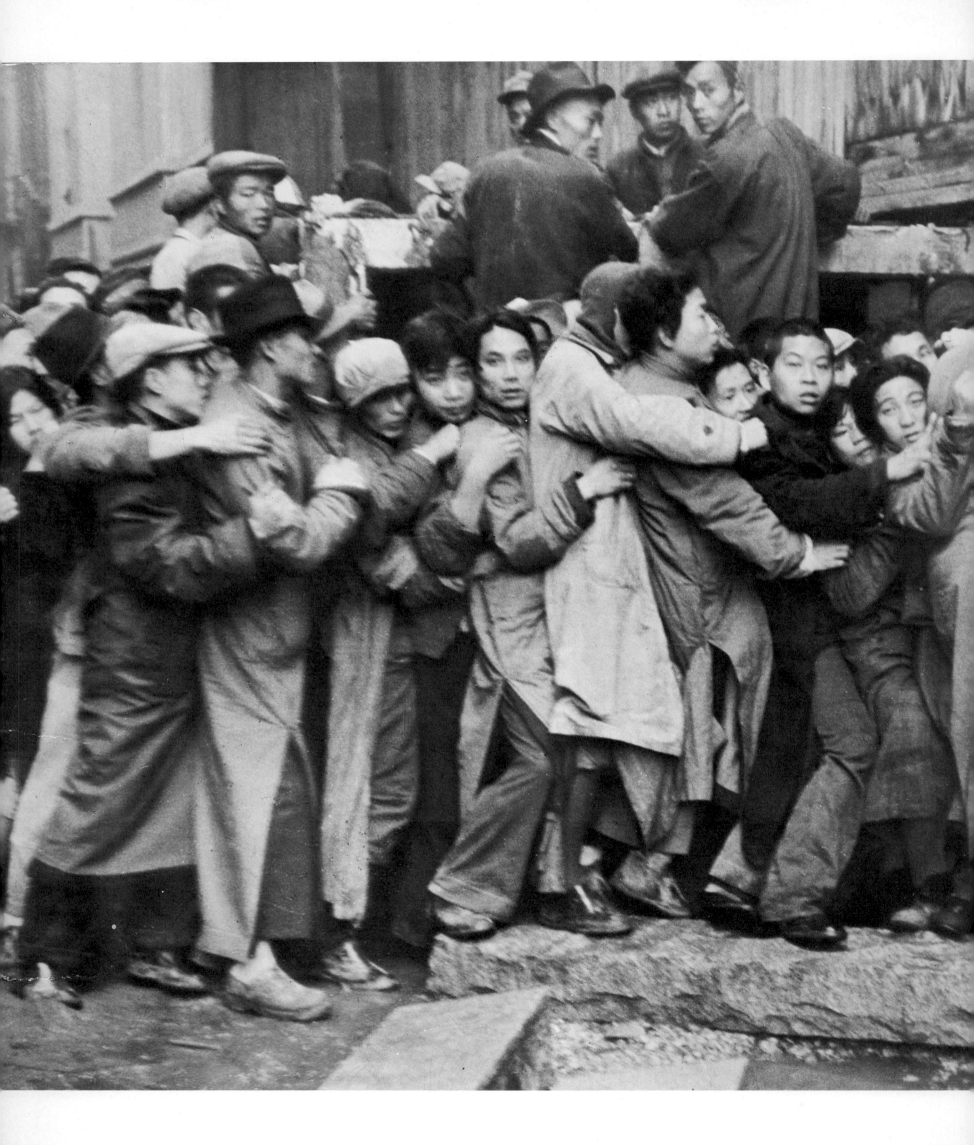

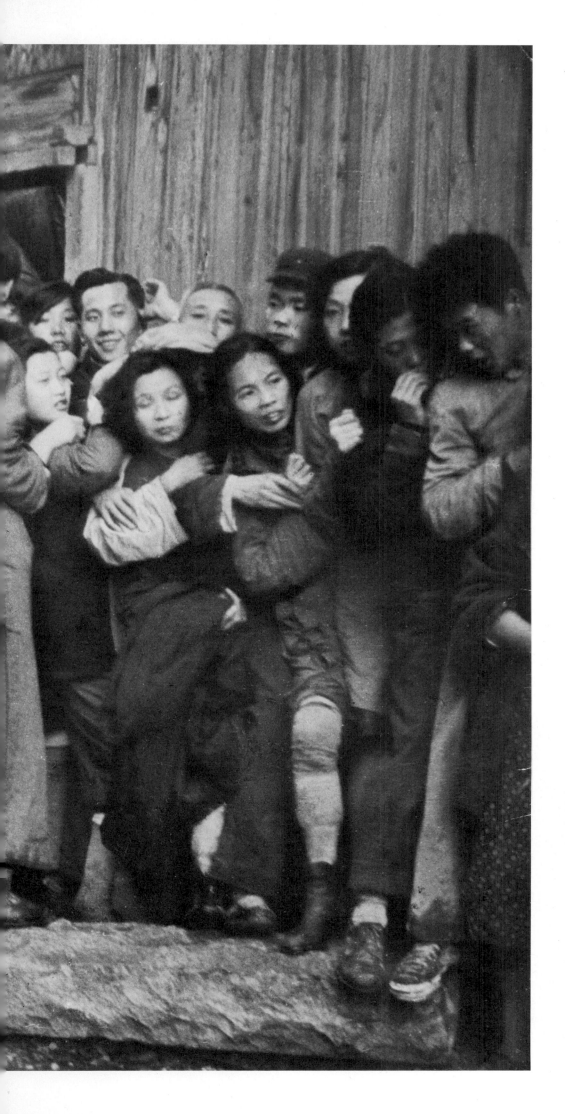

Shanghai, December 1948

In a classic example of panic, Shanghai citizens converge in a tangle of arms and legs outside a government bank where they are trying to exchange their paper money for gold before the Communist takeover.

HENRI CARTIER-BRESSON

Lingling, April 1946

An ironic study of China's famine was presented by this starving boy begging for food in front of a plump and smiling rice merchant.

GEORGE SILK

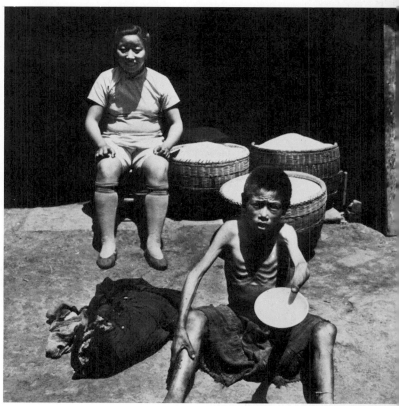

Fukui, June 28, 1949 Everyone rushed outdoors when the earthquake began. But Carl Mydans, ignoring personal hazard, concentrated on photograph- ing the devastation. This frame caught the moment when a department store tottered from its foundation and the people fled.

CARL MYDANS

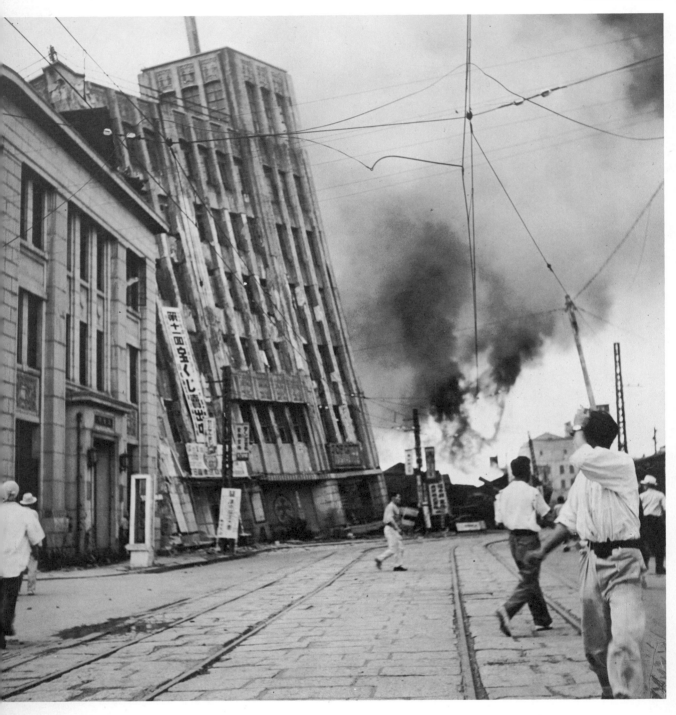

Berlin, June 1948 In the 18 months when Britain and the U.S. airlifted 2,343,315 tons of supplies into Berlin over the Red blockaders, many pictures were taken. But none captured the feeling of entrapment as well as this one of besieged Berliners near the airport watching a plane land.

WALTER SANDERS

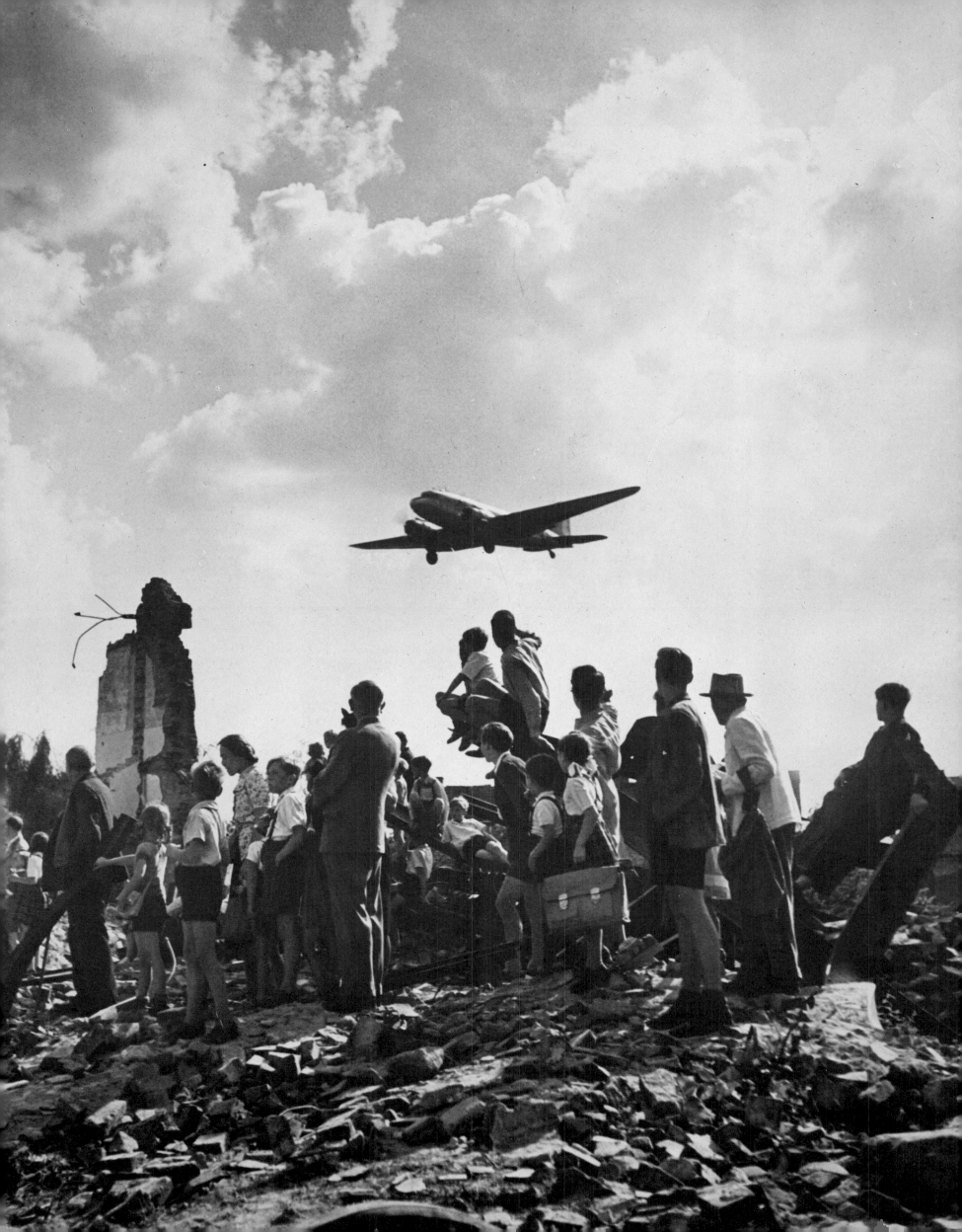

East Berlin, June 1953 German workers hurl stones at Soviet tanks in an intense depic- tion of the imbalance between armed might and raw courage.

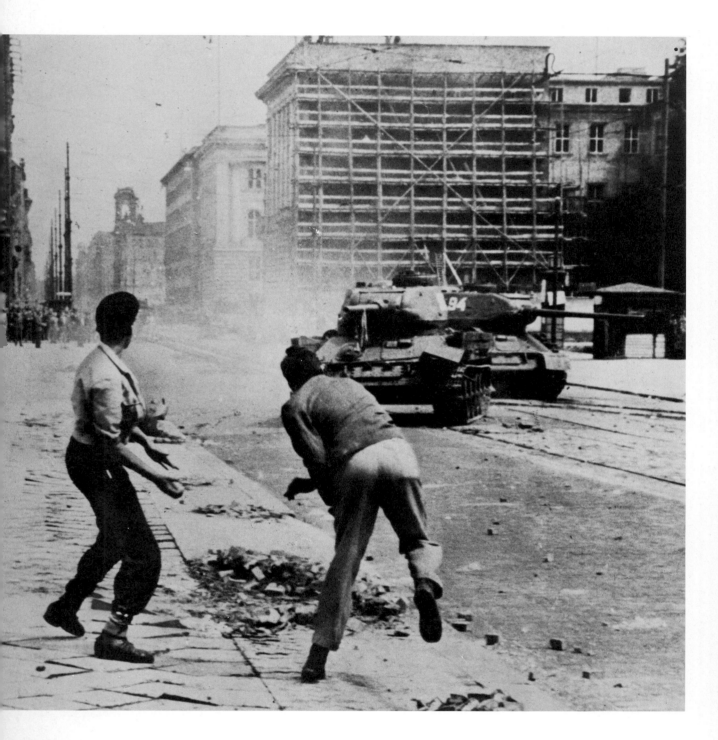

London, Feb. 11, 1952 In a famous portrait, three English queens mourn George VI. Rebec- ca West said that Queen Mary, shown between the new Elizabeth II and the Queen Mother, embod- ied "all women who have felt an astonished protest because their children have died before them."

RONALD CASE

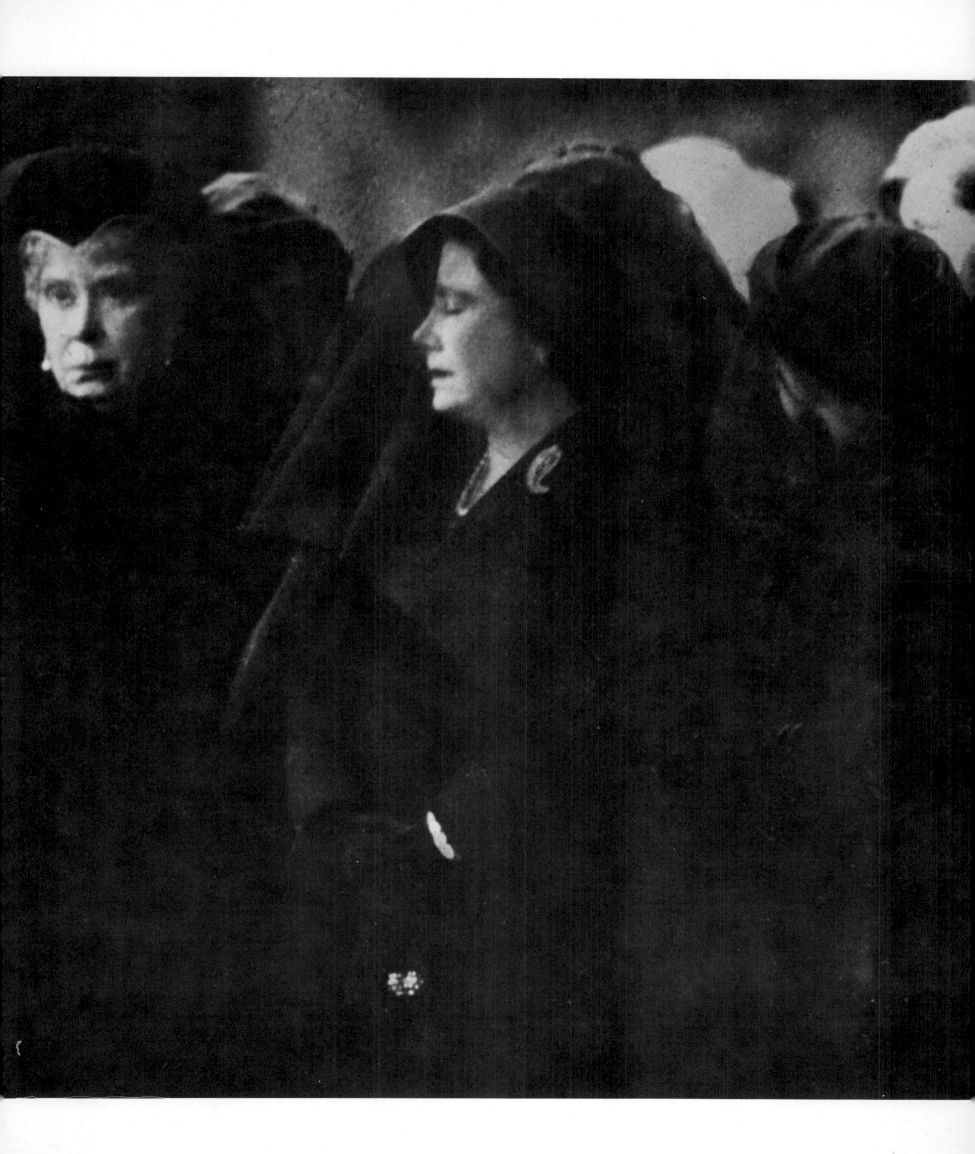

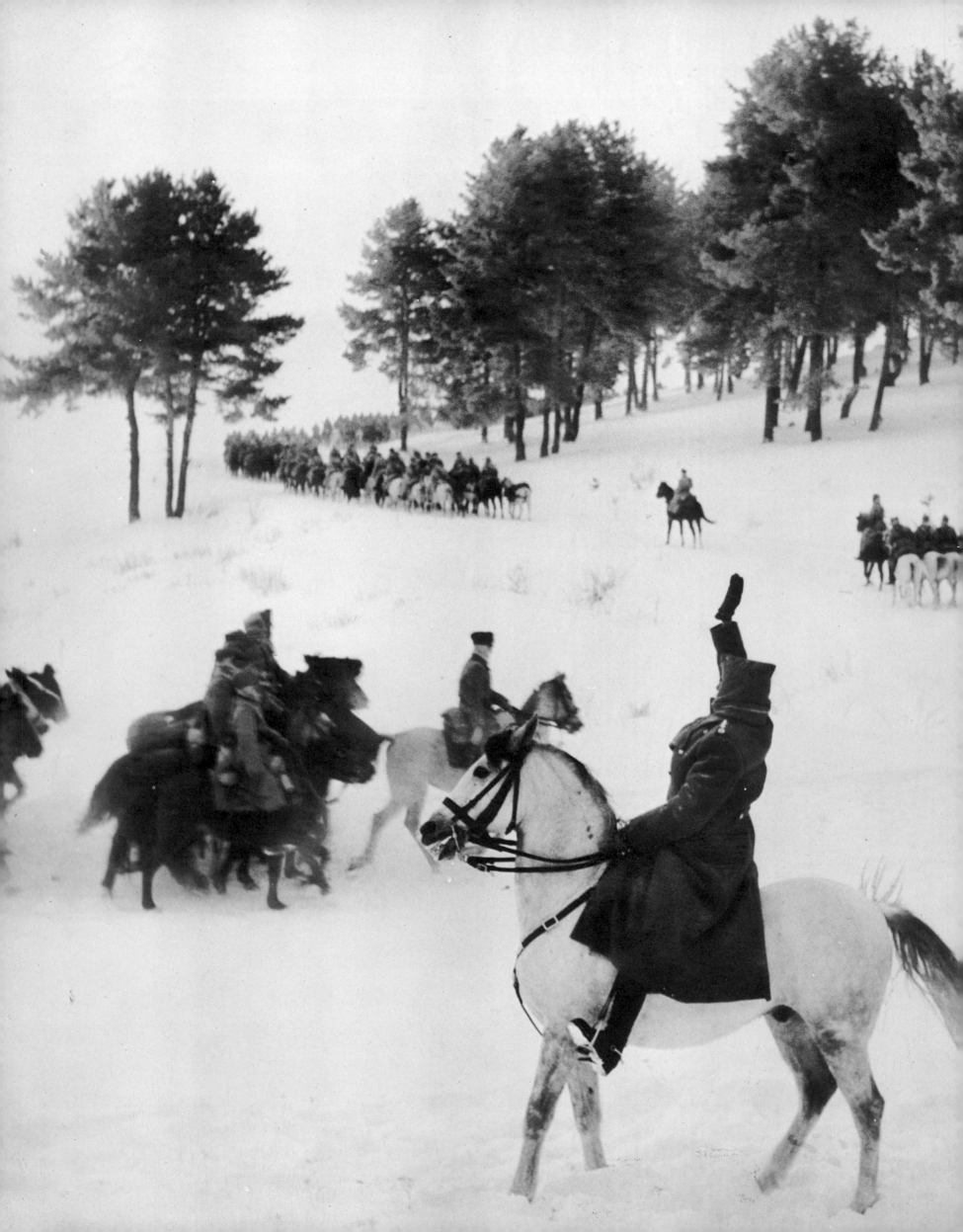

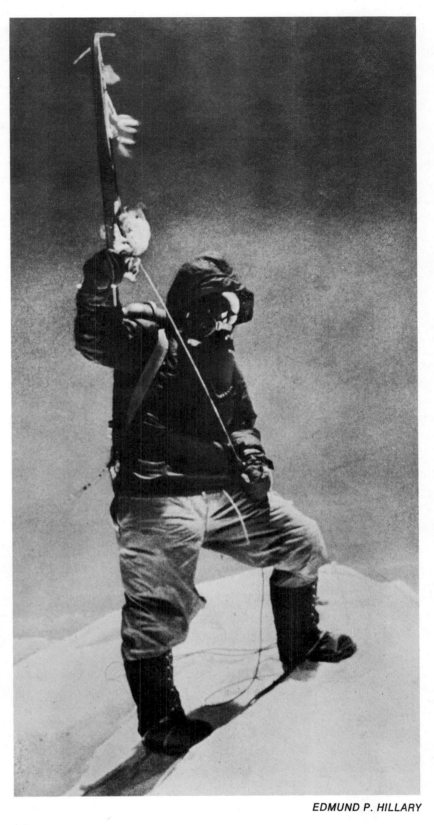

EDMUND P. HILLARY

Nepal, May 29, 1953

In a mountaineering milestone—man's first ascent of the world's highest mountain—Sherpa climber Tenzing Norkay holds a string of flags on top of Everest's wind-driven 29,028-foot summit and is photographed by his New Zealand climbing partner.

Turkey, December 1948

Like an old-fashioned lithograph come to life, the Turkish cavalry rides out on its winter maneuvers along the eastern frontier.

DAVID DOUGLAS DUNCAN

Budapest, October 1956 Hands lifted in terror *(below),* two members of the Soviet-controlled secret police are shot by patriots in Hungary's briefly successful revolt. It was later discovered that both miraculously survived.

JOHN SADOVY

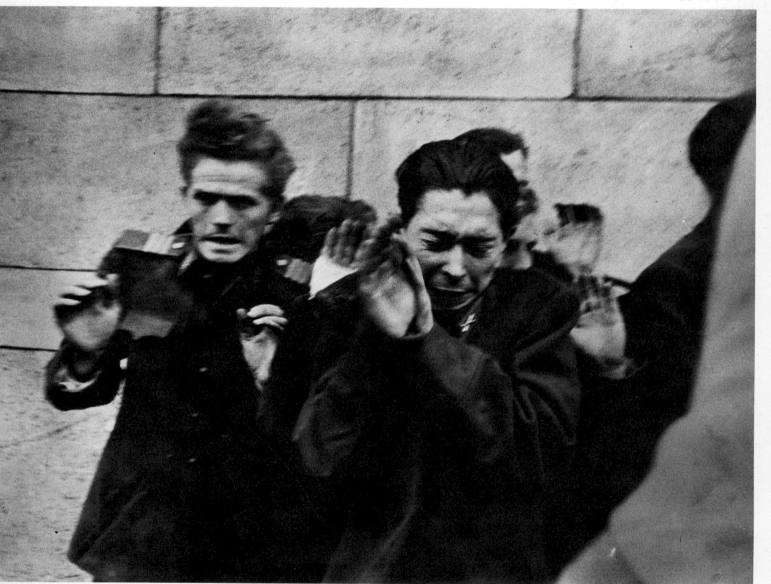

Tokyo, October 1960 Socialist leader Inejiro Asanuma, already mortally stabbed, tries to ward off a second thrust by an ultra-Rightist who has climbed onto the stage to attack the politician in the midst of a speech.

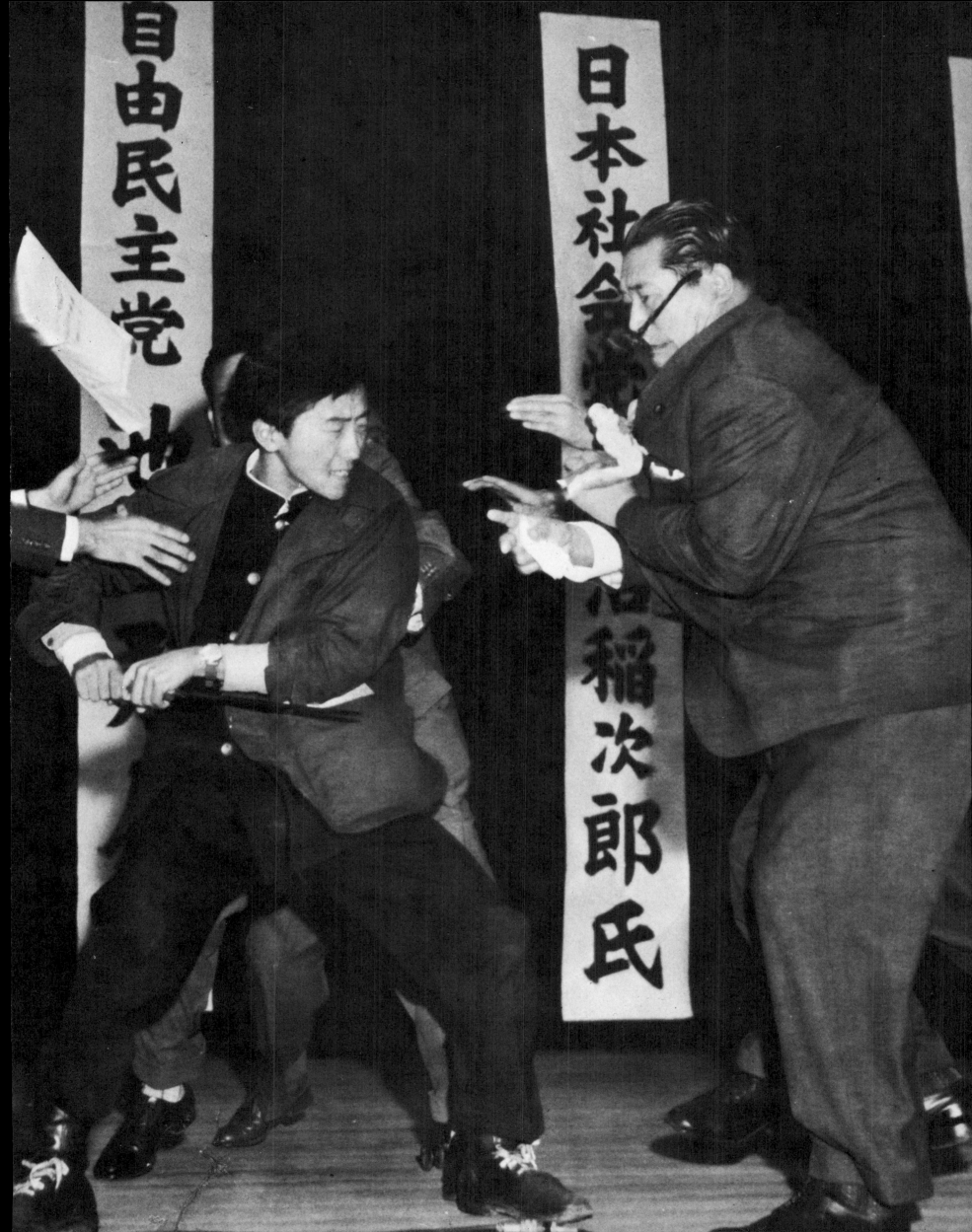

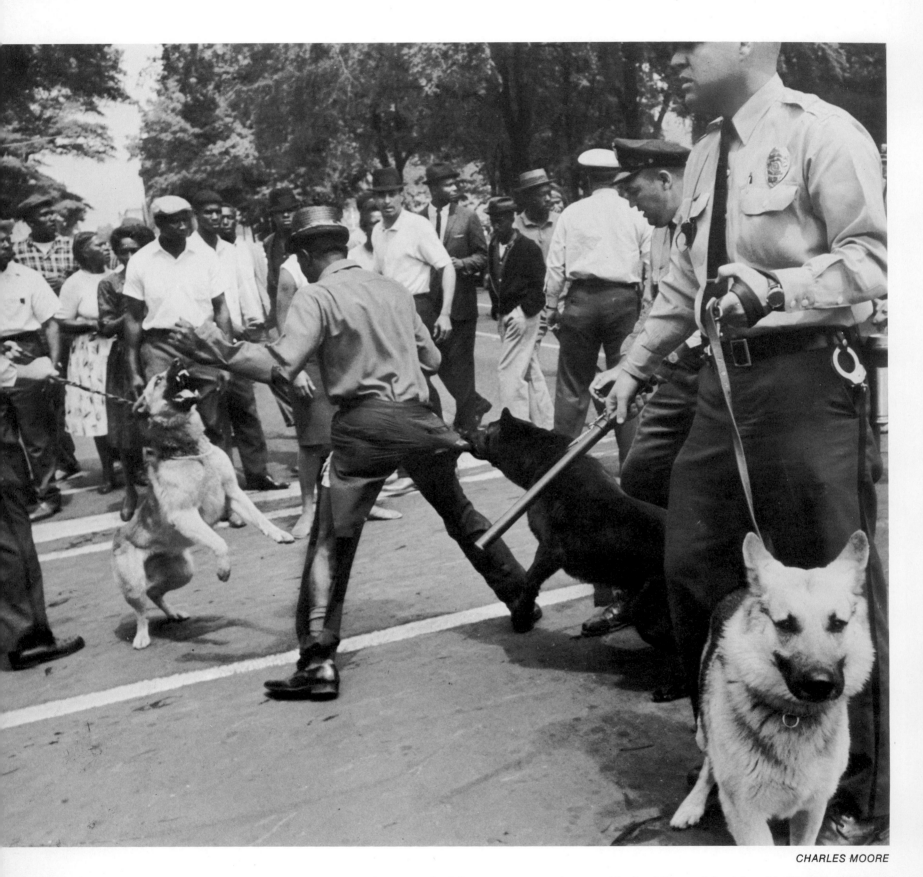

Birmingham, Ala., May 1963 In a brutal climax to black-white confrontation in the South, demonstrators led by Martin Luther King are set upon by guard dogs (*above*) and battered by jets from fire hoses (*right*) at the instigation of Birmingham's Police Commissioner Eugene ("Bull") Conners.

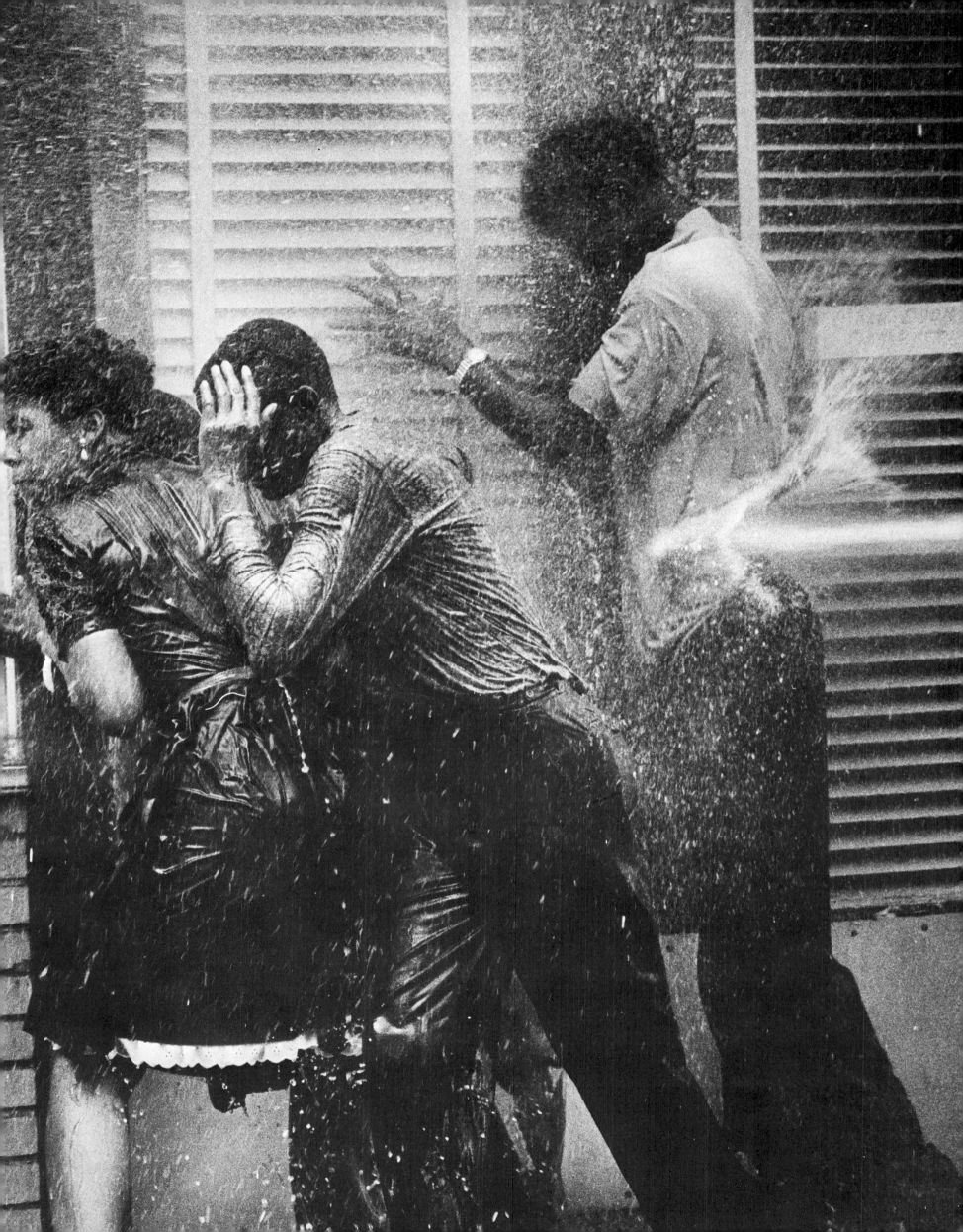

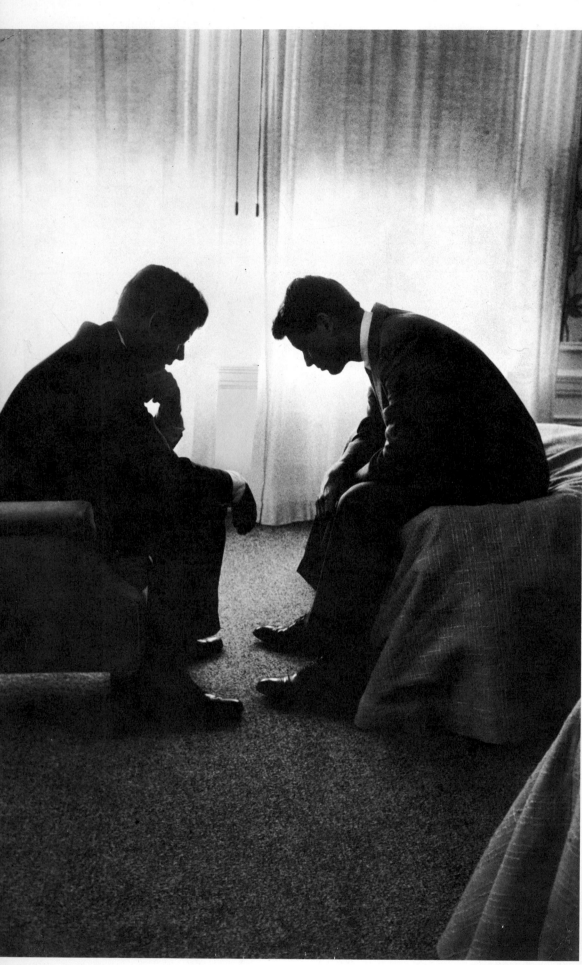

HANK WALKER

Los Angeles, July 1960

John and Robert Kennedy plan their winning nomination strategy, oblivious of the camera that immortalized their brotherly political collaboration.

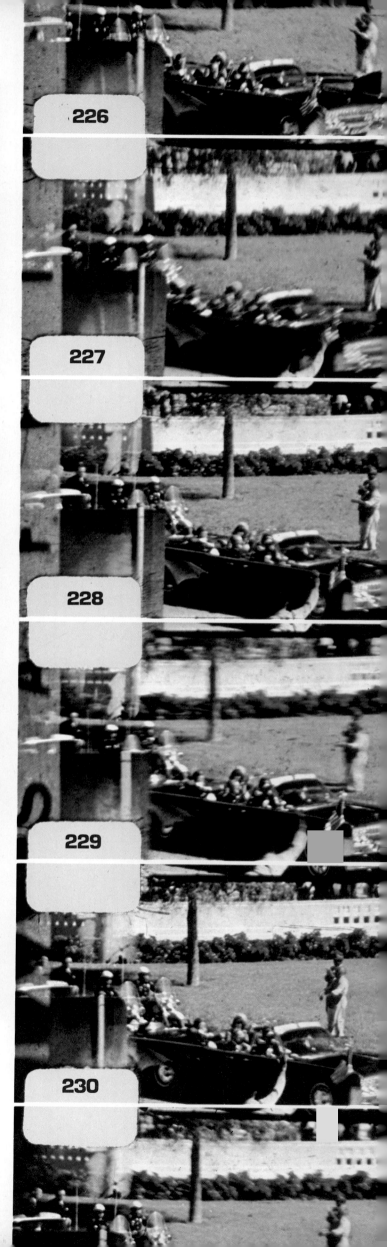

226

227

228

229

230

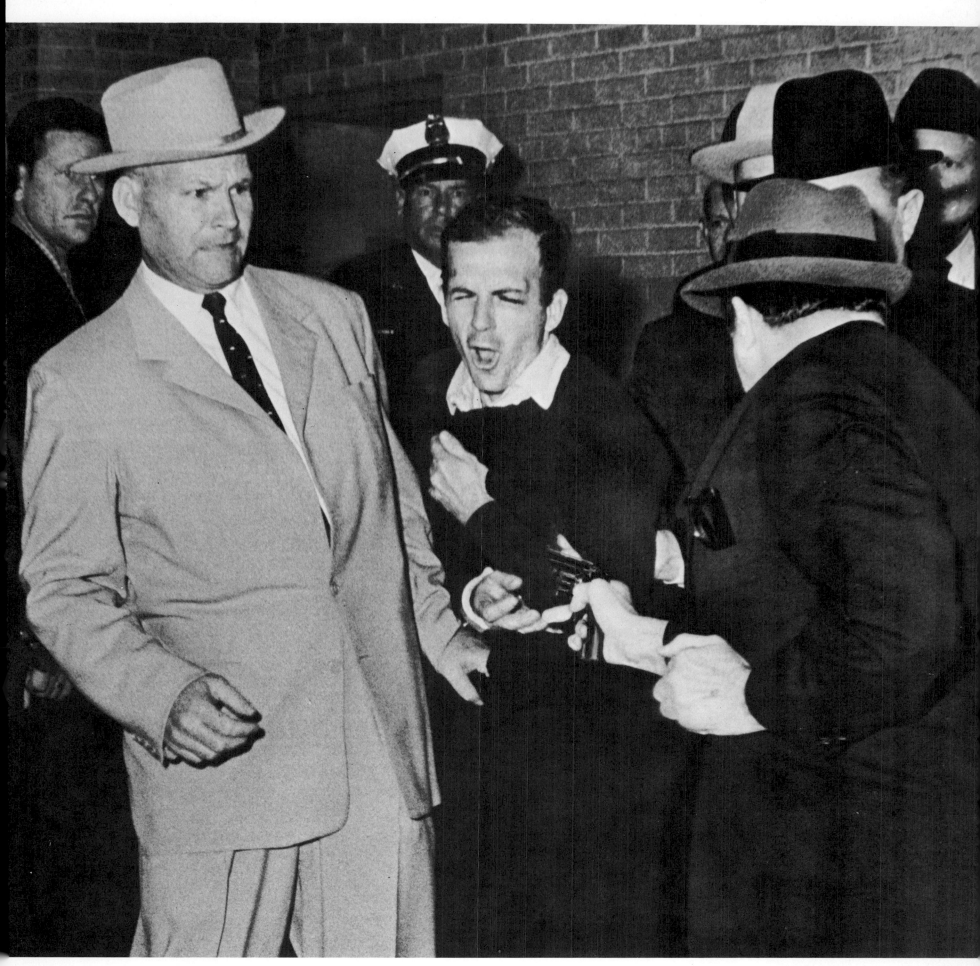

BOB JACKSON

Dallas, Nov. 22, 1963

The key strip of the famous 8mm movie film that LIFE published shows President Kennedy as he is hit by his assassin's fire.

ABRAHAM ZAPRUDER

Dallas, Nov. 24, 1963

The precise instant of a historic act of revenge is captured as Jack Ruby shoots Kennedy assassin Lee Harvey Oswald.

41

Memphis, April 4, 1968 On the balcony of a Memphis motel Martin Luther King lies in a spreading pool of blood as his aides point in the apparent direction of the shots that killed him. The picture was caught by a TV producer, on the scene at the time making a documentary film.

JOSEPH LOUW

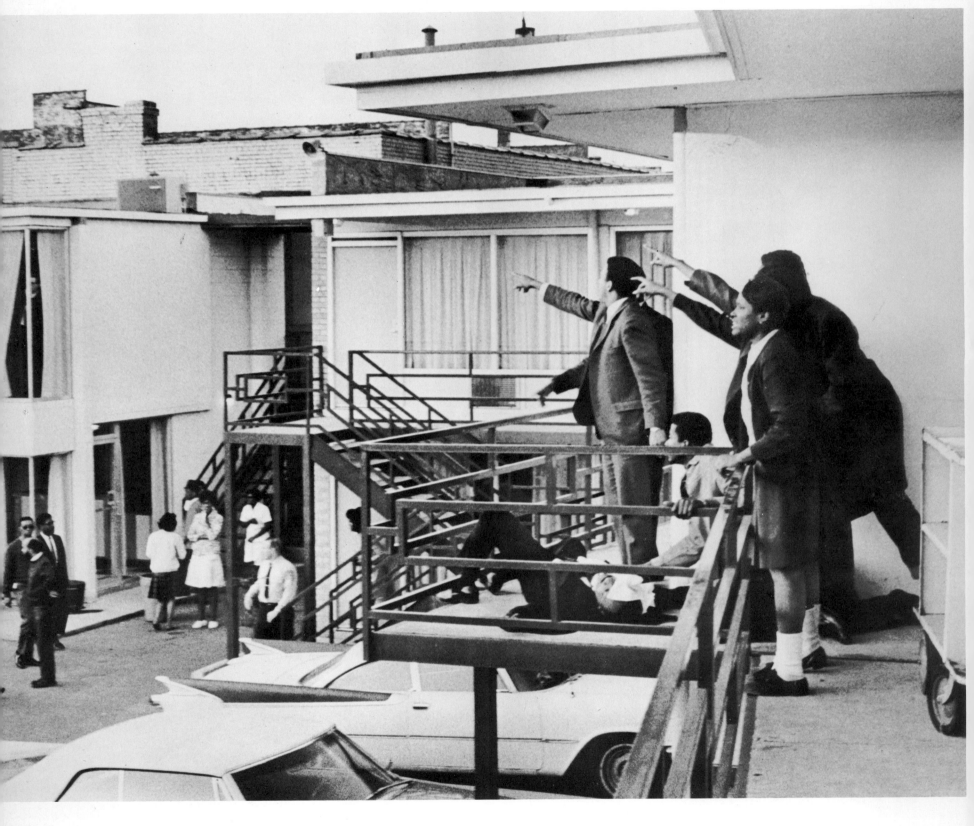

Los Angeles, June 5, 1968 When Robert Kennedy ended his speech in the Hotel Ambassador ballroom, Bill Eppridge followed as he exited through the kitchen and caught up to him a moment after the shooting. Kennedy was being comforted by a bus boy whose hand he had just shaken.

BILL EPPRIDGE

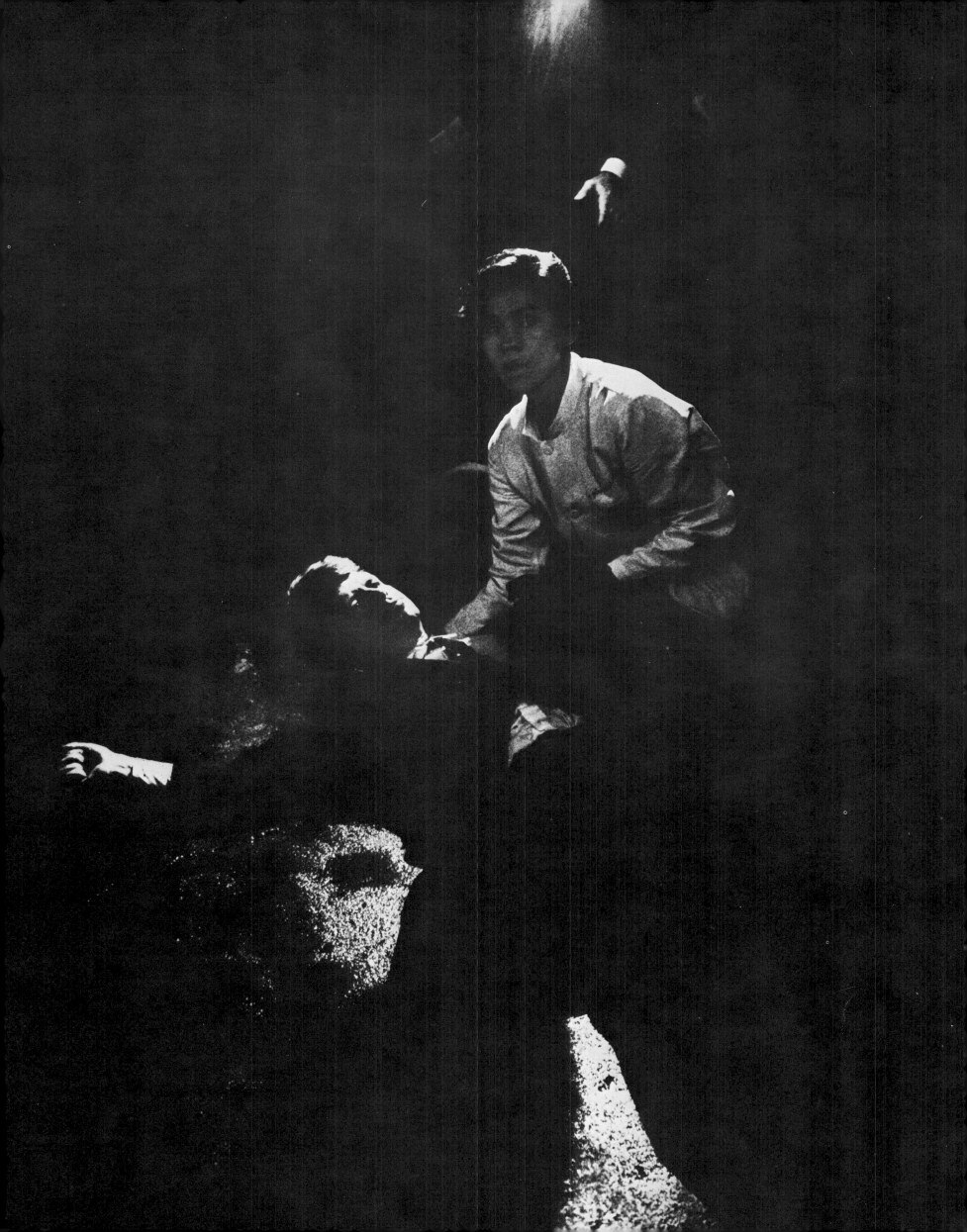

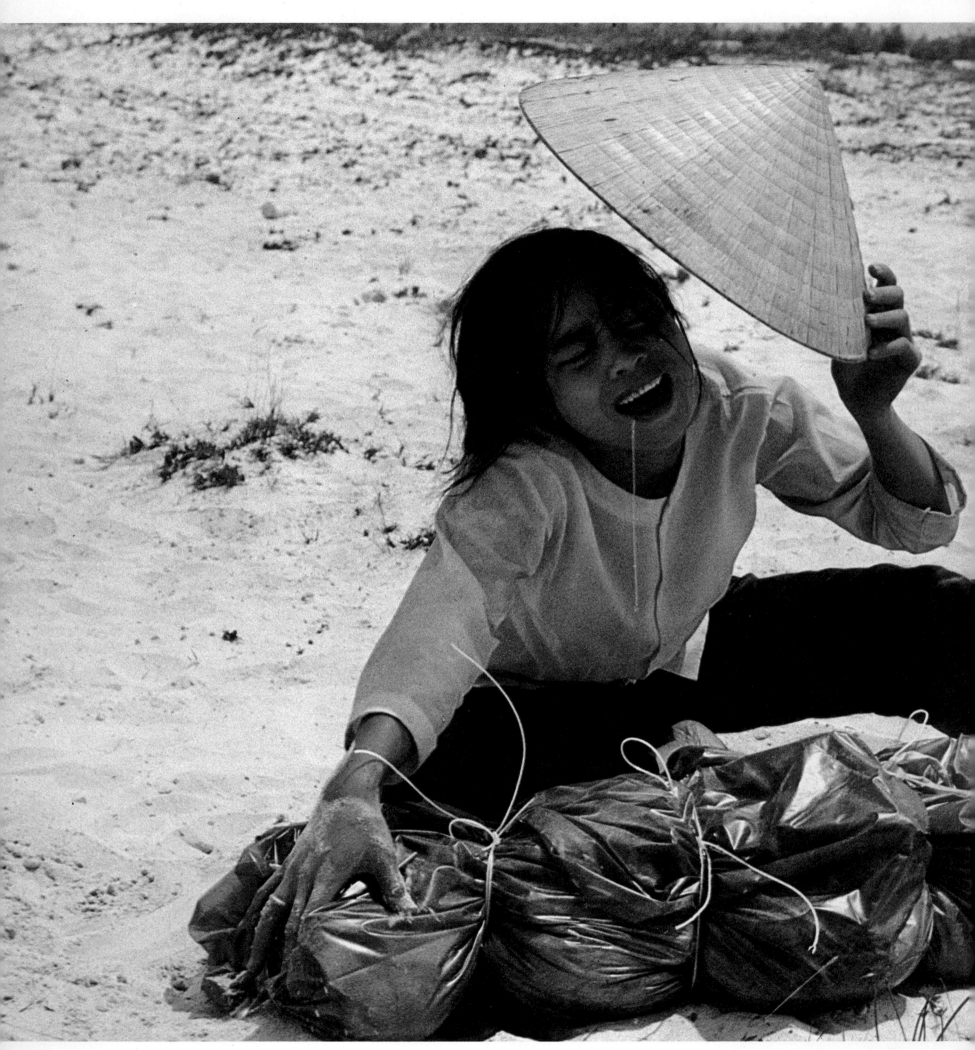

Hué, April 1969 A Vietnamese woman wails inconsolably over the trussed-up remains of her husband, found when mass graves were opened more than a year after the wholesale Tet killings by the Viet Cong.

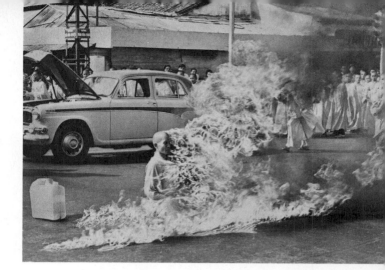

Saigon, June 1963

In a climax to the religious and political protests against the regime of Ngo Dinh Diem, a 73-year-old Buddhist monk, doused with gasoline by fellow monks, sets himself on fire in Saigon.

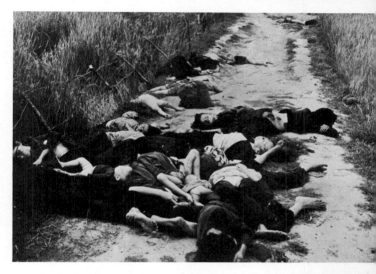

Mylai, March 16, 1968

Victims of the slaughter at Mylai sprawl on a road outside the village. It was more than a year after the event that the news finally got out and Army photographer Haeberle's pictures were published.

RONALD HAEBERLE

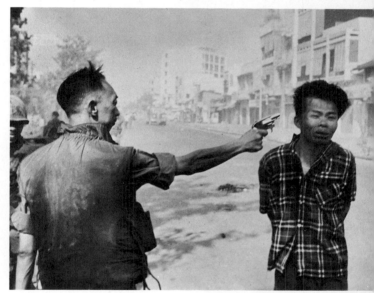

Saigon, February 1968

At the height of the Tet offensive, Saigon Police Chief Nguyen Ngoc Loan summarily executes a Viet Cong suspect. A few months later LIFE ran a picture of Loan himself wounded in a street battle.

EDDIE ADAMS

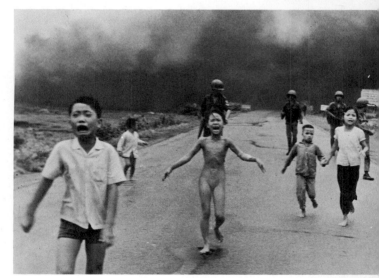

Trang Bang, June 1972

Napalmed in error by a South Vietnamese plane, Phan Thi Kim Phuc flees from the scene after tearing off her flaming clothes.

NICK UT

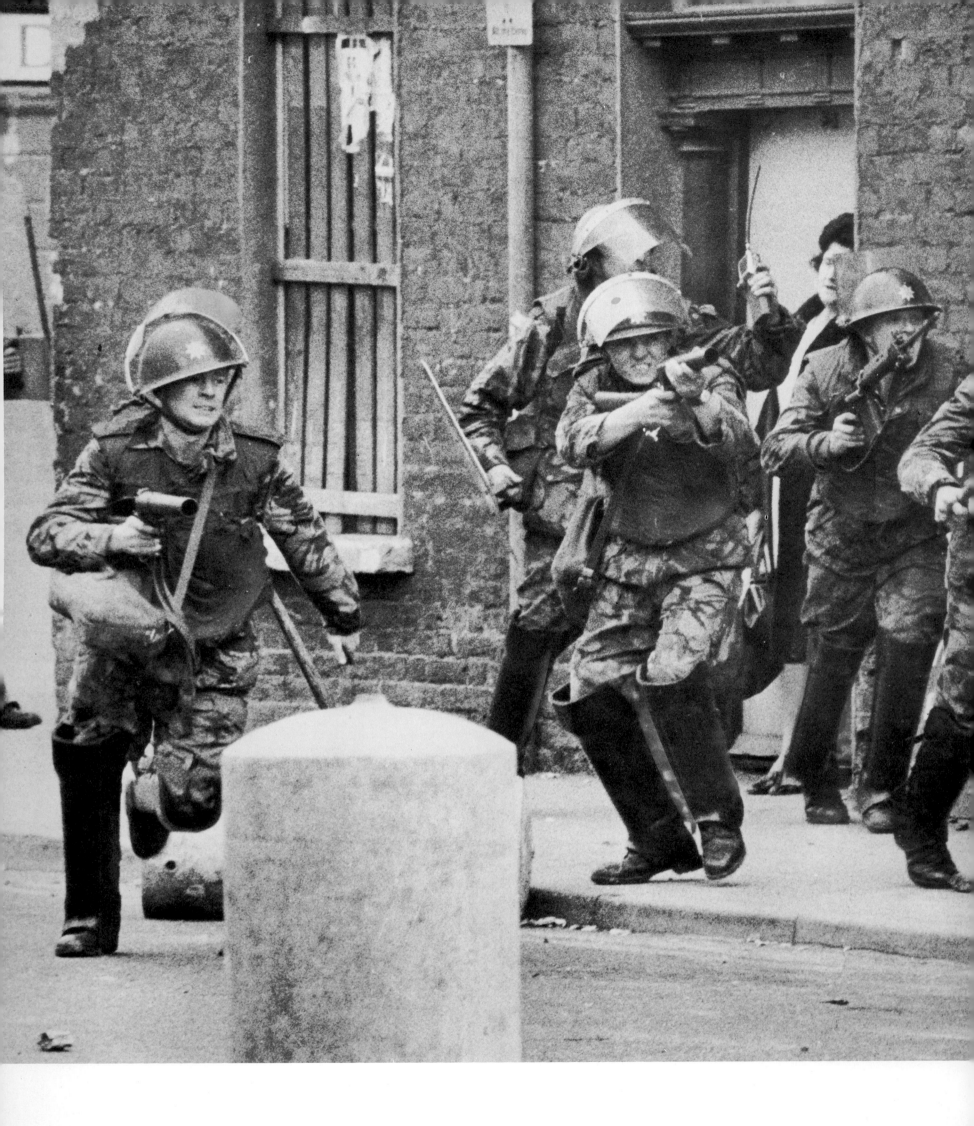

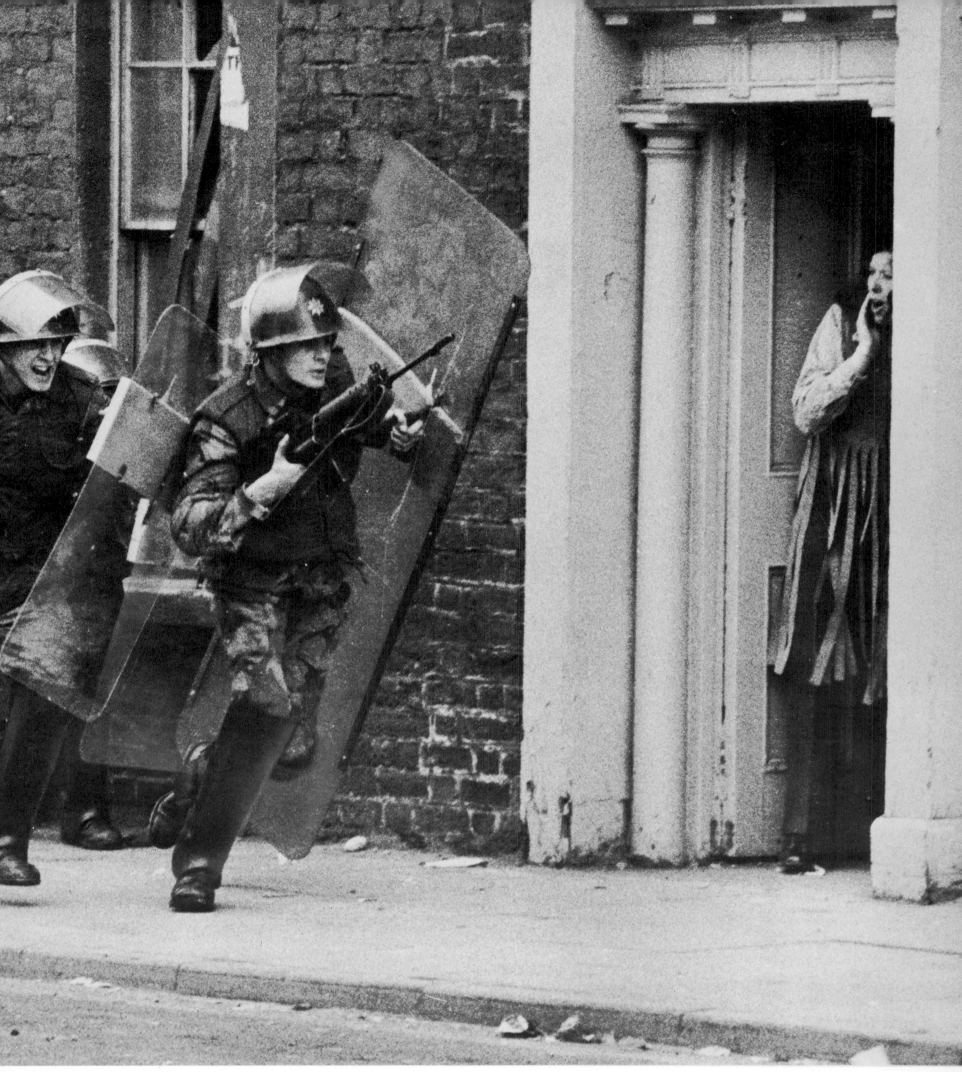

Belfast, November 1971 While two women cower in their doorways, British soldiers, carrying plexiglass shields and armed with truncheons and submachine guns, charge down the street after the Irish Republican enemy.

47

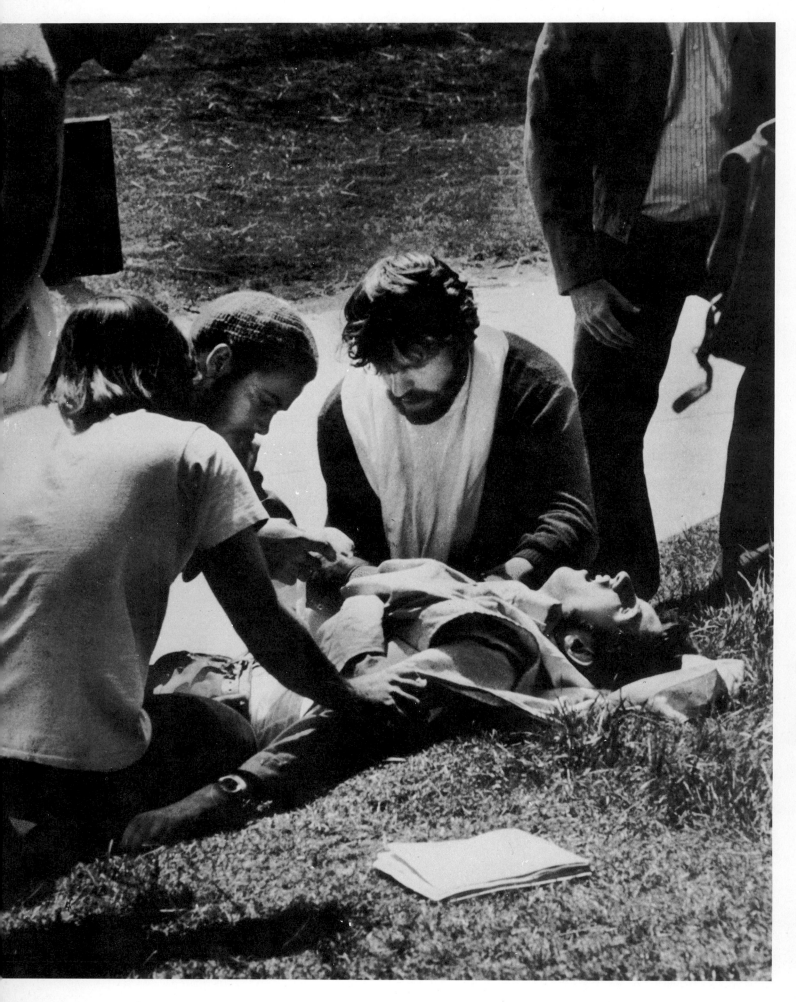

Kent, Ohio, May 4, 1970

In the aftermath of the rioting at Kent State University, students kneel over a colleague shot by National Guardsmen.

HOWARD RUFFNER

Laurel, Md., May 15, 1972

Seconds after he has been struck down during a rally, George Wallace is embraced by his distraught wife.

FREDERICK H. STIRES

48

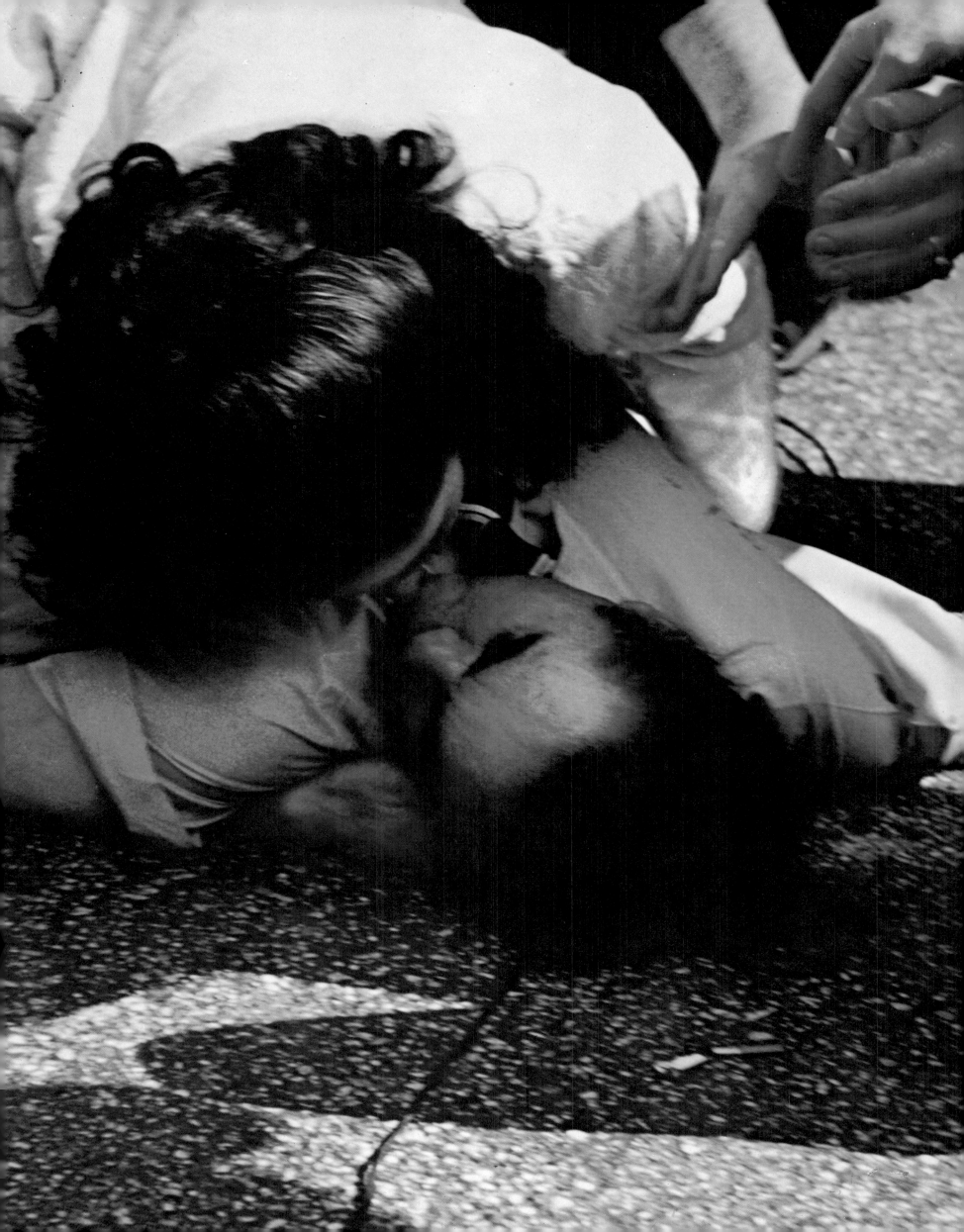

Kyushu, December 1971 A Japanese mother holds and tenderly bathes her daughter, 17, who was born blind and maimed as a result of mercury poisoning from a chemical plant polluting the waters of Minamata village.

W. EUGENE and AILEEN SMITH

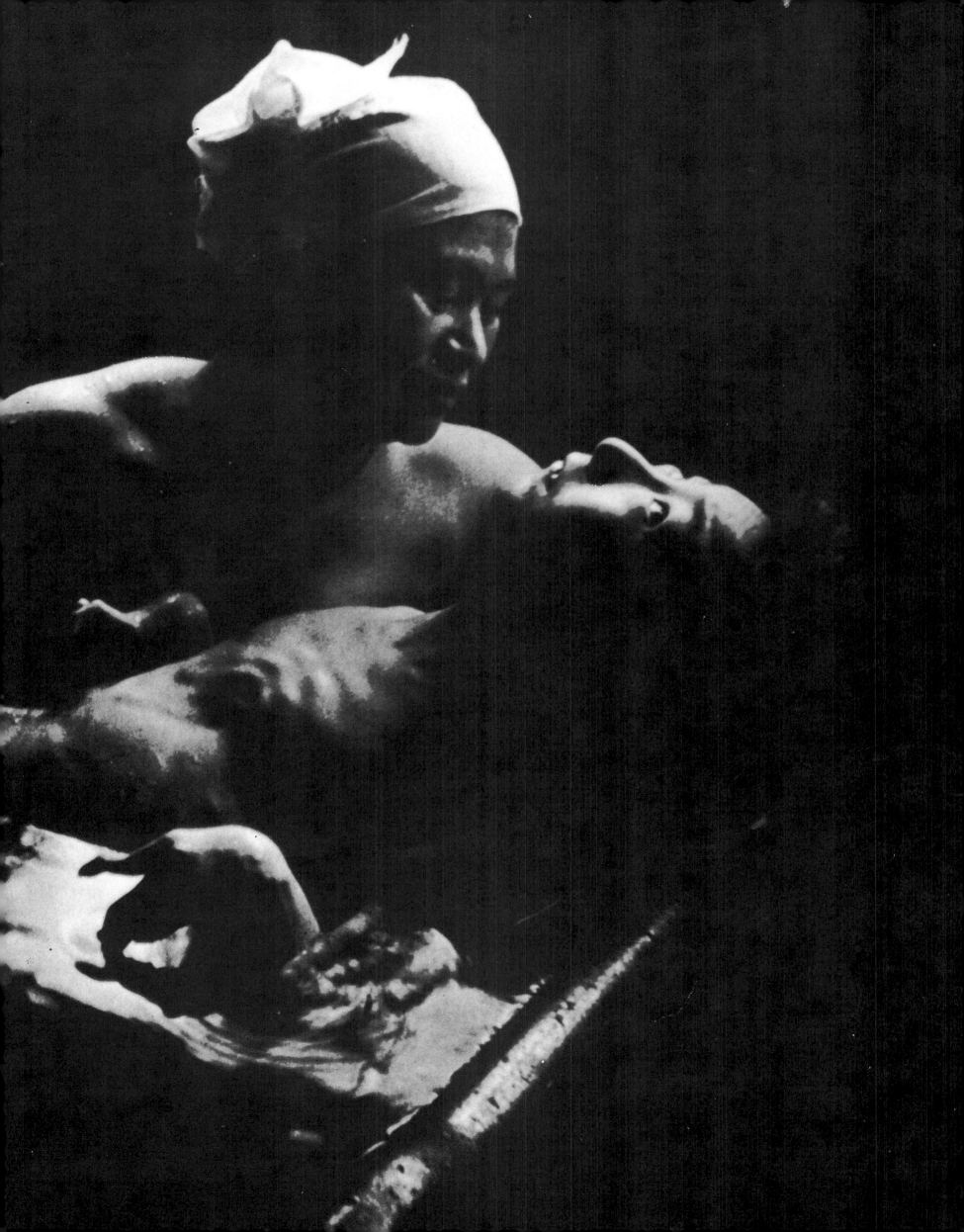

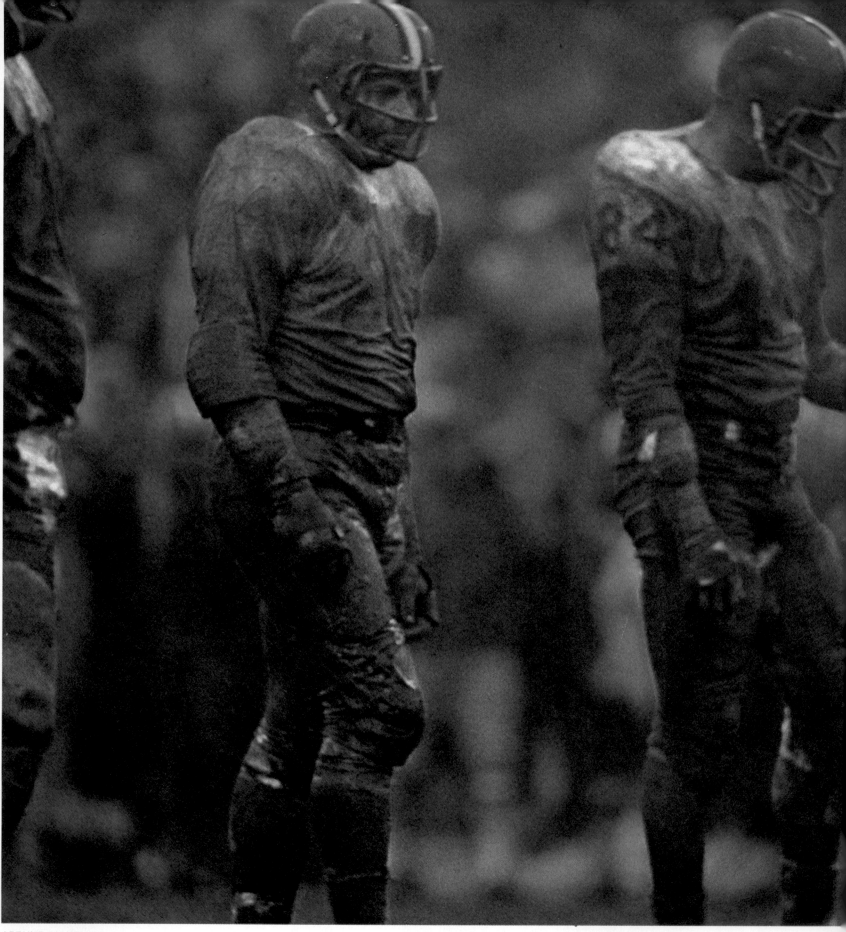

ARTHUR RICKERBY

Late in a losing game, Cleveland's weary defense lines up for another Green Bay rush.

Saturday's hero, 1937

Baseball pioneer Robinson

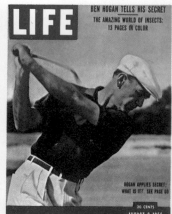

Hogan at his peak

THE ATHLETES

A feast of champions, served up with ingenuity, courage—and stamina

Inventiveness and persistence were the most important qualities LIFE brought to the coverage of sports. The resulting photographs captured the drama of athletics as nothing else ever had. Some of the memorable pictures were poignantly simple, like Babe Ruth's farewell *(below)*, or as accidental as a baseball traffic jam *(page 54)*. Art Rickerby, after covering 14 games for a single pro football essay, decided to go to "just one more," on a dark and muddy January Sunday. The outcome is shown at left. Gjon Mili, a pioneer in strobe lighting, took his equipment to Madison Square Garden and added a new dimension to photographs of fighters.

George Silk—four times Magazine Photographer of the Year—took a sailboat's portrait from a bosun's chair 80 feet up and while hanging over its bow. It was Silk who attached a camera to his skis and later to a plunging surfboard. Co Rentmeester, on the other hand, made the superb close-up of Mark Spitz on pages 62 and 63 by running the length of the pool, shooting as he ran.

In 1947, ailing Babe Ruth filled Yankee Stadium for the last time.

RALPH MORSE

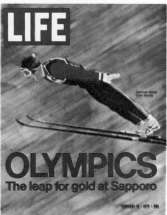

Japan's winning leap

Jug-eared Rookie

Mickey McDermott, 19 *(below)*, suits up. He was the Red Sox' "promising southpaw" of 1948.

JOE AND FRANK SCHERSCHEL

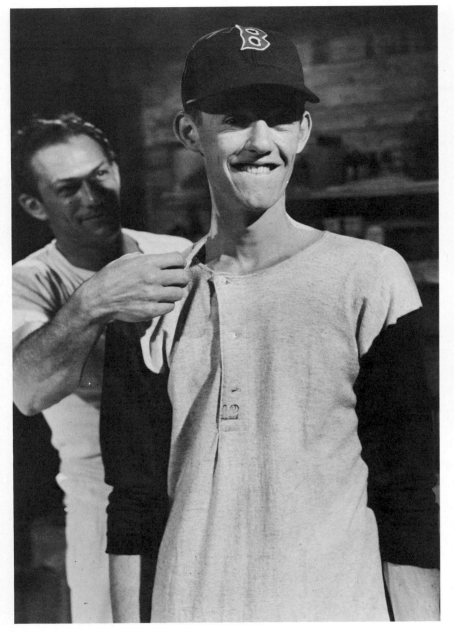

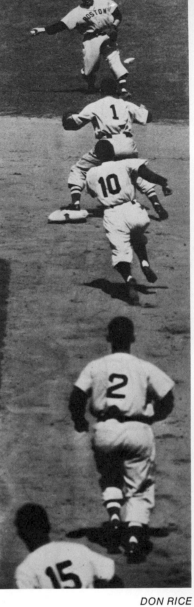

DON RICE

Scooter in Traffic

Boston Red Sox infielders converge on Yankee Phil Rizzuto (10) in this 1948 jam. The "Scooter" made it to second base safely.

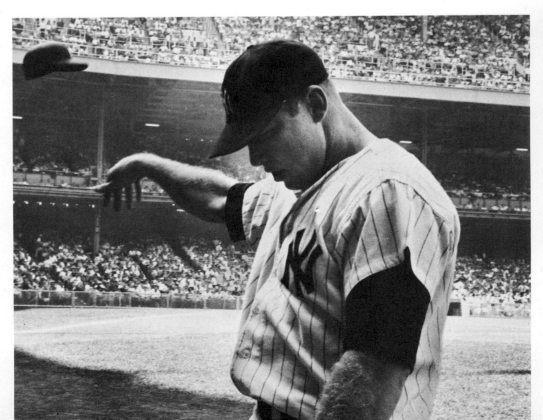

Painful Season

Mickey Mantle vents his frustration after grounding out in 1965.

JOHN DOMINIS

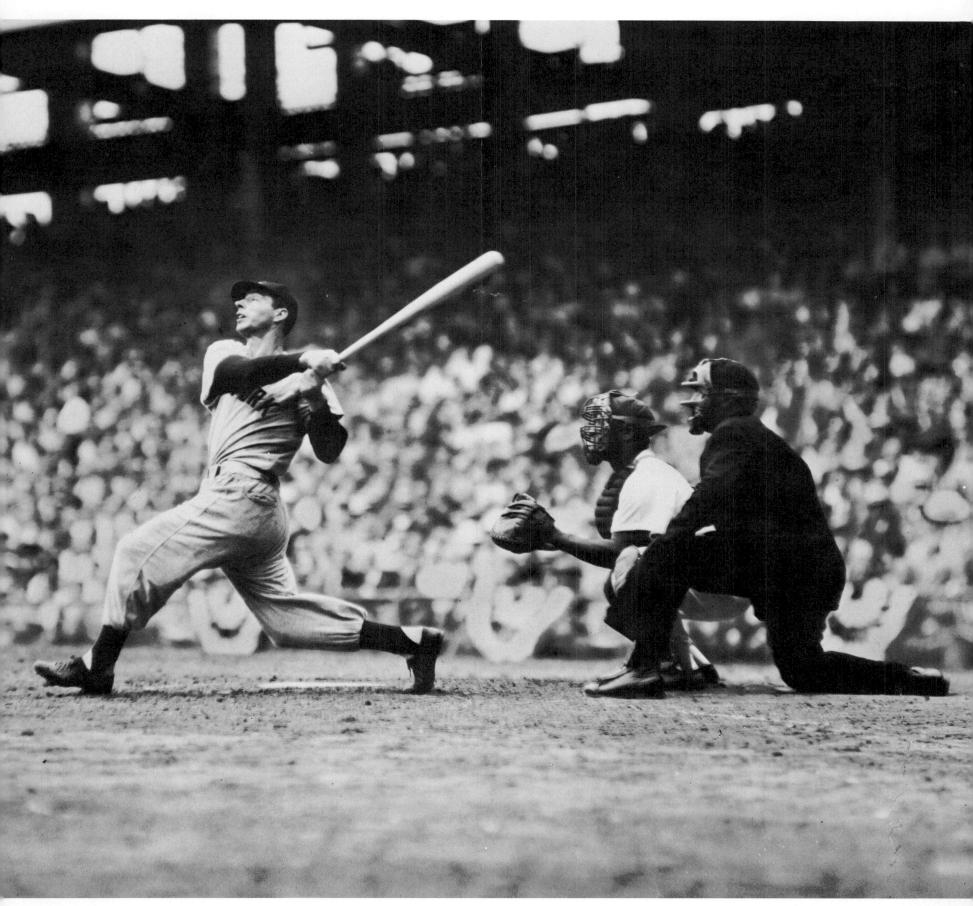

Sweet Comeback

Recovered from a bone spur in his heel, Joe DiMaggio strokes a double in the 1949 All-Star game.

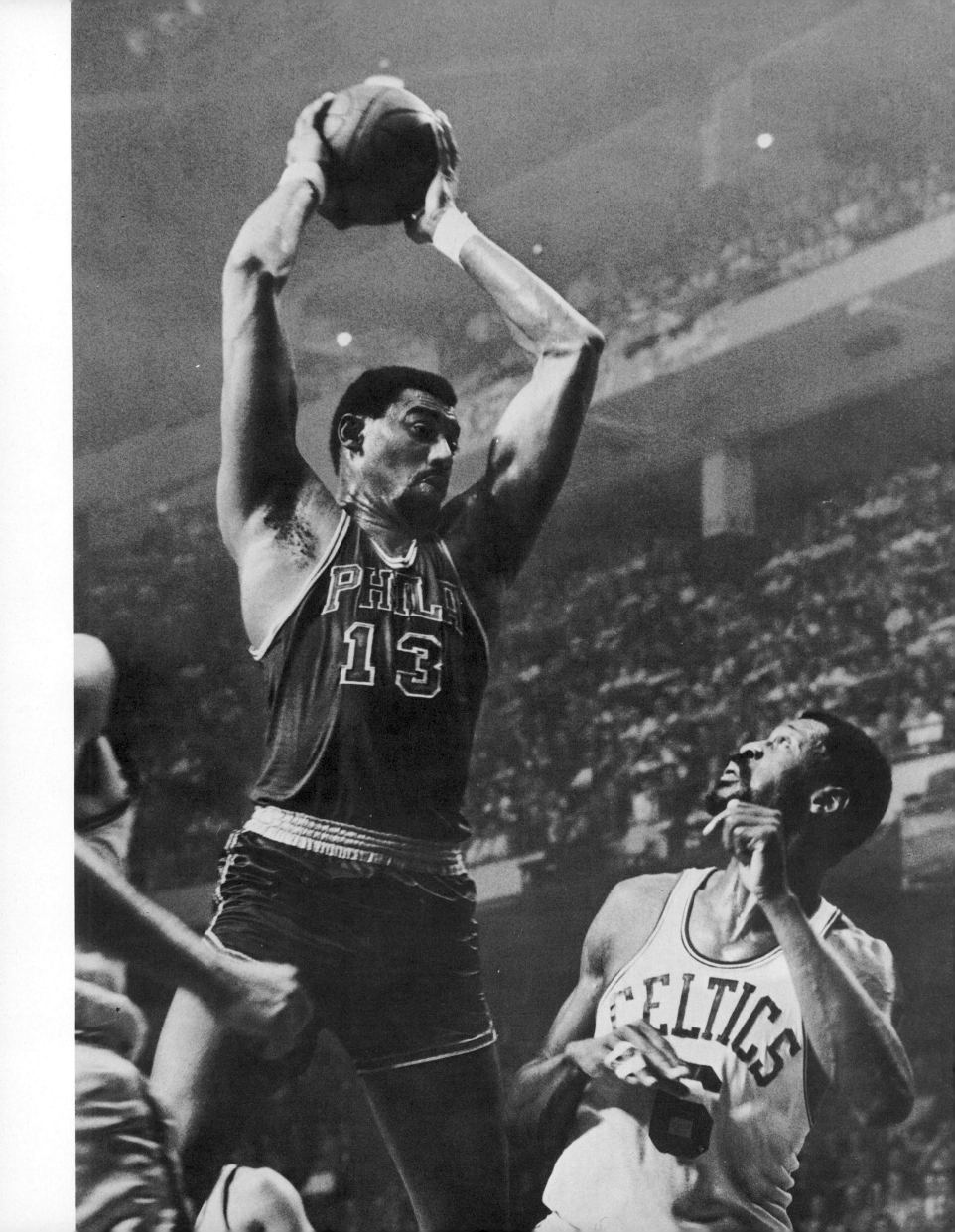

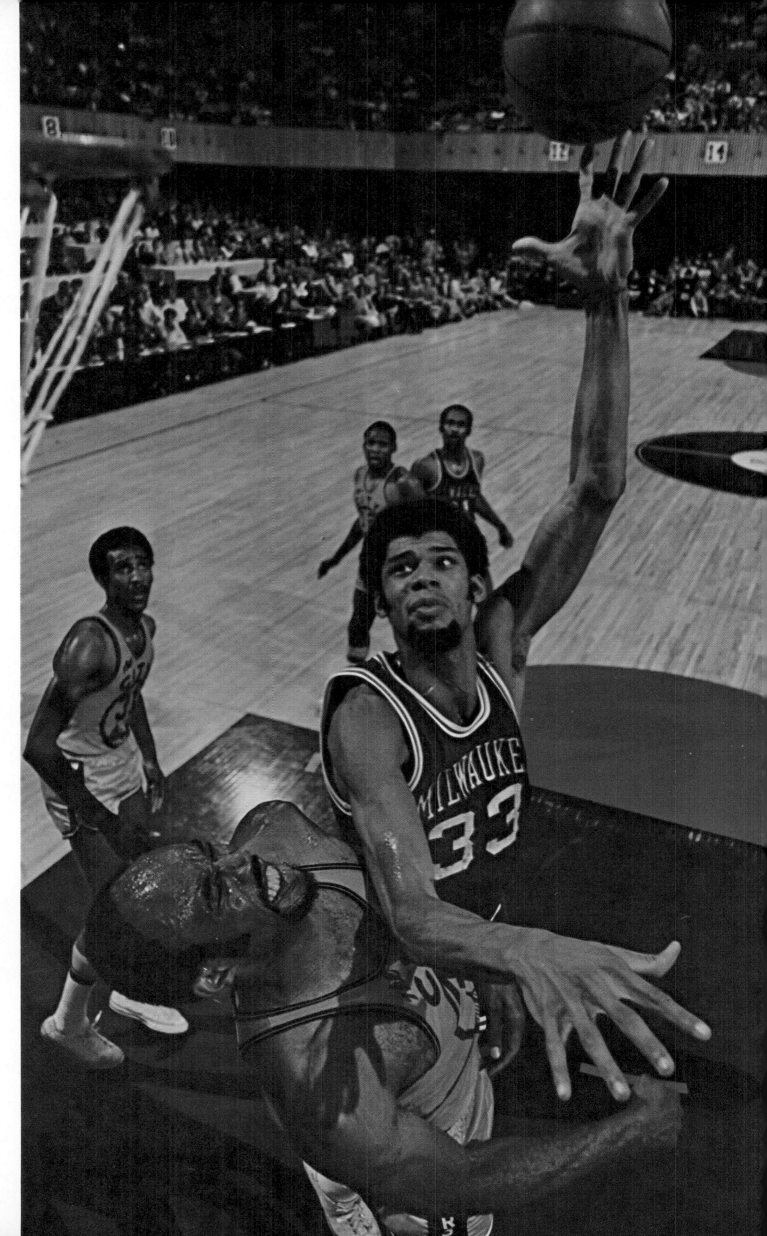

Wilt the Stilt

After seven seasons of titleless frustration, Wilt Chamberlain at last overcomes his nemesis, Bill Russell of the Boston Celtics, to win the 1967 pro championship for Philadelphia.

JOHN G. ZIMMERMAN

Big Lew

LIFE first covered Lew Alcindor as a seven-foot high-school phenomenon in 1965. Four years later *(right),* as the best pro rookie ever, Lew (later Kareem Abdul-Jabbar) could hold his own with the game's strongest men, including the Warriors' Nate Thurmond.

JOHN G. ZIMMERMAN

The Brown Bomber

Incomparable Joe Louis stopped *(left to right)* Schmeling in one round, Galento in four, Godoy in eight. Eventually, in 1950, age and Ezzard Charles felled Joe.

The Supermouth

"I am the greatest," announced Cassius Clay (later Muhammad Ali) after a knockout in 1963. For a while, he was.

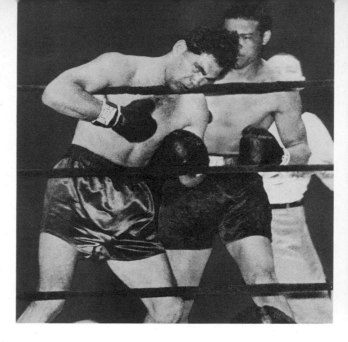
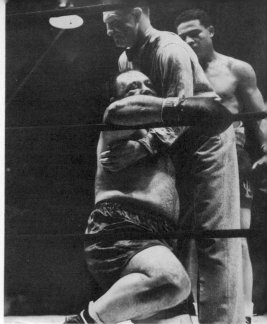

HARRY COUGHANOUR

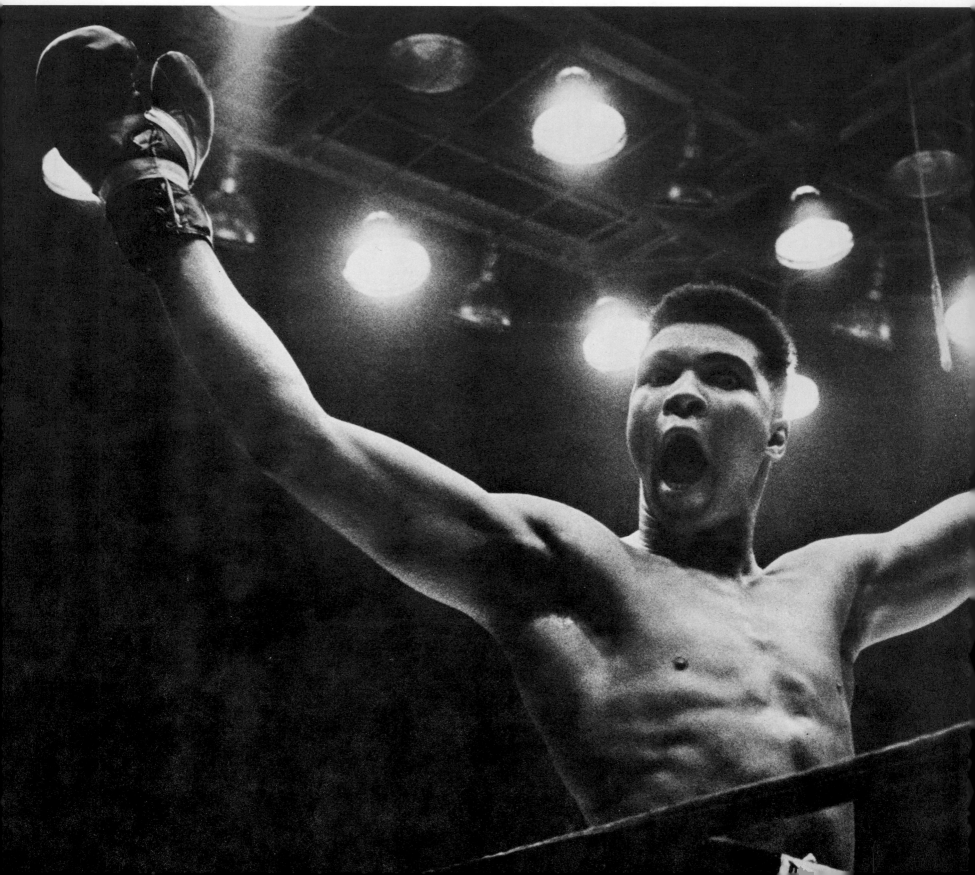

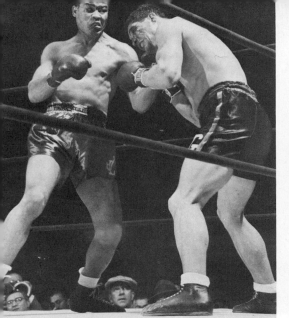

The Undefeated

Neither Ezzard Charles *(below)* nor any man of the '50s could withstand Rocky Marciano's fists. Marciano retired undefeated, but later died in a plane crash.

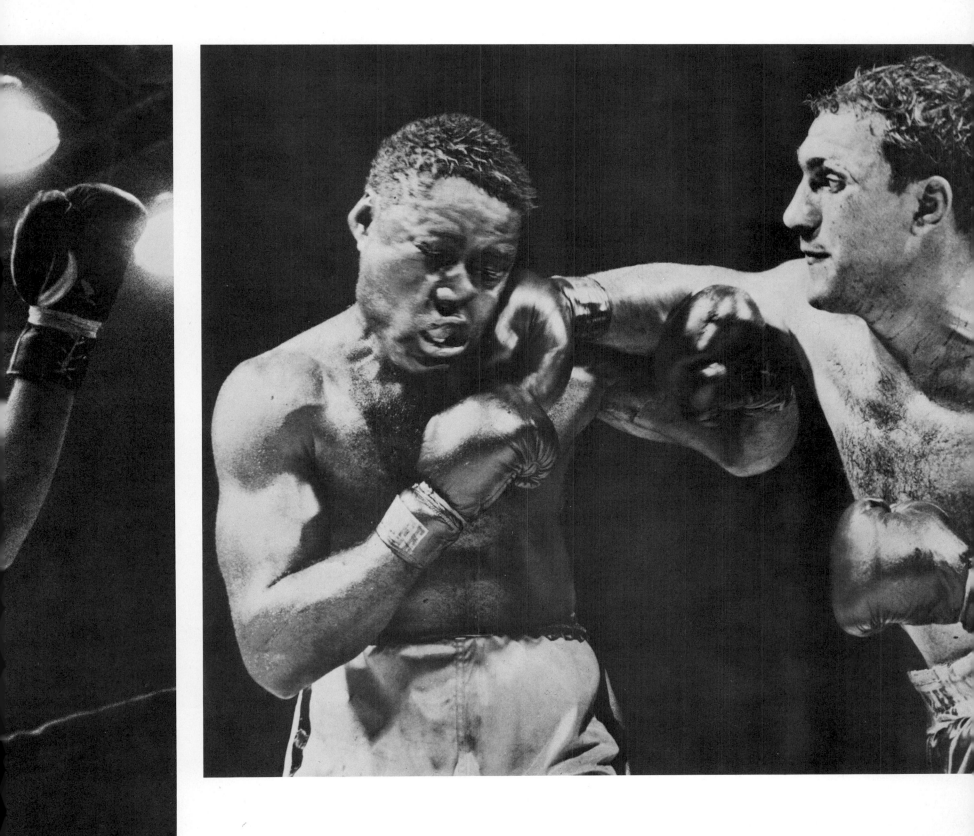

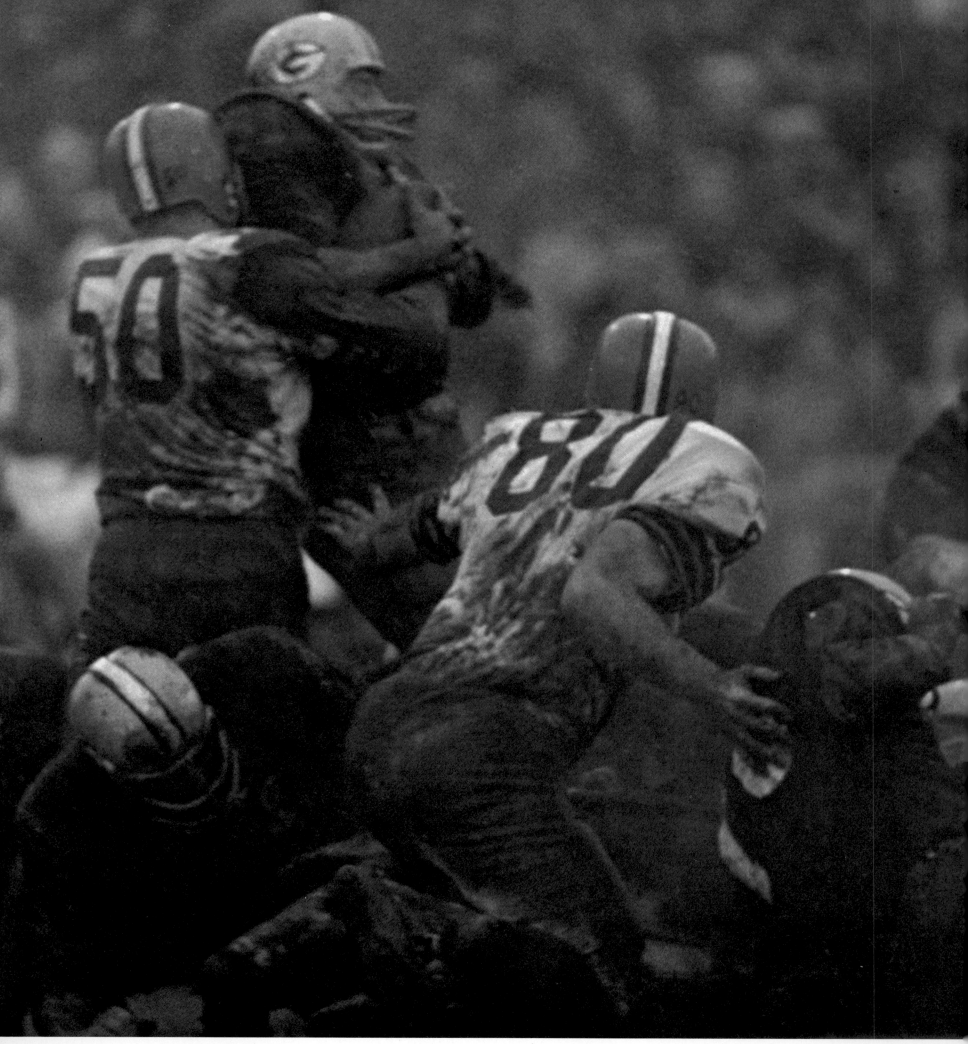

Mayhem in the Mud

With the 1965 title at stake, Cleveland's Vince Costello (50) rises up to thwart Green Bay's Jim Taylor.

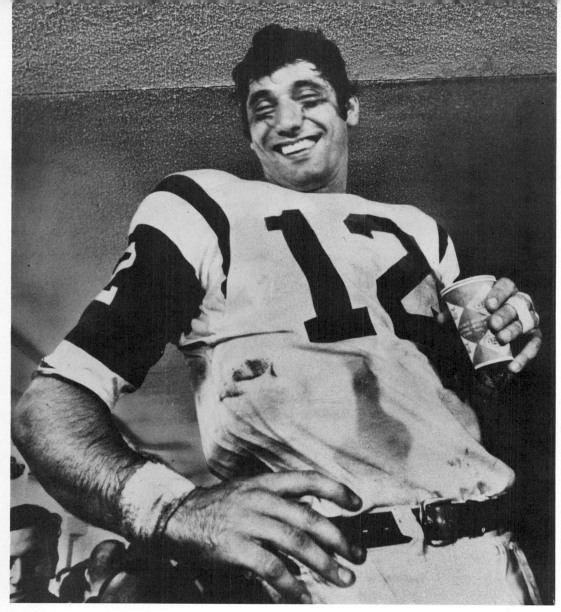

Vindicated Joe

The New York Jets' ebullient Namath toasts the 1969 Super Bowl victory he had brashly predicted.

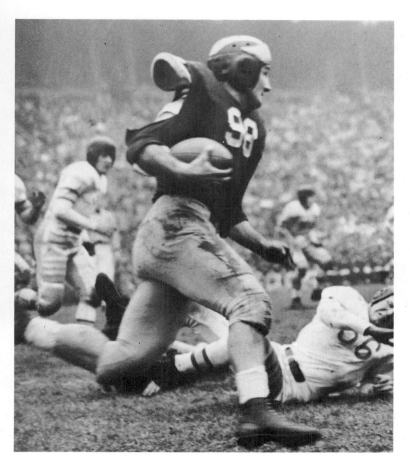

The First Harmon

"Ole 98," Tom Harmon, rambles for Michigan in 1940. By 1972 his son Mark was a star at UCLA.

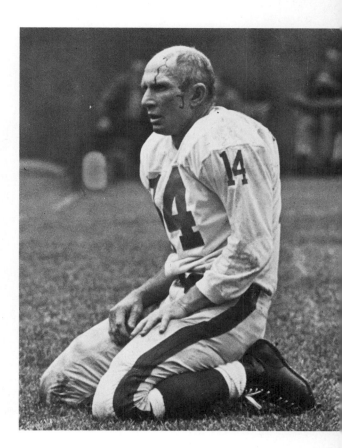

A Tossed Tittle

Dazed and bleeding, the Giants' Y. A. Tittle tries to recover from a bruising tackle in 1964.

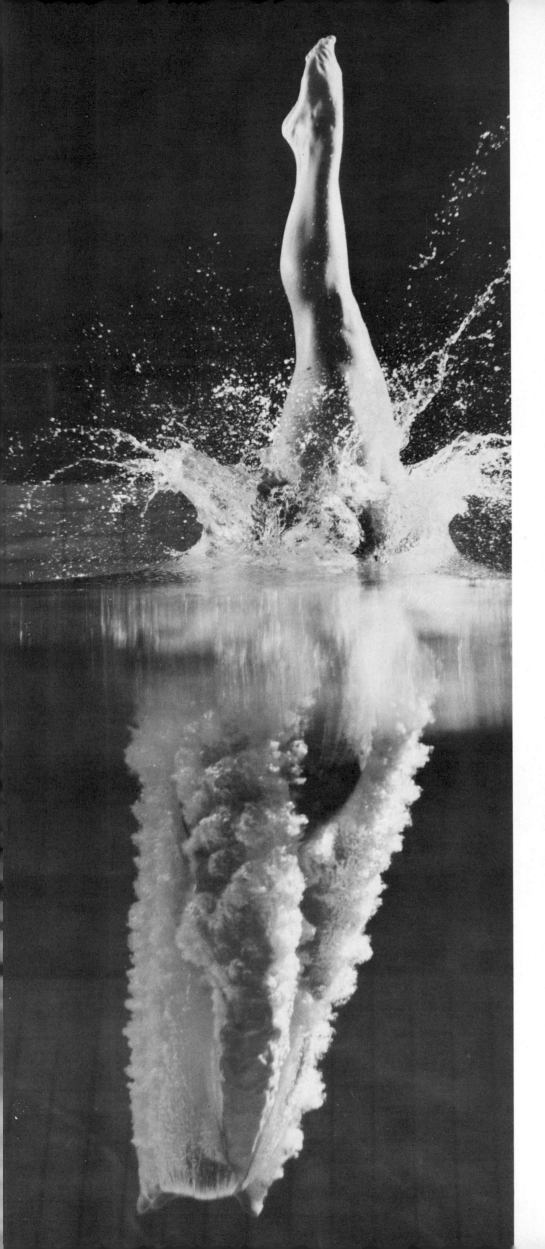

Slashing Dive Her form as faultless as the photographer's timing, Kathy Flicker, 14, neatly knifes the water.

GEORGE SILK

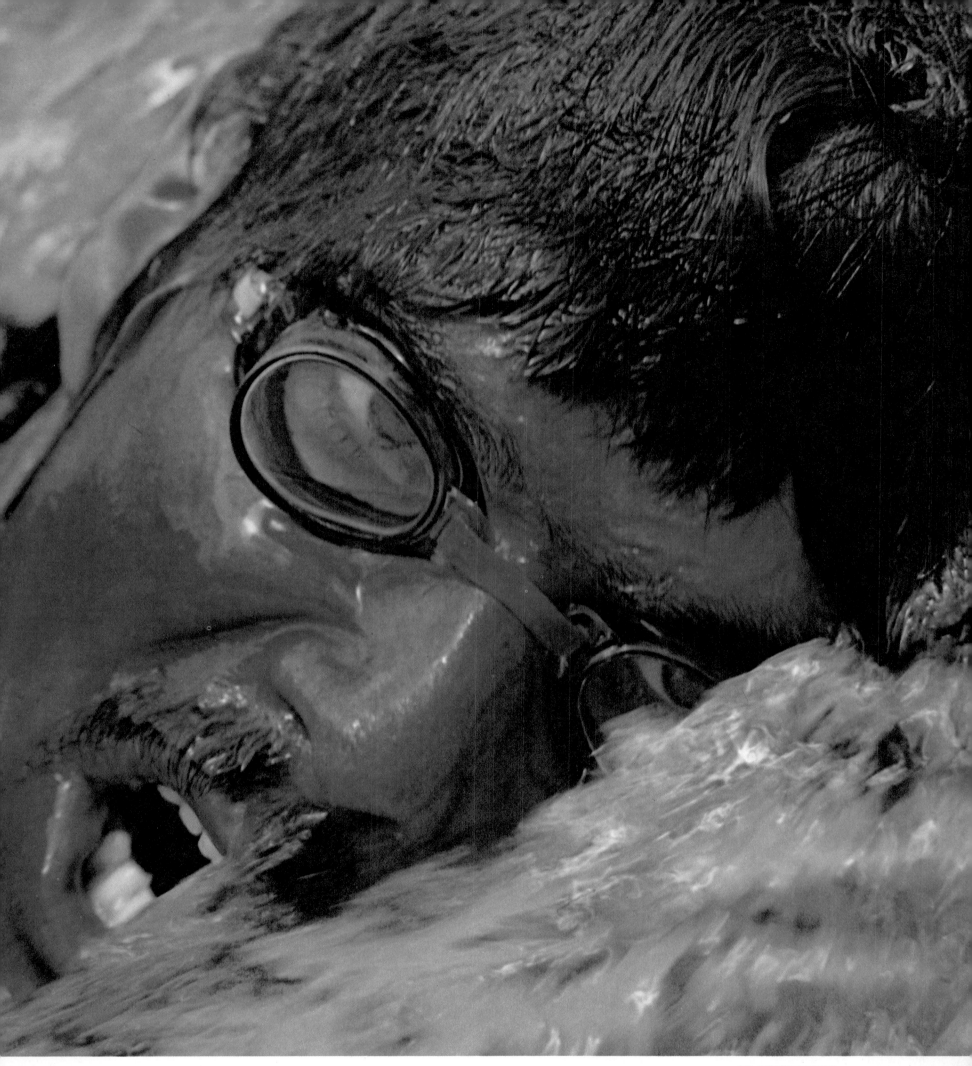

Splashing Drive Training for his seven-gold-medal Olympic effort, Mark Spitz seems more amphibian than human.

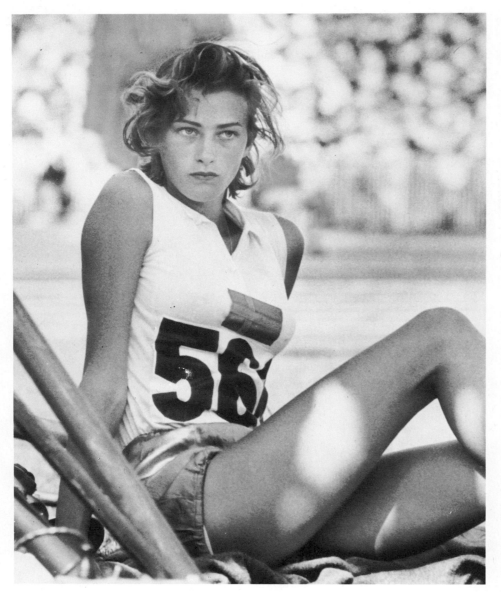

GEORGE SILK

Graceful Loser

At the 1956 Olympics, Silk's camera was lured from the winners to a svelte also-ran: Swedish high jumper Gunhild Larking.

Total Effort

The strain of the ultimate endeavor contorts shot-putter Al Feuerbach's face as he begins a throw in training for the 1972 Olympics.

CO RENTMEESTER

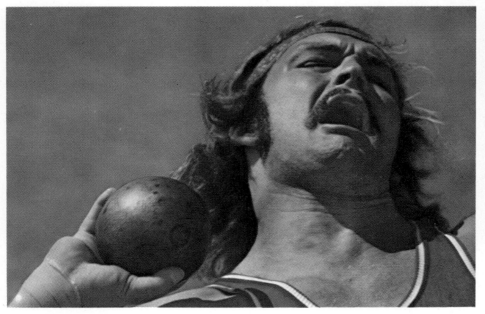

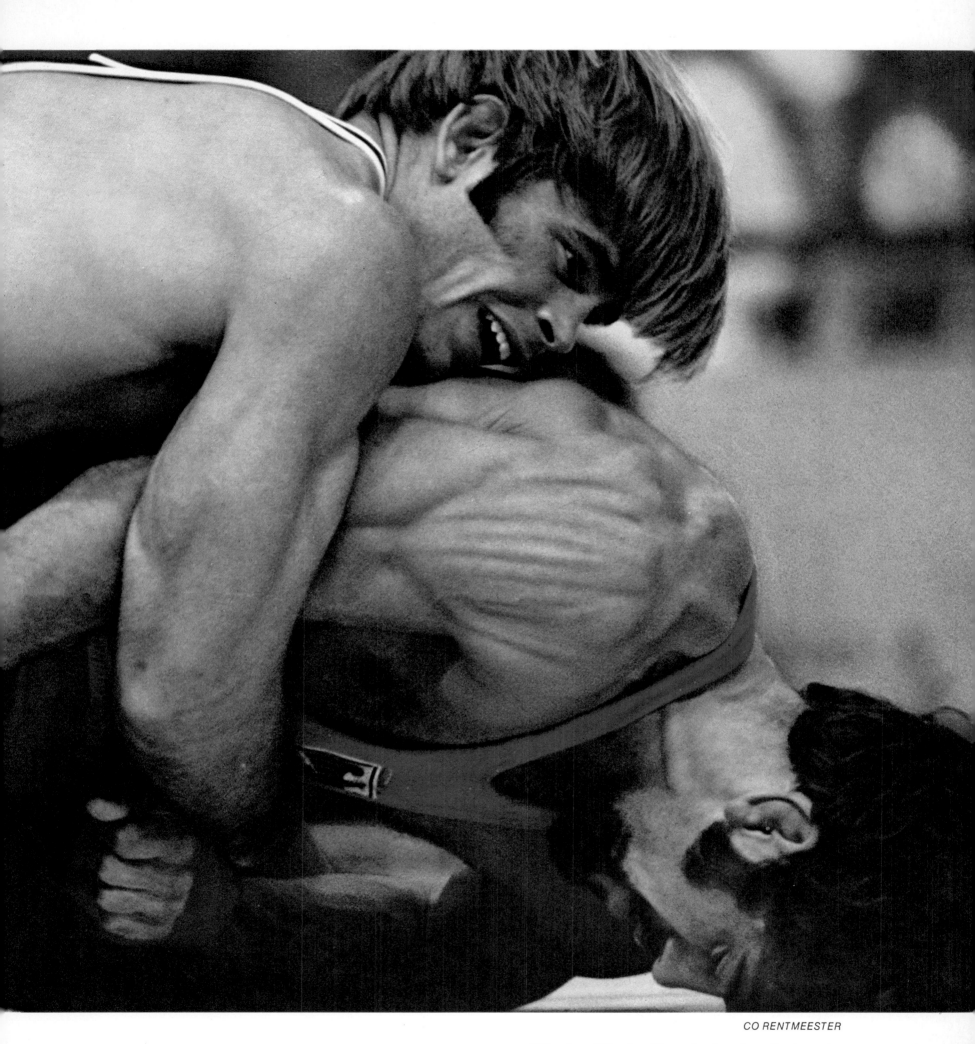

CO RENTMEESTER

Winning Clinch Through a long lens, Rentmeester produced this taut-muscle view of U.S. wrestler Wayne Wells clinching a gold medal at Munich.

Two Views of the Twelves Perched at masttop, Silk got nearly all of 12-meter *Nefertiti* in his lens. He hung from a rail to snap *Easterner*'s bow *(bottom)*.

GEORGE SILK

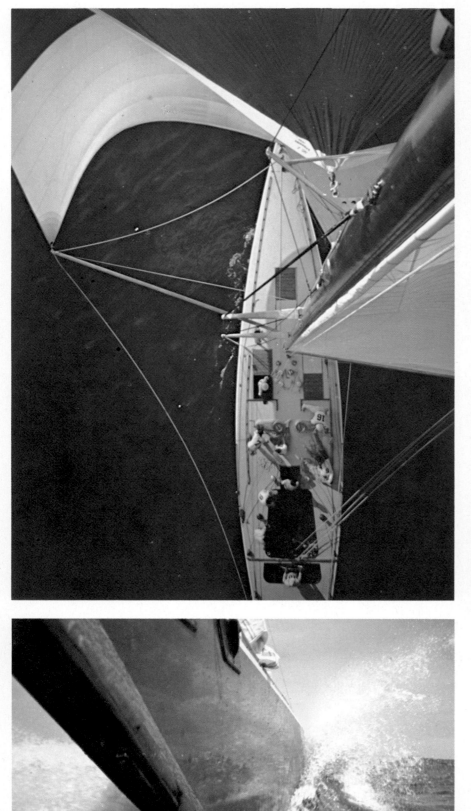

Surfer's Self-Portrait Silk showed surfer Nick Beck, poised at wavetop off Oahu, by mounting a camera on the board and having Beck pull the string.

GEORGE SILK

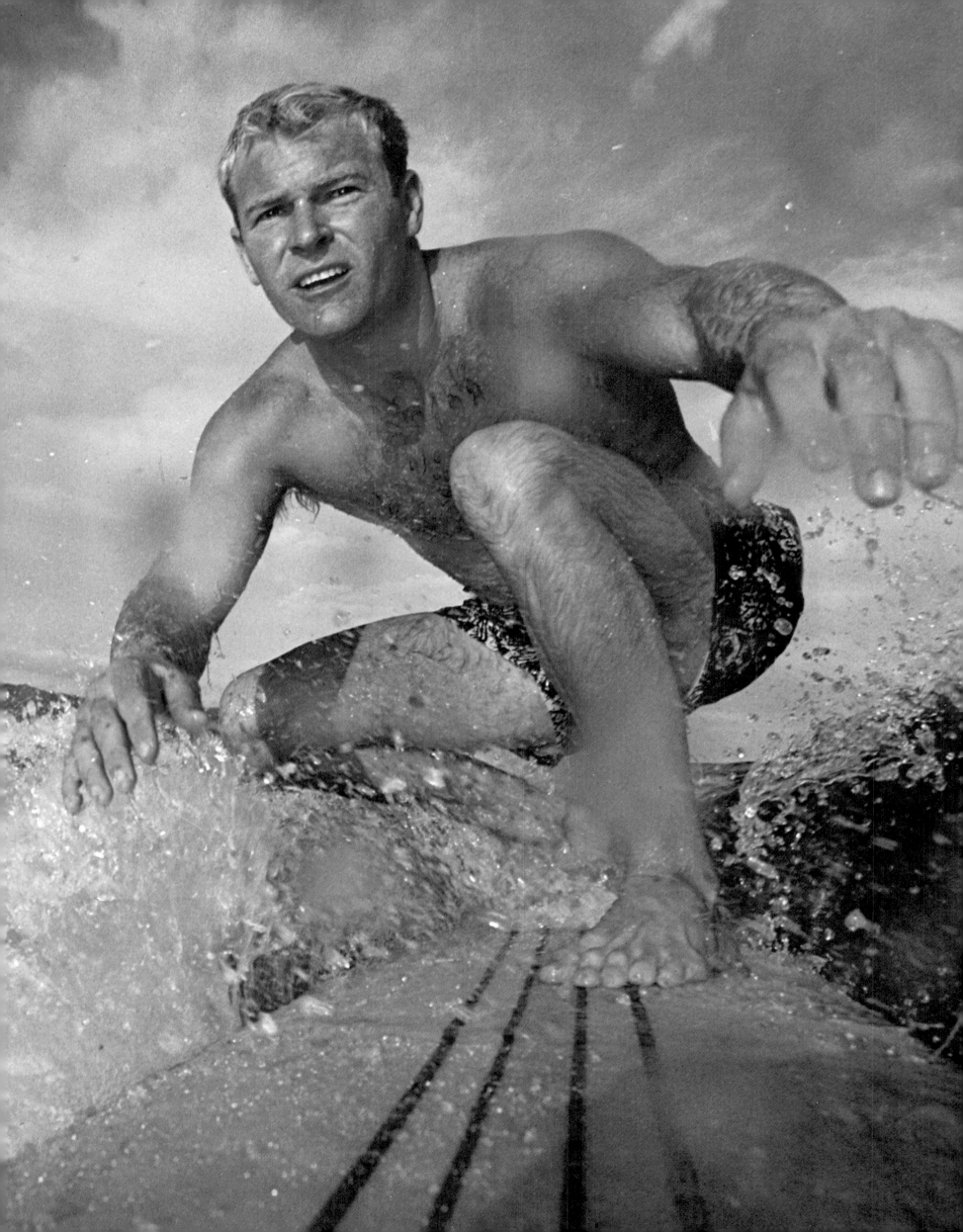

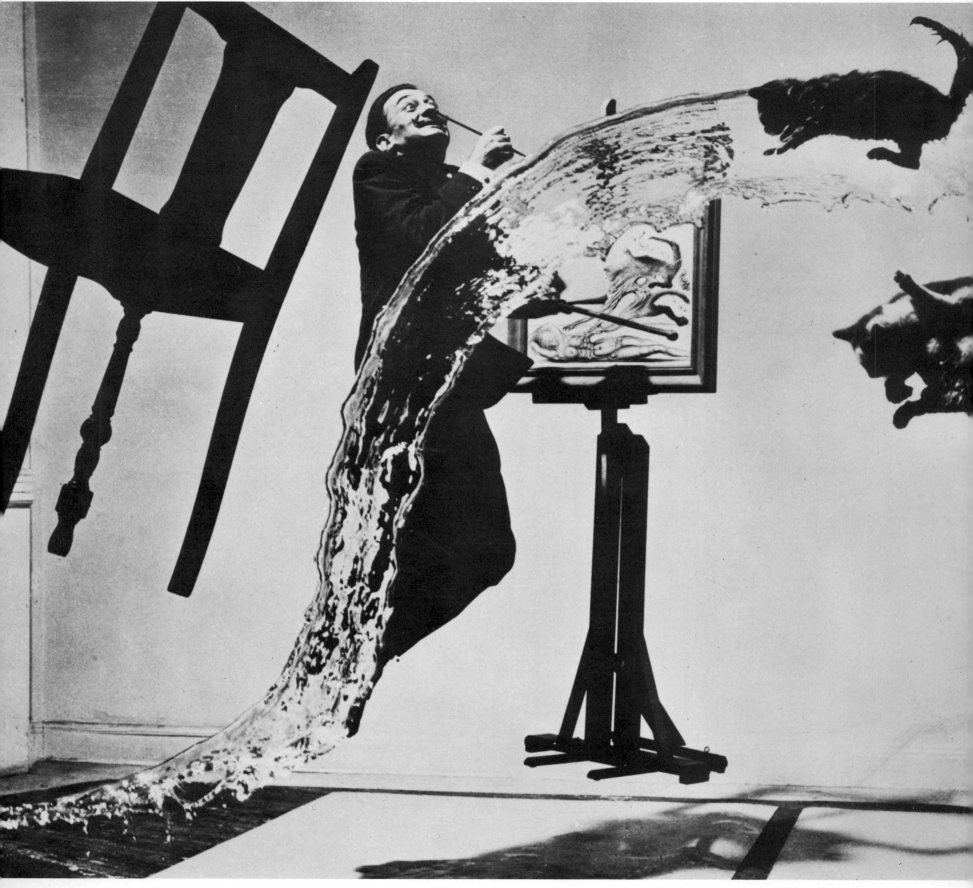

PHILIPPE HALSMAN

The studio becomes a scene wor-
thy of Salvador Dali's own art as
cats and water arc through space,
a chair floats, and even Dali is in
mid-air—thanks to wires and five
off-camera assistants.

PICTURES

Tracing a skater's path

A weekly department of surprises in which imagination had free rein

For art or science, or just for laughs, the photographers tinkered insatiably with the new-found capabilities of light, lens and film made available by technological breakthroughs. The published results appeared most often in a special department titled Speaking of Pictures.

SOP's only mandate was to present at least one photographic surprise every week. The goal could be as loony as inventing a picture of Salvador Dali *(left)* that unmistakably belonged to that surrealistic artist's own genre, or as educational as showing how one fish *(below)* traps its prey. Gjon Mili embedded flashlights in an ice star's skates to reveal the patterns they make *(upper right)*. Ralph Morse found a stranger light pattern *(right)* in the scheme scientists used to measure a jet airman's head—so that his flight helmet would fit exactly.

A favorite tactic was to use a camera built for one purpose to photograph something entirely different. Thus on film *(page 74)* a pretty girl could be multiplied in a "Mercator projection" and kids in the backyard might be distorted for Halloween fun.

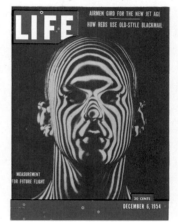

Mapping a jet pilot's face

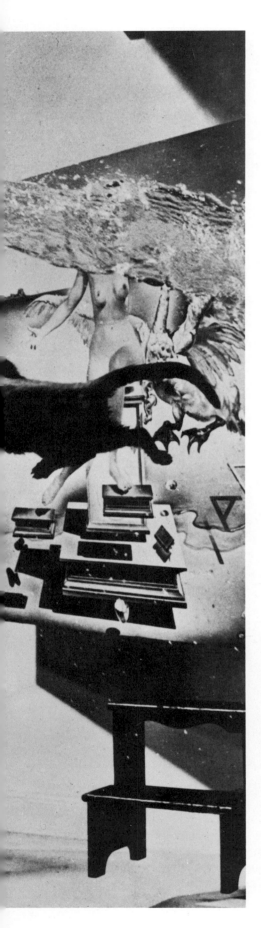

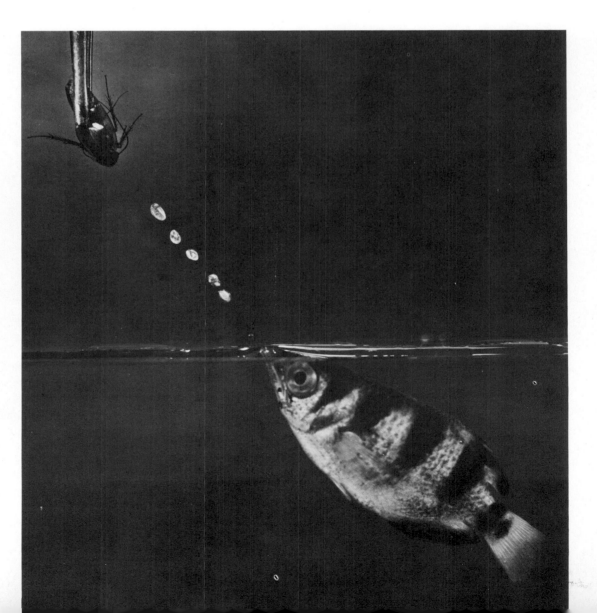

An archerfish spits drops of water while zeroing in on a cockroach that soon will be its dinner.

LILO HESS

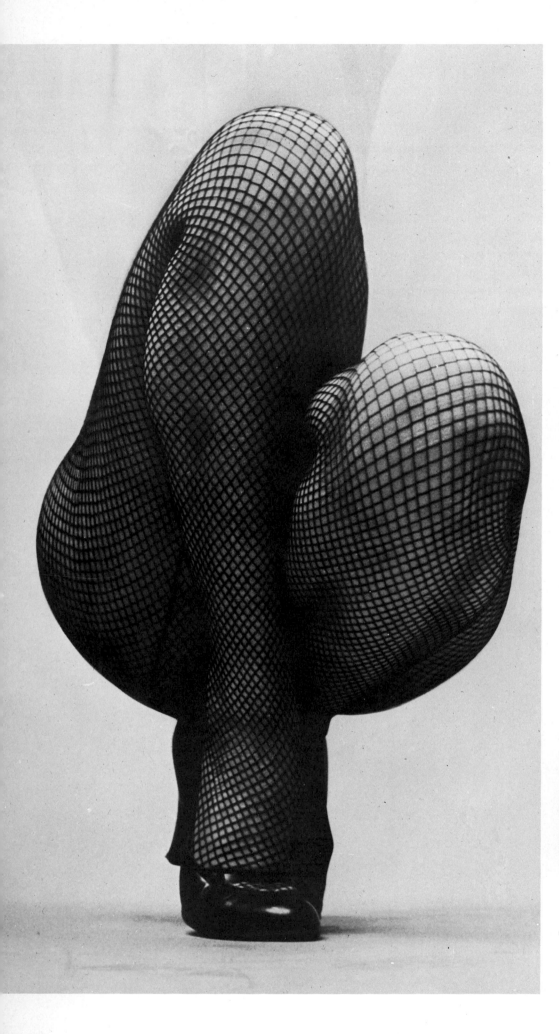

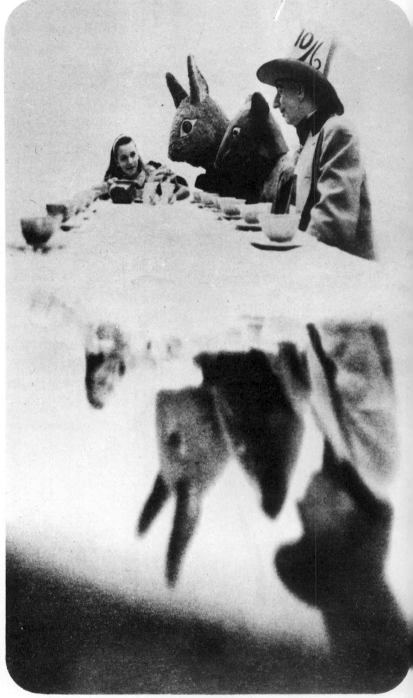

Lyrical Legs

A dancer's legs in mesh stockings create a pattern that reminded the photographer of a musical "crescendo and diminuendo."

FERNAND FONSSAGRIVES

MILTON H. GREENE

Looking Glass

For the television debut of *Alice in Wonderland,* the photographer mirrored the cast in a looking glass during the tea-party scene.

Nightmare Castle

By soaking his negative in hot water until the emulsion ran, Foucault turned France's Mont-Saint-Michel into a hallucination.

MARC FOUCAULT

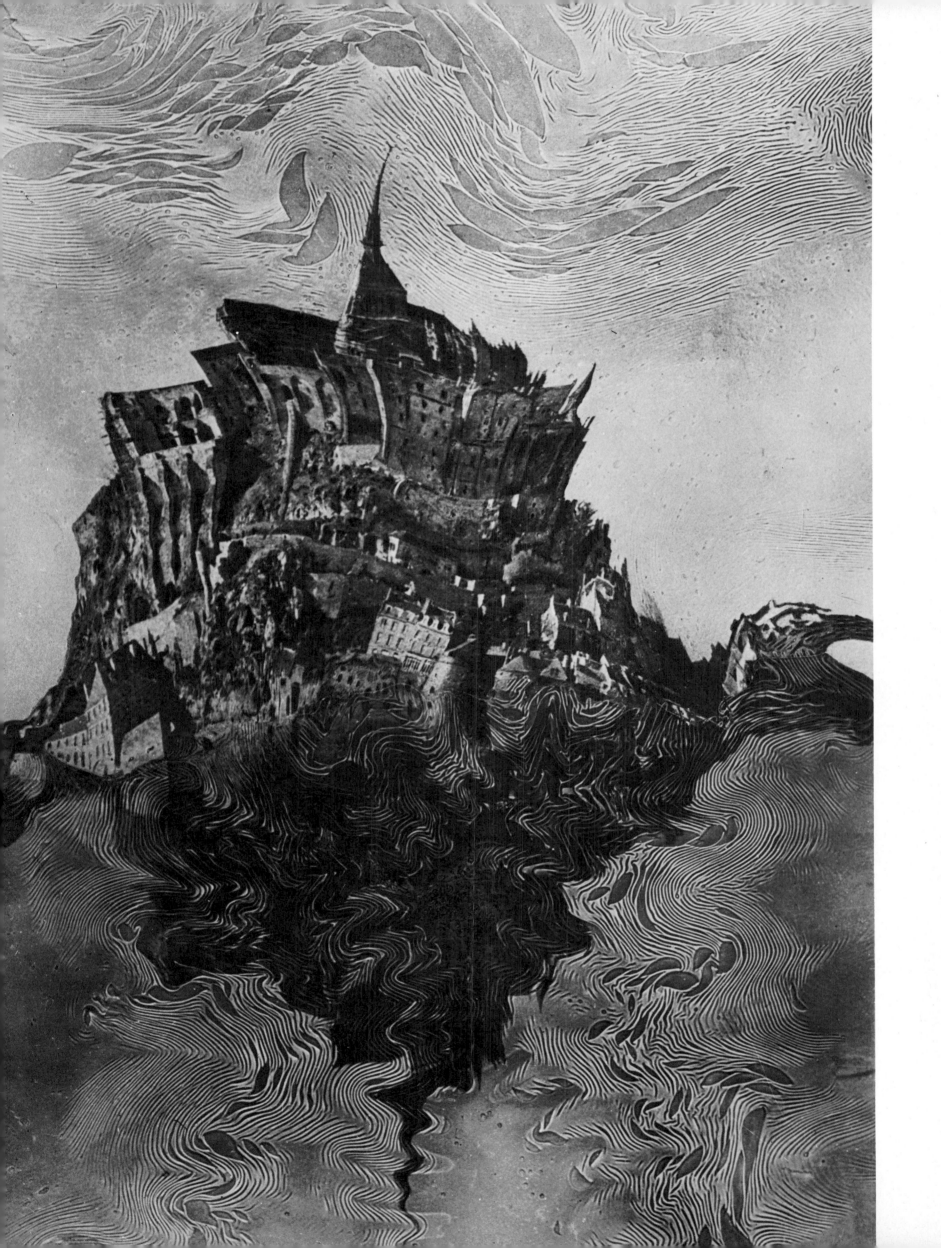

Watching Marion Grow Up

Millions shared the pride of the Chadwicks as they faithfully recorded their daughter's progress over 33 summers.

Wind-blown Look

In a 1948 Navy test, volunteers (a different man is in the photo at far right) show the effect of 300 mph wind in a simulated bail-out.

Edible Art

Sculptor Henry Rox created the stylish musicians below from tangerine, pear, orange and walnut.

Smoke-Ring Champion

Unofficially the world's best blower of smoke rings, William Patterson puffs concentric rings.

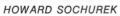

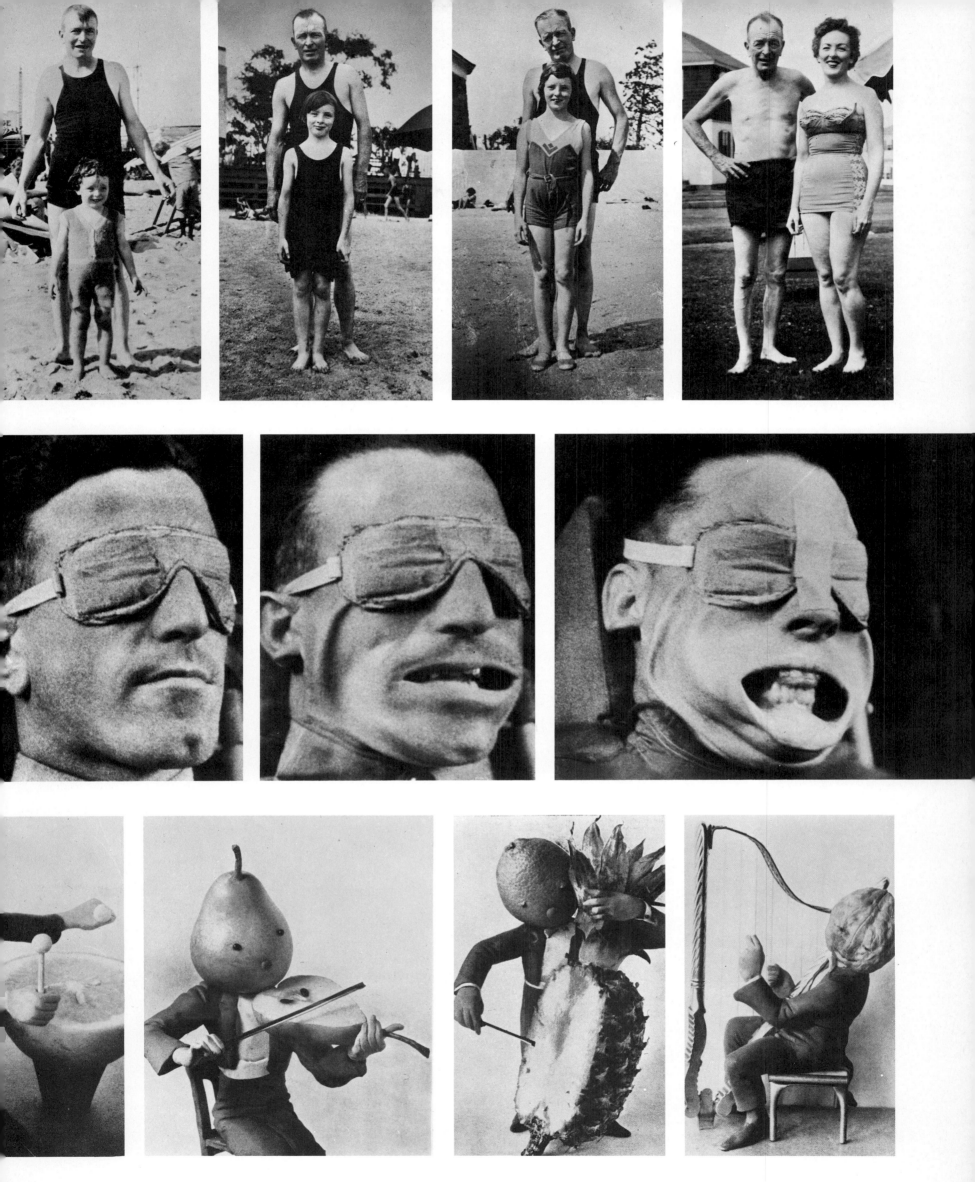

Halloween Fantasy

Employing a modified race-track photo-finish camera and his own children as models, George Silk commemorates Halloween antics with a ghostly scene *(below)*.

GEORGE SILK

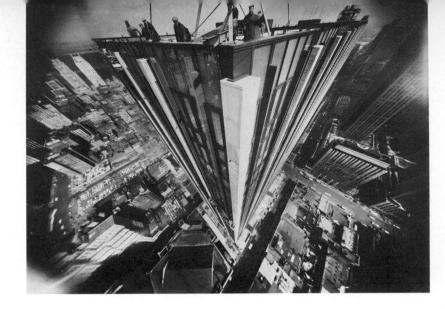

View from the Top

To gain a new perspective on the nearly finished Time & Life Building in 1960, Yale Joel fixes his camera to a long boom.

YALE JOEL

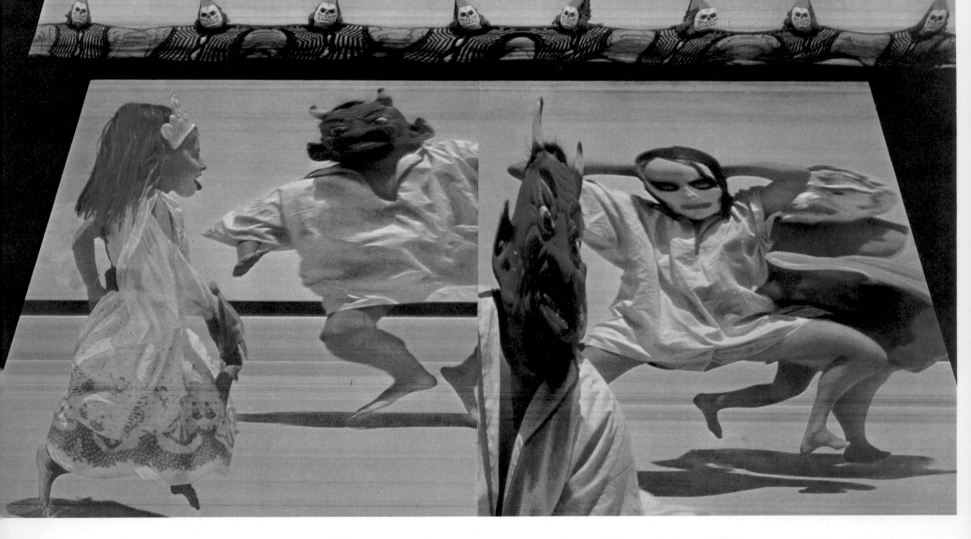

Mercator Projection

Photographed by a camera normally used to turn the globe into a flat map, a model revolving slowly on a turntable *(left)* evolves into a fun-house image.

A. Y. OWEN

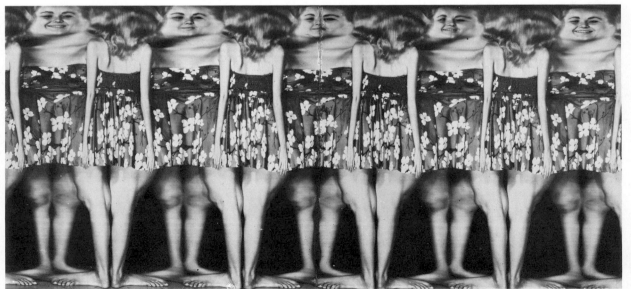

Super Schnozz

What better subject for the wide-angle lens in 1936 than Jimmy Durante's proboscis, taken at a range of one-half inch?

RALPH STEINER—LEO HURWITZ

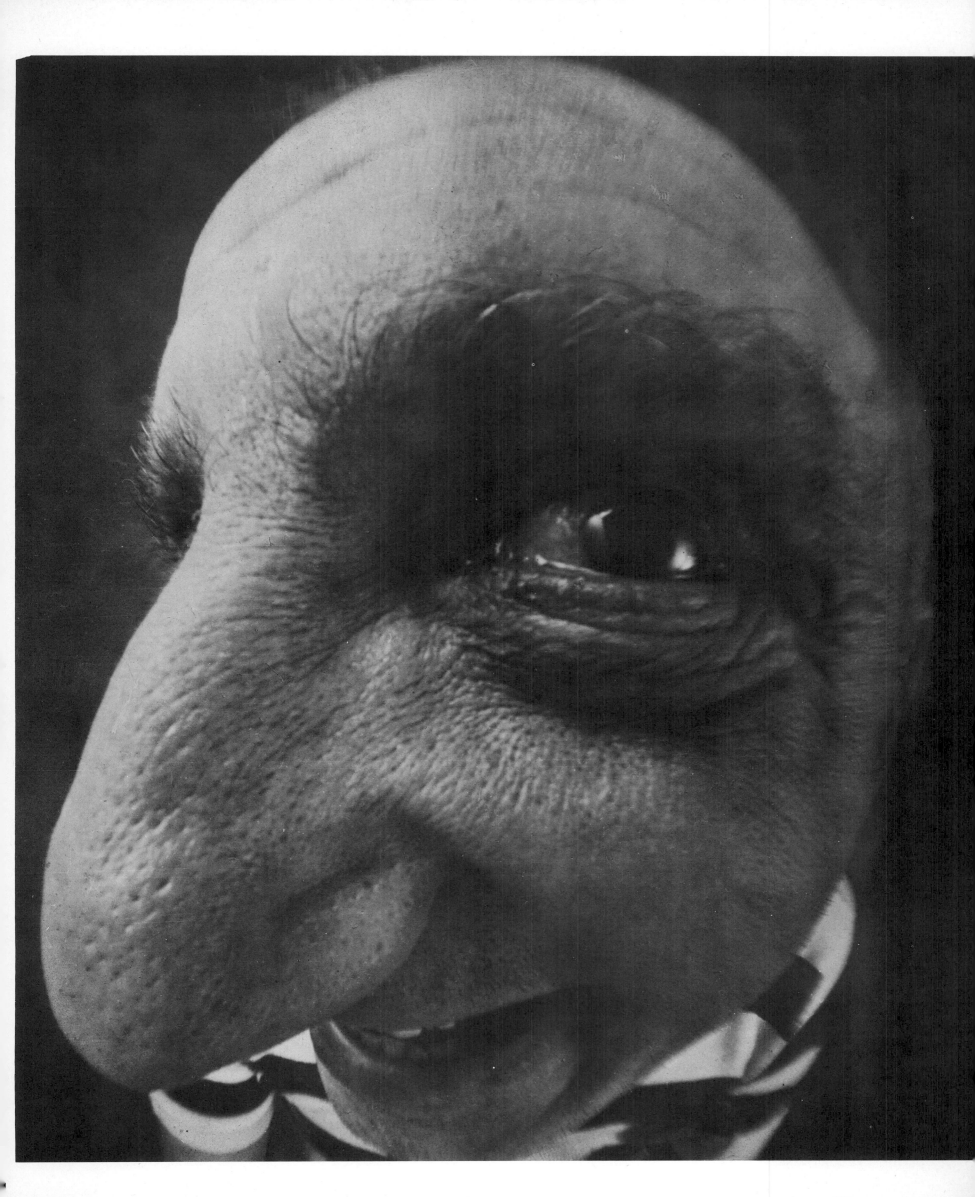

THE LEADERS

Eden as foreign secretary

Tito as deviationist

A gallery of the great, captured not only on-stage but off-guard

For years the weight of the world hung on the shoulders of a few titans, and the camera showed its finest genius in keeping its eye on them. The staid and formal portraits of the past, the set shots of the old big-camera photographers all fade into a half life when set against this photojournalists' gallery.

The news photographers—LIFE's foremost among them—went everywhere with the leaders. Some became part and parcel of the events they recorded. For Carl Mydans, captured in Manila and released in mid-war from a Japanese prison camp, Douglas MacArthur's return to the Philippines signaled his own. A few photographers became warm friends of their subjects, as Mark Shaw was of Jack and Jackie Kennedy, whom he recorded with such affectionate grace. Some had to play games with the great men. When Churchill, having given Karsh only four minutes of his time, sat stubbornly chomping his cigar, Karsh reached out, snatched the cigar from between Churchill's teeth and, clicking the shutter, caught the peerless Briton in an instant of awesome outrage.

Marshall in the Cabinet

Stevenson as candidate

Ho Chi Minh at war

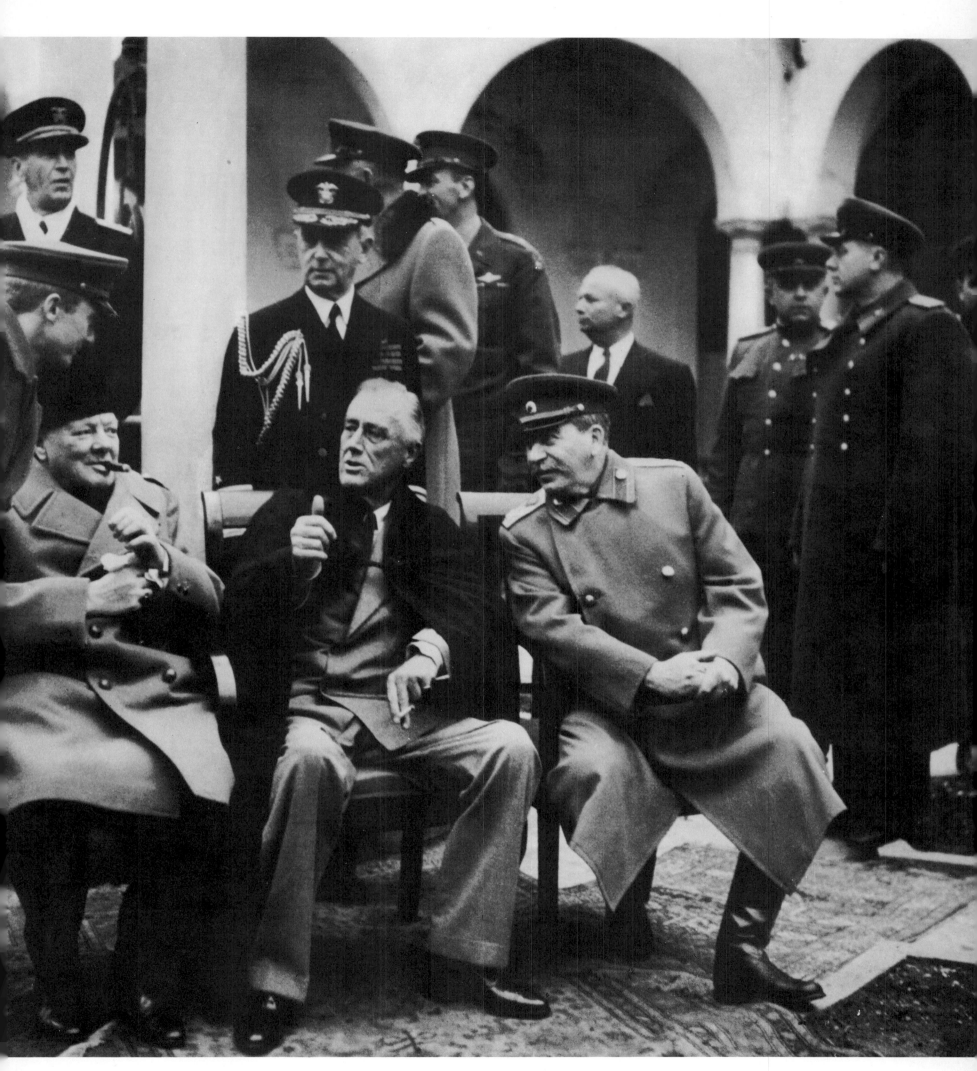

At Yalta an armed forces camera-man caught the three allied giants —Churchill, Roosevelt, Stalin—in the discourse (conducted through an interpreter, left) that masked their underlying differences.

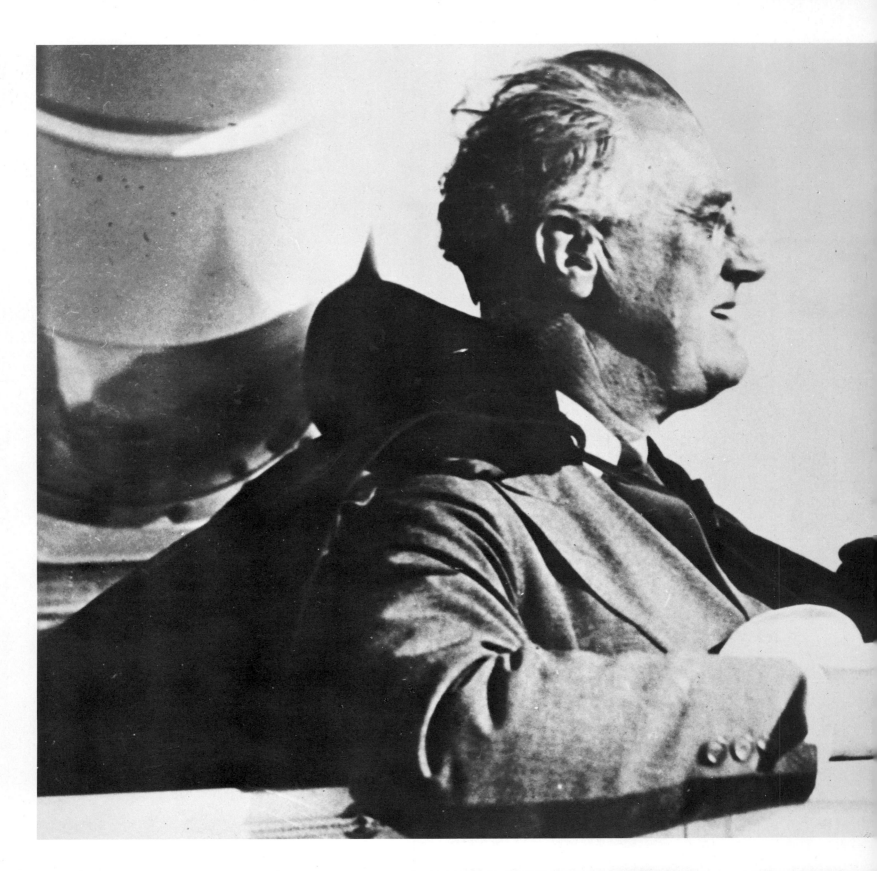

Sea Dog F.D.R.

Roosevelt's love of both sea and Navy shows up in this wind-blown portrait as he reviews the U.S. fleet from a warship bridge.

Politician F.D.R.

After formal photos of a 1938 political dinner were taken, Tom McAvoy stayed and got this shot of an insouciant F.D.R.

THOMAS D. McAVOY

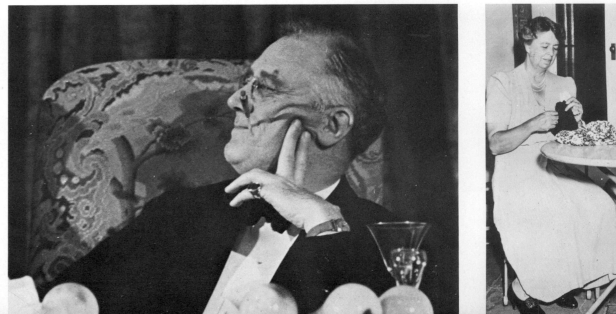

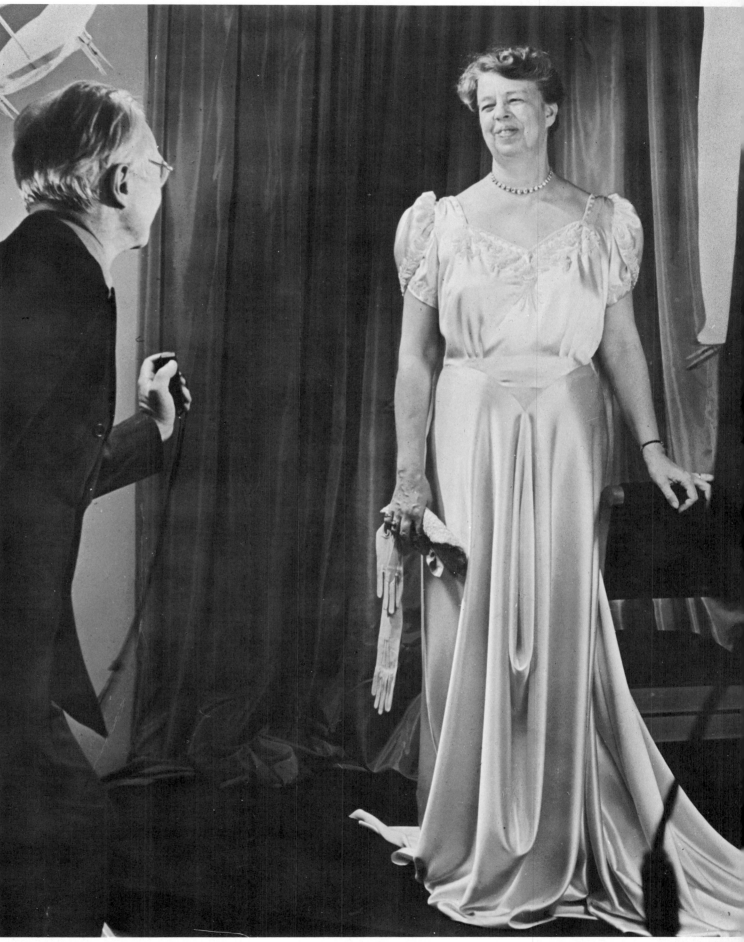

Playmate Fala

While Eleanor knits during a 1941
Hyde Park weekend, F.D.R. plays
with Fala, the coddled Scotty he
took with him into history.

Formal Eleanor

As Edward Steichen asks for a
smile, Eleanor Roosevelt obliges
self-consciously, even though it is
her third inaugural gown.

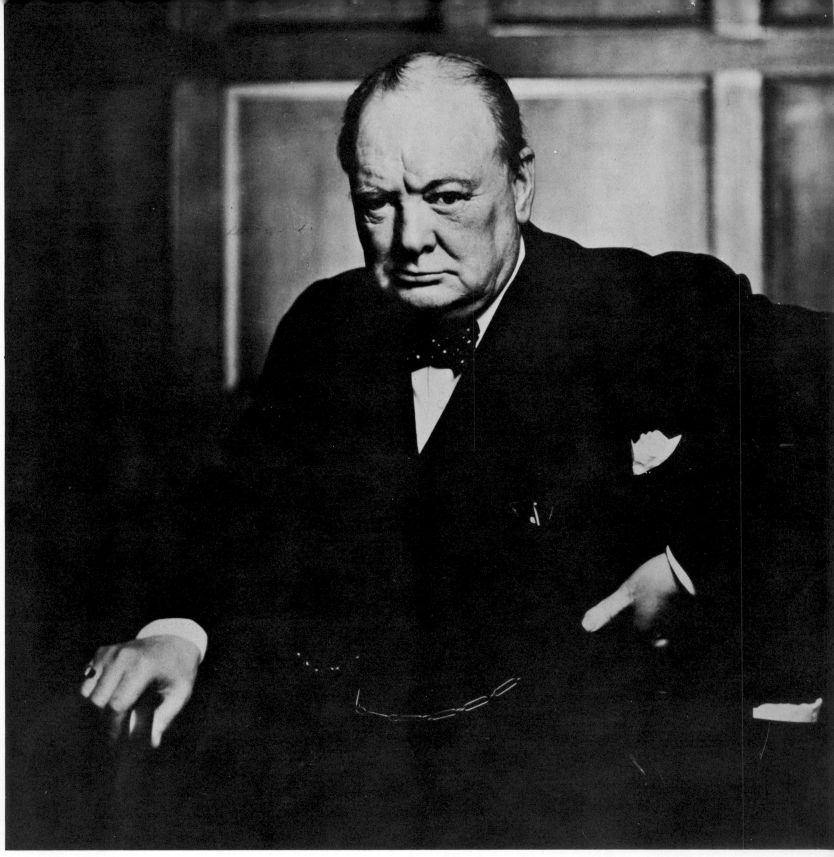

Indomitable Briton

From front or back, Churchill was imposing. Above: he glares at the photographer, who has grabbed away his cigar; right: he surveys garden masonry he helped build.

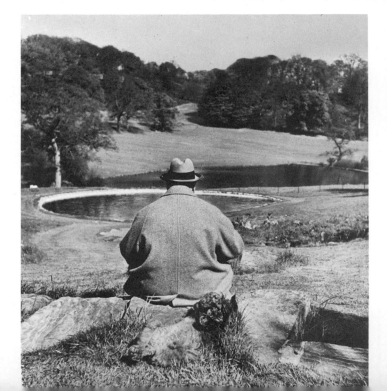

Kingly Confrontation

The royal pig was luckier than it seemed to know. In wartime Britain animals were drafted for service or table. But George's prize porker was enjoying a deferment.

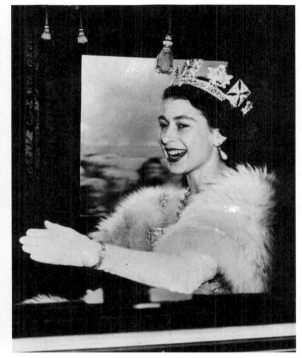

Royal Radiance

Happiness in her young face and Queen Victoria's coronet on her head, Elizabeth II drives to her first opening of Parliament.

CHARLES JAMES DAWSON

Queenly Pout

Disdain clouding the royal visage and a scarf warding off the damp, Elizabeth stretches at a horse show in search of a better view.

Budding Romance

He was not yet king, she was not yet famous and their romance was not yet public when Edward and Wallis were snapped in a London nightclub in 1935.

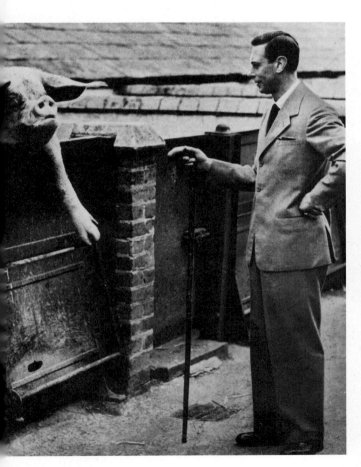

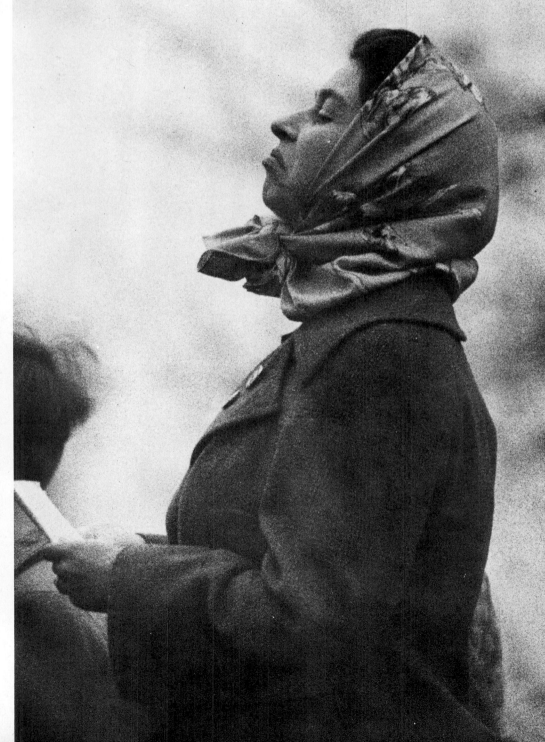

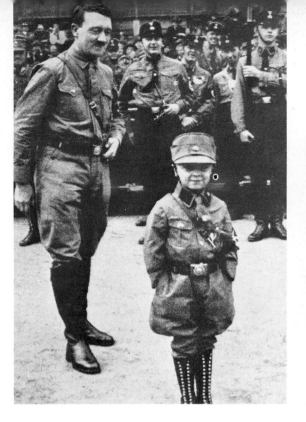

Tomorrow's Nazi

Hitler beams on a proud young Brownshirt, the chilling embodiment of a new Nazi generation.

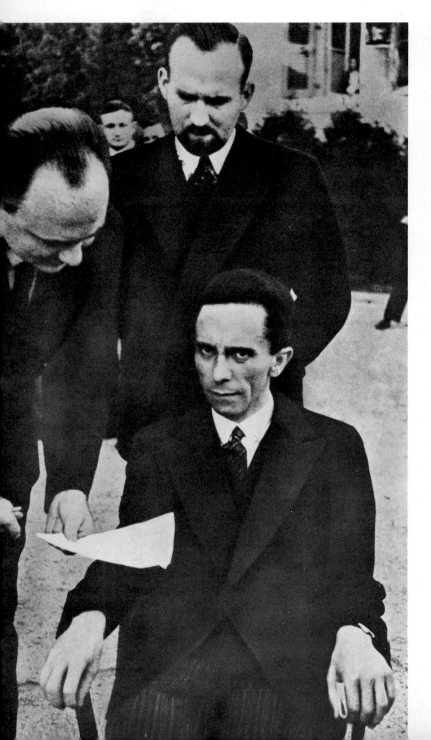

Minister of Hate

Joseph Goebbels, Adolf Hitler's propaganda chief, glowers at the camera during a 1933 League of Nations meeting in Geneva.

ALFRED EISENSTAEDT

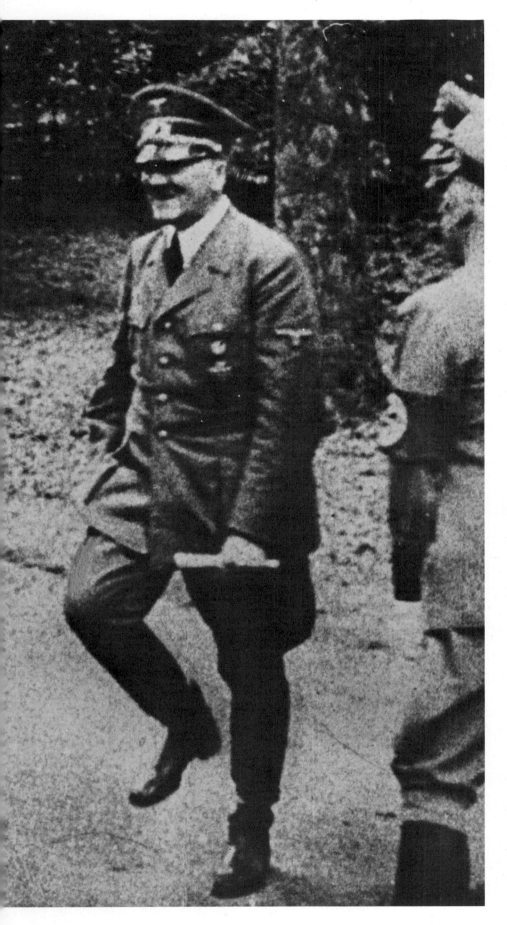

Gleeful Victor

No conquest ever had such a preposterous celebration: Hitler doing his jig at Compiègne, where the French surrendered in 1940.

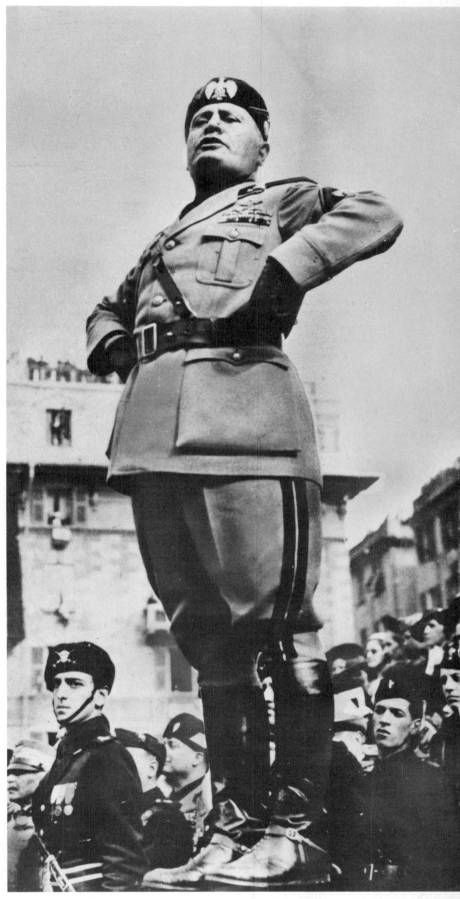

Overblown Duce

At a 1938 rally, Italy's dictator, Benito Mussolini, puffs himself up to commanding presence to impress his admirers.

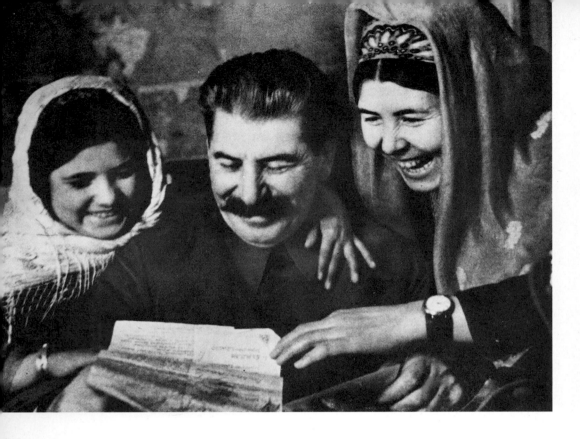

Contented Tyrant

It is 1938. The great purges are over. The confrontation with Hitler lies ahead. So Stalin's smile may have come from the heart.

Ebullient Guerrilla

After waging guerrilla war from the hills, Fidel Castro and his cigar arrive triumphantly on the outskirts of Havana in 1959.

GREY VILLET

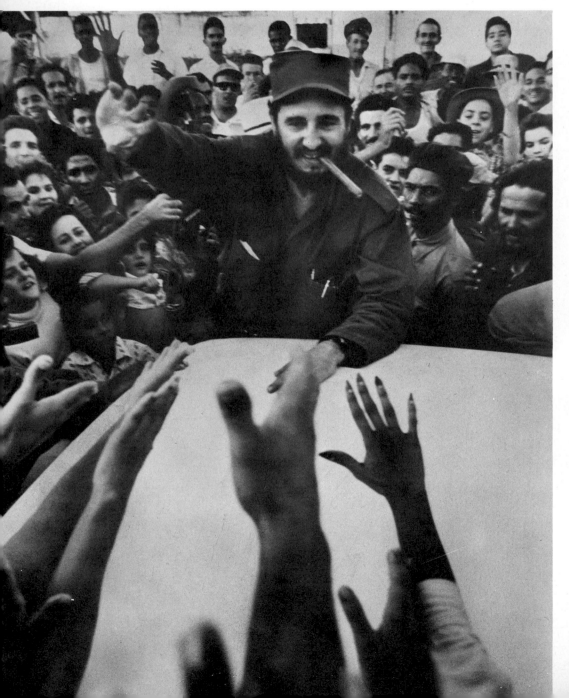

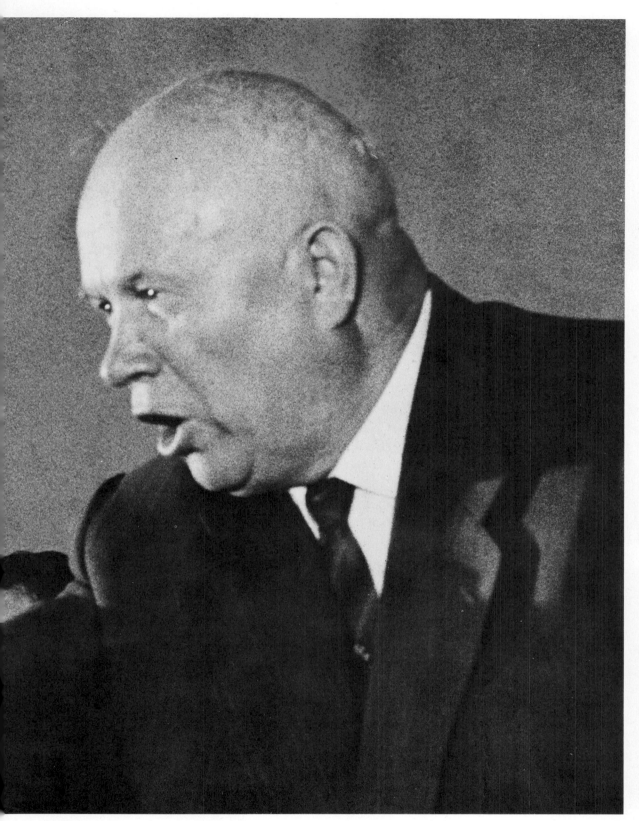

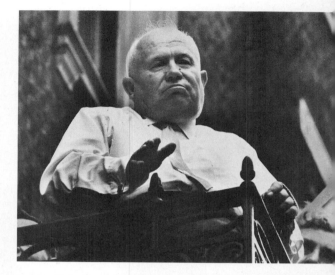

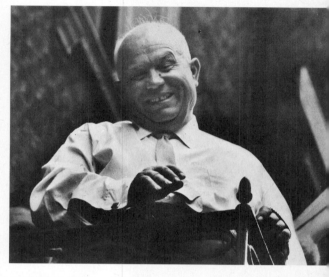

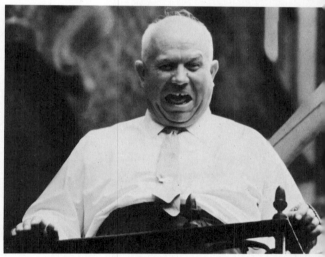

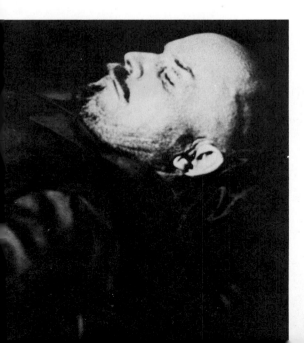

Embalmed Bolshevik

In 1940, LIFE thought that it had a U.S. scoop in this first picture *(left)* ever to be released of Lenin in his tomb—and then learned it had already been printed in *Casket and Sunnyside,* a trade journal for undertakers.

Mercurial Dictator

Nikita Khrushchev *(at left, above)* pours out vitriol and shakes his fist as he breaks up a summit conference in Paris. Above, while in New York visiting the United Nations, he puts on a jovial balcony act in his shirt sleeves.

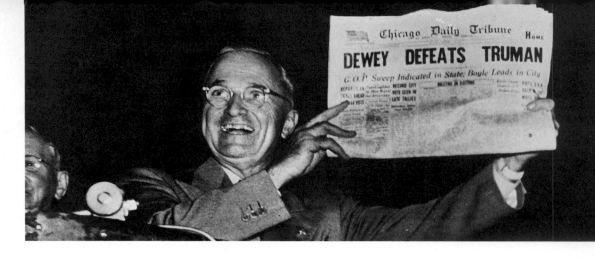

Harry and the Big Goof

Truman gleefully flaunts a premature headline that failed to anticipate his upset victory in the 1948 Presidential campaign.

W. EUGENE SMITH

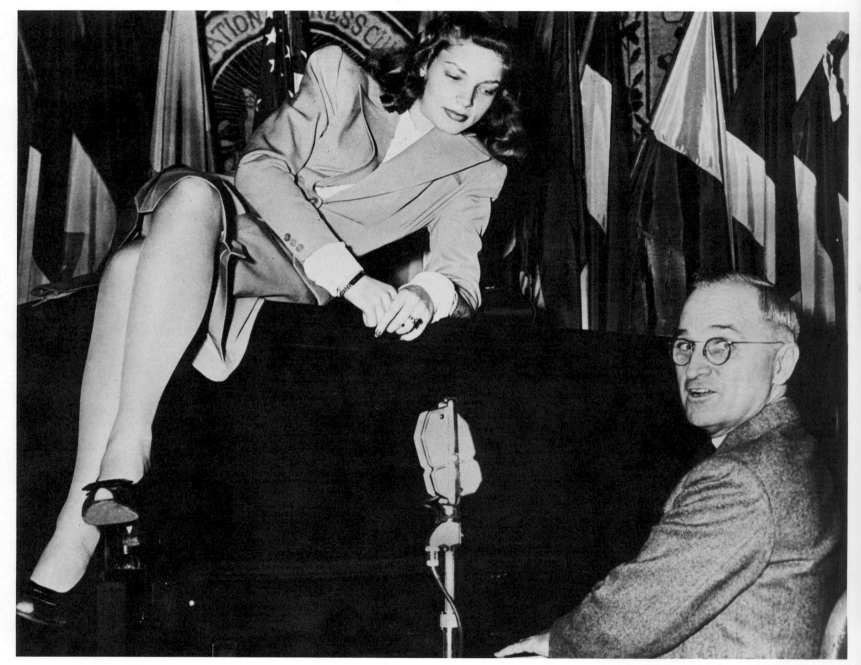

CHARLES CORT

Harry and the Big Spoof

Lauren Bacall plays the role of torch singer and then-Veep Harry Truman joins in on the joke at a 1945 servicemen's party.

Second Return

The first time he returned, the photographer, an old pal, wasn't there. So MacArthur re-enacts the scene for him three months later.

CARL MYDANS

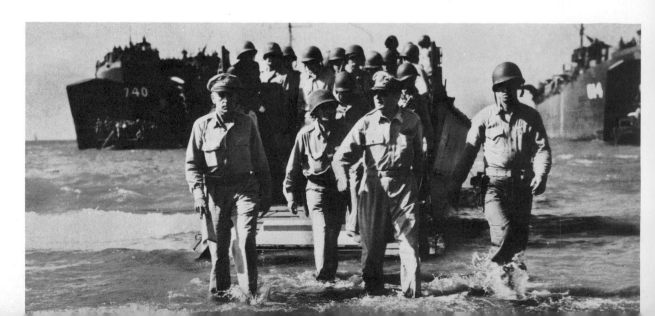

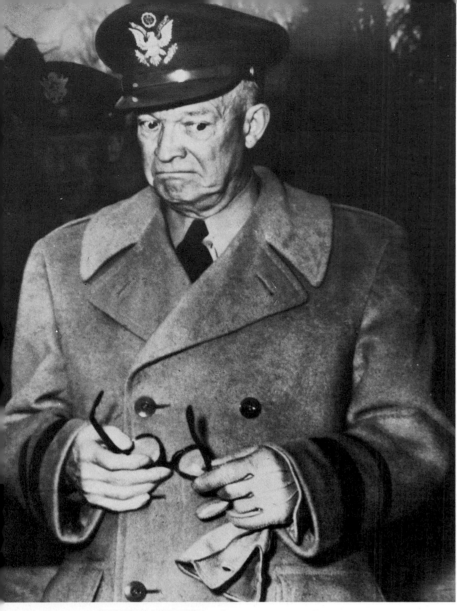

FRANCIS J. GRANDY

Surprised Ike

Hearing the news that MacArthur has been fired by Truman, Eisenhower grimaces thoughtfully at the fate of his fellow general.

CECIL STOUGHTON

Tragic Ceremony

His wife on one side, John F. Kennedy's widow on the other, L.B.J. takes the Presidential oath while flying from Dallas to Washington.

CECIL STOUGHTON

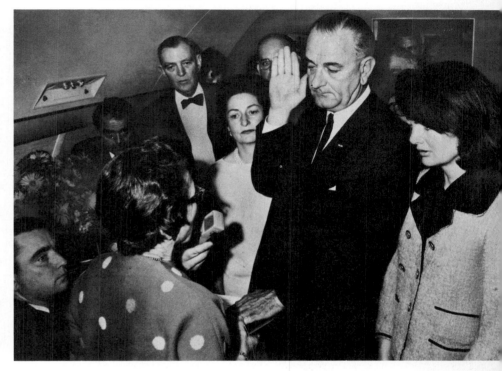

L.B.J. All the Way

Certain that every red-blooded American wanted to see his operation, President Johnson shows the scars left after his gallstones and kidney stones were removed.

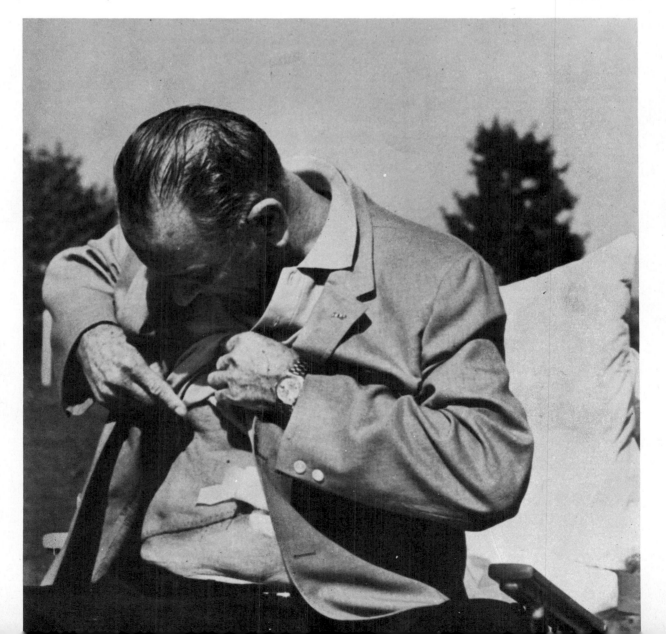

Popular Pontiff In 1958, a wise and compassion-
ate son of peasants, soon to be-
come well loved as pope, begins
his reign as John XXIII.

JAMES WHITMORE

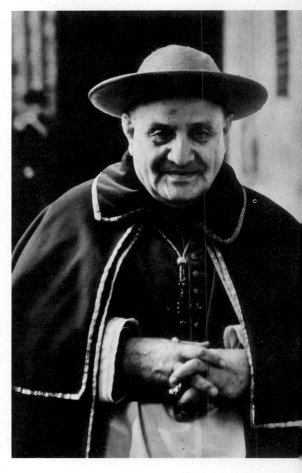

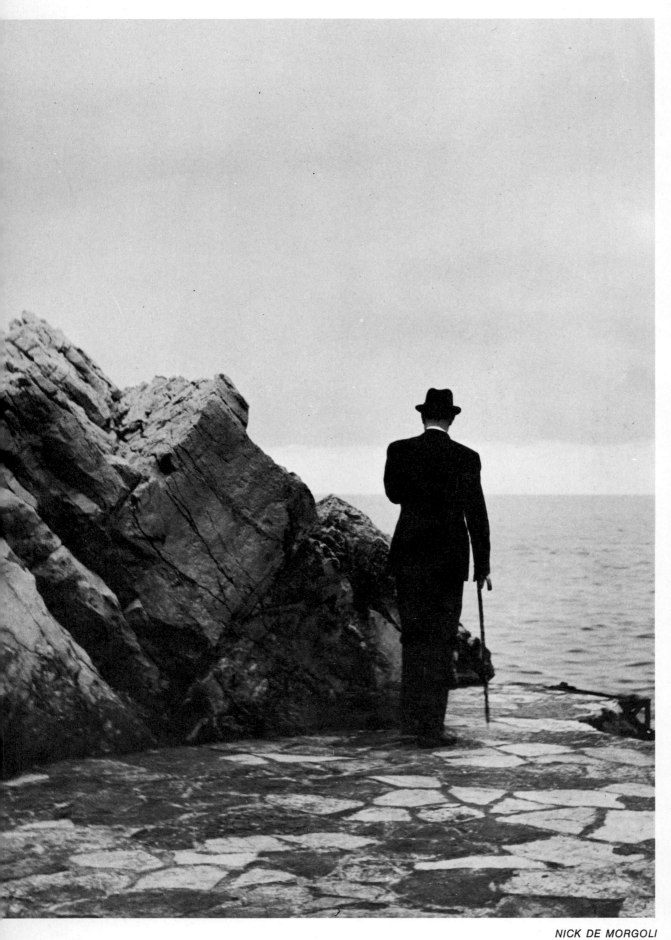

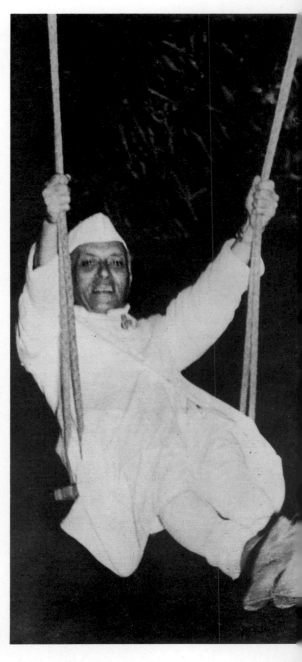

NICK DE MORGOLI

Sullen Savior His glamor as savior of France
eroded by politics in 1946, a sulk-
ing Charles de Gaulle *(above)*
contemplates the sea at Antibes.

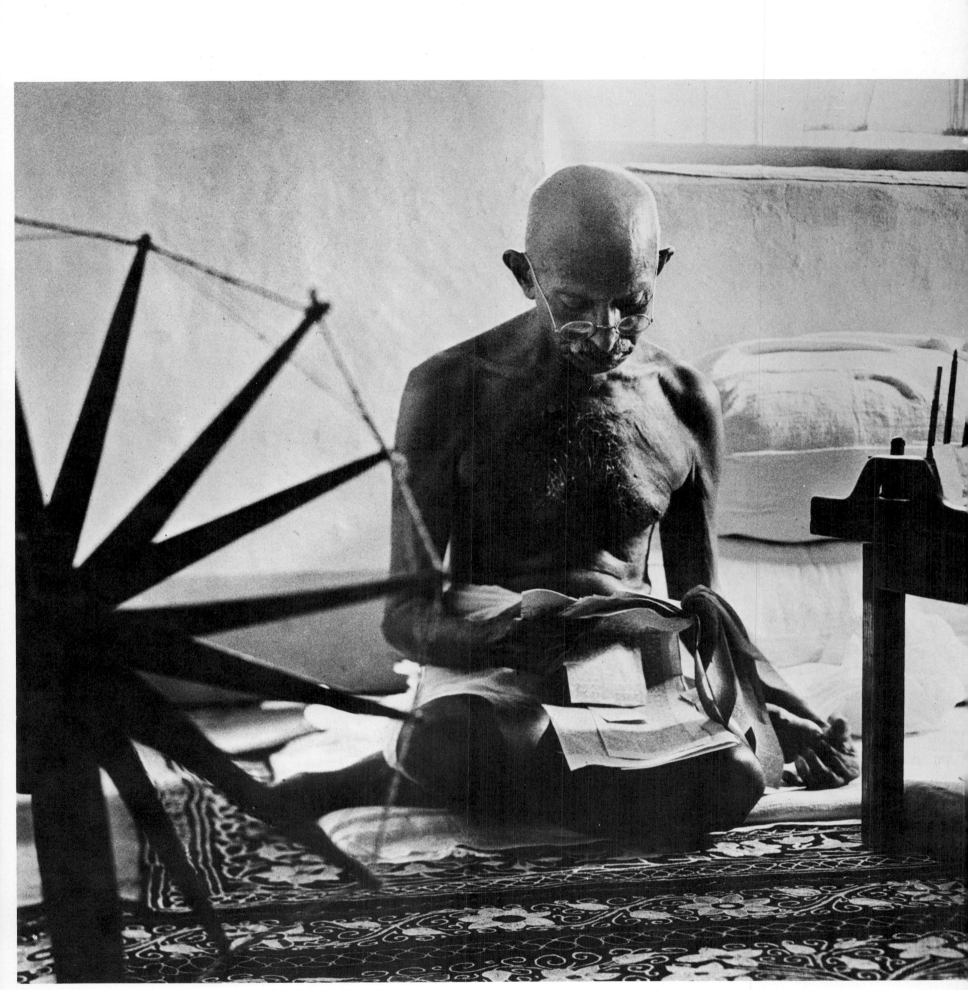

MARGARET BOURKE-WHITE

Swinging Pandit Premier Jawaharlal Nehru *(left)* unbends in a traditional Indian way to celebrate the arrival of the life-giving monsoon rains.

Martyred Spinner Mahatma Gandhi, at his ritual work, let it be known that photography and spinning were both fine crafts, but spinning was greater.

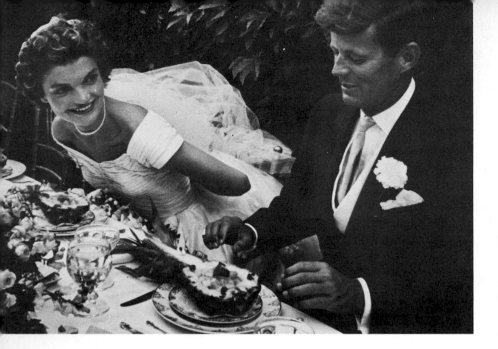

Regal Newlyweds

"It's just like a coronation," said a prescient reception guest. The 1953 wedding of Senator John F. Kennedy and Jacqueline Bouvier, society girl turned reporter, was a feast for romantics.

LISA LARSEN

Relaxed Campaigner

The candidate *(below)*, his wind-blown wife and their 2½-year-old daughter Caroline escape for a respite at his beloved Cape Cod, before starting the grueling 1960 Presidential campaign.

MARK SHAW

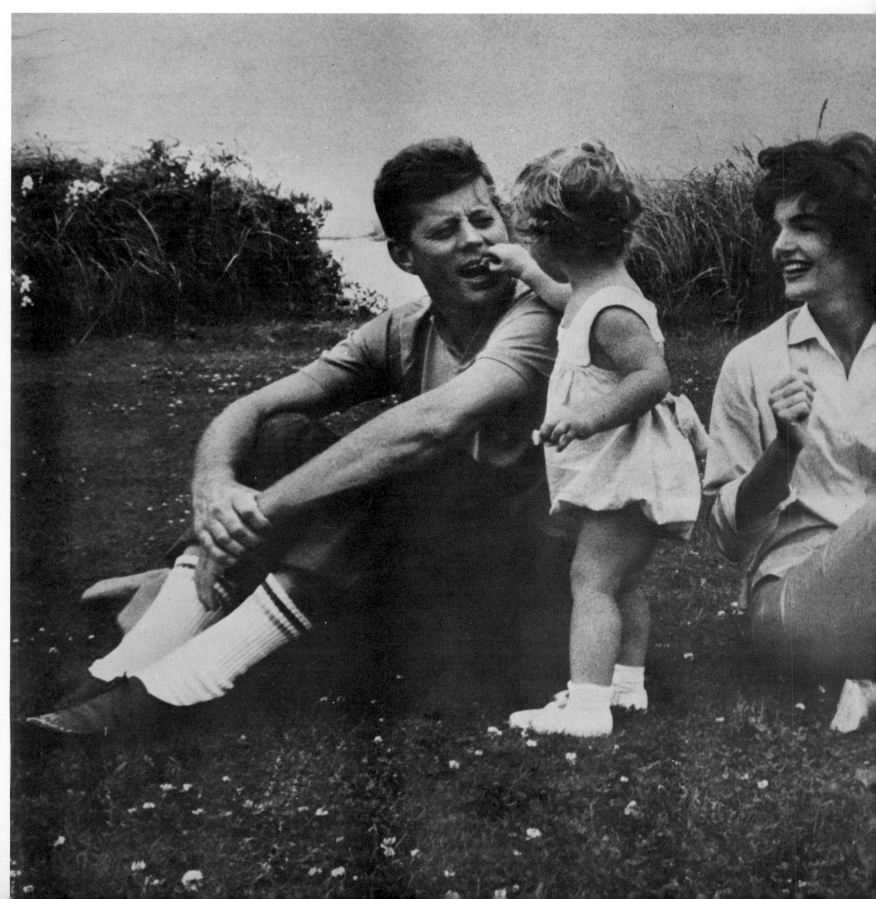

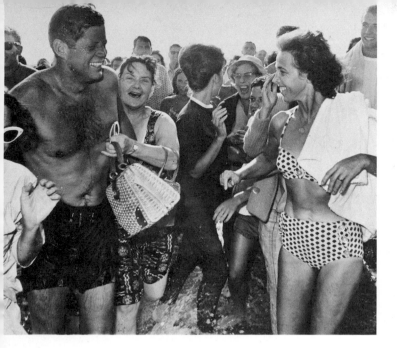

Moist Mob Scene

Not many Presidents could be so self-revealing and get away with it: Jack Kennedy steps onto a California beach in trunks, unveiling what LIFE described as a "still-modest displacement."

BILL BEEBE

Day of Triumph

At the Inaugural Ball, J.F.K. turns from an impressed audience. In an address earlier that day he had said: "Ask not what your country can do for you, but what you can do for your country."

PAUL SCHUTZER

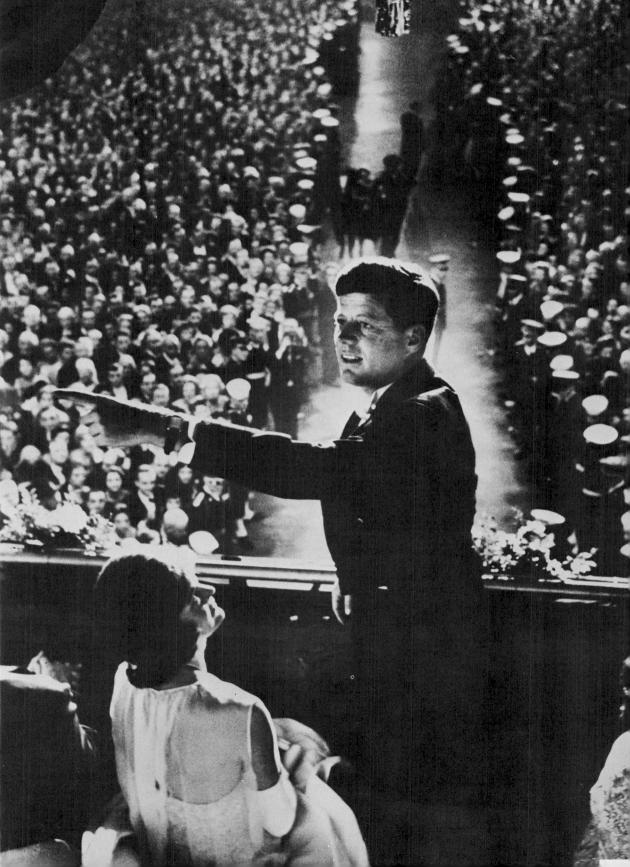

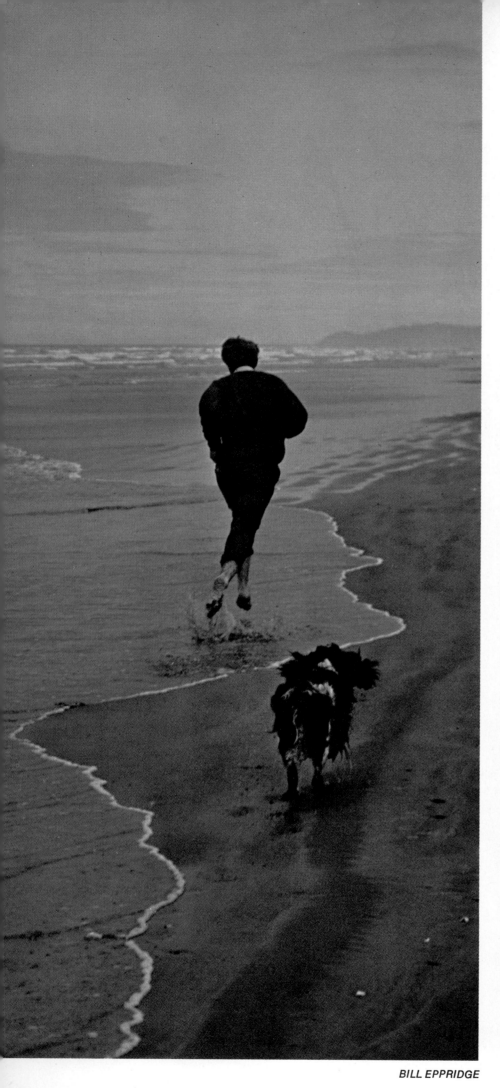

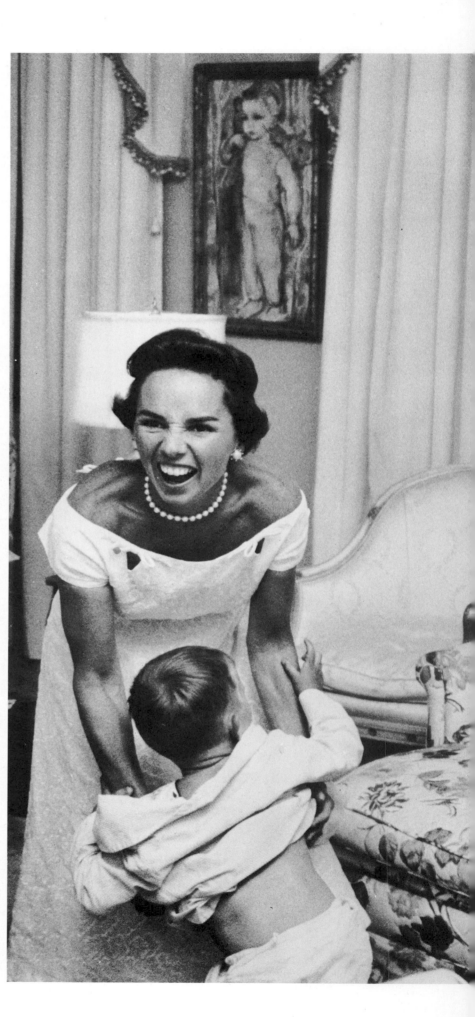

Carefree Jogger Savoring the outdoors all the energetic Kennedys enjoy, Bobby splashes through an Oregon tide.

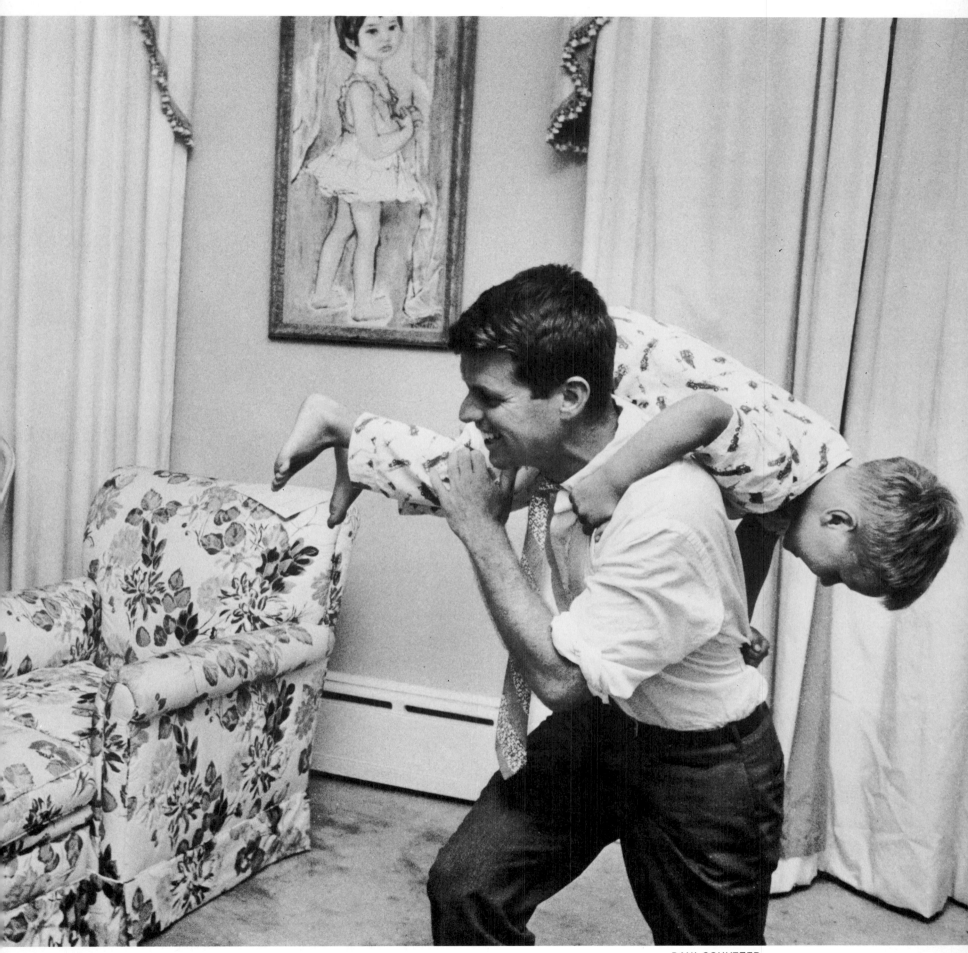

PAUL SCHUTZER

Dedicated Father Bobby and Ethel roughhouse with their children in a typically unself-conscious Kennedy scene. At the time he was a U.S. Senate committee counsel and the toughest cross-examiner on Capitol Hill.

Tearful Candidate

Accused in 1952 of receiving unethical campaign contributions, Vice Presidential candidate Richard Nixon weeps after Eisenhower absolved him.

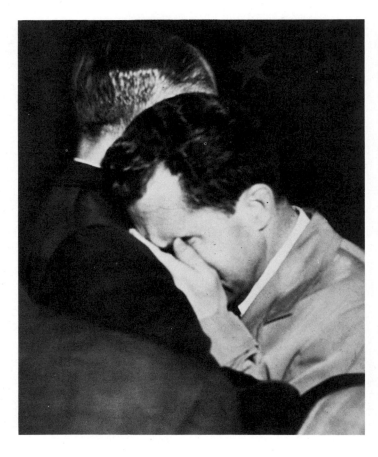

Determined Swinger

An earnest golfer, his brow furrowed with concentration, Nixon makes an all-out effort to lower his handicap, though he consistently has played in the low 90s.

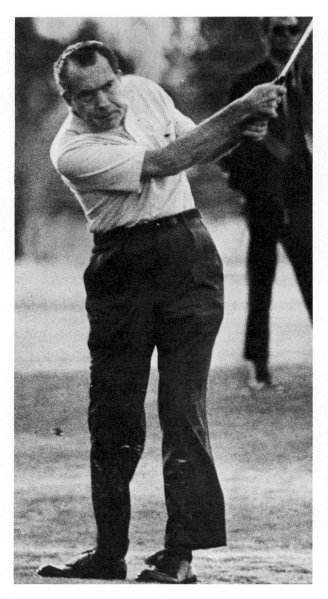

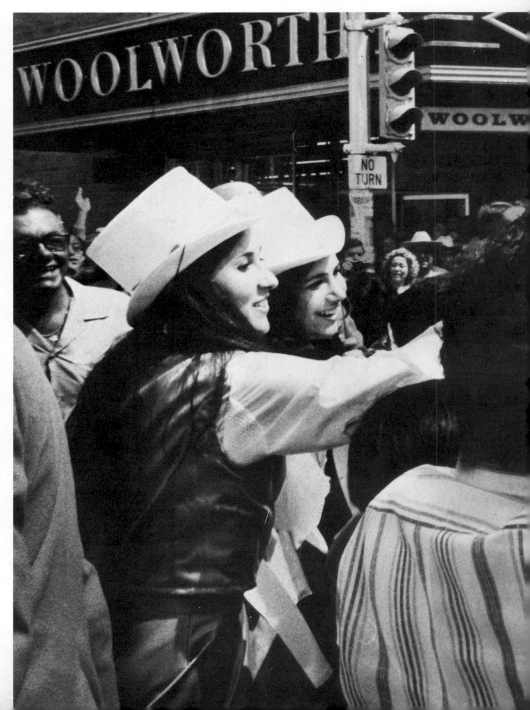

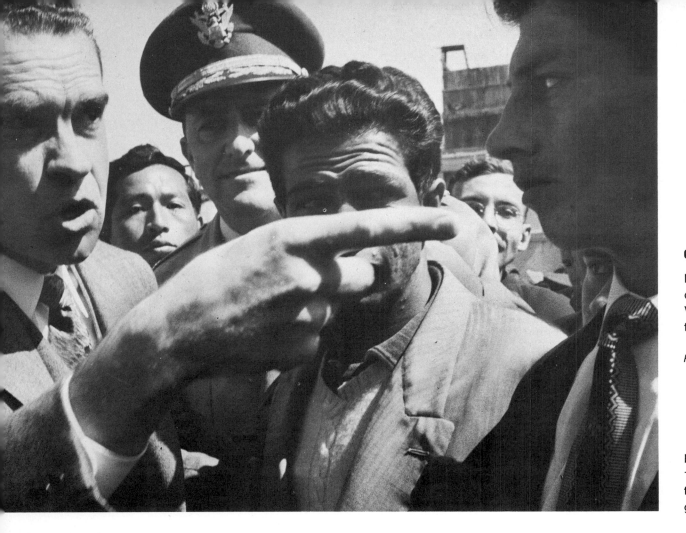

Courageous Envoy

Beset by rock-throwing students during a visit to Lima, Peru, the Vice President bravely challenges them to try debate instead.

PAUL SCHUTZER

Delighted President

Engulfed by Texas admirers in 1972, Nixon eagerly reaches out to shake hands as Secret Service guards try to protect him.

HARRY BENSON

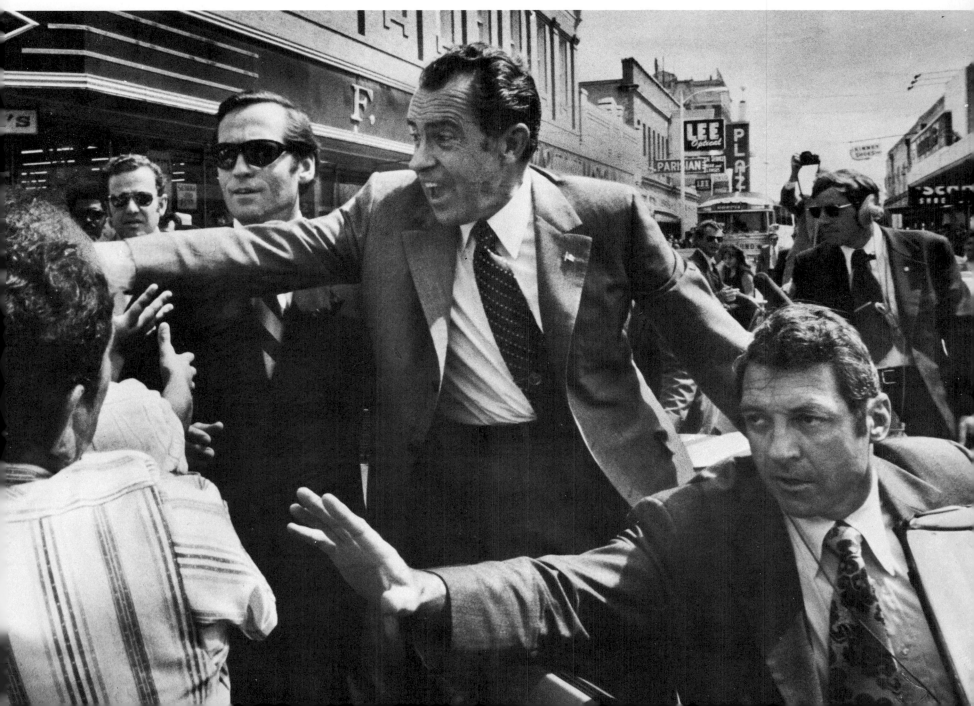

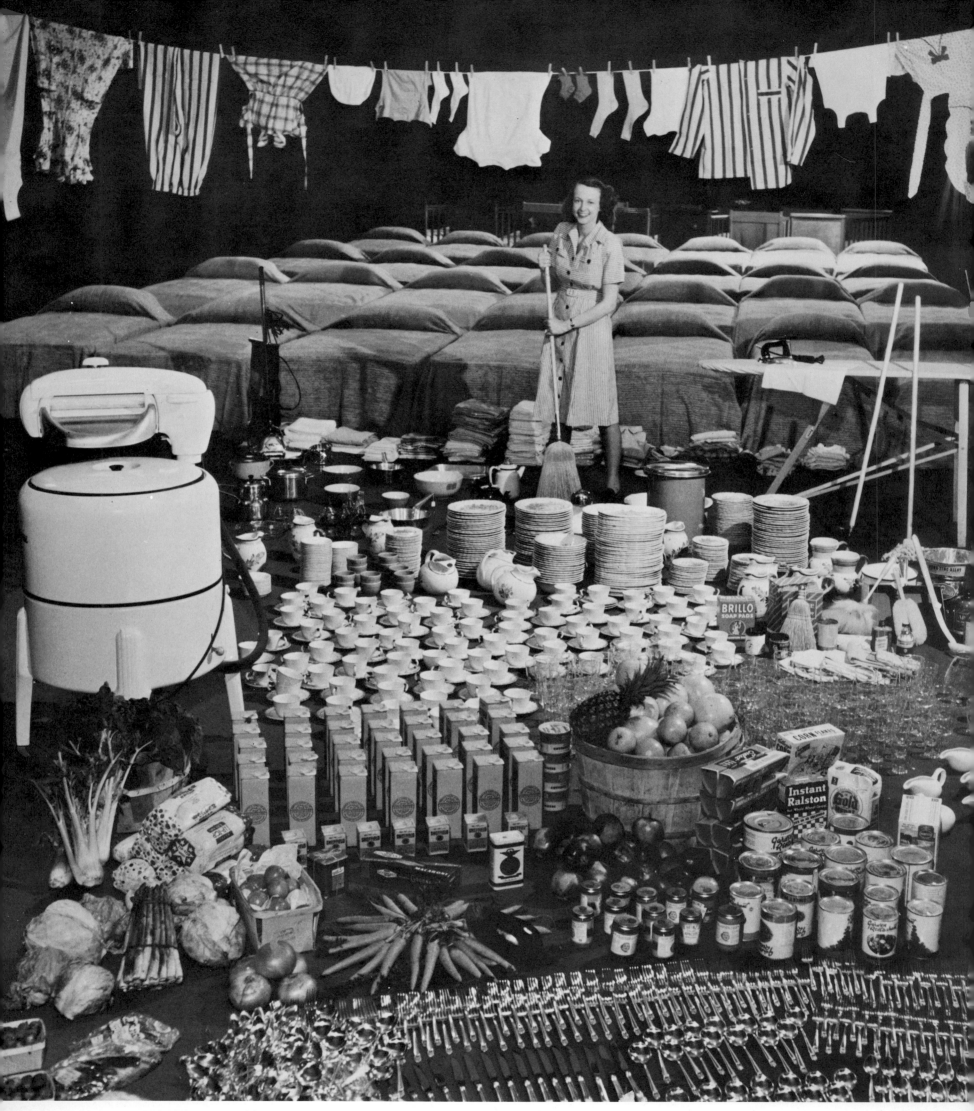

Rye, N.Y., housewife Marjorie Mc-
Weeney mans a broom in pre-lib

1947, amid a typical week's load
of housework and supplies.

A Cleveland couple listens to an
F.D.R. "fireside chat" in 1938.

THE VARIETY OF LIFE

An illuminating look at the manners and morals of a nation in transition

The evanescent terrain of ordinary American society was every bit as challenging to LIFE's editors as politics, war and stop-press news. To win photographic entree to a remote counterculture commune in the Northwest, John Olson first spent two days cajoling—and the next two weeks sleeping on the ground amid his dozen cases of gear. He did it because "it was something worth showing; that's what picture journalism is about."

With similar blarney, bluff and brass, Ralph Crane (no hunter he) joined a gaggle of shotgunners to cover a Texas dove-shoot. On the other hand, assigned to shoot a nude encounter group, Ralph refused to disrobe. Mark Kauffman found that trying to keep up with a housewife was so exhausting he had to start taking afternoons off. Nina Leen's logistical feat in composing the photo at left dwarfed her subject's own work load. No recess was too intimate to poke a lens into, no subject too horrendous, no request too preposterous. Again and again LIFE found, as George Silk did in persuading a newly wed couple to pose in a tub, an eagerness to become a permanent record of our time. As another photographer, Harry Benson, explained, "When you've got them, you don't let them off the hook—it's for posterity."

Ms. Germaine Greer and chum watch her taped TV interview.

HARRY BENSON

Soldierly farewell

Pot problem

Two Stories That Ignited Readers and the Public: Birth of a Baby...

Medical experts and health officials hailed the story as a valued educational effort, but many readers reacted to "The Birth of a Baby"— the complete sequence began with hushed counsel offered by the mother-in-law—in shock and anger. Police confiscated 10,000 copies of the April 11, 1938, issue containing the story; it was banned in more than 33 cities and Canada, and Publisher Roy Larsen himself was arrested.

 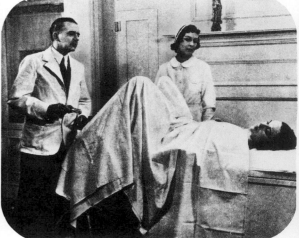

...and How to Undress in Front of Your Husband

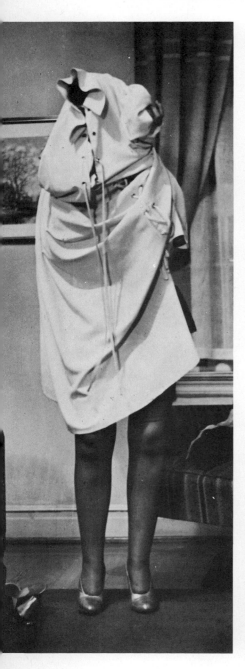 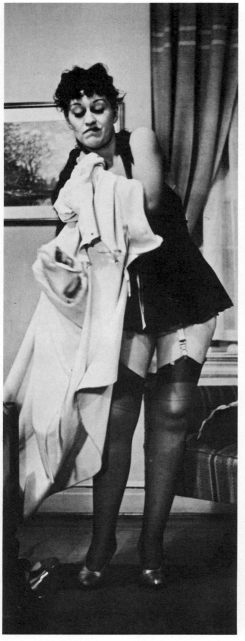 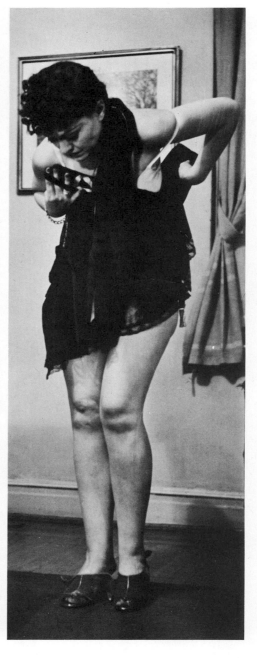

"Too many American wives reveal bad bedroom manners," the editors of LIFE insisted in 1937 as they undertook, allegedly as a public service, to educate women readers in the proper way to disrobe. At left, a faculty member of a Manhattan establishment called the Allen Gilbert School of Undressing dramatizes some common gaffes. The sylph at right demonstrates the finesse to be achieved by taking the school's $30 course, taught by veteran burlesque troupers. Subscribers from Boston to Boise protested, but others wrote in to demand a sequel—for men. LIFE obliged them in a later issue.

PETER STACKPOLE

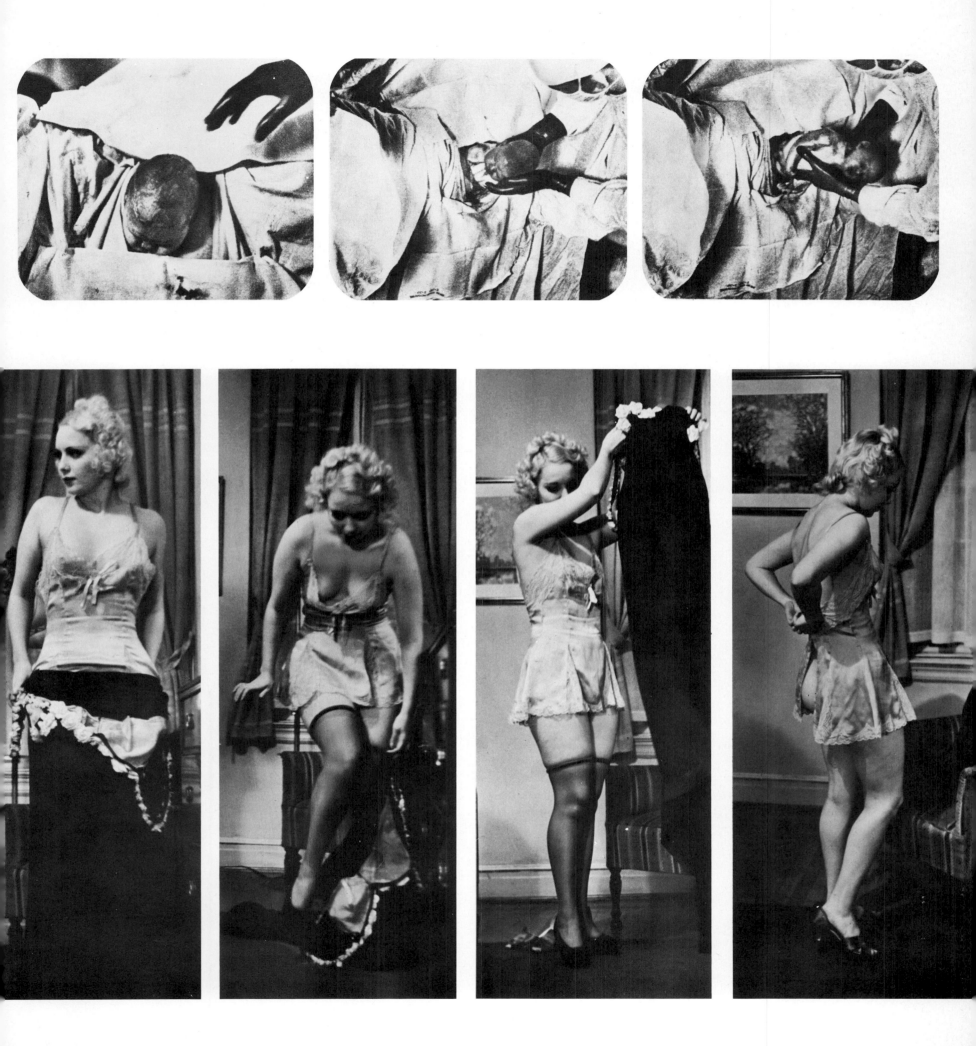

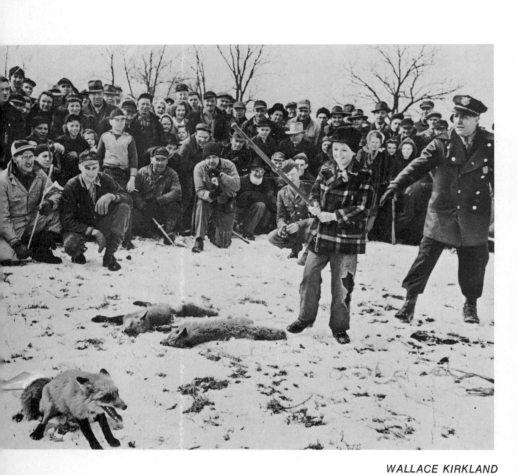

WALLACE KIRKLAND

Club-swinging Ohioans Some 600 folk in Holmes County, Ohio, stirred an outcry among LIFE's readers in 1944 when they were shown enjoying a peculiar local pastime: encircling foxes and clubbing them to death.

Gun-slinging Texans One three-day open season on white-winged doves brought out 10,000 shotgun-wielding Texans from all over the state. And, as LIFE's coverage showed in frightening vividness, they seemed to fire away at everything in sight.

RALPH CRANE

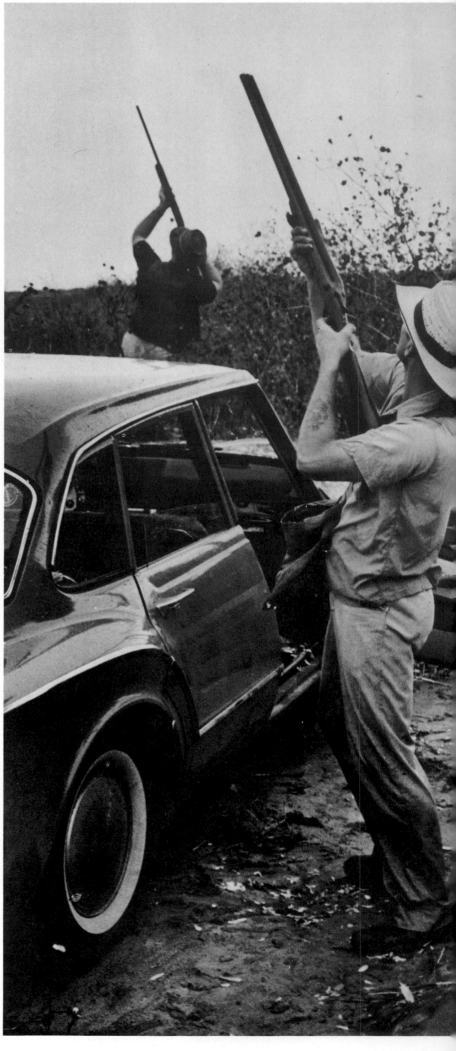

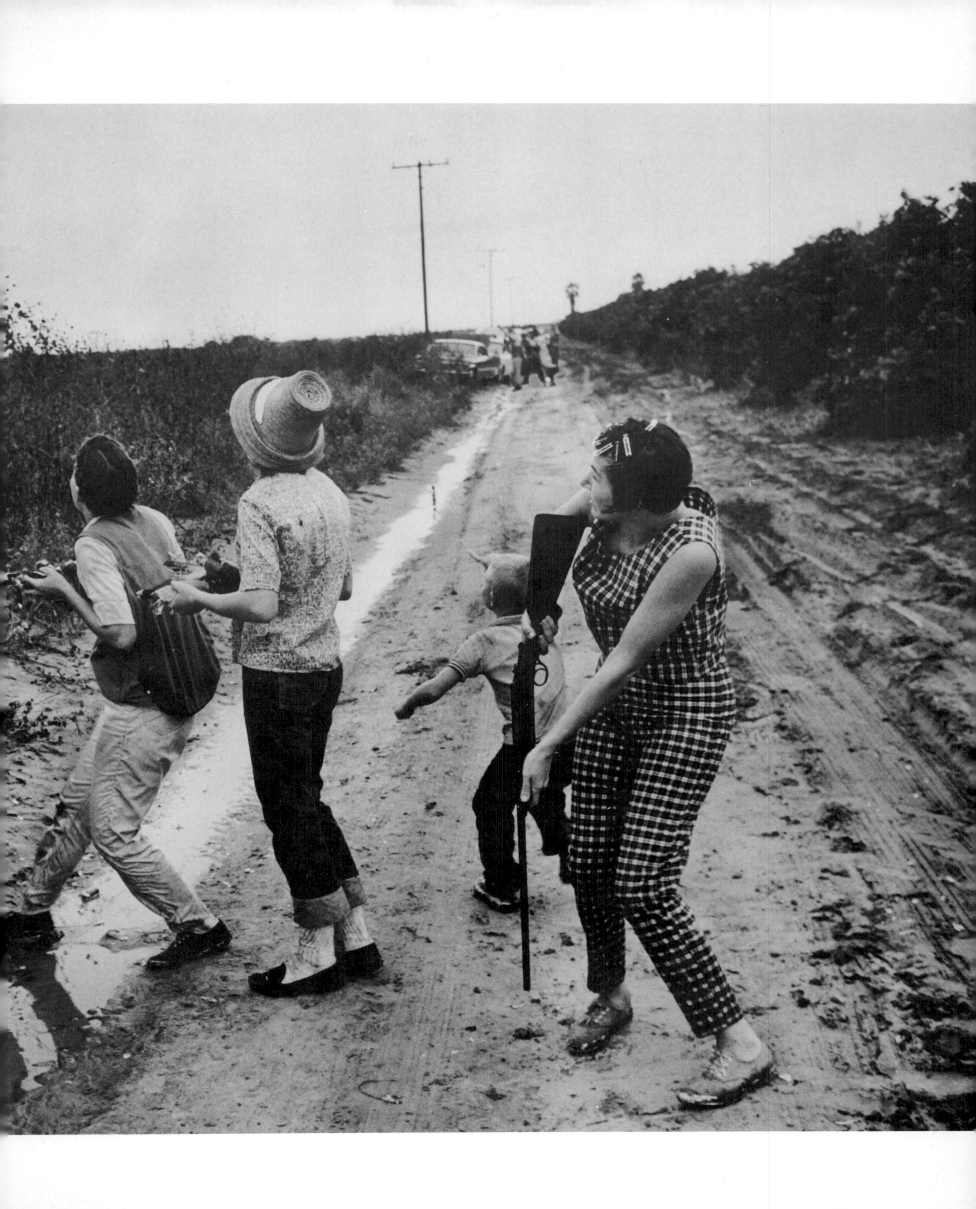

Chirping for the Chicks

Nest-watcher Margaret Nice addresses some friends. After raising four girls, Mrs. Nice became an amateur expert on songbirds.

ALBERT FENN

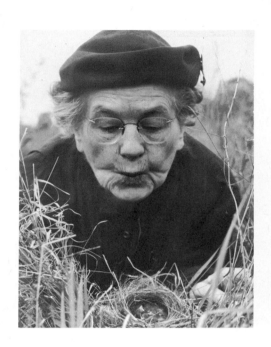

Hypnotic Wheel

Mesmerized and anonymous, she waits in the gambling salon of the Caribe Hilton in Puerto Rico as fortune's timepiece clicks away the hours and the markers.

GORDON PARKS

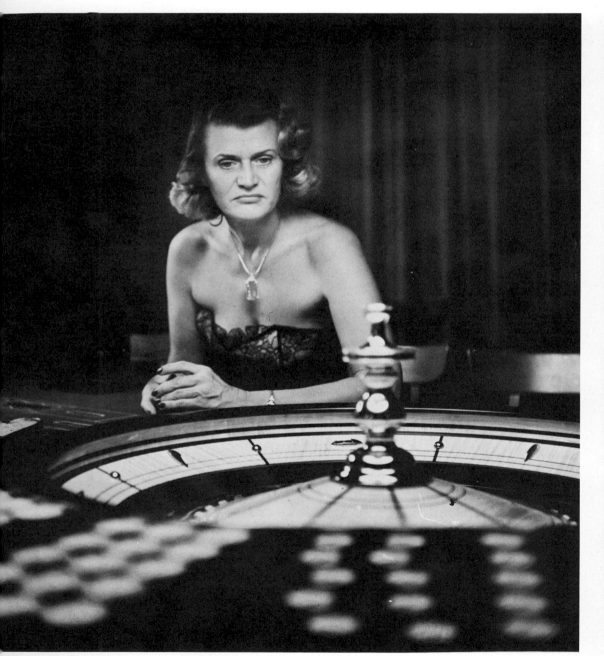

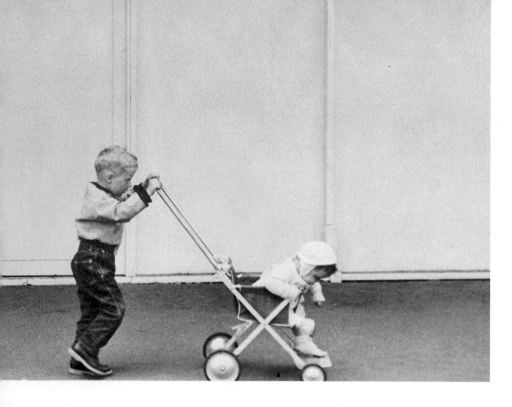

Family Lock Step

Content with her lot, this Seattle mother nonetheless confessed . of her 80-hour work week that "there are times I just wish I was away on a long trip."

MARK KAUFFMAN

The Wading Game

In sculpted cookie-cutter pools across the country, kicky young singles, ever hopeful, get together in clubs—to become unsingle.

ARTHUR SCHATZ

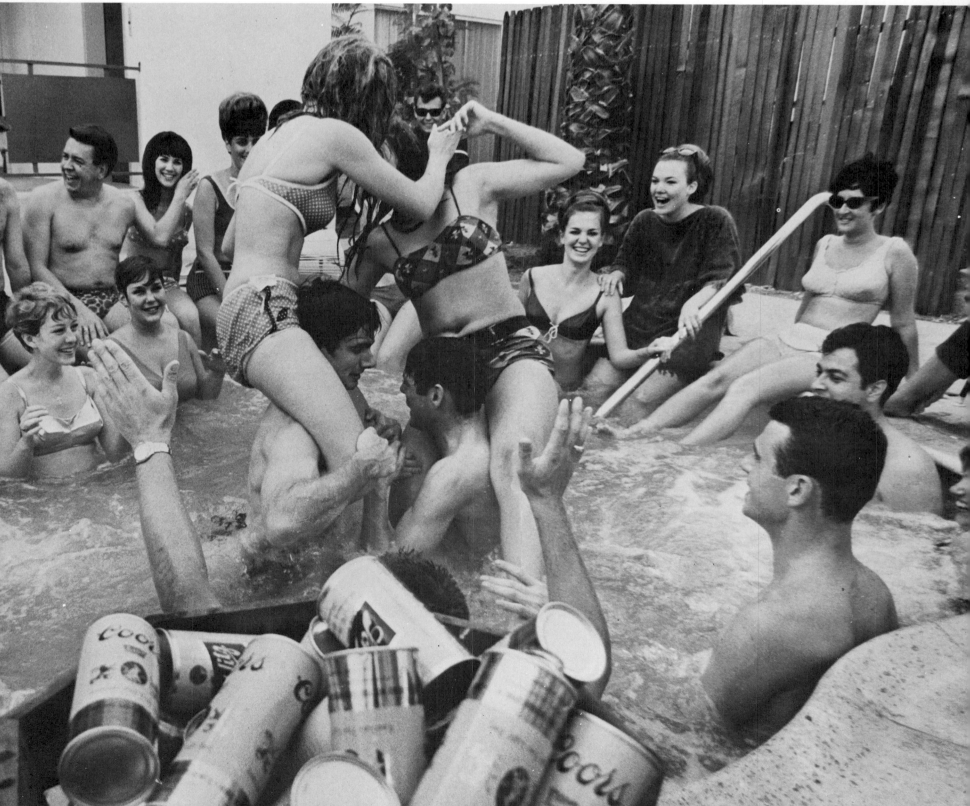

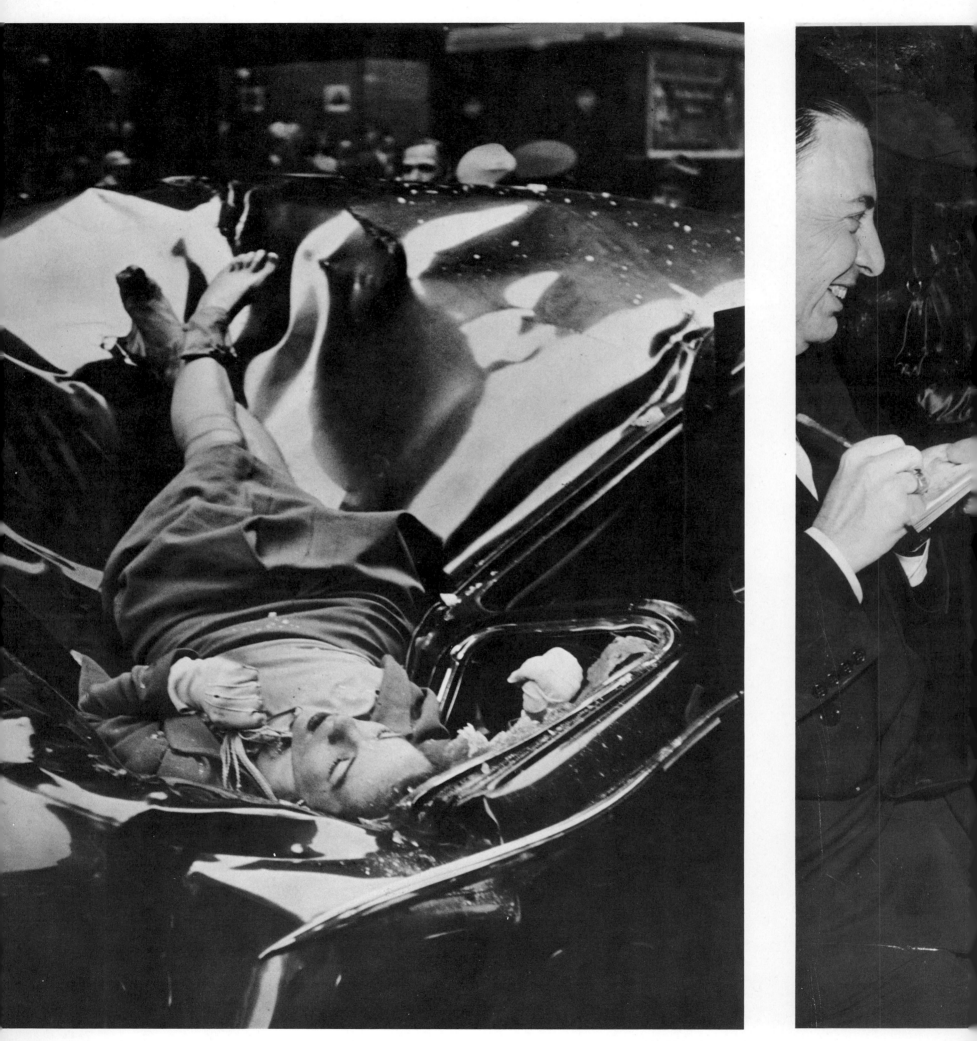

ROBERT C. WILES

Death at an Early Age After plunging 86 floors from the observation deck of the Empire State Building, an attractive 23- year-old lies peacefully atop the crumpled sedan she struck on West 33rd Street.

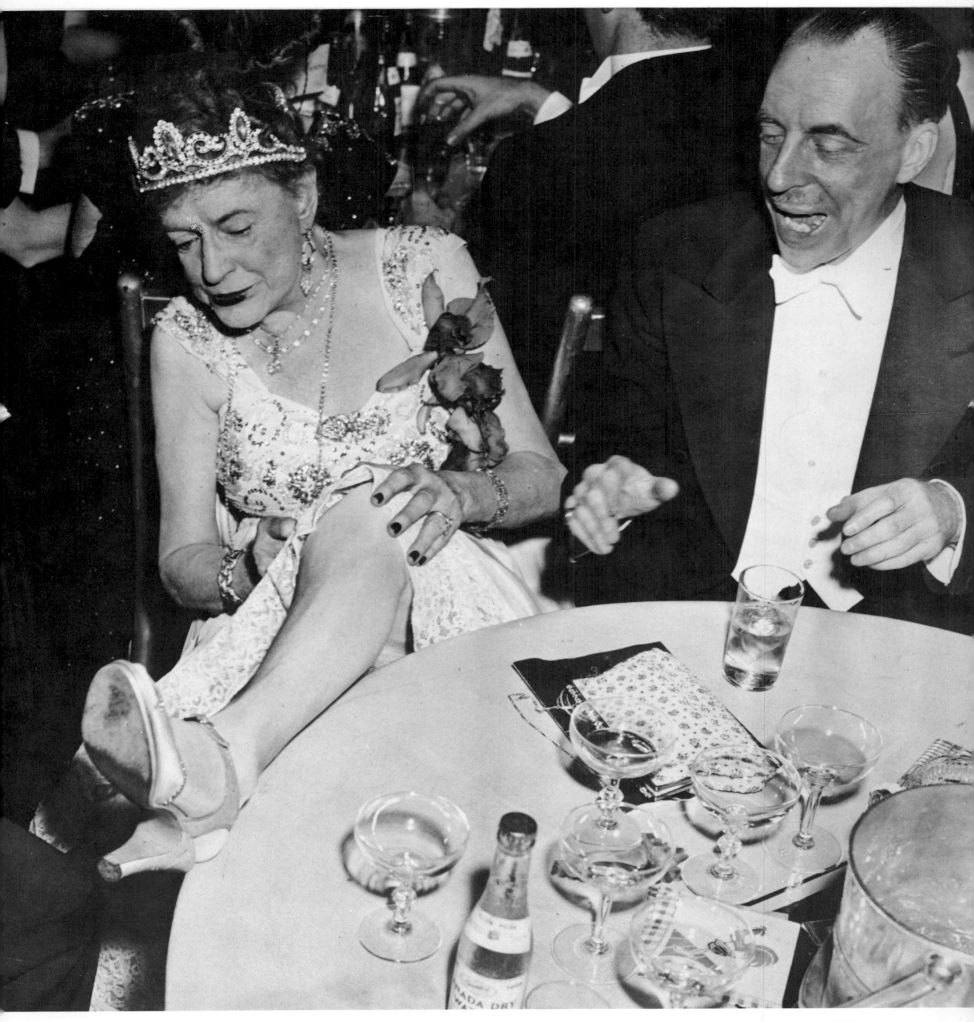

Still Kicking at 72 Her spirit undimmed by the years, Mrs. Frank Henderson, tiaraed and bespangled, puts on a show of her own during the opening-night high-society turnout for the Metropolitan Opera.

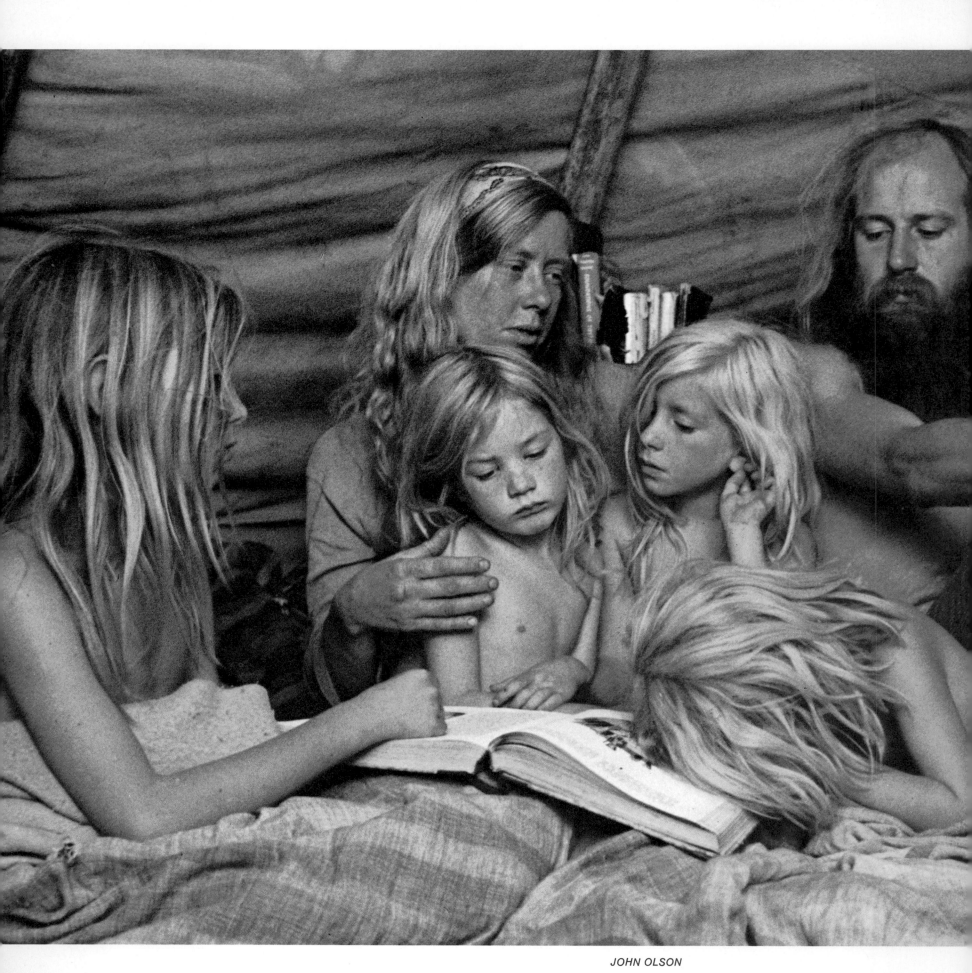

JOHN OLSON

Dedicated Dropouts Commune dwellers (a computer programmer, his Radcliffe wife and four children) seek a new life in a West Coast tepee.

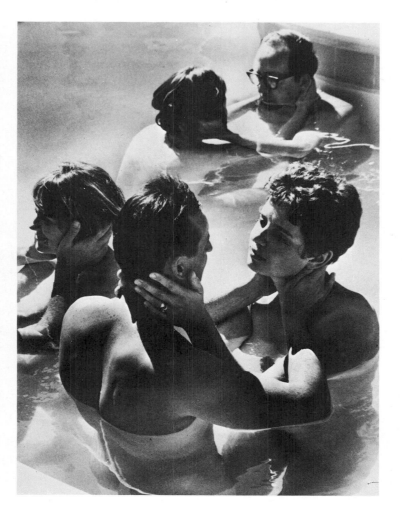

Group Gropes

Trying the encounter route to a more satisfying existence, these self-searchers in a Palm Springs swimming pool reach out for their less-inhibited selves.

RALPH CRANE

Honeyed Honeymoons

Prompted toward togetherness in a tub, a happy couple enjoys a soapy interlude in a fantasies-come-true honeymoon inn.

GEORGE SILK

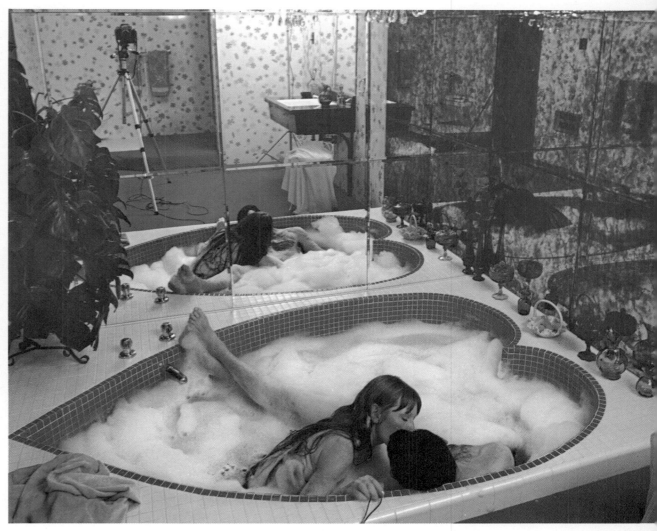

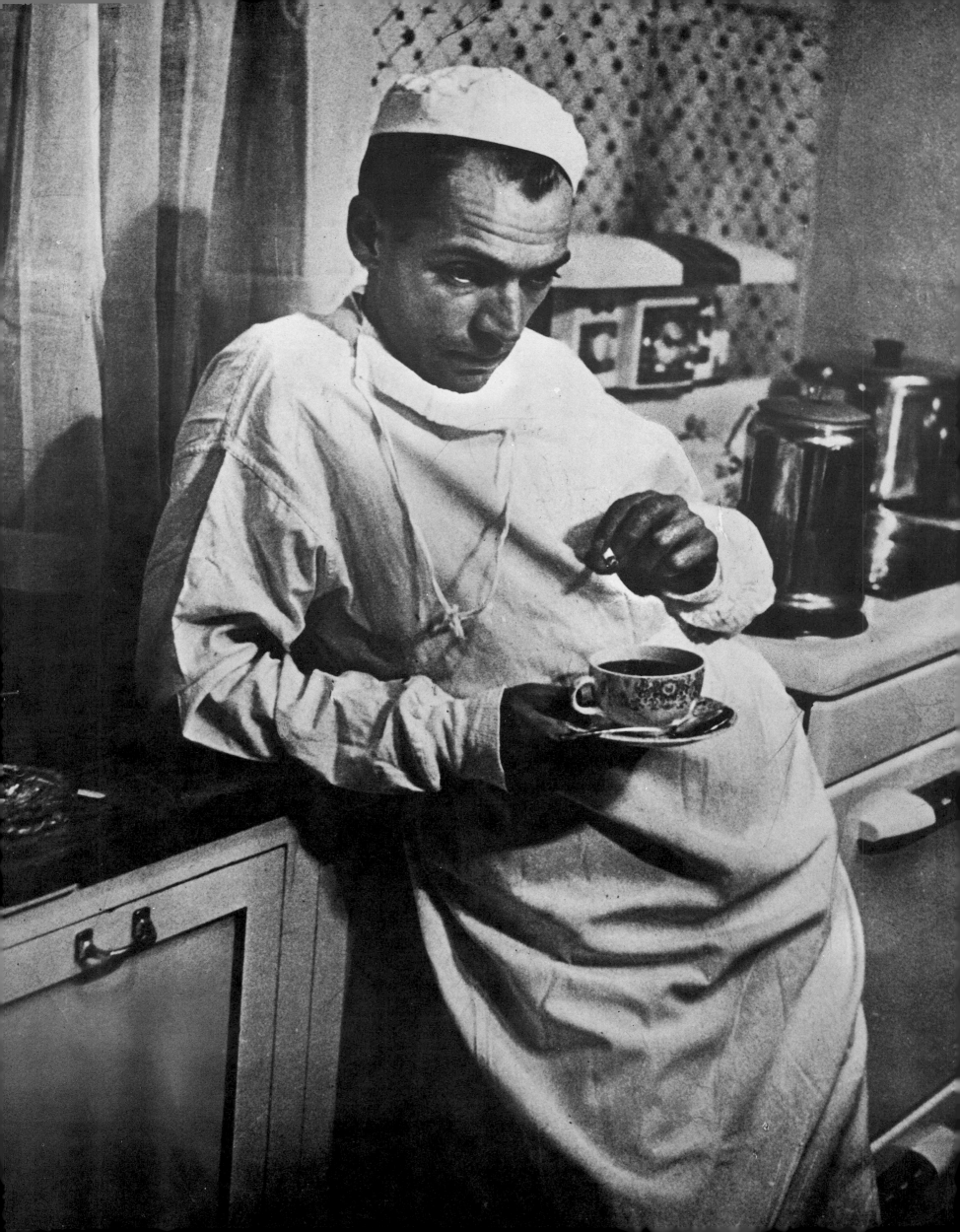

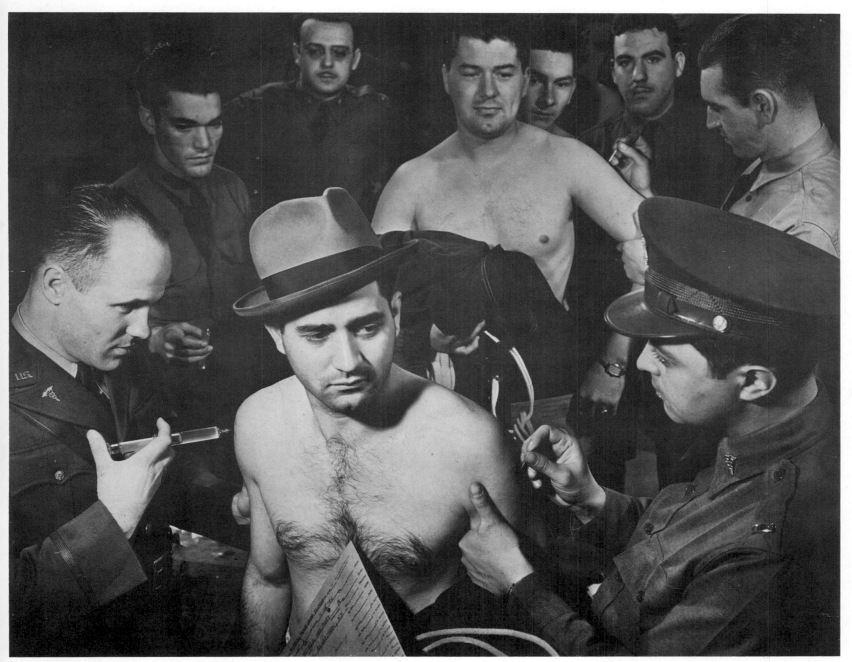

Weary Country Doctor

Coffee and a smoke in the hospital kitchen at 2 a.m. ends one day for Dr. Ernest Guy Ceriani. In a few hours, another would begin in his endless job as the only physician for Kremmling, Colo.

W. EUGENE SMITH

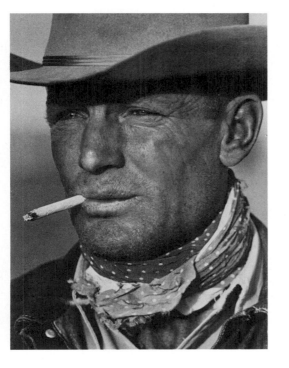

Well-punctured Draftee

His hat the only—and dubious —relic of civilian dignity, 1940 draftee Thomas Militello submits to a ritual that would become a rite of passage for a generation of war-bound American men.

Rough-hewn Cowboy

Puffing on a handmade, the quintessential cowboy, foreman C. H. Long of the JA spread in Texas, squints into the sun. His picture proved to be one of LIFE's most popular covers.

LEONARD McCOMBE

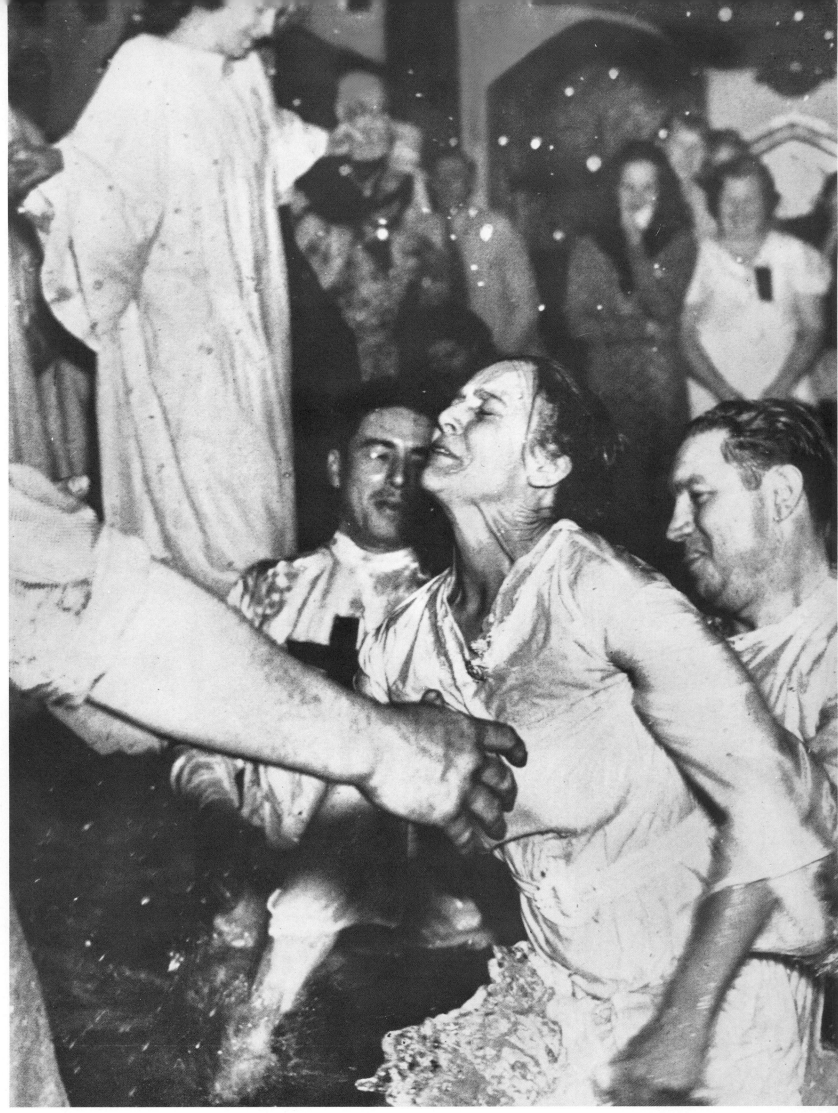

GEORGE STROCK

Total Immersion In the ecstasy of promised salvation, a Los Angeles convert is baptized in a mass ritual.

Total Congestion Hot escapees at New York's Manhattan Beach leave no room for a seagull to land.

JOHN MULLER

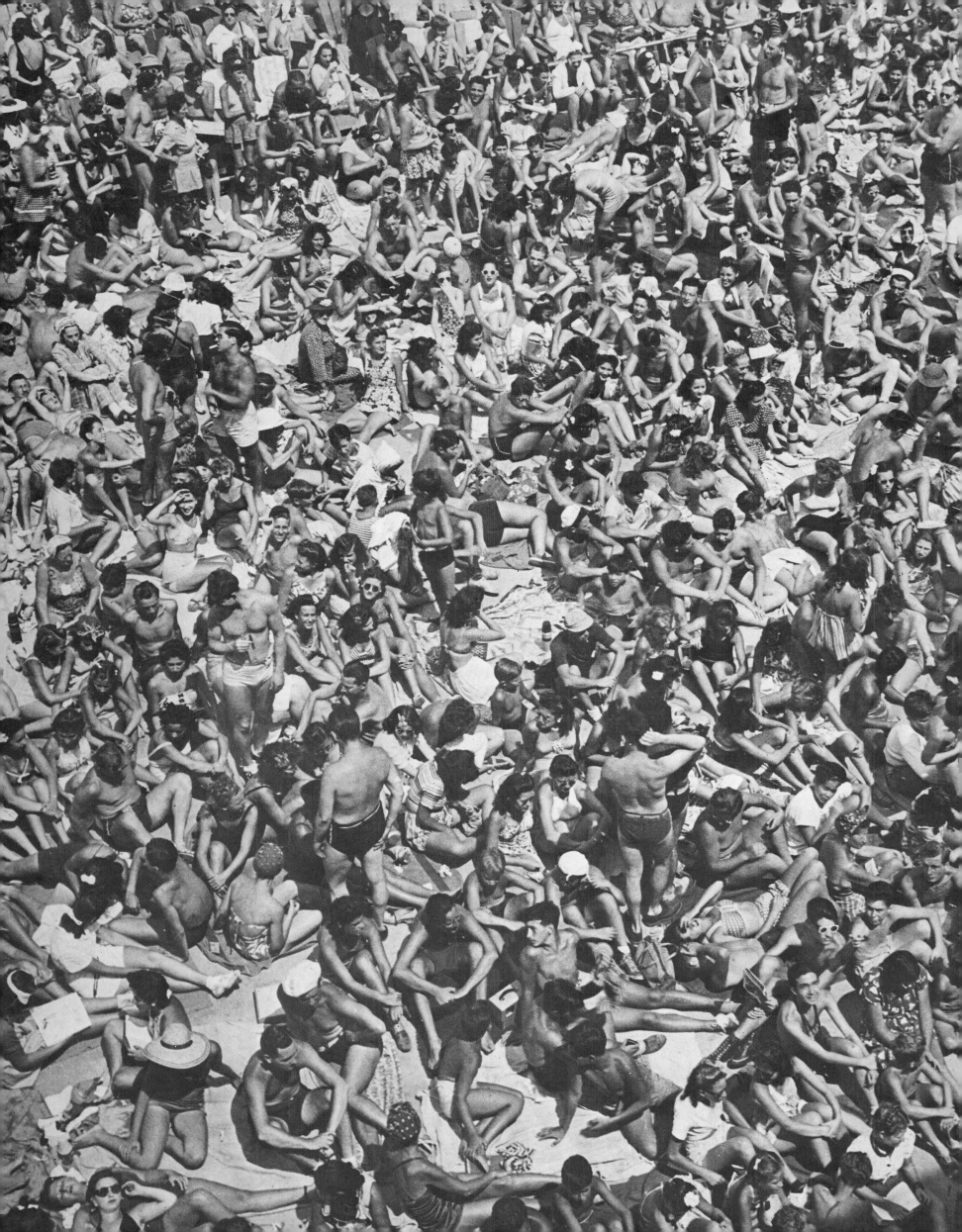

THE SCIENCES...

Back to the roots

Man's cultural evolution

Chemistry and heredity

Pioneering inside the heart

Task forces to cope with difficult subjects in an age of discoveries

When it comes to science, general interest magazines either nibble timorously around the edges or avoid the subject completely, assuming that it is way over people's heads. LIFE tackled the sciences head-on and on all fronts, with results that were always memorable, often prophetic, translating even such difficult topics as genetics and atomic theory into stories that were authoritative, easy to understand and fascinating to look at. Task forces of editors, photographers, reporters, artists and modelmakers teamed up to produce series that were carefully saved by millions of readers.

LIFE's career coincided with the most astonishing proliferation of scientific discovery in history. The awesome task of recording it all fell to a new breed of photographer whose expertise and tenacity approached those of the experts with whom LIFE's staff worked. Photographer Fritz Goro worked a solid week to portray adequately the ferocious power of a laser beam *(right)*. His pictures, many taken years ago, are still in demand for scientists' publications. Swedish photographer Lennart Nilsson had to invent new techniques and equipment for his extraordinary microscopic landscapes of the human body *(page 116)*. It took him 10 years to complete the awesome sequence on human growth in the womb —his unique and revelatory tribute to the miracle of life.

A laser beam cuts through a razor blade in a shower of sparks.

FRITZ GORO

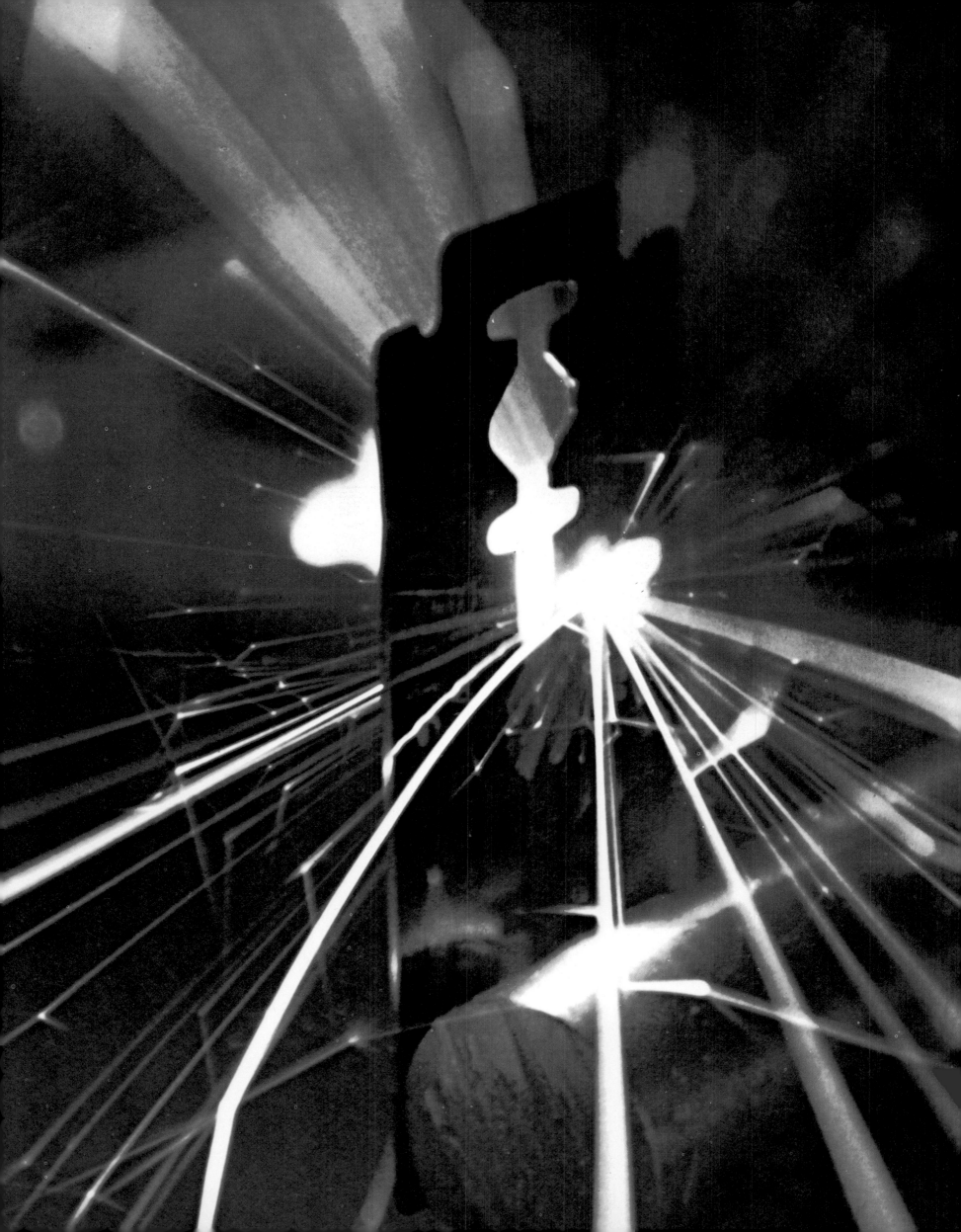

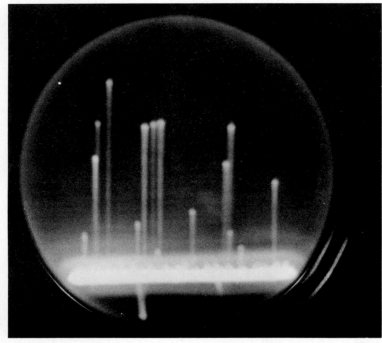

Future Power This epochal photo appeared in April 1939. It shows bursts of energy released by the fission of atoms of uranium, recorded on a fluorescent screen.

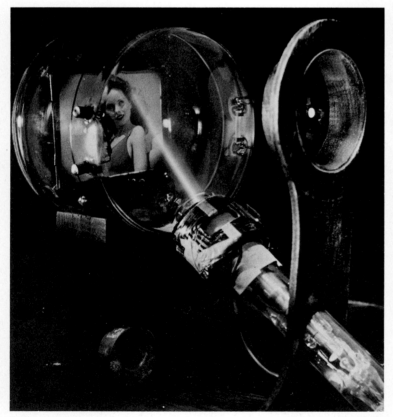

Future Image A 1944 forerunner of the TV camera tube beams an image of a girl onto its screen. TV's impact on U.S. civilization, LIFE said then, "is beyond present prediction."

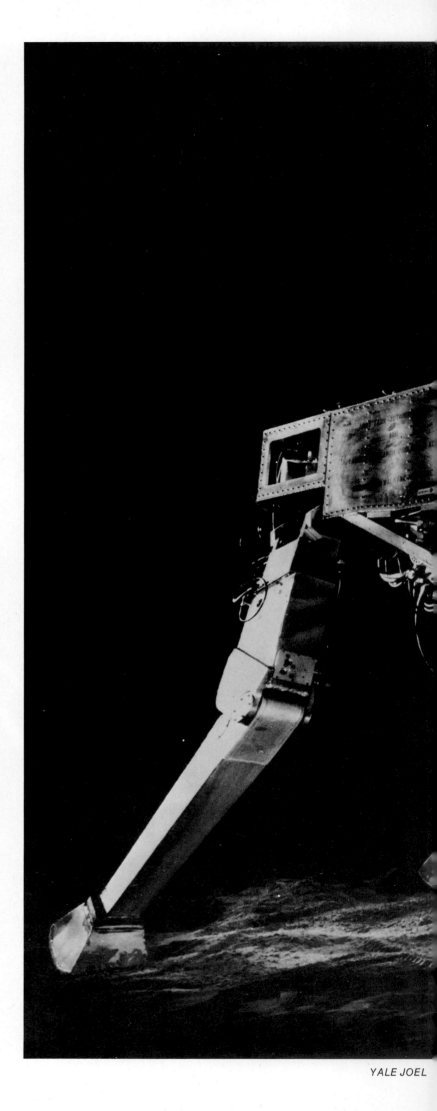

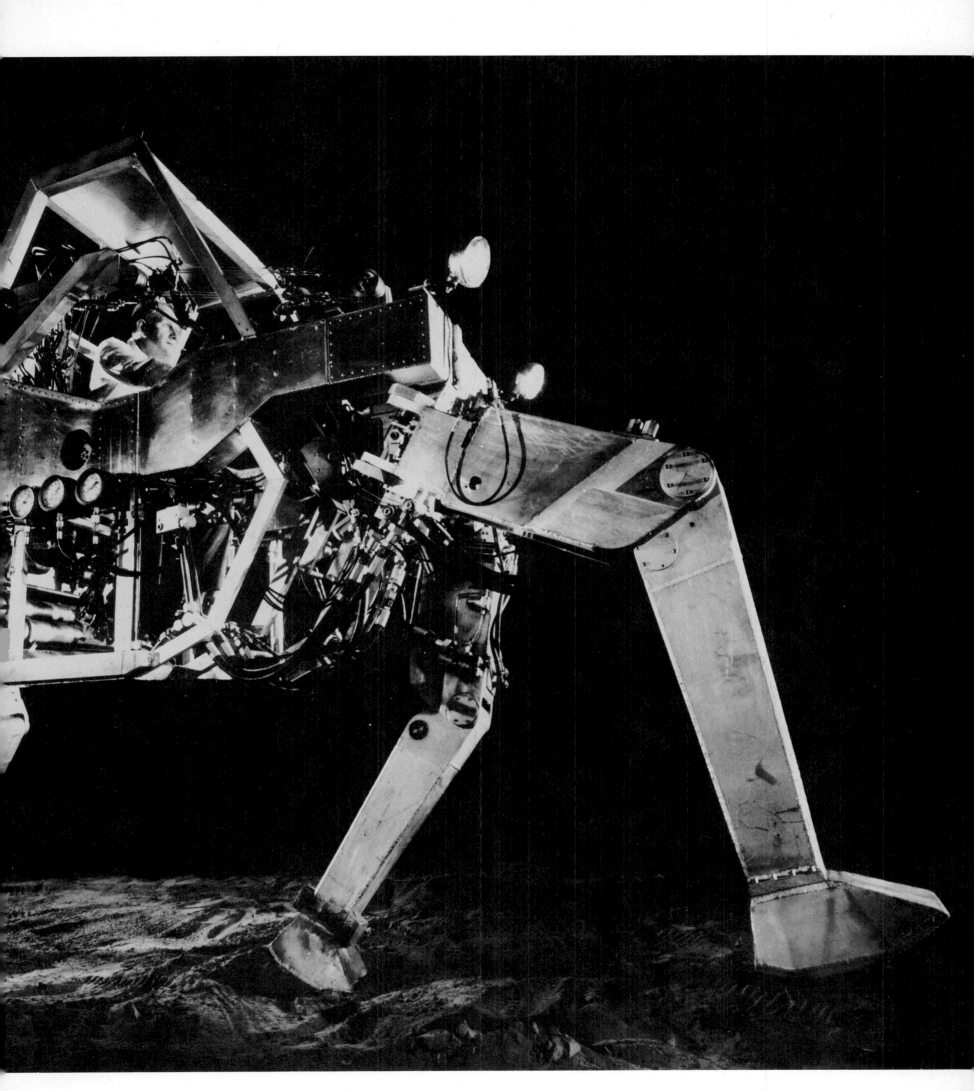

Future Slave Inventor Ralph Mosher sits in his nameless mechanical quadruped and walks it forward. Built to car- ry loads on rough earth terrain, it could make five mph and lift 500 pounds with one limb.

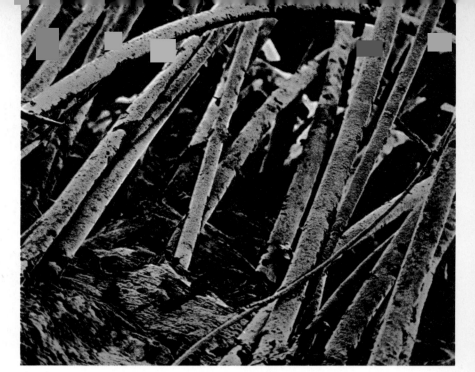

Woodsy Grove
of Human Hair

Lennart Nilsson's 1970 odyssey by microscope through the human body includes the aspen-like grove of hairs at right magnified 500 times, emerging from a scalp.

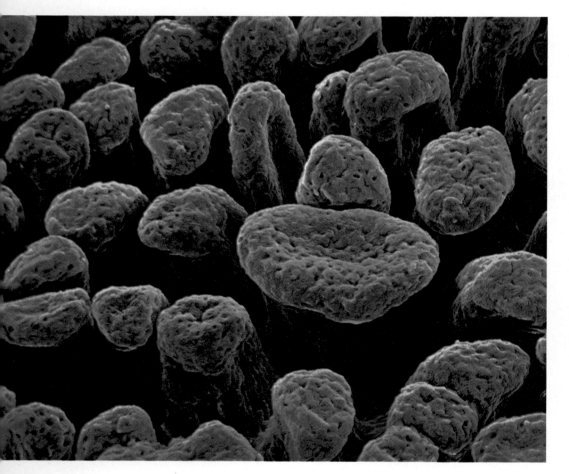

Tiny Buds for Tasting

A tongue tip *(left),* 60 times life size, turns into a field of fleshy mushrooms under Nilsson's scanning electron microscope. Taste buds girdle the stems.

Natural Cavern in the Skin

The gaping hole at right is a single human pore magnified 2,400 times. Common bacteria, tinted green by the photographer for contrast, cling to its walls.

Fragile Antennae
of Hearing

Crests of tiny hairs, magnified 3,500 times, grow inside the inner ear. When agitated by sound waves, their vibrations trigger impulses to the brain.

LENNART NILSSON

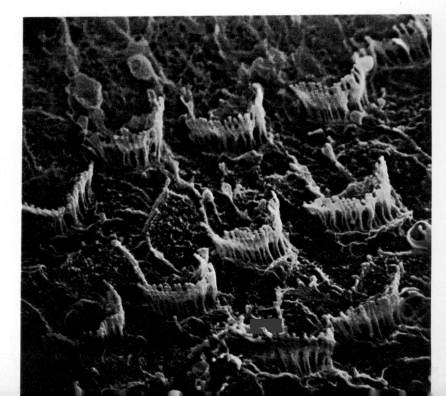

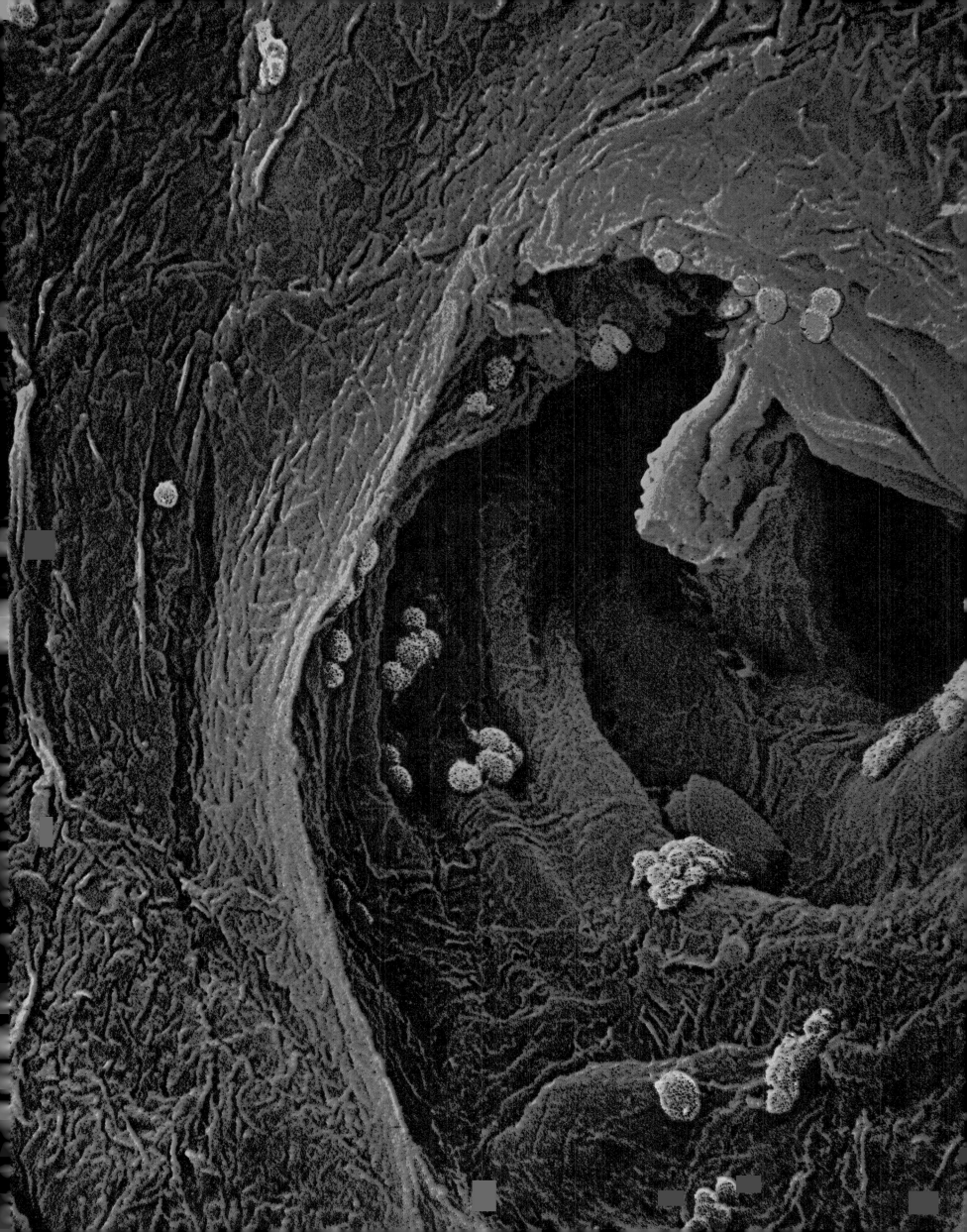

Miracle in the Womb

Nilsson's extraordinary essay on life before birth is shown below as it appeared in LIFE in 1965. With rare exceptions he photographed embryos which had been surgically removed for medical reasons. The fetus at right, curled in its amniotic sac at 16 weeks, looks like a fully formed baby although less than six inches long.

LENNART NILSSON

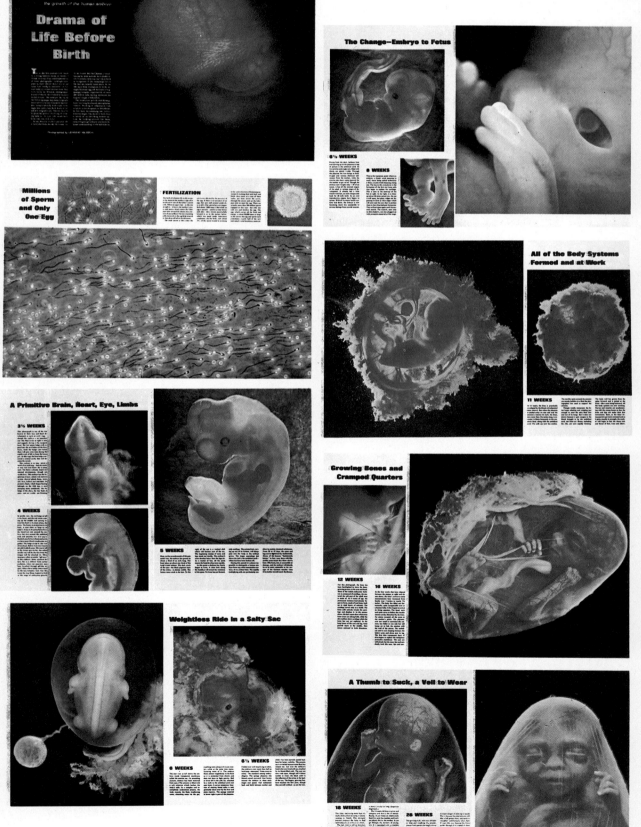

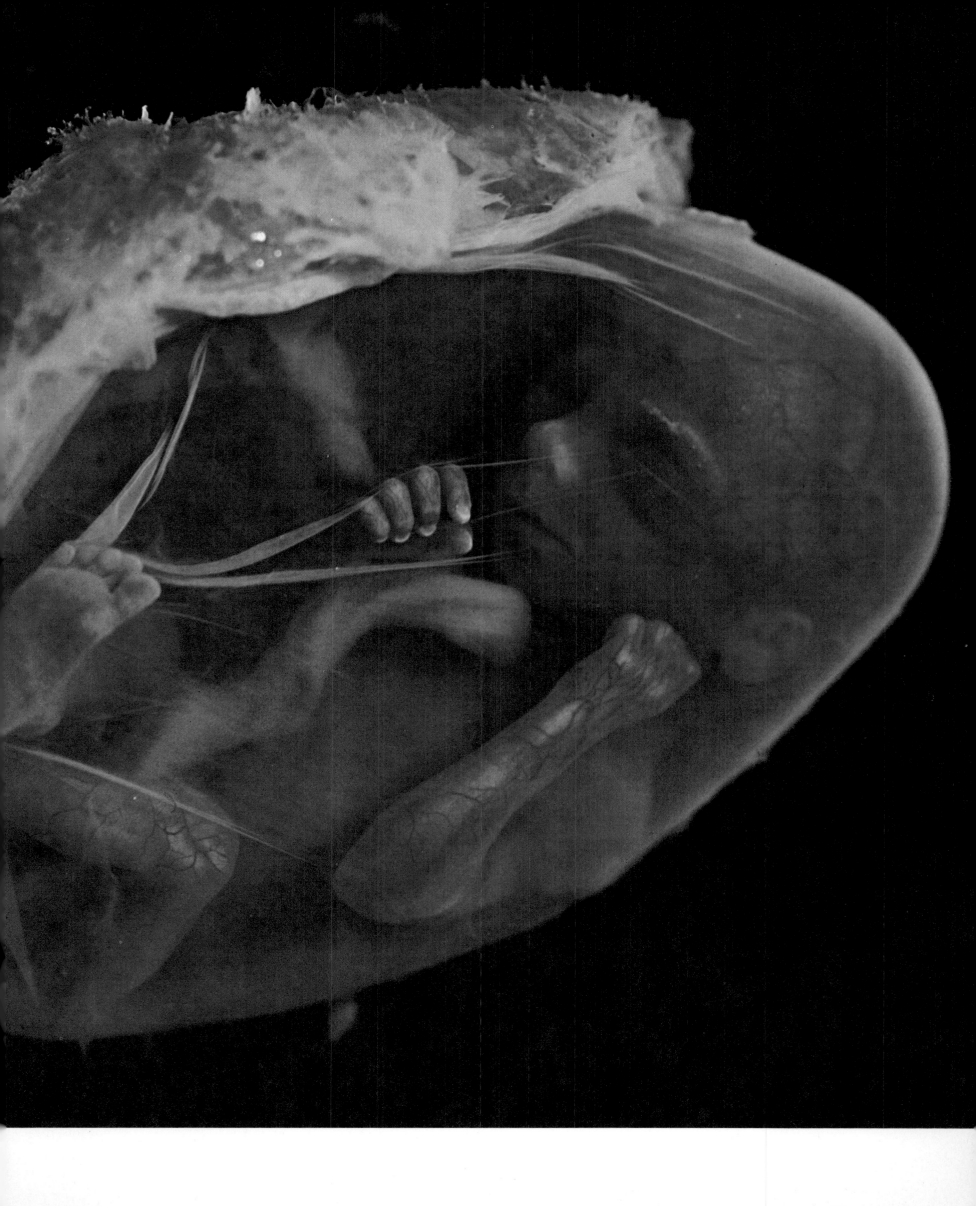

...AND INTO SPACE

Glenn before his famous flight

New camera techniques to match the technology of the astronauts

LIFE went all over the world for great pictures, but some of its most spectacular photographs were of no place on earth. Not only did the magazine carry the exclusive accounts by the astronauts, but LIFE photographer Ralph Morse devised techniques, which NASA also used, to photograph blast-offs with insulated cameras at incineratingly close range. Morse also helped teach spacemen how to devise special cameras that they took into space.

One of Morse's most ingenious photographs dramatized the single goal of Gemini 6 and 7—the rendezvous in space—by photographing the launchings of the two spacecraft, 11 days apart, on one piece of film *(left)*. He set up his motor-driven Hulcher camera on Pad 13, some 7,000 feet from Gemini 7, aimed high to exclude the ground, and caught a sequence of 20 frames of the rocket lifting into the cloudy Florida sky. He took the camera, unopened, to a motel and locked it up in a room kept at 70°F to make sure that higher temperatures would not affect the exposed film. For Gemini 6, Morse rewound the film to the starting position, took the camera to the top of the 260-foot gantry, 7,300 feet from the rocket, and aimed down. As the second mission lifted off, Morse started the camera again and got the remarkable twin exposure at left of two great moments made into one.

Gemini Leaving Earth

Gemini 6 *(left)* and Gemini 7 rockets appear to blast off together in this dramatic double exposure.

RALPH MORSE

Lunar Visitor

Man on the moon: Edwin Aldrin is photographed by Neil Armstrong, who is reflected in Aldrin's visor.

NEIL ARMSTRONG

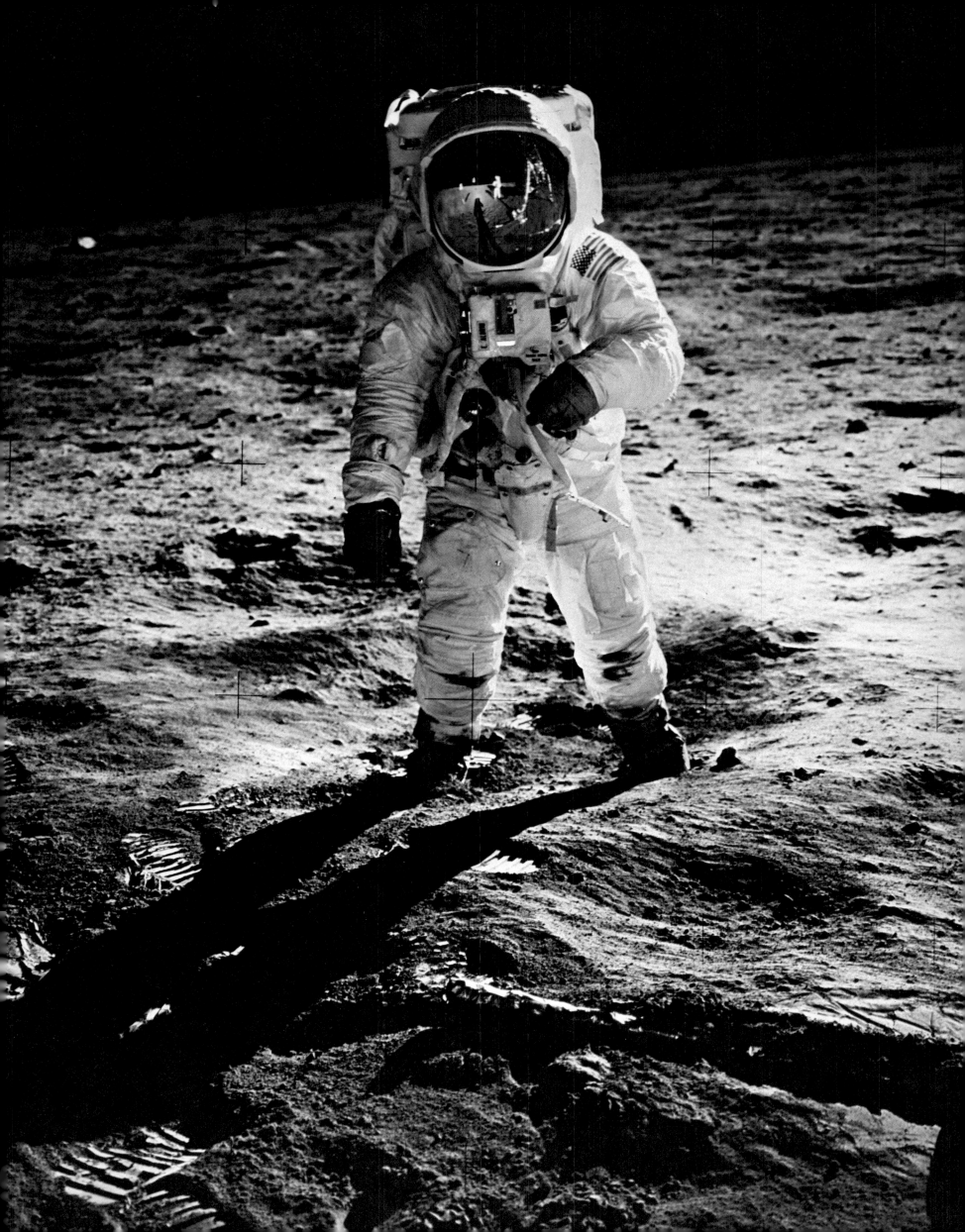

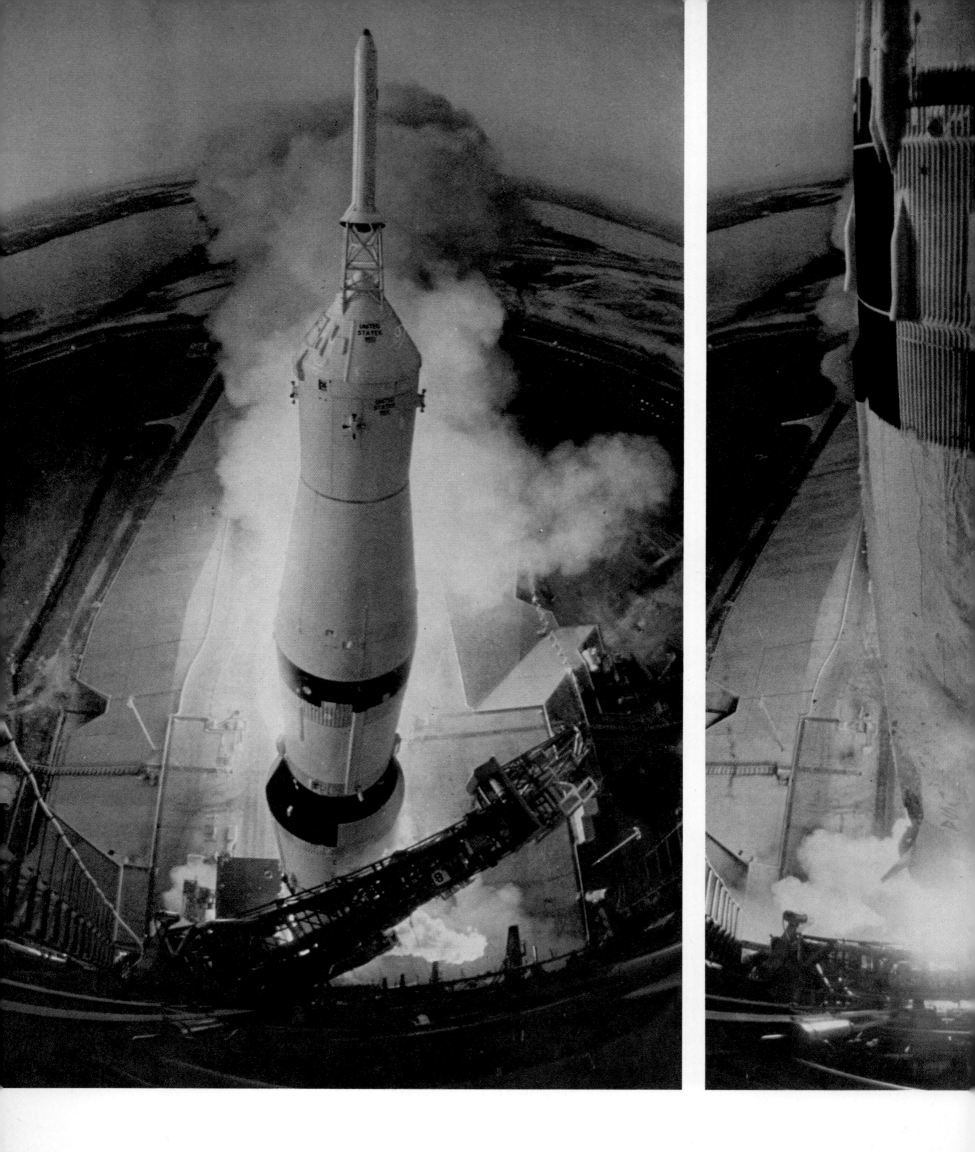

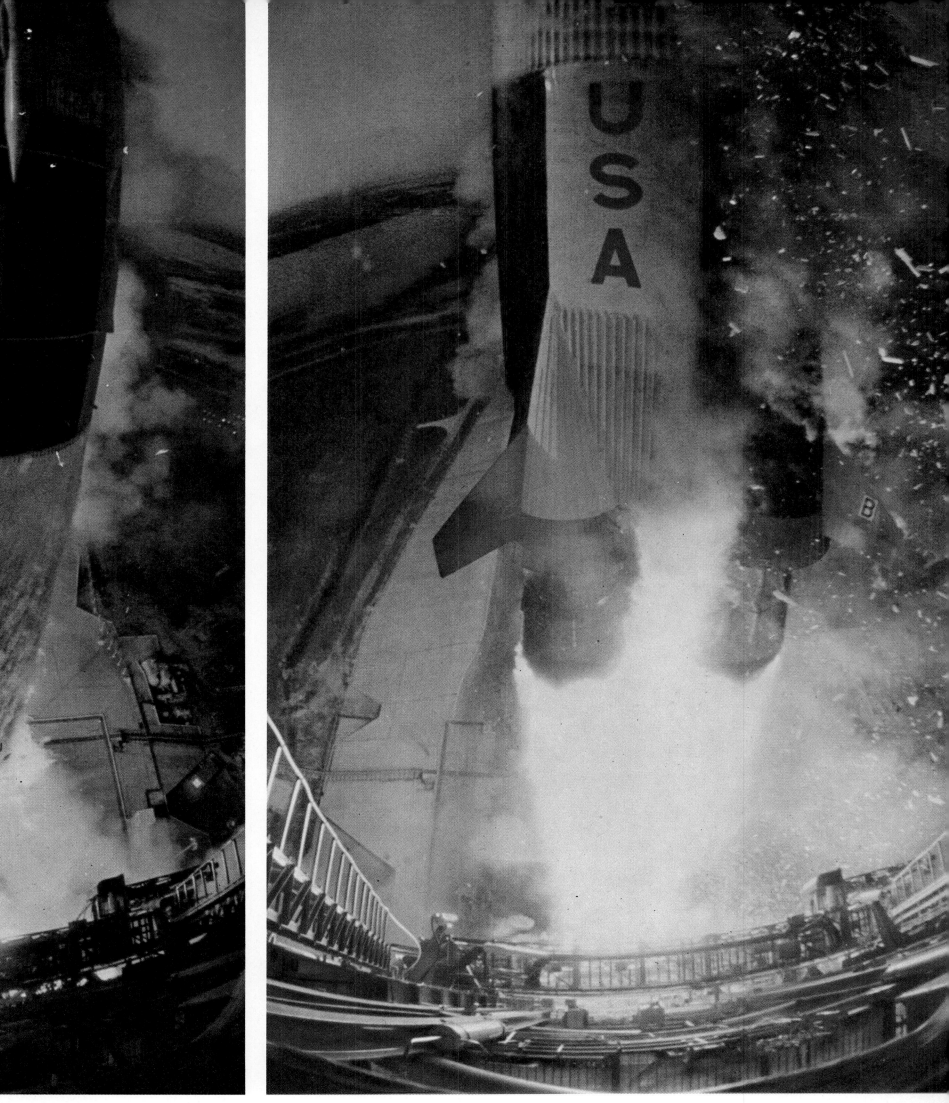

Saturn's Blast-off Seemingly so close the reader could touch it, Saturn V roars skyward. Morse got such close-ups with a remote-controlled camera set in a fireproof box on a tower 40 feet from the rocket's path.

A Walk in Space Ed White was photographed by Jim McDivitt as he maneuvered in the void, secured to Gemini 4 only by his life line. It was a serious test, but also fun. "I'm not coming in," White said.

JAMES A. McDIVITT

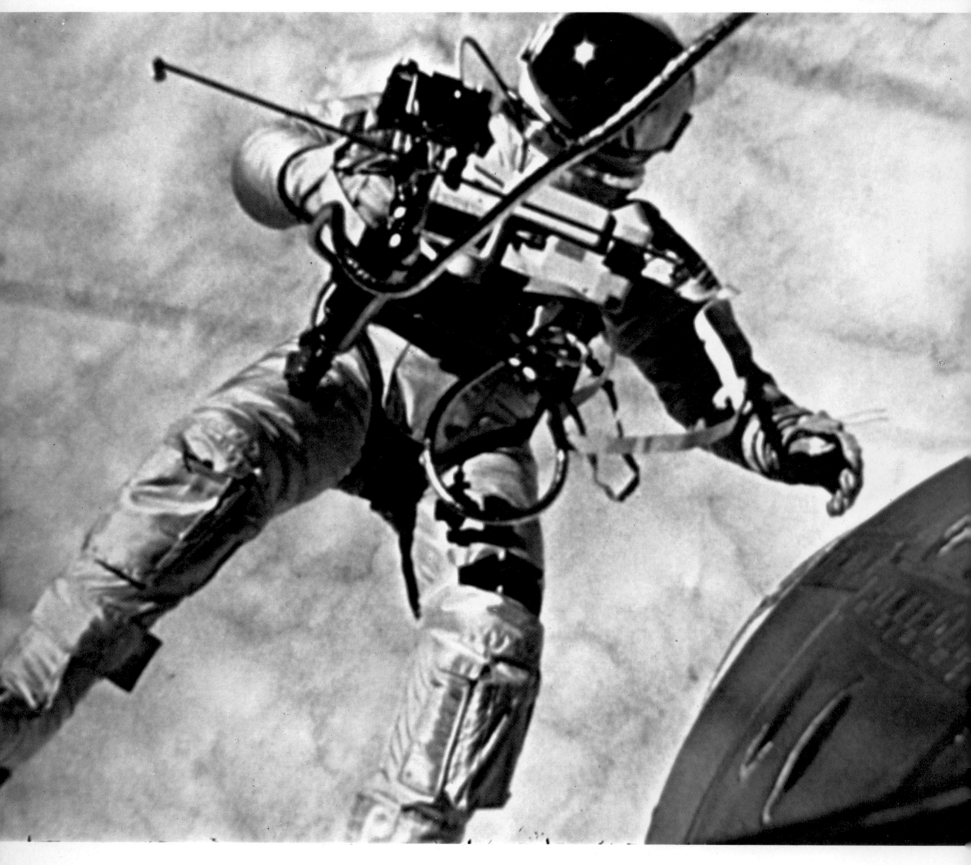

—and on the Moon Four years after Gemini 4, Apollo 11 took what Armstrong called "one giant leap for mankind." As men walked on the moon, Aldrin photographed his own footprint where no man's had ever been.

EDWIN E. ALDRIN JR.

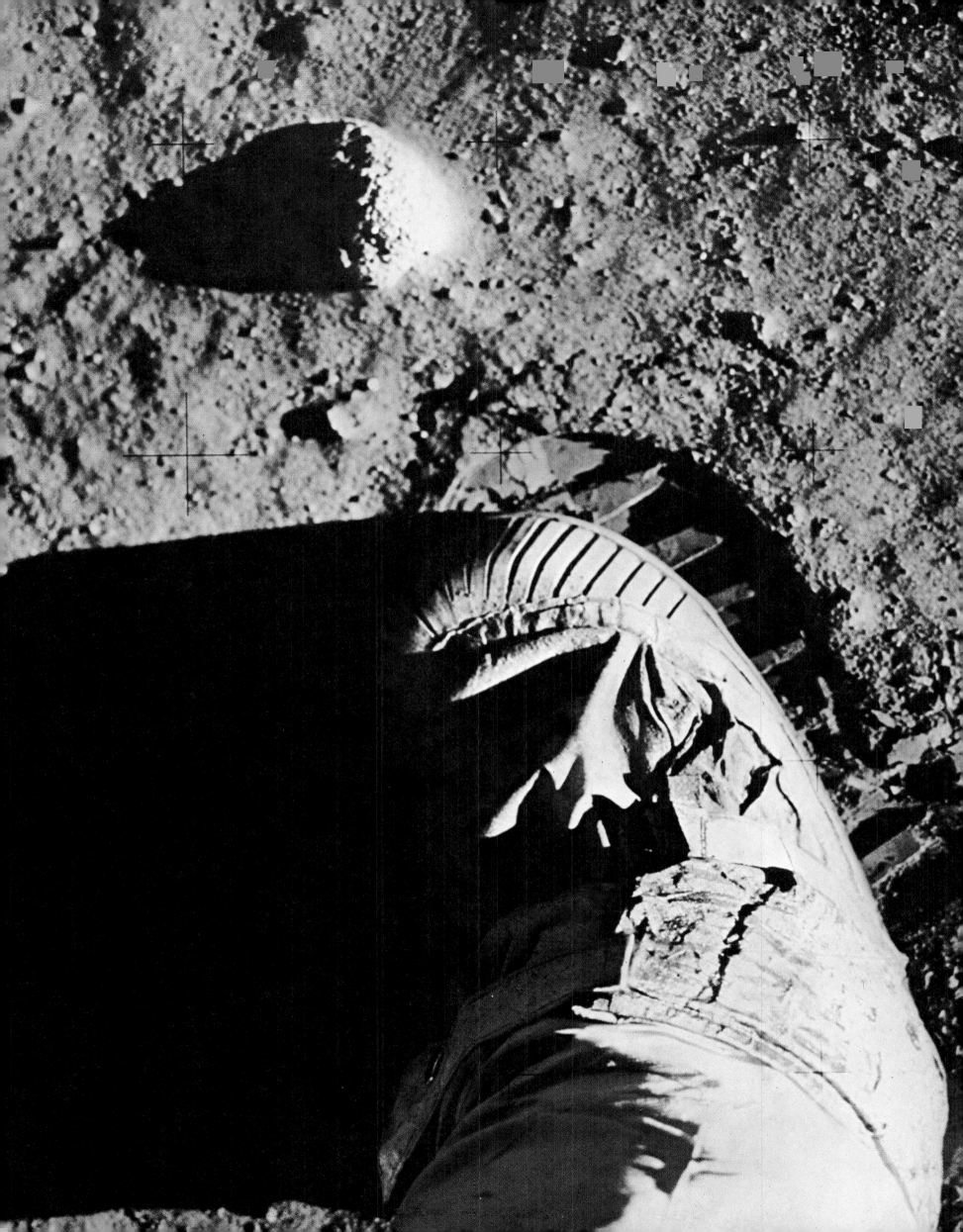

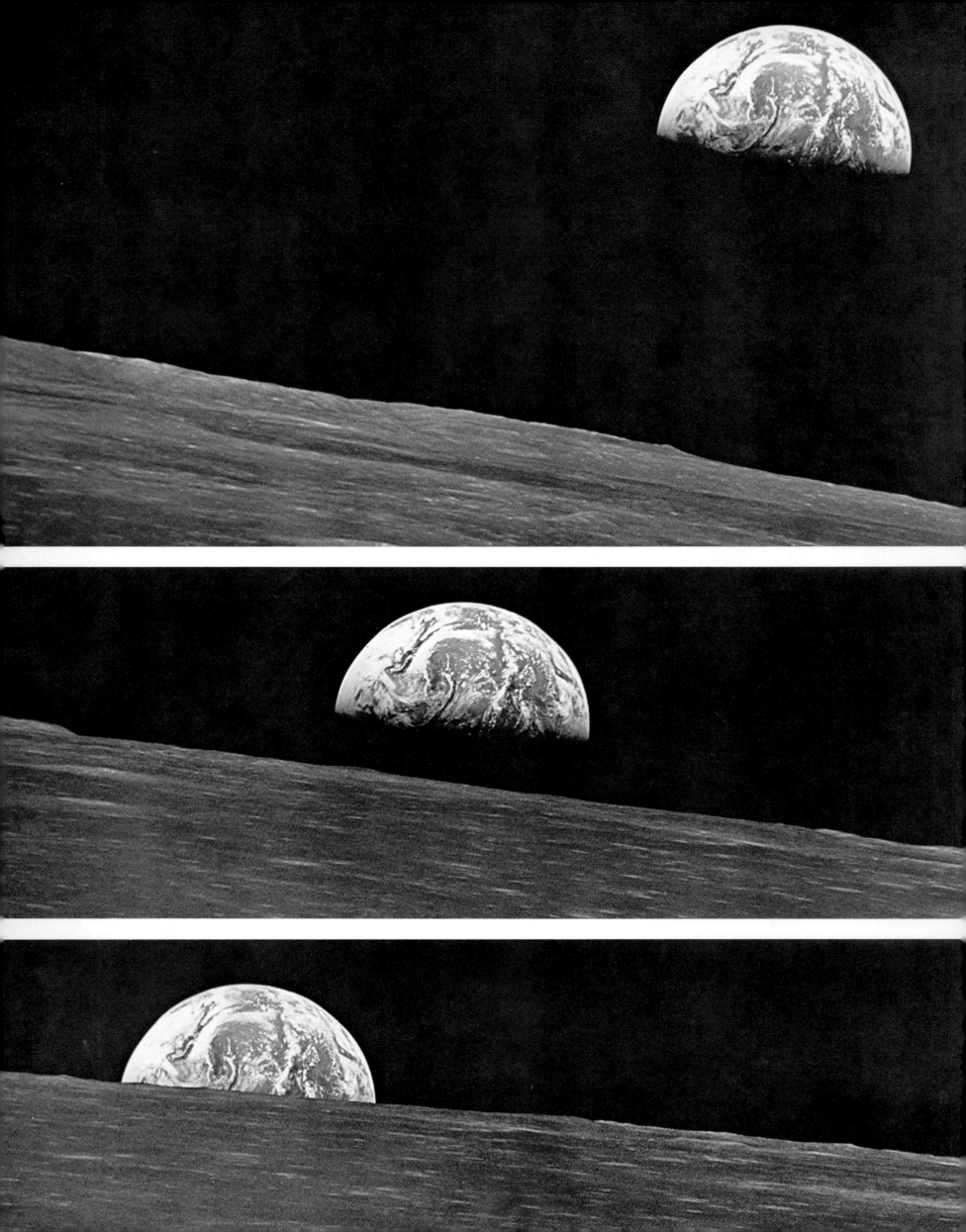

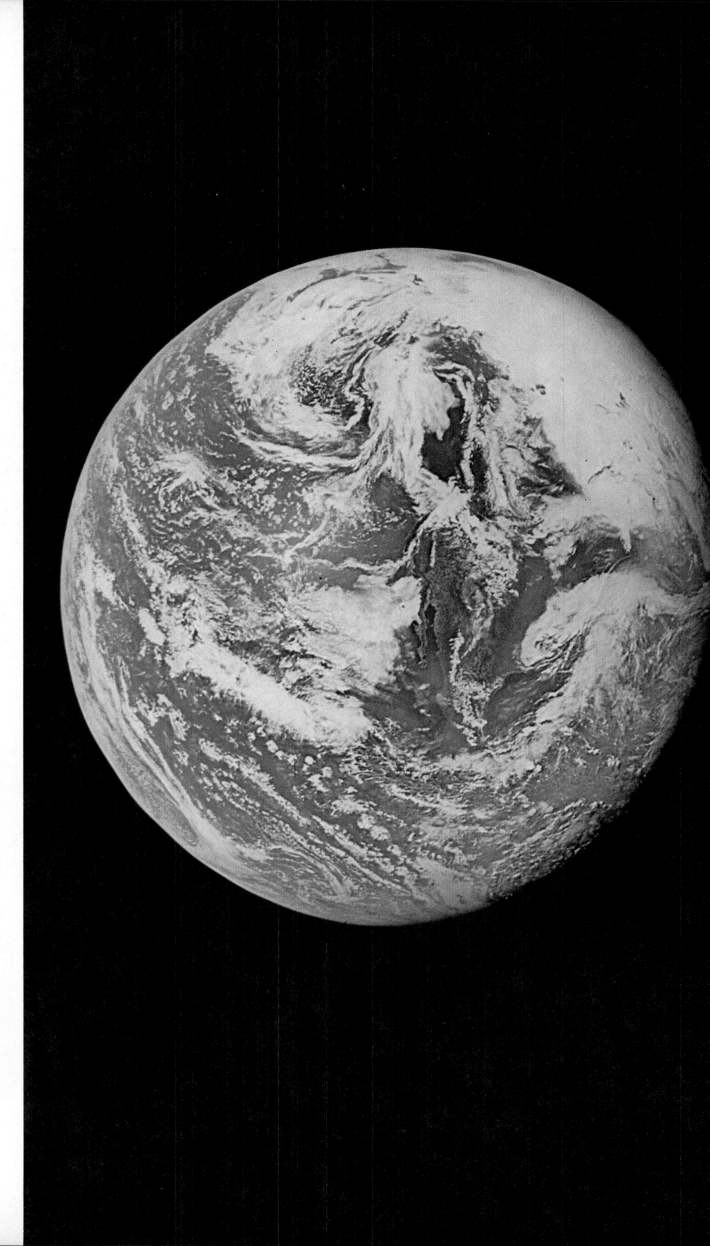

An Earthrise

Tom Stafford, Gene Cernan and John Young of Apollo 10, while orbiting the moon close to its surface (but not landing), saw the earth appear above the lunar horizon. The sight moved Stafford to radio to Houston: "Charlie, we just saw an earthrise and it's just got to be magnificent!"

The Whole Earth

Between moon and earth, the astronauts of Apollo 10 had this view of the most moving sight in all of space: the cloud-swirled orb, glowing blue with oceans, that holds all life known to exist. The west coast of North America shows through the cloud patterns.

FAR-OUT FASHION...

A Donald Brooks evening gown blends with a Beardsley drawing.

The zany approach as an antidote to the monotony of everyday wear

During its first two decades, LIFE pursued fashion with all the normal resources of photojournalism, reporting on Paris and Seventh Avenue collections and going into the streets to watch the rise and fall of heel and hemline. Then, during the 1950s and early 1960s, this reportage evolved into a dazzling display in which the editorial presentation sometimes became as far out as the fashions.

When the drawings of Aubrey Beardsley had a renaissance in England in 1966, LIFE's fashion editors found a dress that blended perfectly with Beardsley's style and photographed a model against a replica of one of his drawings, in such a way that she looked like a part of it. The exotic costumes of Giorgio di Sant'Angelo were likened to dreams and photographed before specially designed psychedelic backdrops. LIFE even mounted expeditions to romantic, and not always practical, locations. Fashions by Greek designers were shown rising from the sea at Mykonos. On one safari to Hungary the state railroad obligingly rerouted express service while the LIFE team shot pictures on the tracks near Budapest.

In this period the milieu became as important as the medium, and most of LIFE's readers got the point: at its furthest reaches high fashion could almost be called a fashion high—without a great deal of relevance to the more mundane clothing of everyday life *(pages 134-139)*.

Bonnie and Clyde fashions

Scandinavian styles

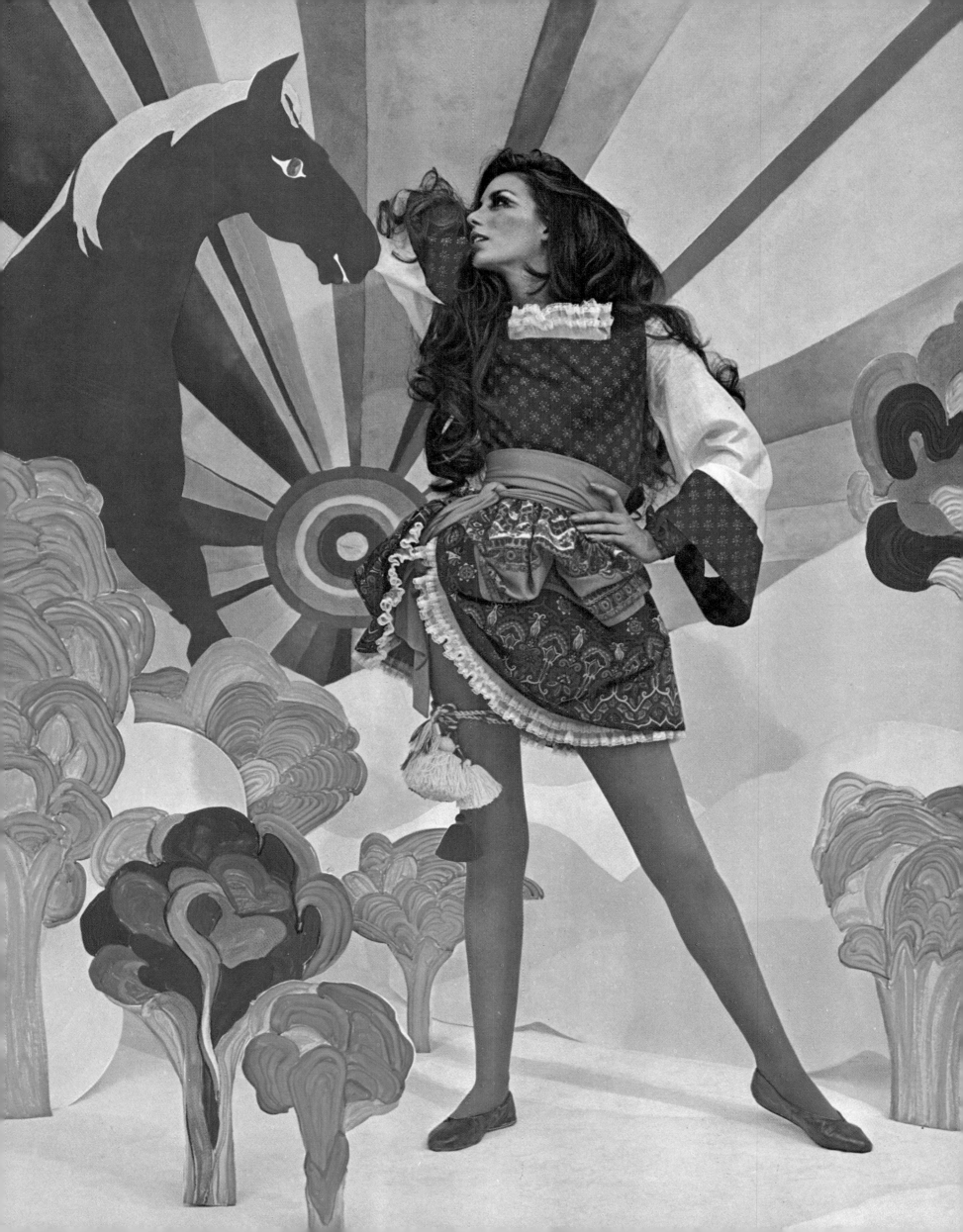

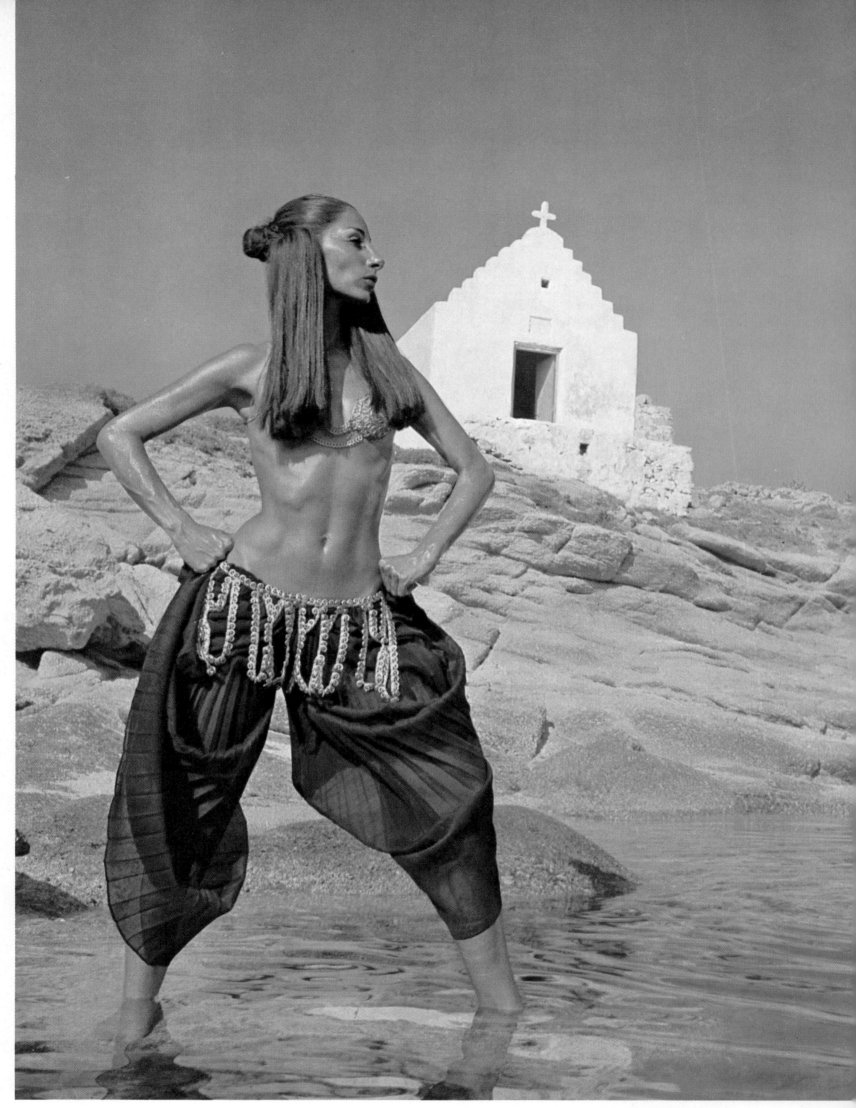

Greek Chic The outer reaches of fashion were documented in a story on Greek styles, including this rather un-functional swim outfit modeled by Marta Montt. Featuring a $10,000 gold belt and harem pants, it seemed to impress a Greek observer named Fivos *(right)*, but he is a professional actor.

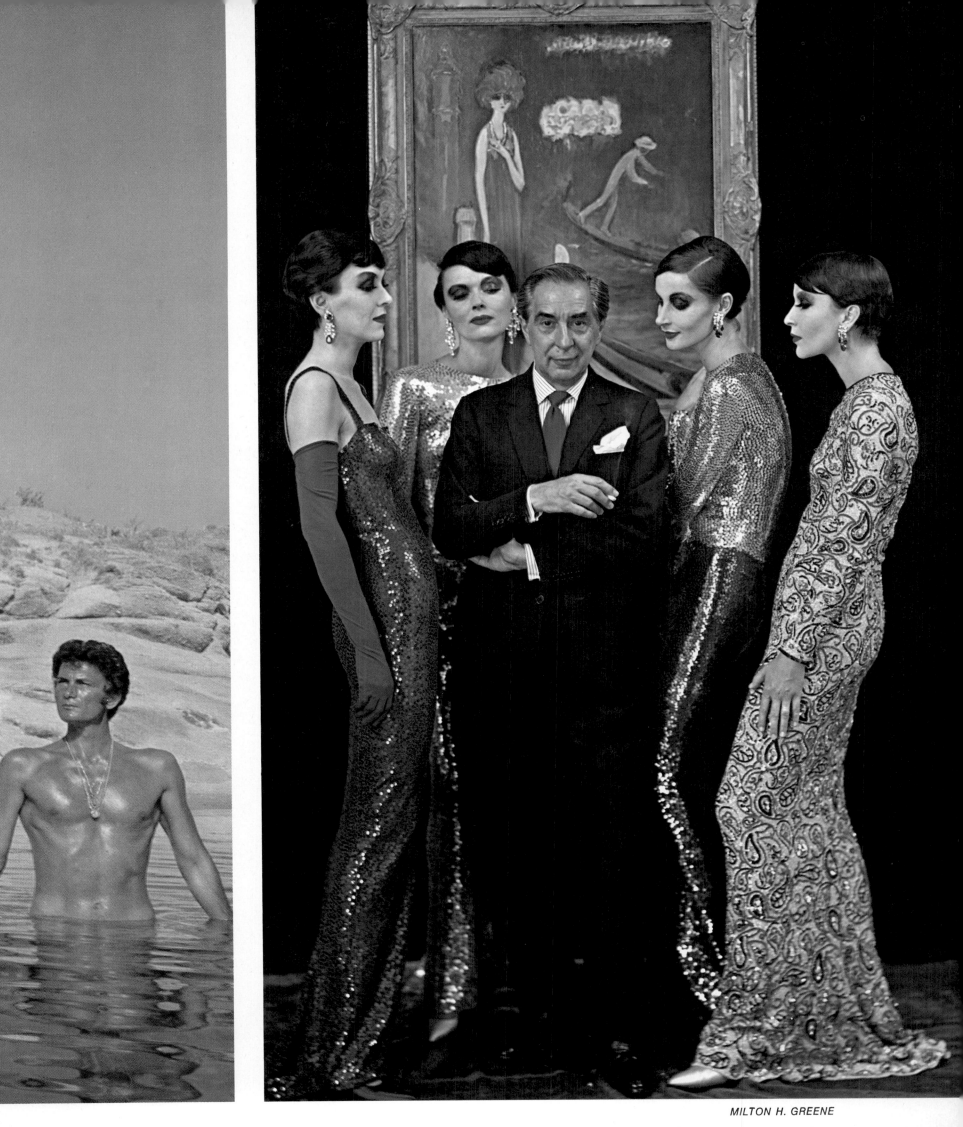

MILTON H. GREENE

Sleek Sheaths Fashion designer Norman Norell is flanked by four of his classic sequin sheaths in front of a favorite painting by Kees Van Dongen, which inspired the stark eye make-up of the models.

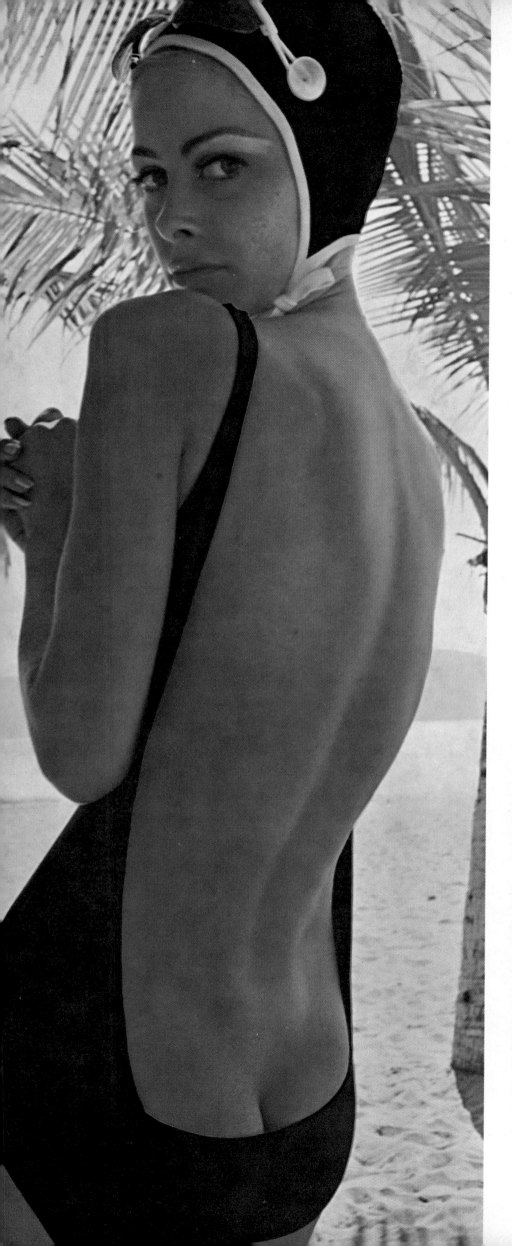

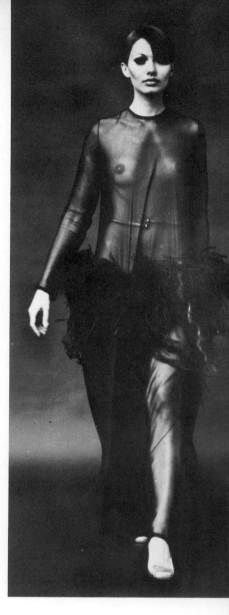

The Bare Back

Reporting a fashion trend that displayed the lumbar curve *(left)*, LIFE showed the lowest-backed suit of the 1967 season.

HOWELL CONANT

The See-through

Yves St. Laurent's gauzy chiffon number *(right)*, with ostrich fluff at the hips, was purchased—usually with underpinnings—by some women who weren't models.

BILL RAY

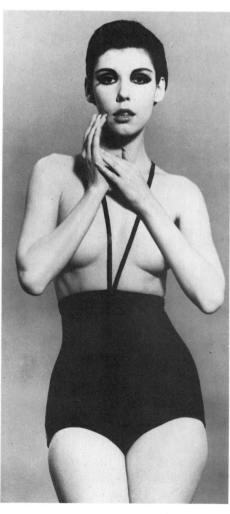

The Topless

The neckline plunged out of existence in 1964. Gernreich sold some 3,000 such suits *(left)* but few appeared on beaches.

WILLIAM CLAXTON

The Mini Top

This bra-and-jeans combination, a trifle less revealing than the topless styles, actually made it onto the city streets, to be recorded in this instance on the Upper East Side of Manhattan.

DOUGLAS KIRKLAND

While the $100-an-hour models postured for the fashion photographers on painted studio sets and in distant seas, real fashions were worn in a world Richard Avedon and Milton Greene never made. Most American women looked at the svelte models in skinny sequin sheaths, and dreamed. They made stabs at emulating them, switching from calf-length skirts to microminis, from beehives of hair to boy cuts, from heavy make-up to none. But they clung to the real U.S. classics—sweaters and skirts, bobby socks, saddle shoes, jeans. Even the debutantes, daughters of the couturiers' prime targets, stuck to their fluffy white formals until "debuts" themselves waned.

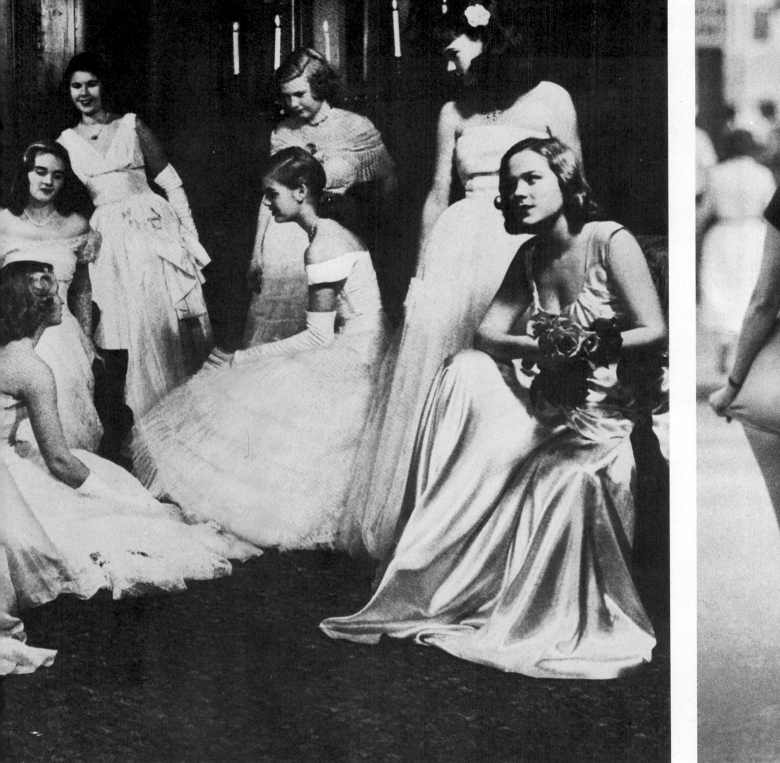

PHILIPPE HALSMAN

Party Dress

As they tried on gowns for a 1947 New York cotillion, these debutantes composed an informal portrait of the formal occasion.

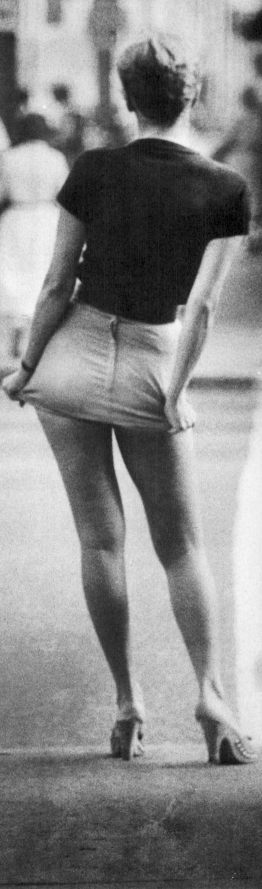

Dressless Dress

By 1956 this Detroit girl's short shorts and her public adjustment of them drew scarcely a glance from passersby.

GORDON TENNEY

135

The Classic Look The sweater and skirt, the athletic stride, the neatly combed bouncing hair all combine to identify the All-American Girl of 1953. To some they still do.

LEONARD McCOMBE

The Sloppy Look When LIFE ran this picture in 1944 of Wellesley girls bringing their sloppy campus attire into town, thus outraging Wellesley citizens, partisan readers debated their propriety.

The Leggy Look This 1969 combination of mini-skirt, well-groomed long hair and sunglasses is a modern classic.

Short Skirt

Focusing on this girl in a micro-mini *(left)*, LIFE deplored the arrival of longer skirts and asked: "How can we bid goodbye to all this?" Perhaps partly because of its plaint, we didn't have to.

VERNON MERRITT III

Short Suits

The advantages, for wearer and onlooker, of the bikini are demonstrated better in a bright, spray-flecked 1970 California seascape than in all the designers' high-fashion photographs.

CO RENTMEESTER

Short Shrift

An early convert to the "bag," a 1957 design imported from Europe, gets unenthusiastic scrutiny from a Central Park passerby. His proved to be the majority opinion, though the bag had its day.

YALE JOEL

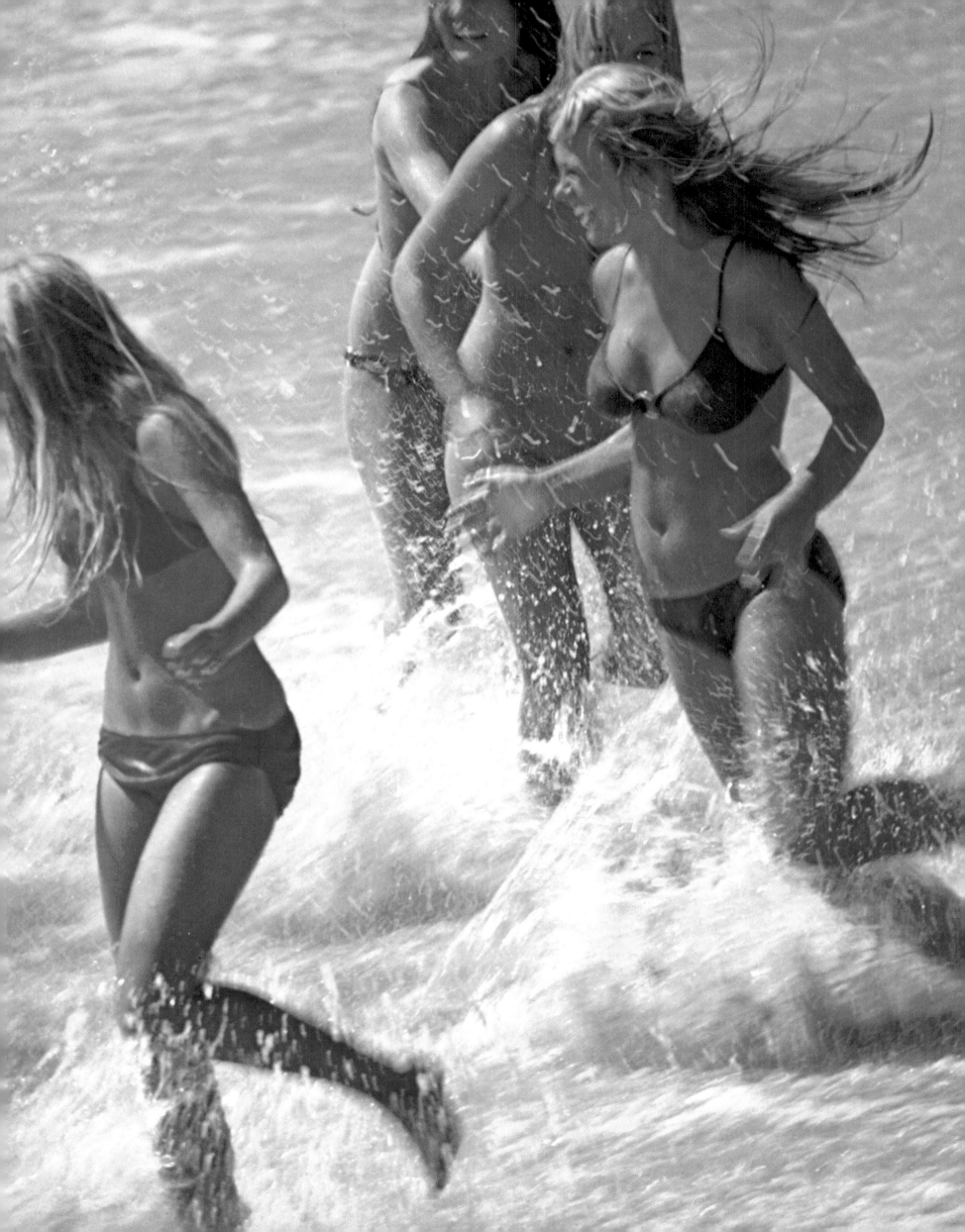

THE BLACK CAUSE

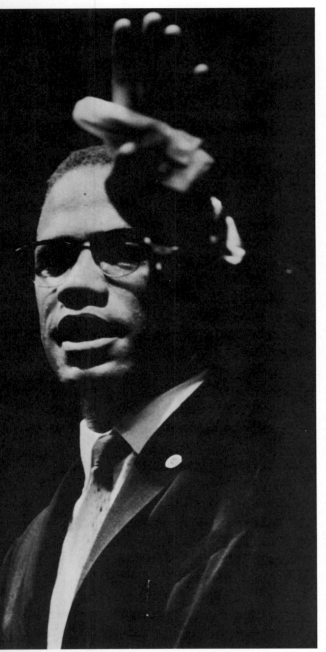

GORDON PARKS

In a Chicago mosque, Malcolm X *(above)* preaches to a congregation of Black Muslims in 1963.

A week before his assassination in April 1968, Martin Luther King Jr. *(second from right)* leads a march through Memphis.

A moving pictorial record of the long, bitter struggle for equality

From the brutal lynching of a helpless Southerner in 1937 *(far right)* to the iron defiance of Angela Davis in 1970 *(cover, lower right),* LIFE's attention to the black struggle for equality comprises a powerful photographic record of the most important social movement of 20th Century America. It was dangerous work. Photographers were kicked and beaten by both blacks and whites, and faced the constant threat of arrest. "I've been in Vietnam, but I was never so frightened as I was in some places in the South," says photographer Charles Moore, himself an Alabamian. "With some white crowds you felt, if they had guns they'd just as soon shoot you down." Nevertheless, Moore's own pictures of the 1963 Birmingham demonstrations led by Martin Luther King Jr. *(page 38)* were so powerful they were used as evidence in the Congressional debate on the 1964 Civil Rights Act.

As the black movement became more militant in the '60s, LIFE relied more and more on black photographers to get the story, since they were often the only newsmen able to win the trust of black leaders. Gordon Parks, who photographed Malcolm X *(left)* and the Black Muslims in 1963, says: "My problem was to keep faith with the people I was photographing, and at the same time to hold the confidence of the LIFE editors." Needless to say, he always managed the difficult role superbly.

Medgar Evers' mourning widow

Angela Davis: hunted militant

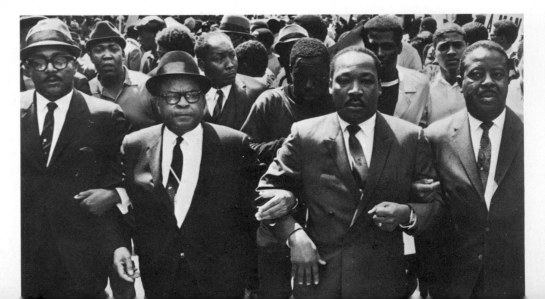

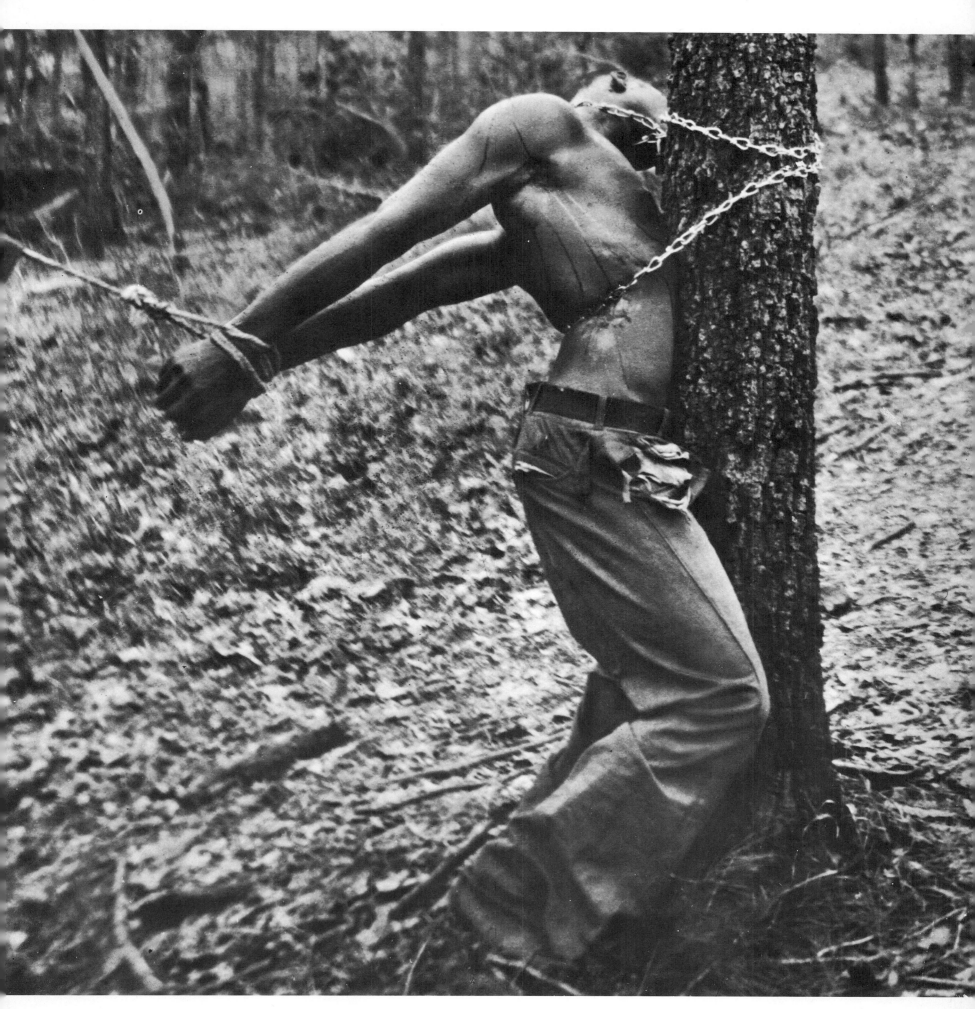

Accused in 1937 of murdering a white in Mississippi, this black man was tortured with a blowtorch and then lynched.

Blazing Freedom Bus A bus carrying some of the first freedom riders into Alabama in 1961 burns outside Anniston.

JOE POSTIGLIONE

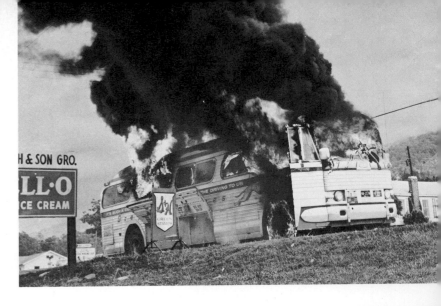

Hunted Gang Leader Harlem gang leader Red Jackson, 17, hides from a rival street gang in an abandoned building.

GORDON PARKS

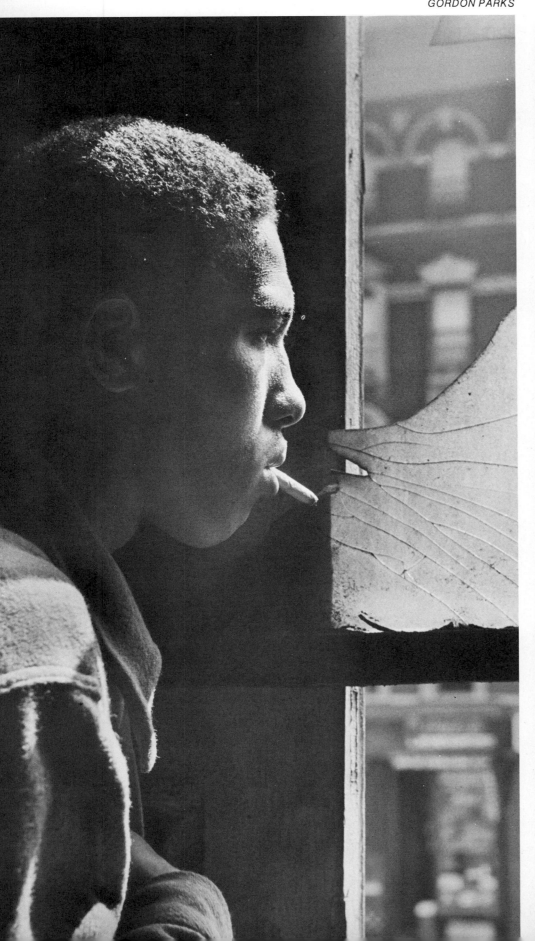

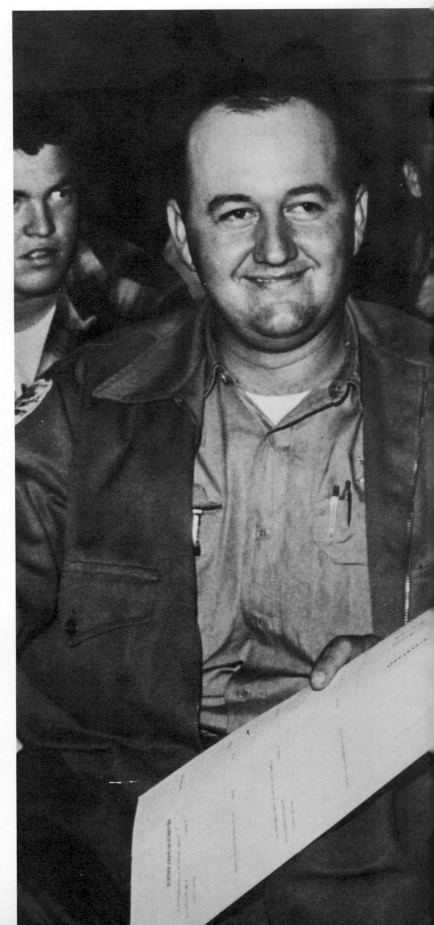

Accused Lawmen Charged in 1964 with conspiracy in the lynch-murders of three Mississippi civil rights workers, Sheriff Lawrence Rainey (at right, below) of Neshoba County and his deputy Cecil Price attend their own arraignment before a U.S. commissioner. Later Rainey was acquitted and Price was given a six-year sentence. After its publication in LIFE, the photograph was reprinted in many newspapers and later enlarged into a derisive poster bearing the legend: Support Your Local Police.

BILL REED

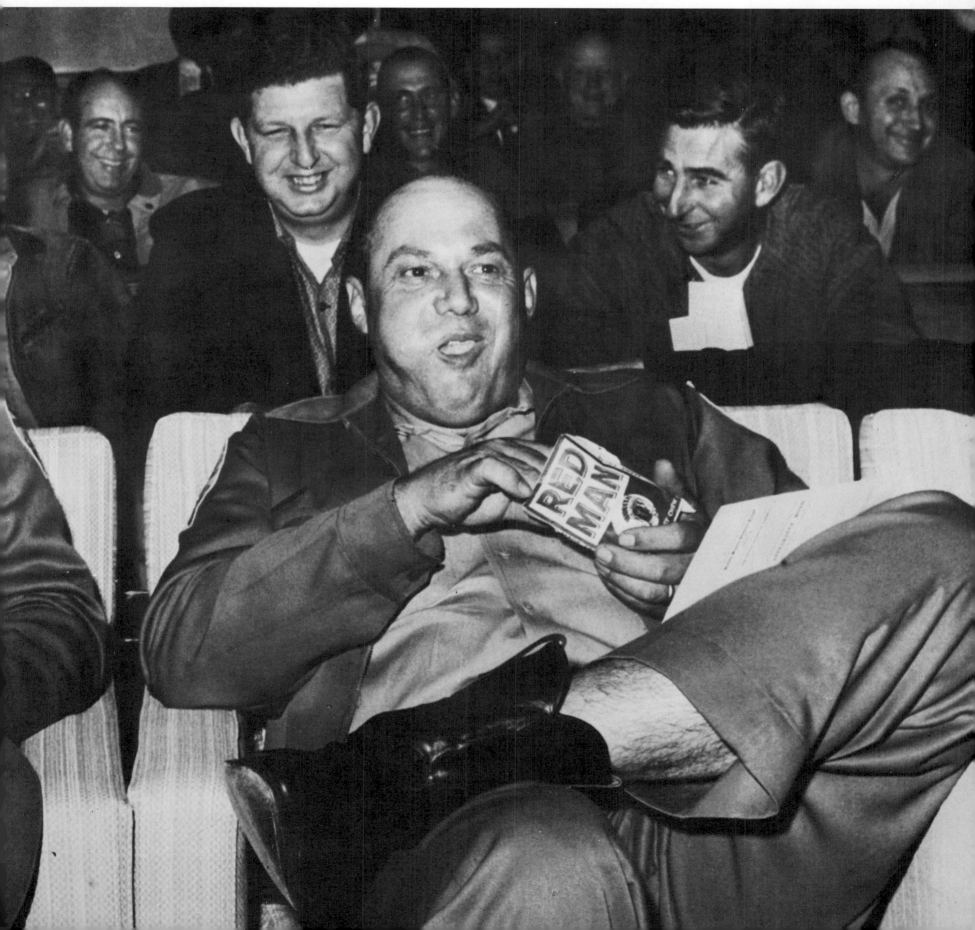

Riot Victim in Newark Inadvertently struck by a police shotgun blast that killed another man, 12-year-old Joe Bass Jr. lies wounded *(below)* during the 1967 Newark riots. LIFE correspondent Dale Wittner, also in the line of fire, dropped to the sidewalk just before the gun was fired.

BUD LEE

Sniper's Victim in the South During a one-man march through Mississippi in 1966, James Meredith drags himself off the road after taking pellets from three shotgun blasts. His assailant was arrested on the scene, and civil rights leaders moved in to complete the march for him.

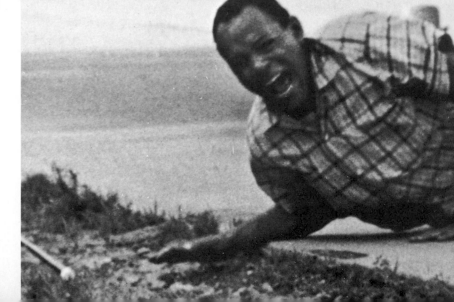

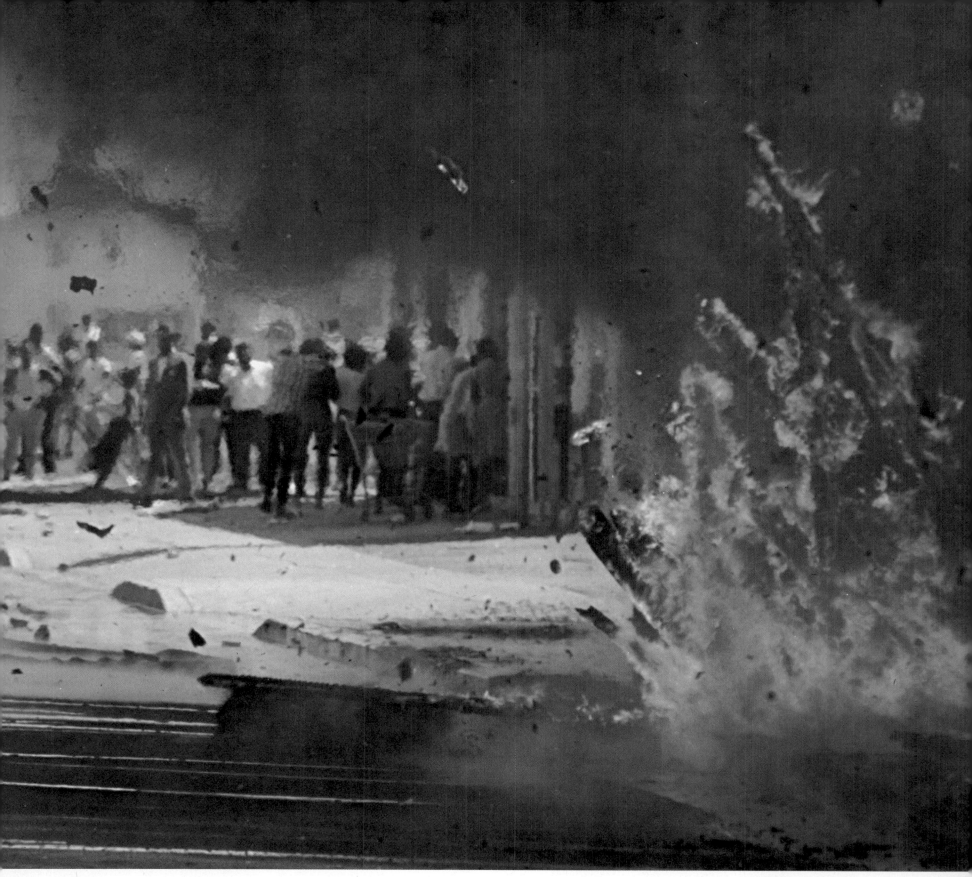

Looting and Arson in Watts Firemen prepare to douse intense flames from a store looted during the 1965 Watts riot, while a mob invades a nearby supermarket. Reviled and stoned by the rioters, the photographers who covered Watts for LIFE did much of their picture-taking through the open windows of their cars.

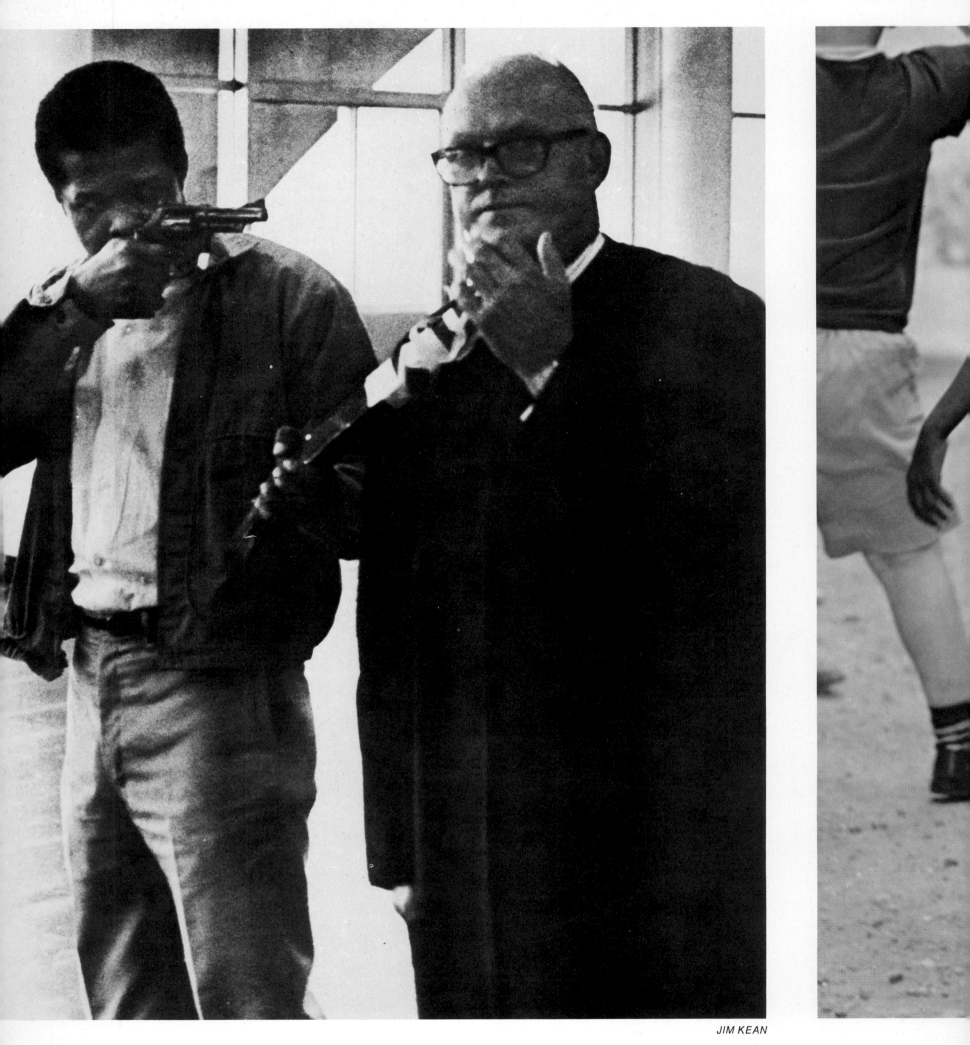

Bonds of Fear During a 1970 courtroom break-out in San Rafael, Calif., con-vict James D. McClain aims a smuggled weapon at Judge Har-old Haley. Moments later, after a shoot-out in front of the court-house, the judge, McClain and two other kidnappers were dead.

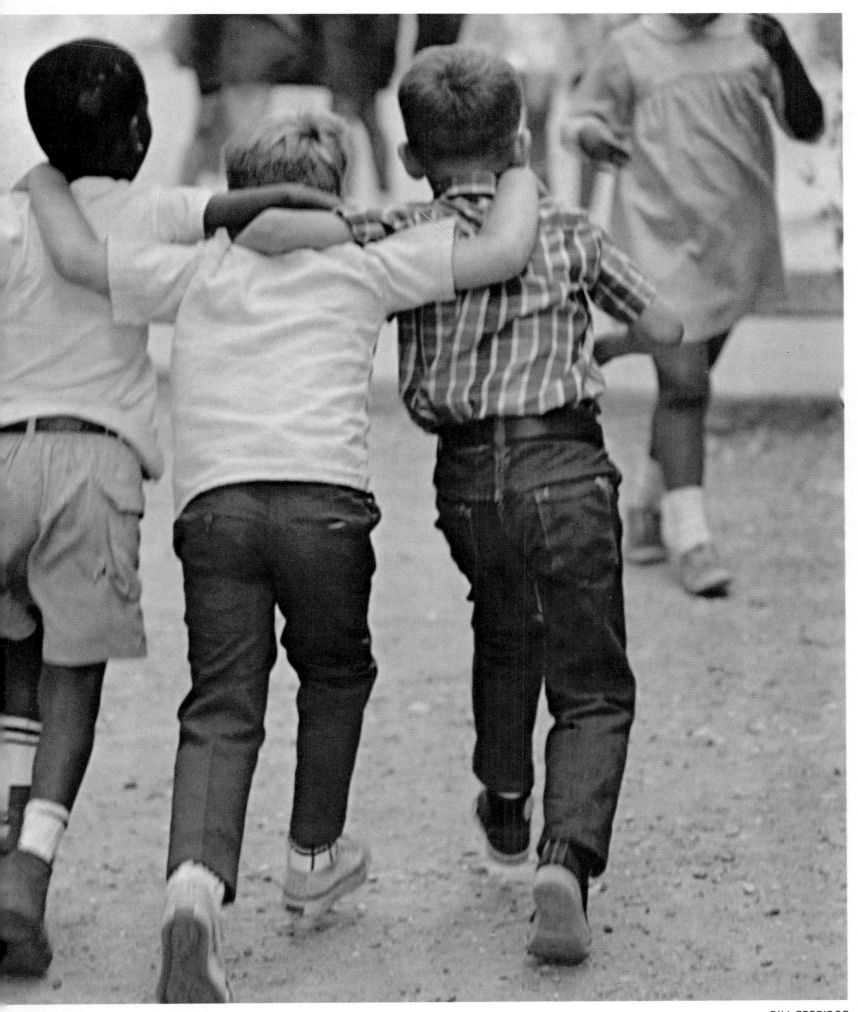

BILL EPPRIDGE

Bonds of Friendship A black child strolls with two whites at the Lusher School in New Orleans. This photograph appeared in a 1967 LIFE essay that detailed the transformation of many Southern schools in the decade following integration of Little Rock's Central High School.

147

THE LAND

Corn against a July sky

The wonders of man and creation appraised through inventive lenses

From the start, LIFE's photographers were smitten with the U.S. countryside, its mountains, its fertile farms and its magnificent distances. But their love was not lavished just upon what God had wrought. It included all that man had done to the land, for better or for worse.

To get their pictures these landscape photographers had to race the sun for their effects, often carrying heavy equipment to impossible heights. John Dominis back-packed his gear up and down snow-steeped mountains to shoot Idaho's wilderness in winter, and rafted through canyons to photograph West Virginia's Cheat River. He got his classic Caribbean beach picture (page 163) only after exploring virtually all of the 29-mile-long island of Dominica and then lying in the water for hours at a time until the sea and the sun cooperated to color the black sand with the hues he wanted. To photograph New York City's open spaces—including, ironically, a crowded cemetery—Arthur Tress hiked hundreds of city miles and climbed to countless rooftops.

The airborne photographers frequently found that getting there was not so simple as it seemed. William Garnett took the picture at right with one hand, while piloting his own plane with the other, and had to make many trips and shooting runs to hit the right angle and the right altitude at the right time with the right light. Without that same kind of planning for light and texture, Margaret Bourke-White's masterful picture of farmland combed into tresses as beautiful as Rapunzel's would have been just another picture of plowed land.

Scrub growth spills inky shadows down an Arizona volcano.

WILLIAM A. GARNETT

148

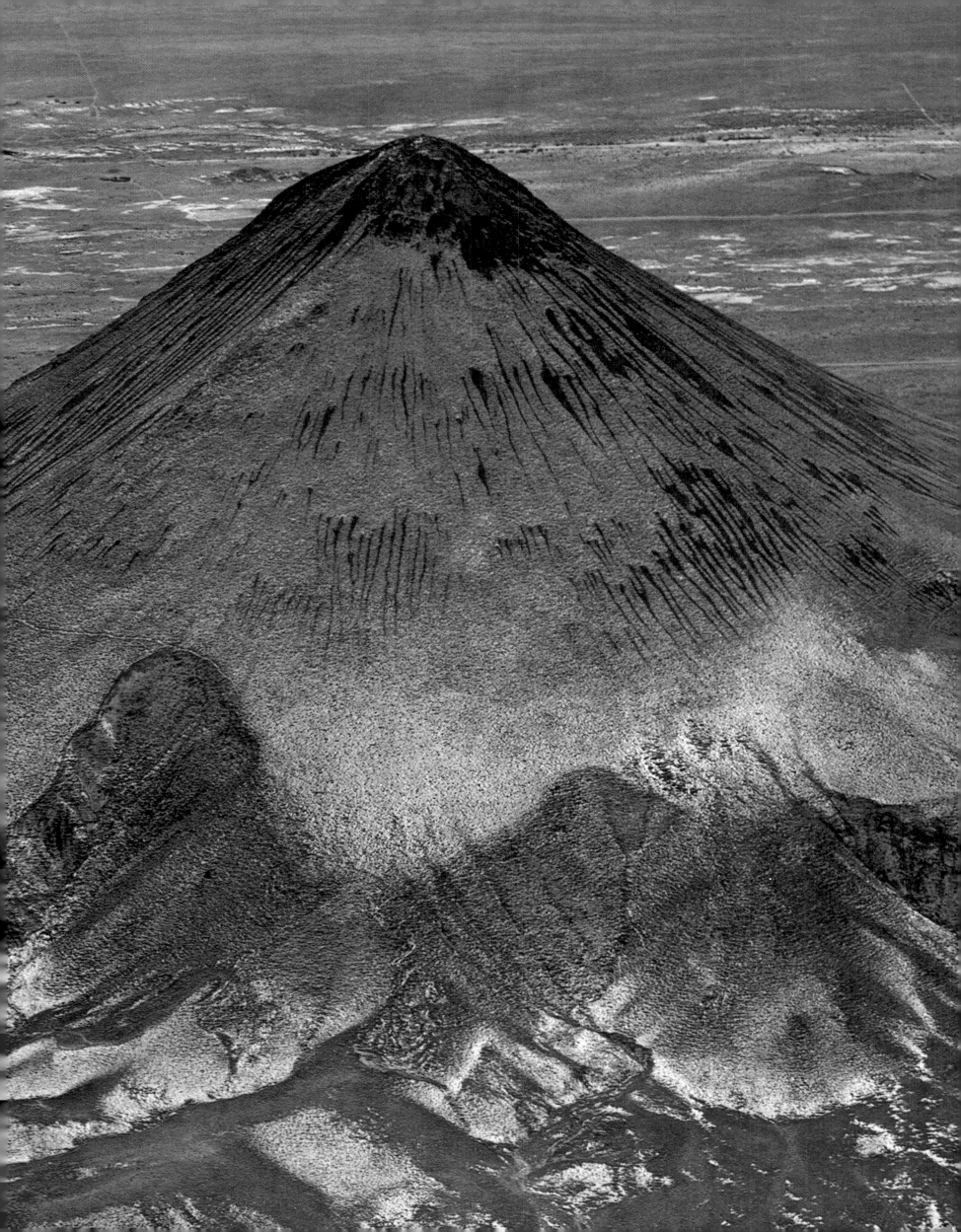

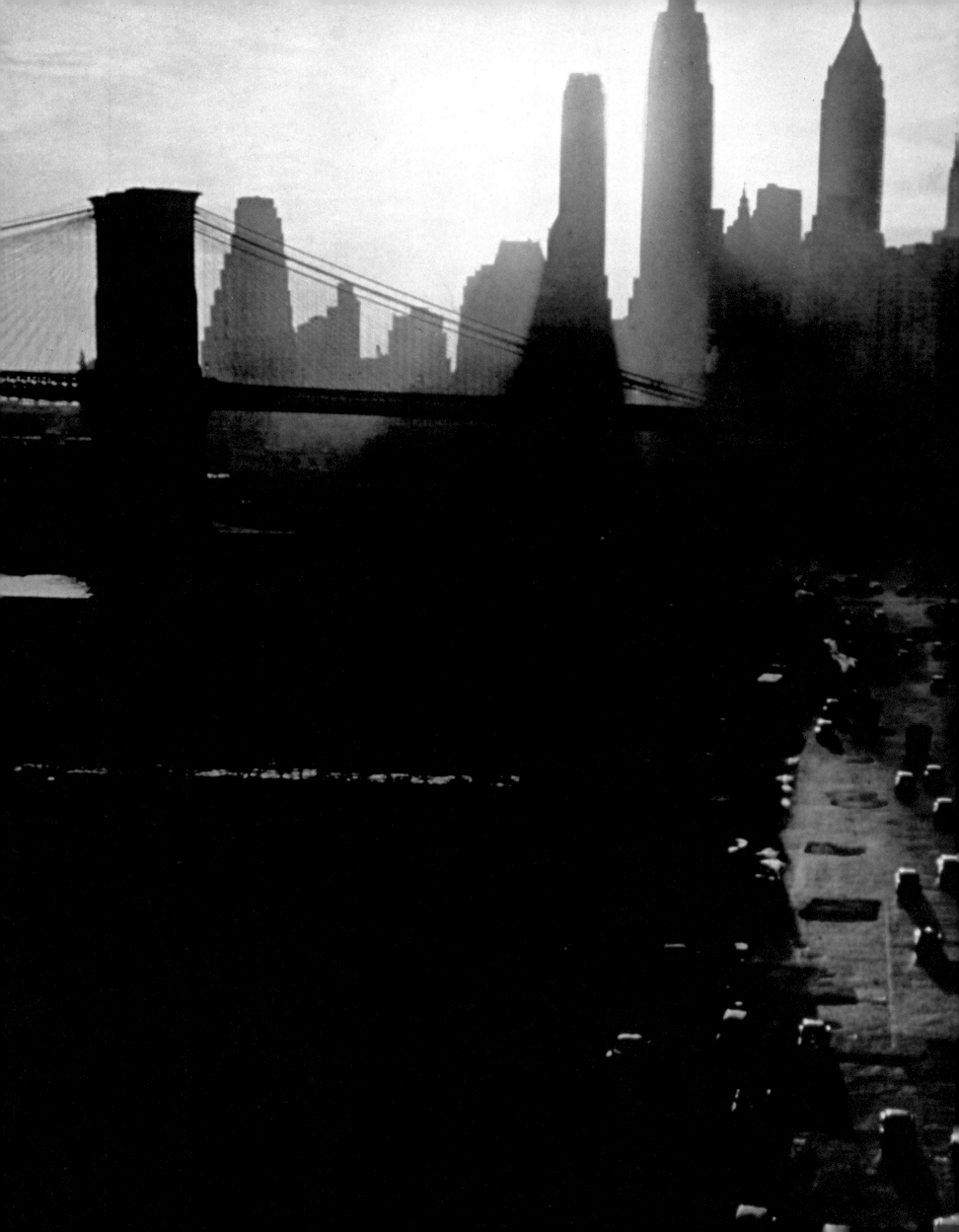

A Man-made Span

A late afternoon sun softly filtering through cloud and urban haze silhouettes the Brooklyn Bridge and bronzes the patched-up asphalt of Manhattan's South Street and its traffic.

ERNST HAAS

A Natural Bridge

Dwarfed by a soaring span of sandstone carved by water and wind, Navajo Indians tend their flock of sheep in Monument Valley on the Arizona-Utah border.

RAY MANLEY

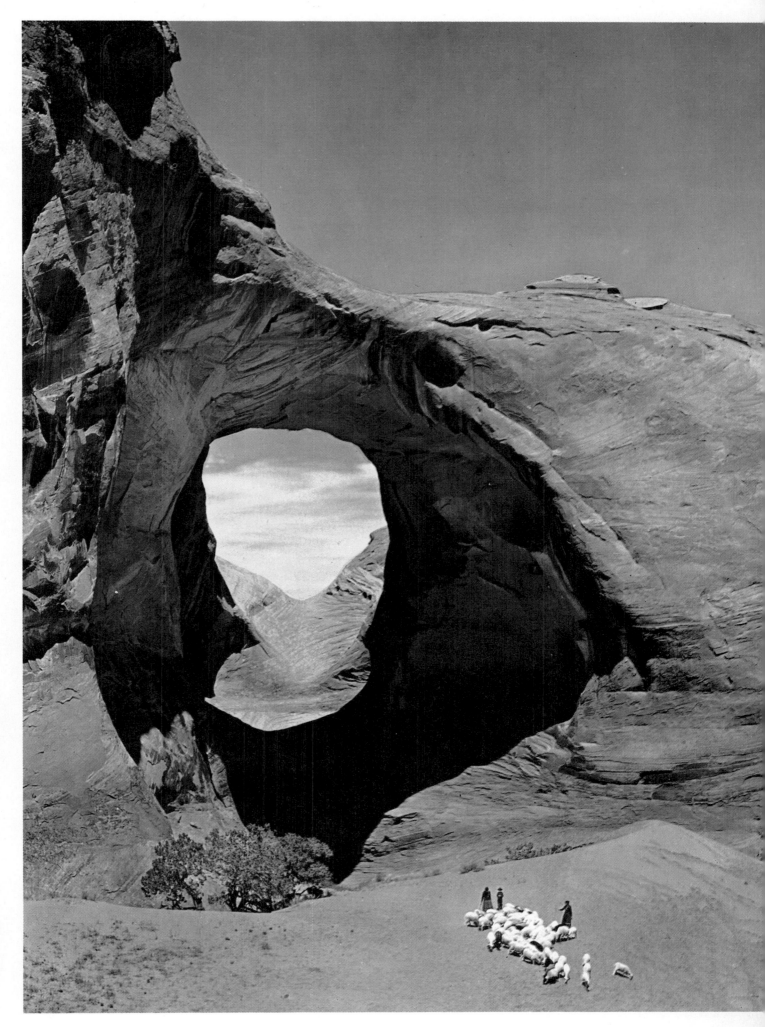

151

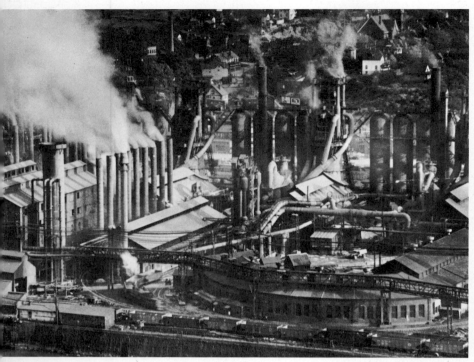

Busy Plant A U.S. Steel mill in McKeesport, Pa., was LIFE's way of telling GIs, in a wartime special issue for troops, that America was really putting out. U.S. Steel alone was outproducing all of Germany.

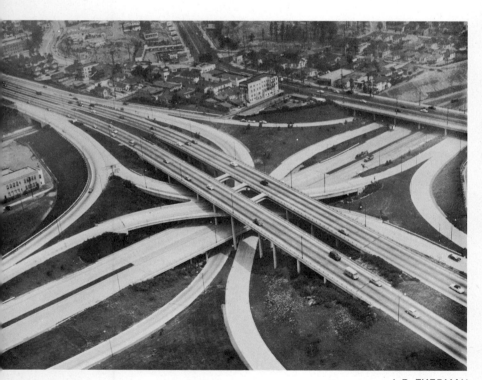

Busy Corner A novelty in 1953, this freeway crossover in Los Angeles carried autos on four different levels in a whirligig pattern of roadways.

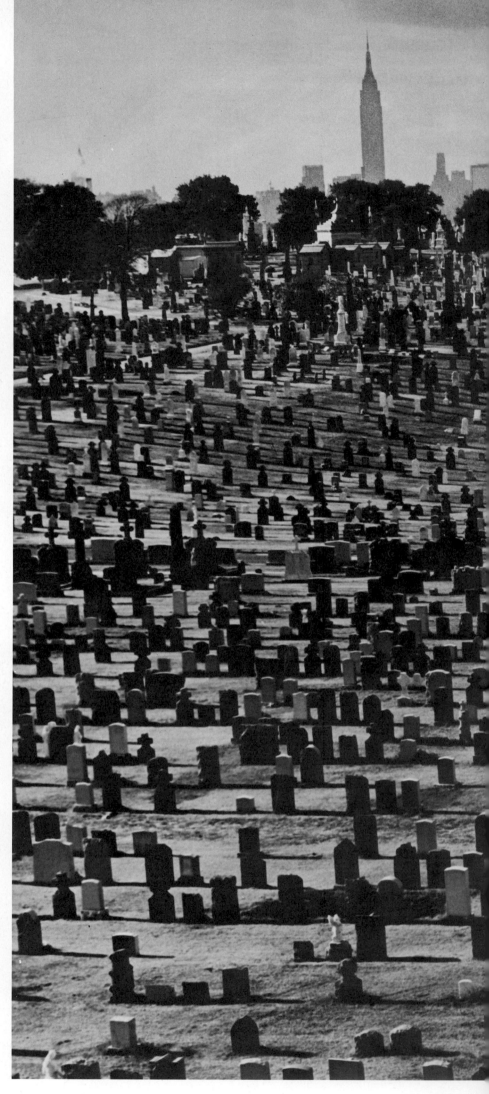

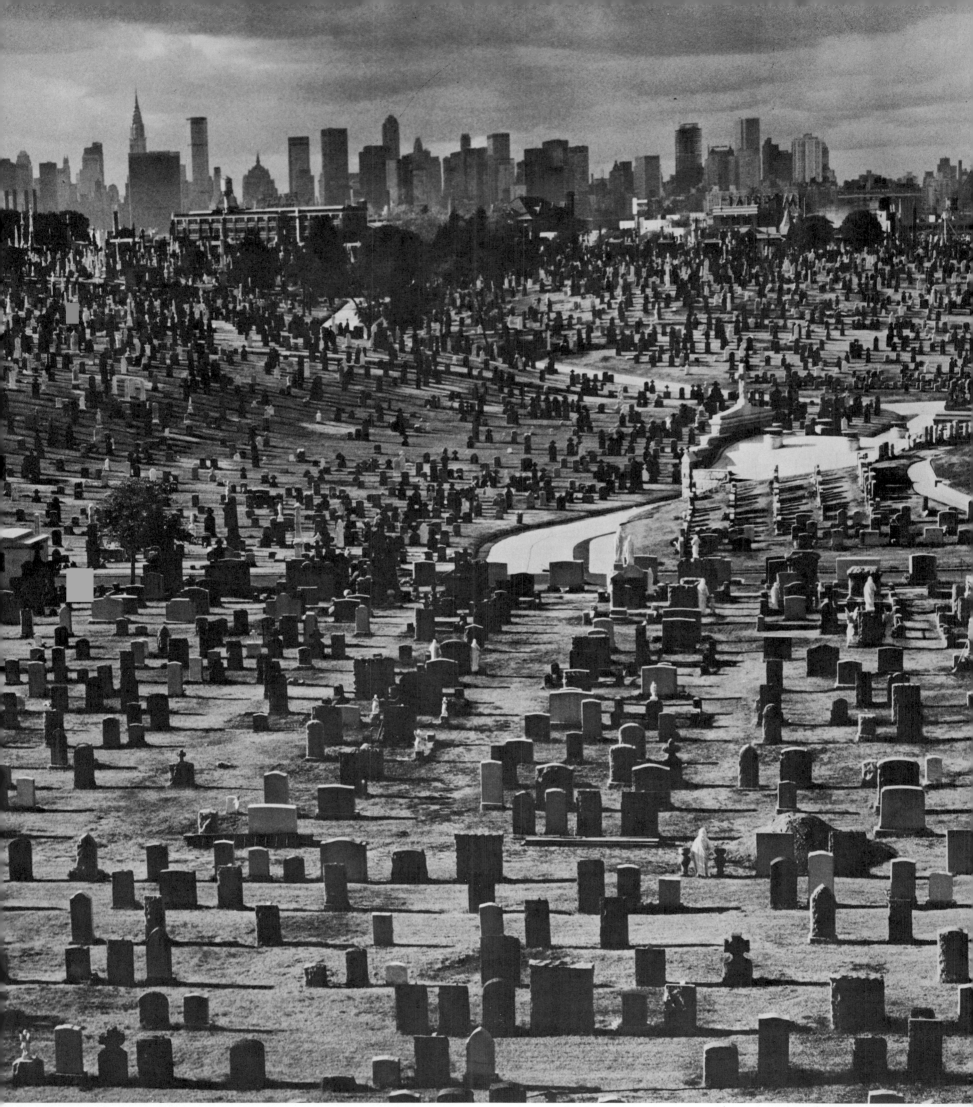

Suburb of the Dead Made from a strategic spot at the edge of New York's Calvary cemetery, this picture by an environ- mentally oriented photographer dramatically raised the question of using urban land for burial.

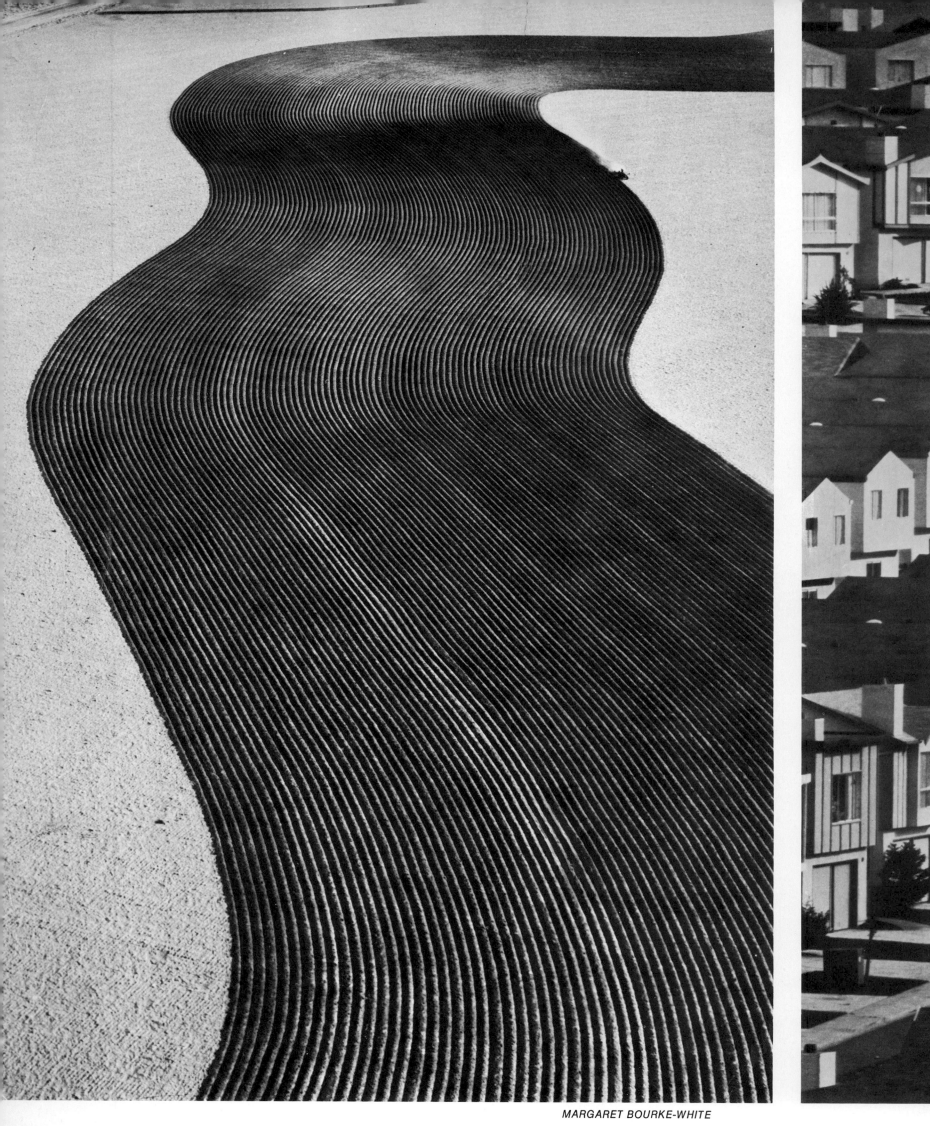

MARGARET BOURKE-WHITE

Flatland Furrows Conserving furrows in the Colorado soil greeted Margaret Bourke-White when she returned to the dust bowl in the '50s.

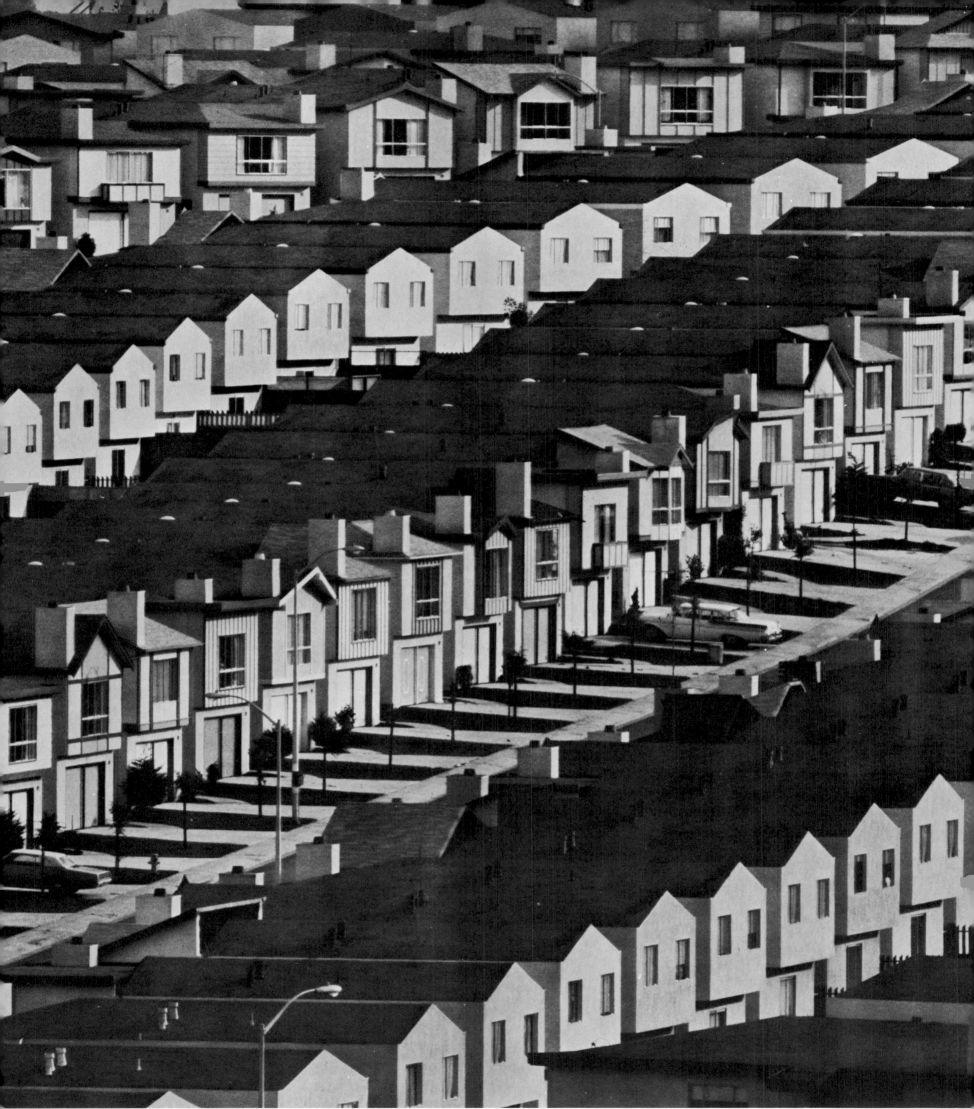

Hillside Burrows A pattern of houses—and a one-picture sociological tract—is cre- ated by a development in the San Francisco suburb of Daly City.

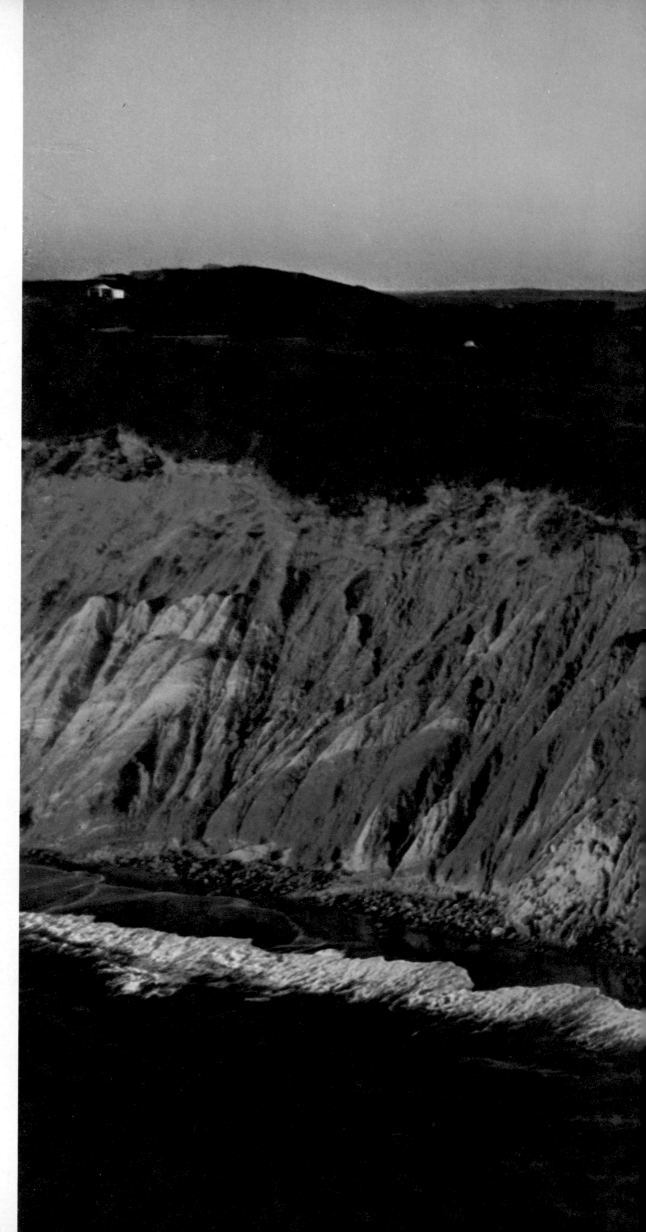

Promontory Aglow

The red-clay cliffs of Gay Head, the western tip of Martha's Vineyard, blaze in the setting sun. Daniel Webster compared Gay Head's cliffs to an iridescent Niagara, but many of LIFE's readers professed to see in them a sirloin steak, medium rare.

LAURENCE R. LOWRY

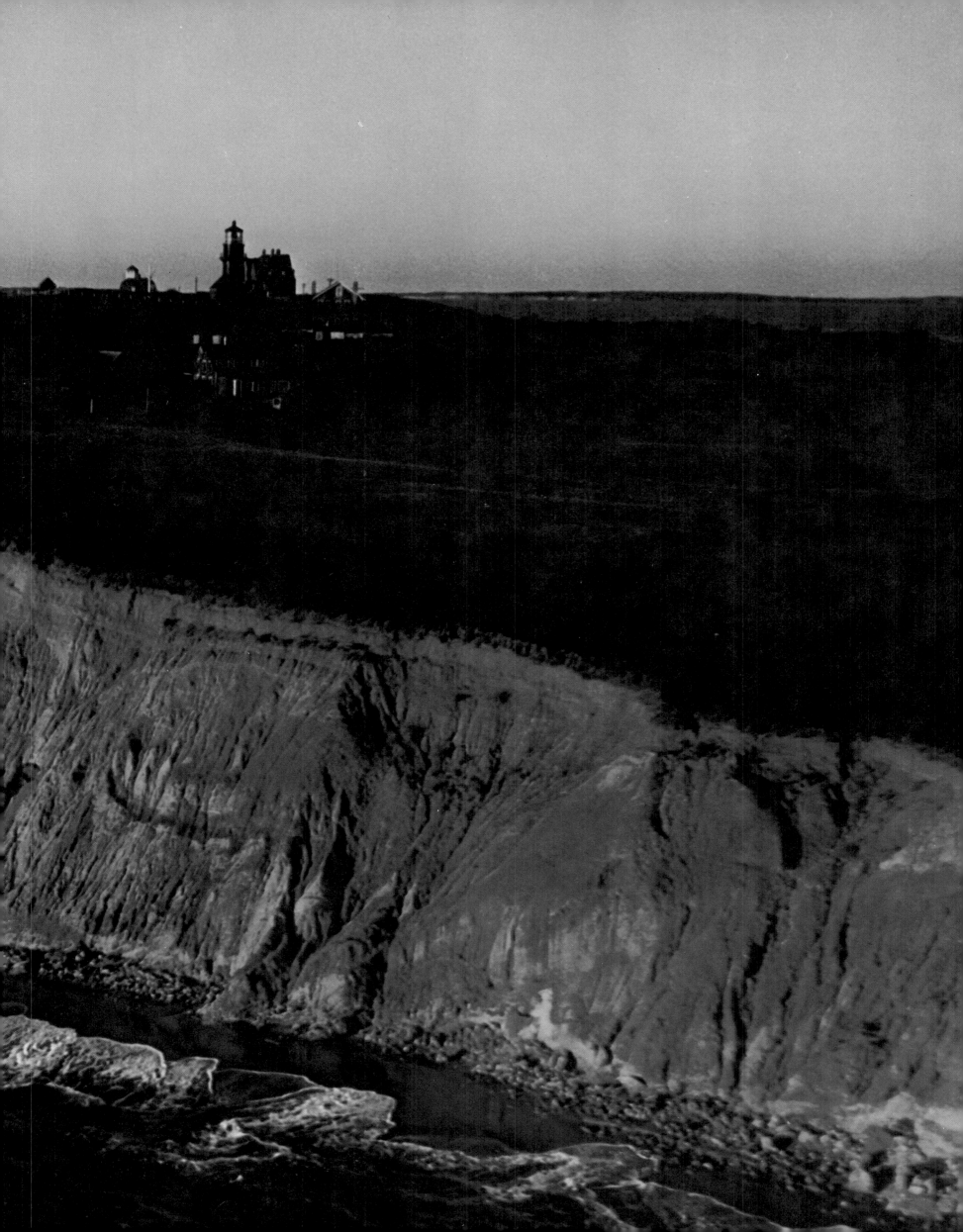

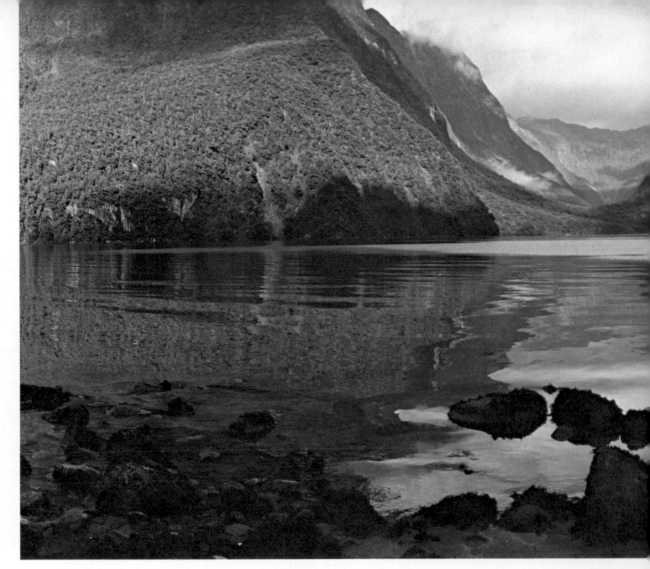

A Fiord Down Under

At first glance the pinnacles rising sheer from blue sea into blue sky spell Norway. But these mile-high mountains surround the glassy waters of the mile-deep Milford Sound in New Zealand.

GEORGE SILK

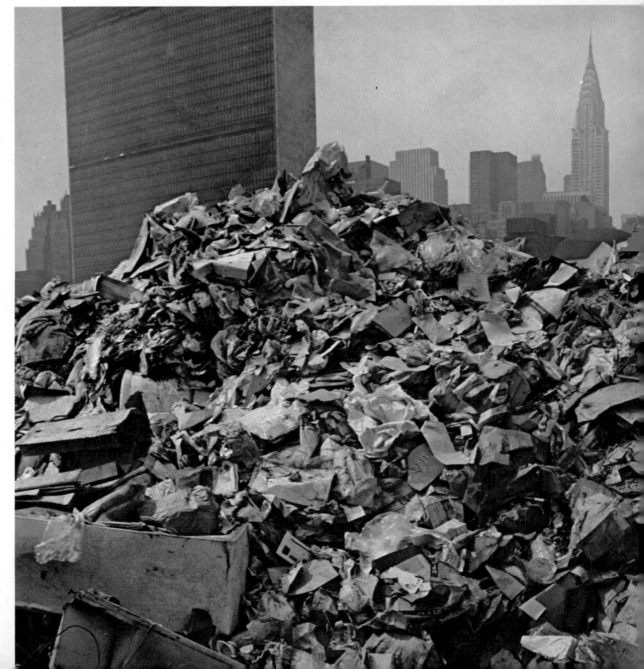

An Urban Mountain

In an attempt to dramatize photographically the statistics of New York's waste disposal problem in 1969—more than seven million tons per year—the camera was focused on a barge hauling refuse across the harbor to a Staten Island dump, setting it against midtown Manhattan's skyline.

RALPH CRANE

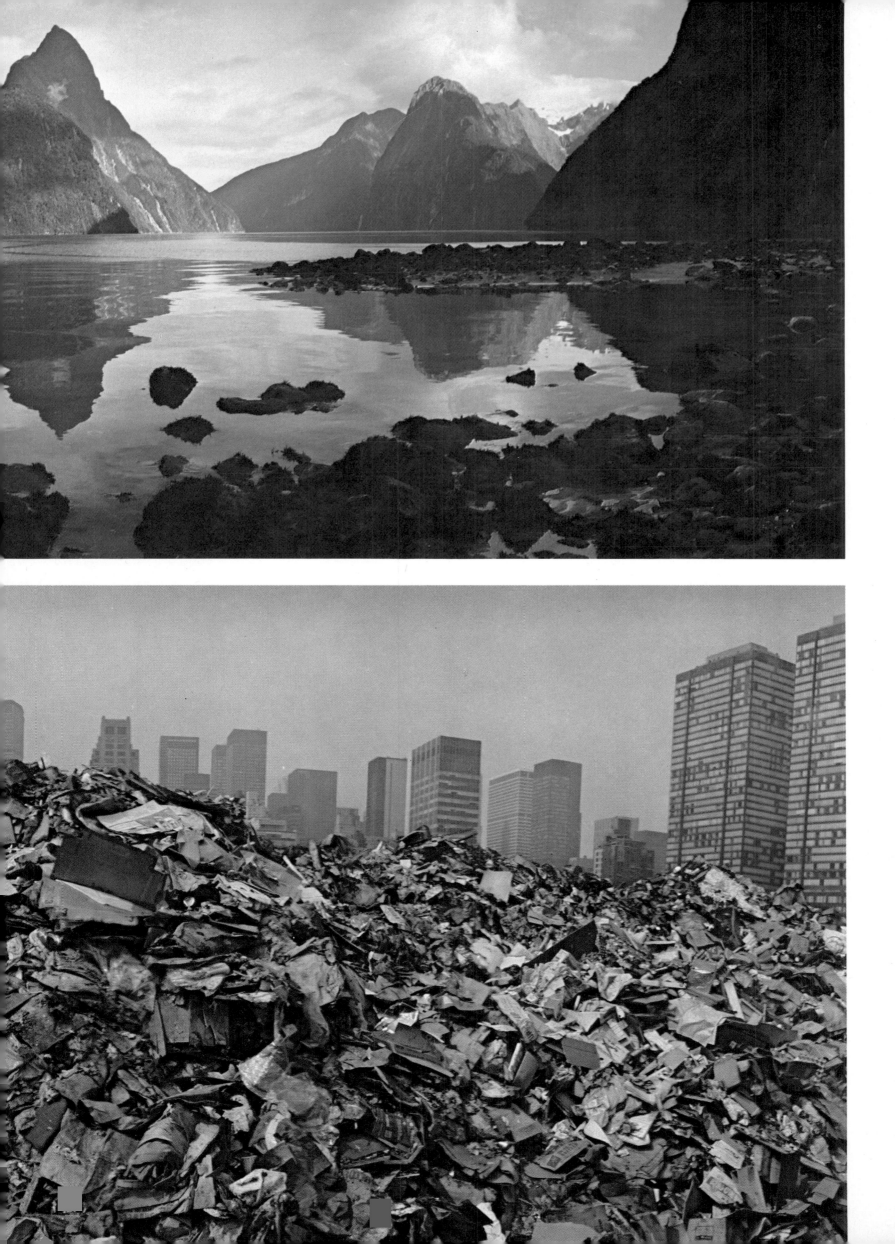

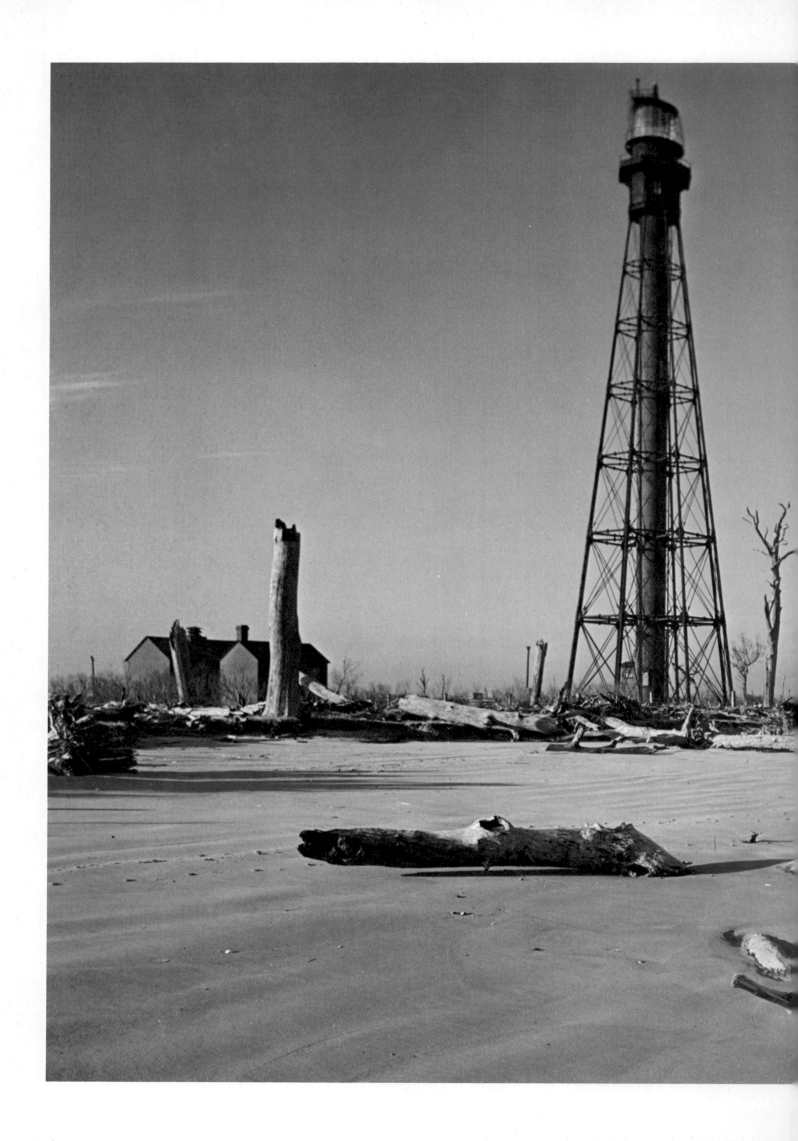

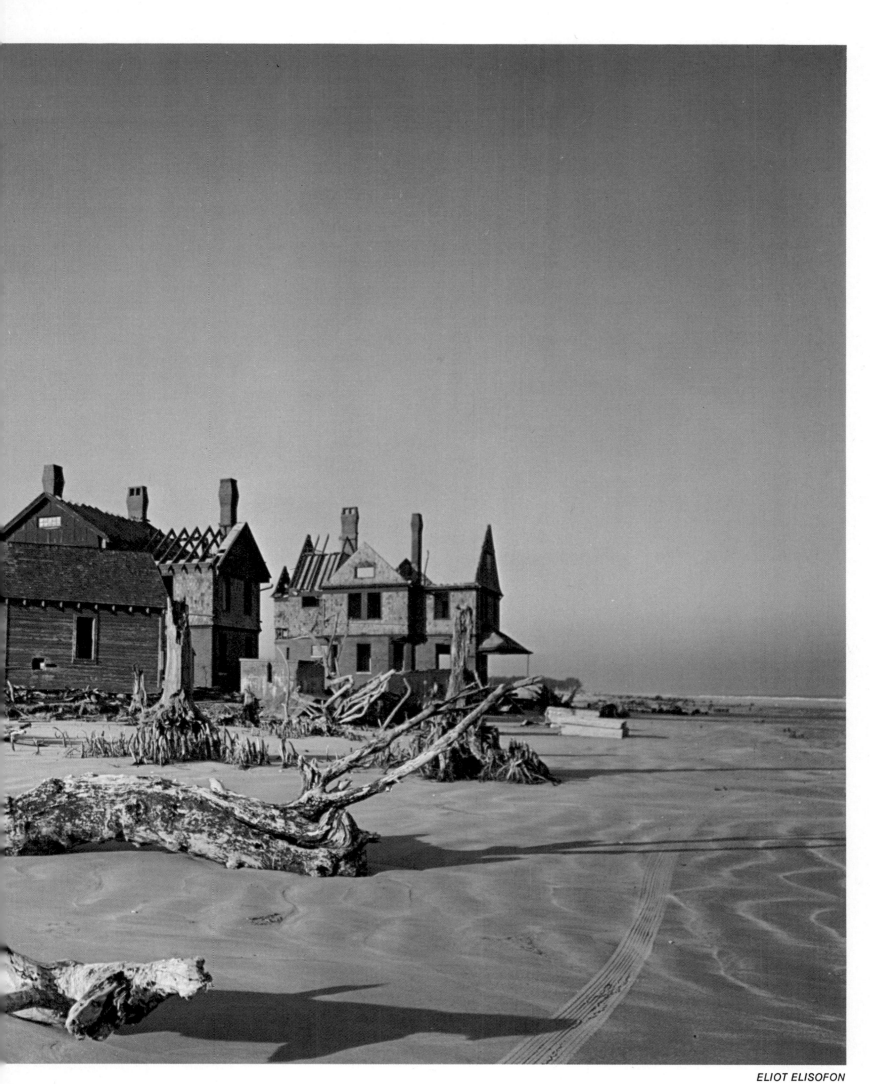

ELIOT ELISOFON

Ravaged Littoral The destructive force of the Atlantic Ocean is emphasized in this gaunt portrait of the beacon, the storm-wracked houses and the flotsam of tree trunks littering the beach on Hog Island, Va.

Soft-hued Seascape A diffusing haze and calm water lend the mood of a Whistler paint- ing to a picture of ketch-rigged fishing boats in the Bay of Biscay.

ELIOT ELISOFON

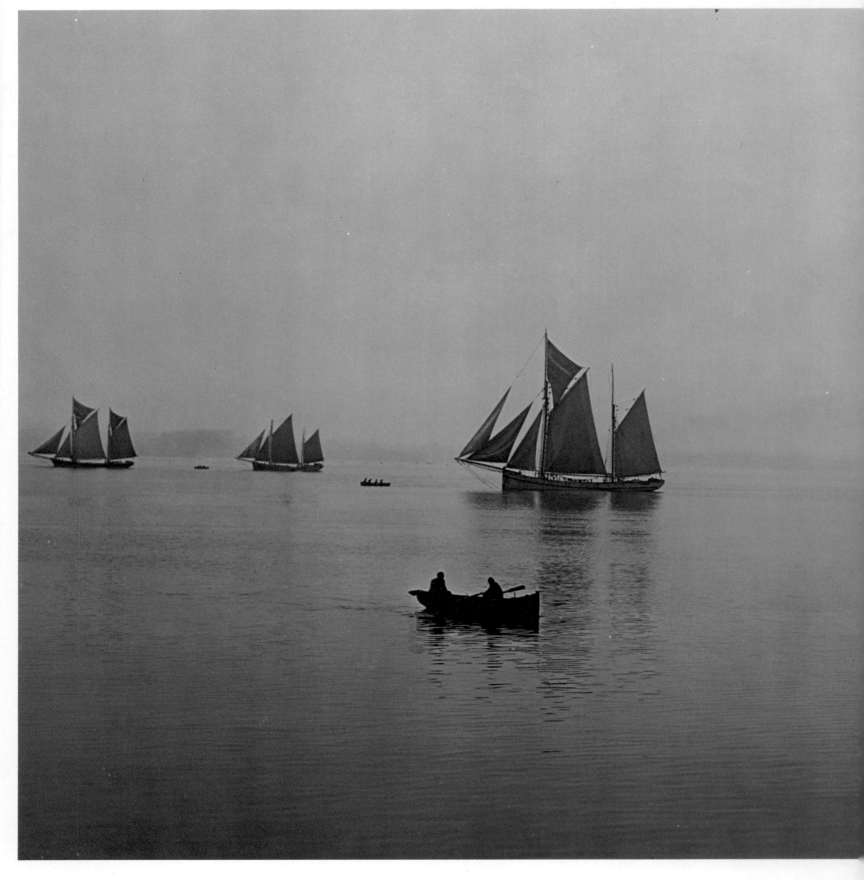

Saturated Strand Caribbean waves on a beach of Dominica spill a spectrum of re- flected colors against wet black sands turned blue by the sky.

JOHN DOMINIS

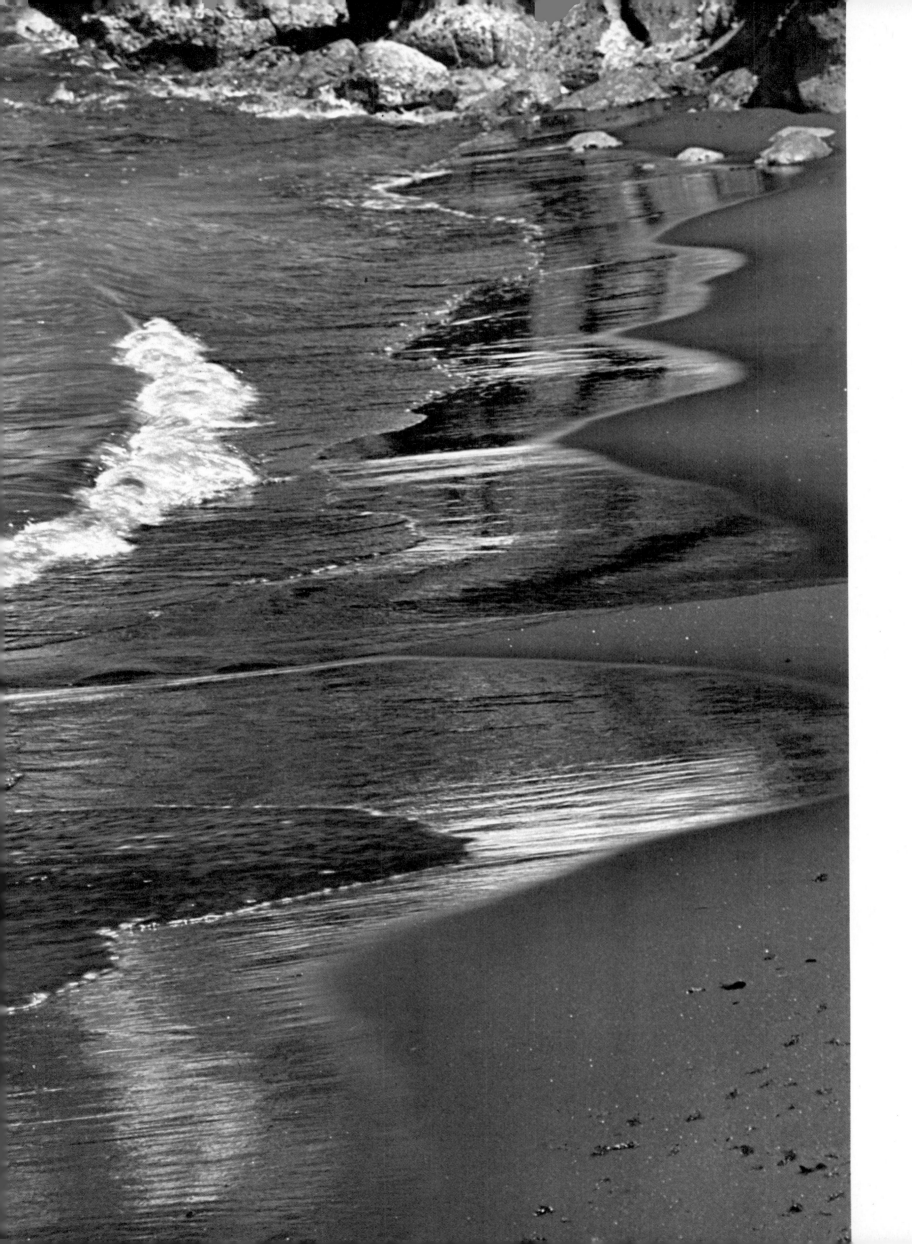

THE SOLDIERS

It is difficult to meet an American fighting man who has not somewhere—in a foxhole or blitzed-out building or rice field—met a LIFE photographer. There *were* a lot of them: 20 men and one woman (Margaret Bourke-White) in World War II alone who spent 13,000 grueling days overseas, half of the time in combat zones. Five were wounded, two torpedoed, half were victims of malaria. In other wars, two, Larry Burrows and Robert Capa, were killed in Indochina; and one, Paul Schutzer, was slain in the Middle East.

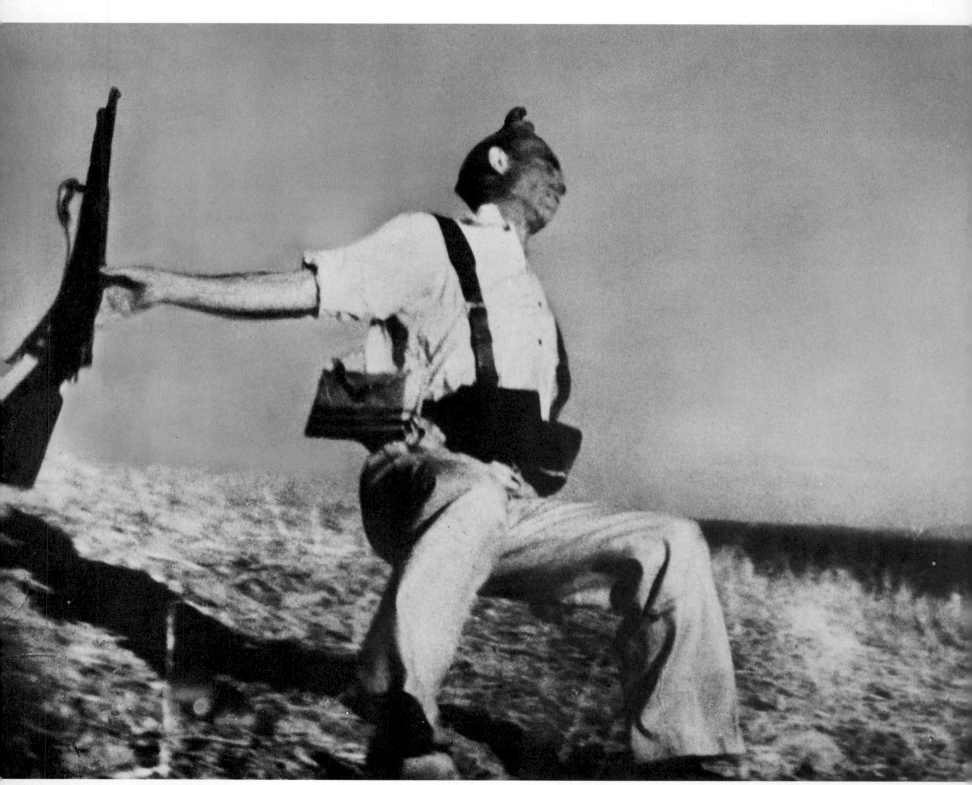

ROBERT CAPA

A millisecond after his enemy's bullet struck him, a Spanish soldier falls. This 1937 picture first brought Bob Capa world fame.

gambled their lives to obtain them

Simply having the guts to be at the front was not enough. To bring back the kind of graphic record presented here required standing up to aim the camera when every instinct screamed against it. Why did they do it? Gene Smith, gravely wounded on his 13th Pacific invasion, once tried to explain that he took such risks because he had a need to reveal war's inhumanity. His explanation could speak for all: "The belief, the try, a camera and some film—the fragile weapons of my good intentions. With these I fought war."

GI in France GIs in Korea

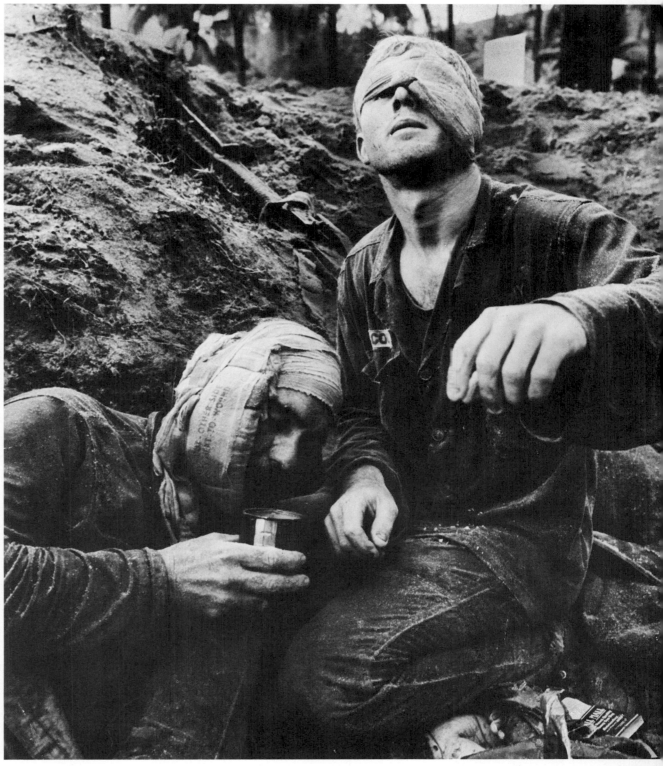

HENRI HUET

This photograph of medic Thomas Cole, himself wounded, caring for a comrade in Vietnam, won a Robert Capa bravery award.

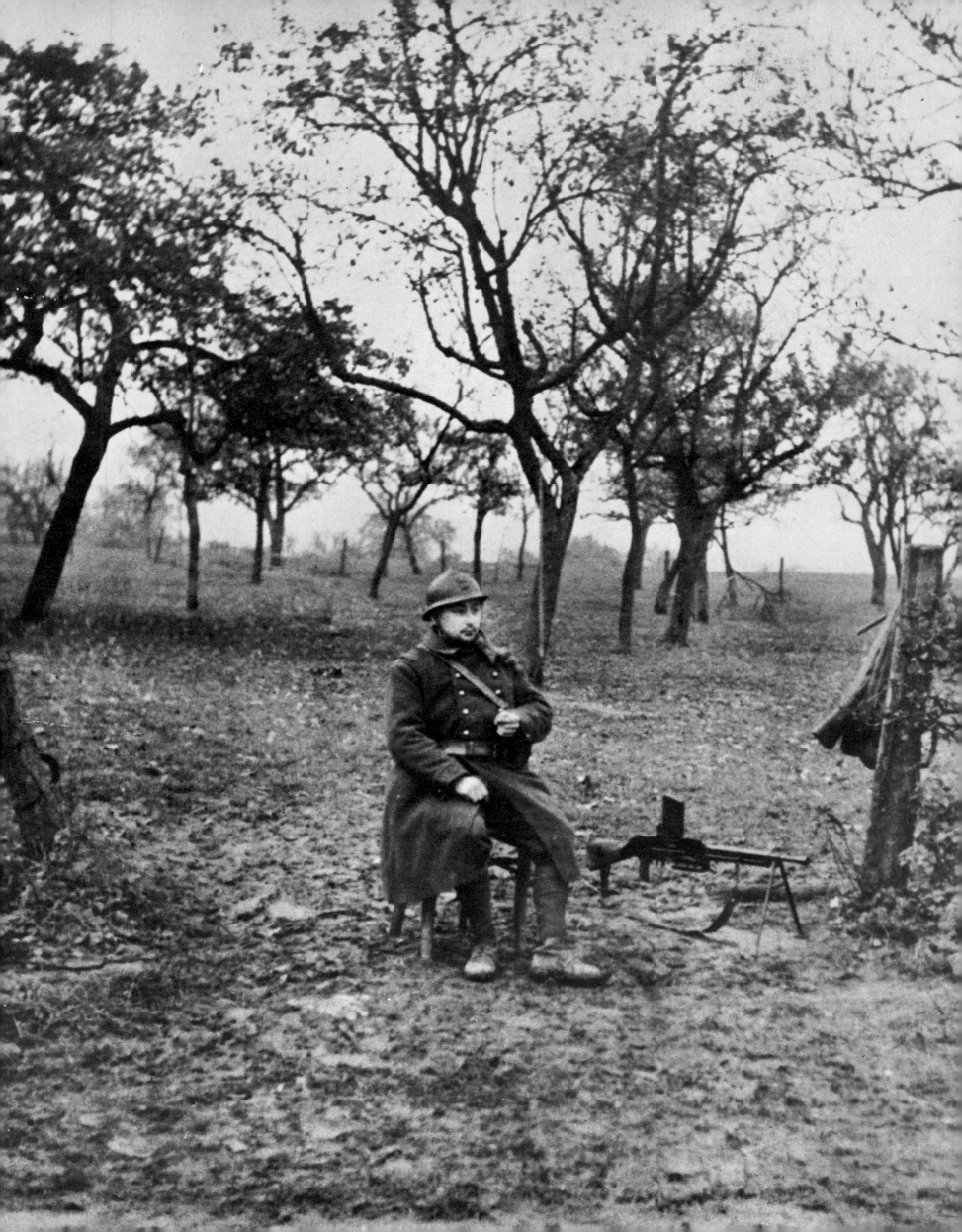

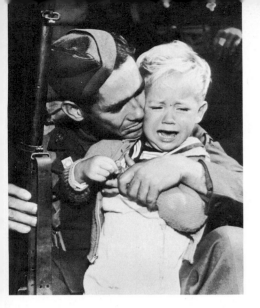

ROBERT JAKOBSEN

Soldier Father

Pfc. John Winbury's attempt to calm his young son Robert's anguish stands for all the sorrowful partings that afflicted American families during World War II.

Soldier en Garde

Reassured by the Maginot Line, a French poilu plays his part in what was called the "Sitzkrieg" on the western front in 1939, before the Nazi invasion.

Soldier Son

A demure British mother caddies her son's rifle and looks away as she waits her turn to say goodbye before he leaves for France.

Soldiers Saved

Weary, but thankful that they have survived and will live to fight again, British troops *(below)* await evacuation at Dunkirk.

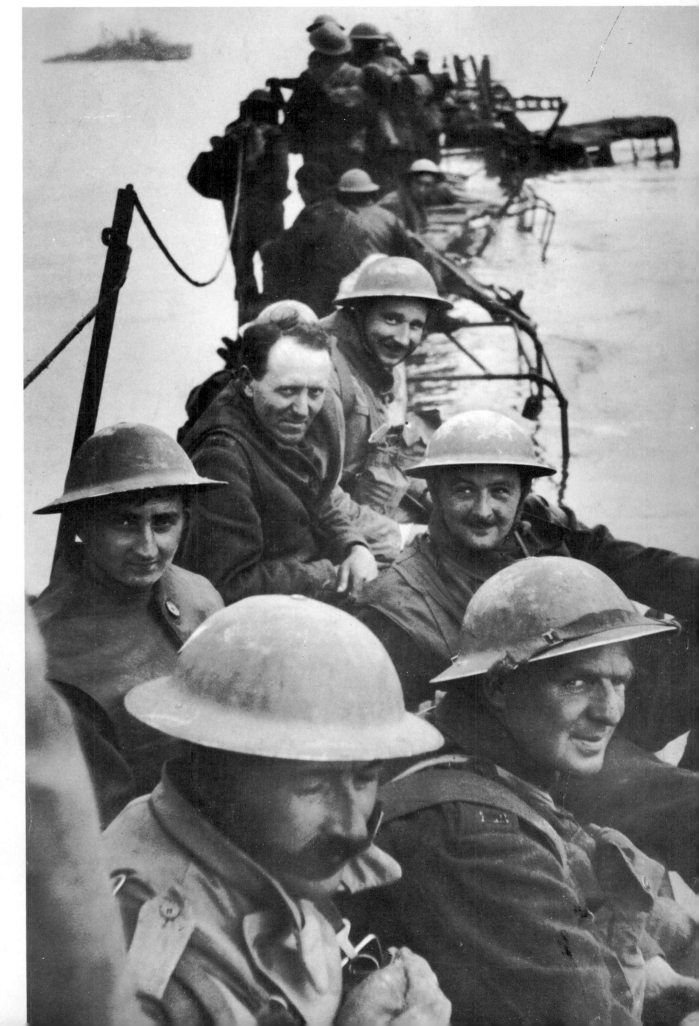

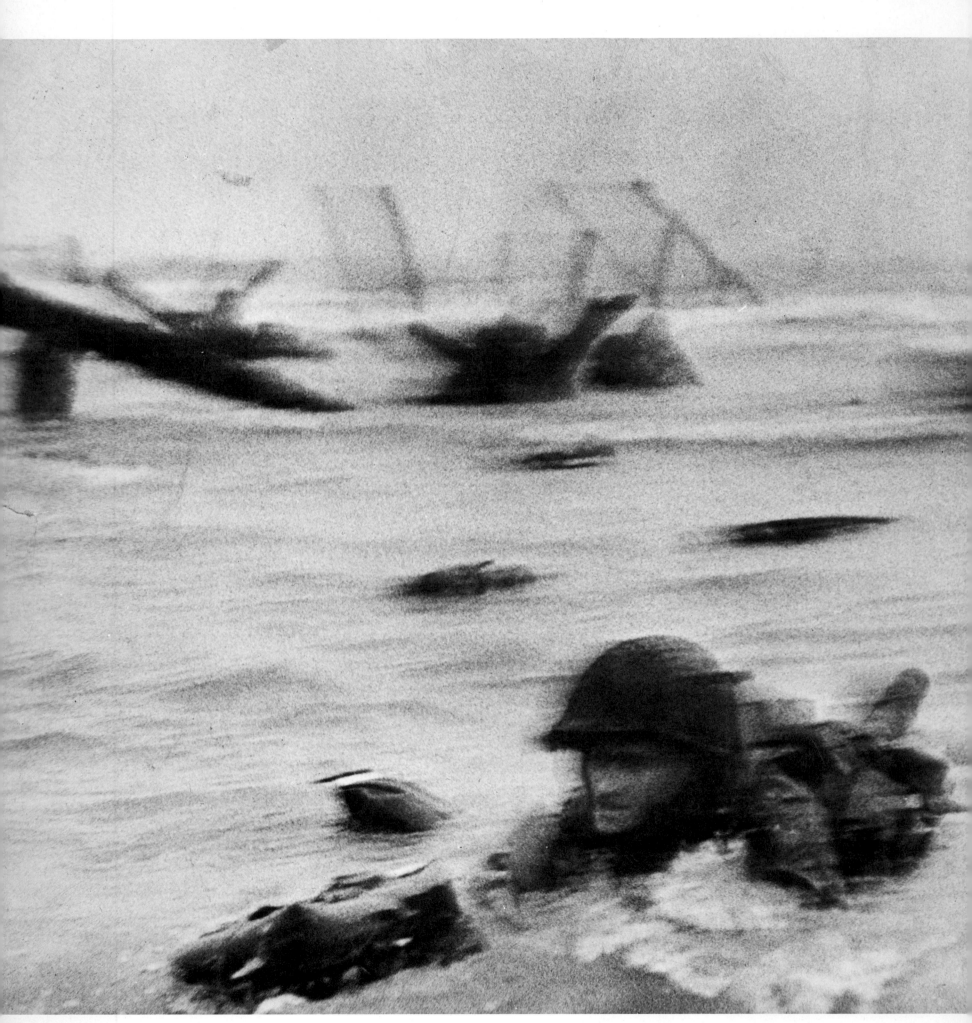

ROBERT CAPA

D-Day: Onto the Beach The dawn rush onto the beaches of Normandy, over anti-invasion obstacles and through heavy fire, was recorded for all time by this grainy, headlong picture that almost cost Bob Capa his life.

Death in the Last Drive

On a jury-rigged pontoon bridge that turned into a shooting gallery, a GI is killed by enemy mortar fire while crossing the Roer on the last drive into Germany.

GEORGE SILK

Odyssey of Pain

The jolting agony of a change of dressings is one more stage in this soldier's excruciating journey, from casualty in Lorraine to postoperative recovery at home.

RALPH MORSE

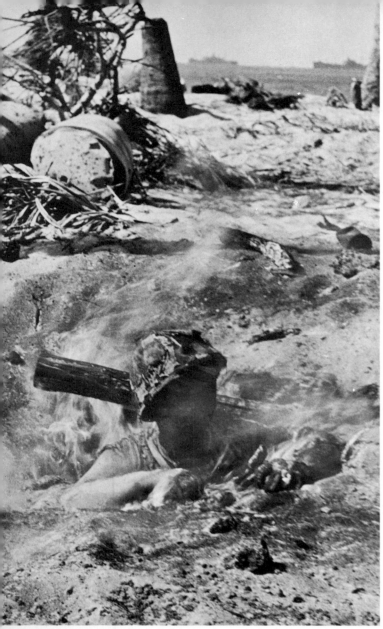

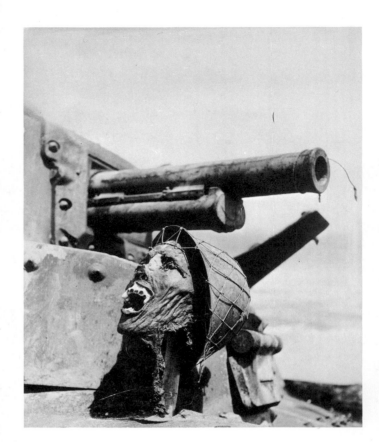

Roasted in a Tank

A gruesome relic of the ferocious battle for Grassy Knoll on Guadalcanal, this skull of a Japanese soldier was propped up on his burned-out tank.

RALPH MORSE

Shot Down in the Surf

This photograph, which was taken in 1943 at Maggot Beach near Buna, New Guinea, was one of the first to show American soldiers killed in World War II combat.

GEORGE STROCK

GEORGE STROCK

Incinerated in a Foxhole

A smoking corpse is all that is left of a Japanese soldier who waited in ambush on Eniwetok atoll — and was caught by assaulting GIs armed with flame throwers.

Blinded by a Shellburst

This 1943 record of a New Guinea tribesman's compassion for a blinded Aussie was blocked by Australian censors who judged it bad for morale. LIFE later ran it and hired the photographer.

GEORGE SILK

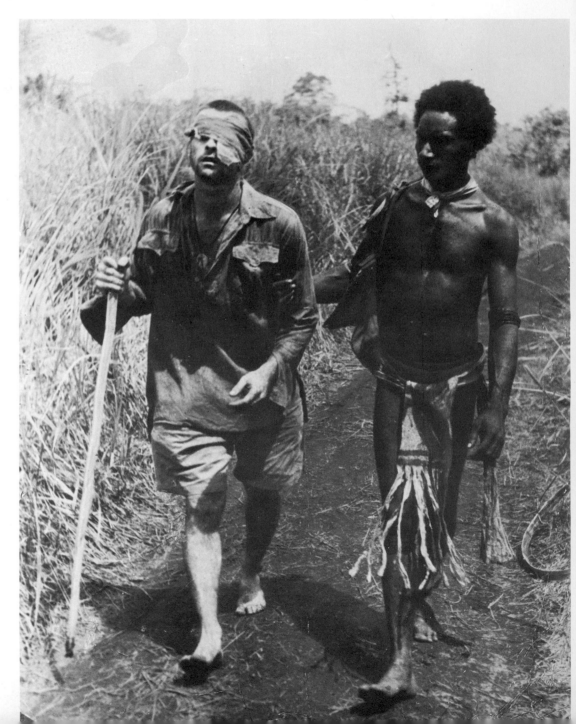

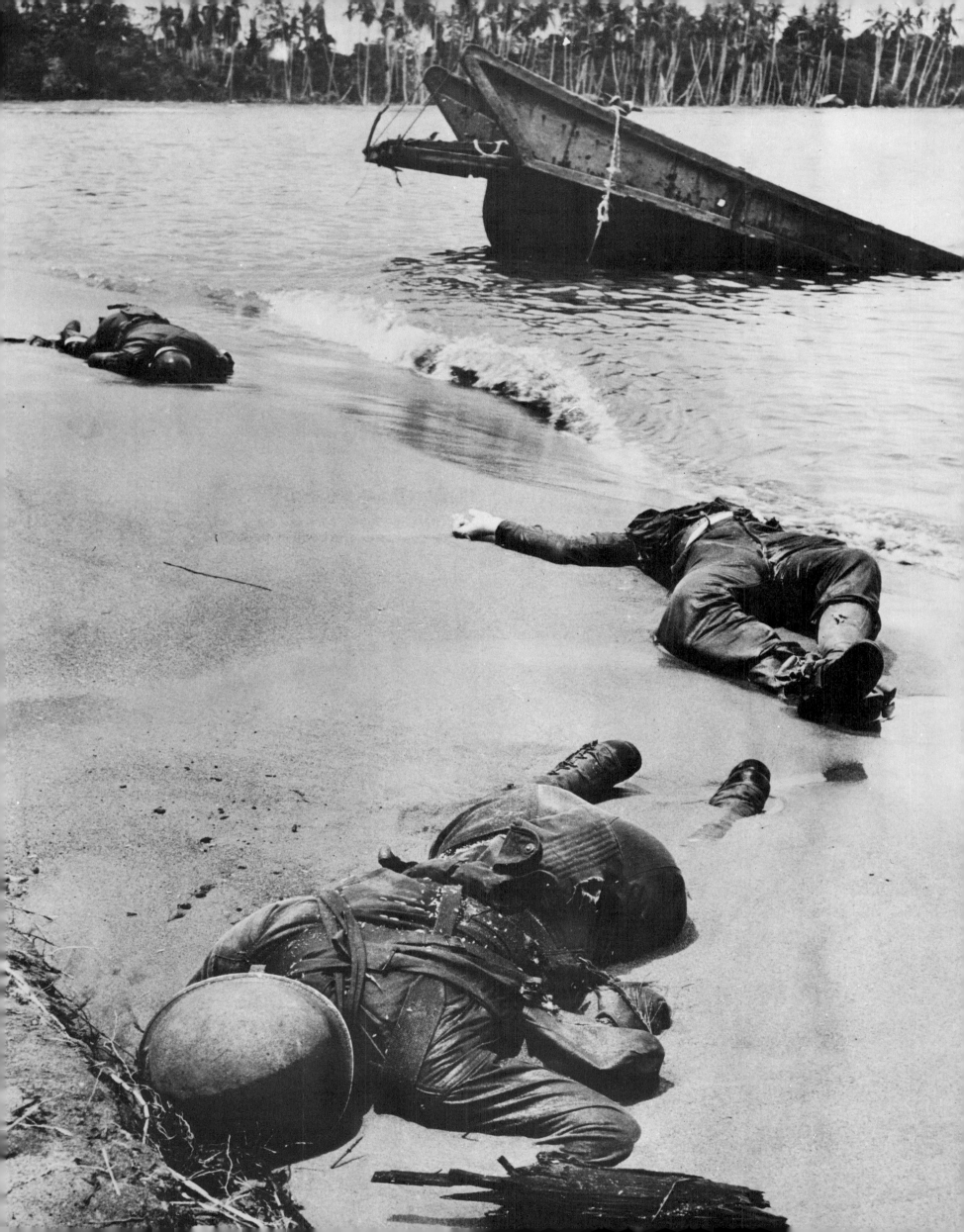

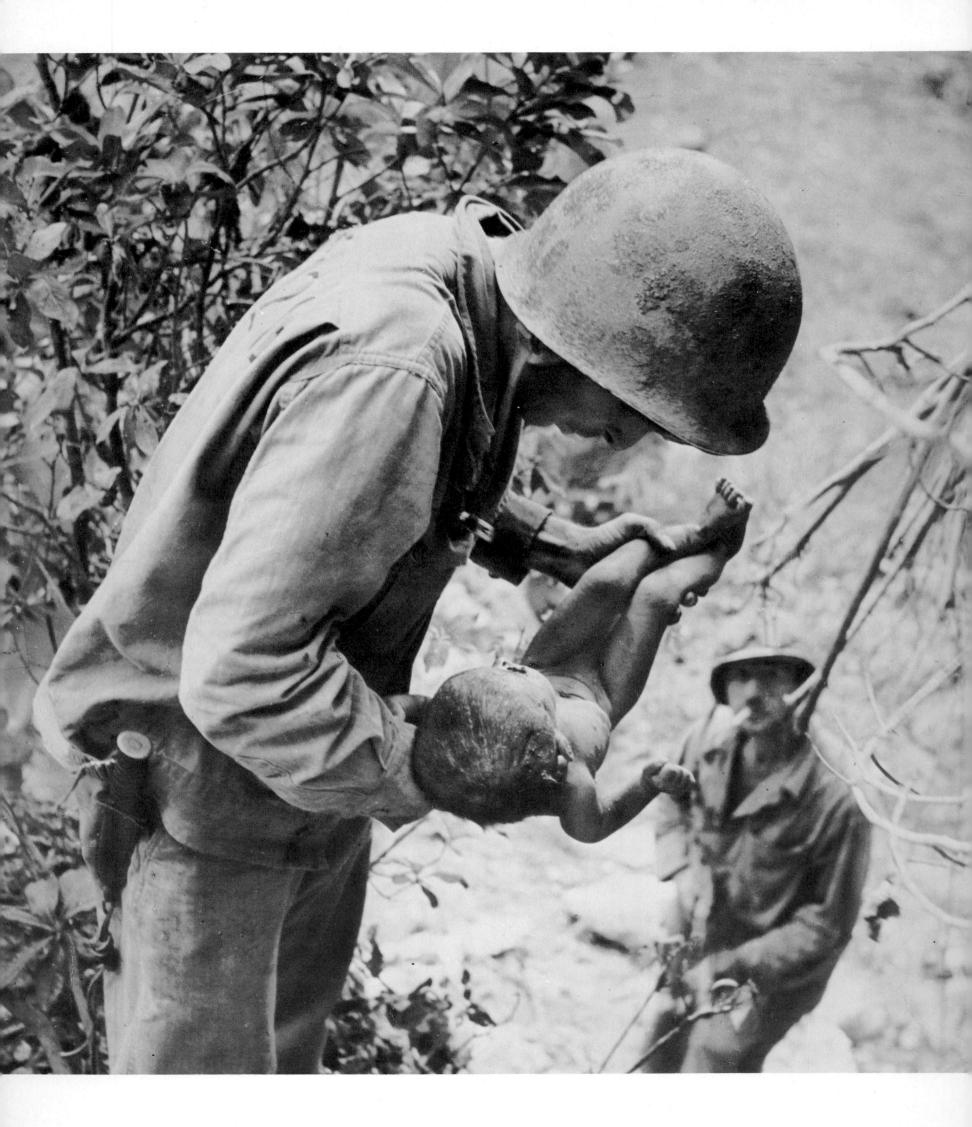

Only Survivor

Plucked alive from a Saipan cave filled with the corpses of hundreds of Japanese civilians and soldiers, this baby was rushed to a GI hospital.

W. EUGENE SMITH

Sanctuary Hospital

Bandages covering his burns, a U.S. officer *(right)* lies on a cot while mass is held in a Leyte church converted into a hospital.

W. EUGENE SMITH

Prisoner of War

This living skeleton of a U.S. soldier was among those freed from a prison near Limburg as U.S. troops entered Germany.

JOHNNY FLOREA

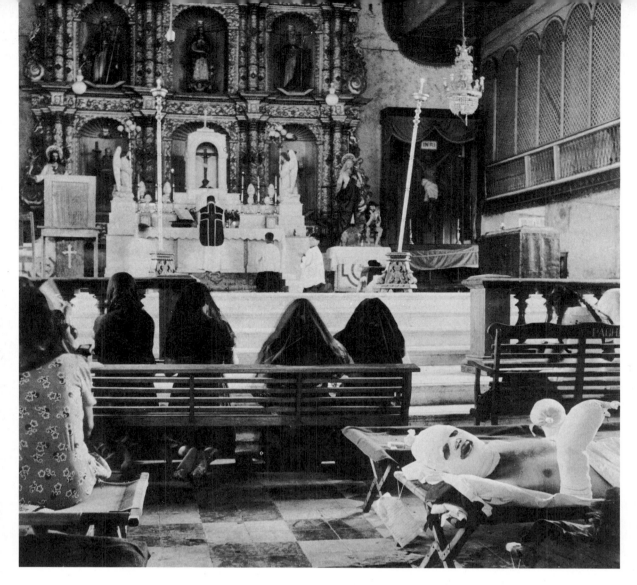

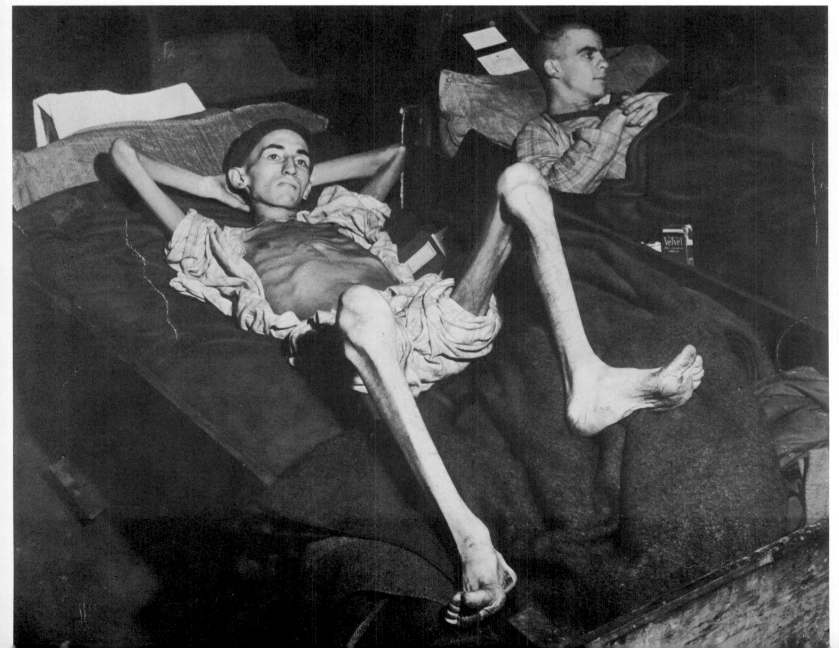

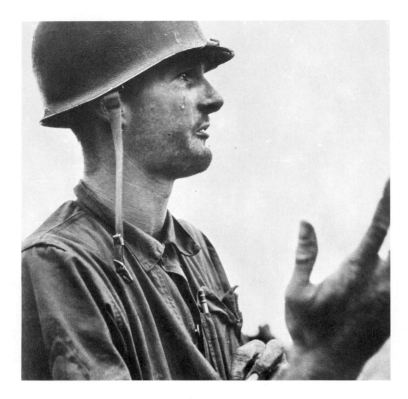

Tearful Squad Leader

Down to the last two men in his squad and out of ammunition, a U.S. corporal assigned to assault a Korean ridge gives way to tears of helpless rage.

DAVID DOUGLAS DUNCAN

Leatherneck in a Hurry

During a skirmish with North Korean troops, a mud-spattered U.S. Marine sprints unheedingly past an enemy corpse while searching for better cover.

DAVID DOUGLAS DUNCAN

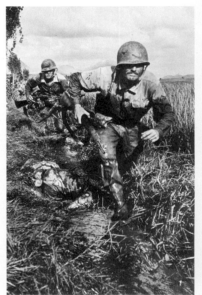

Christmas for a GI

Christmas in Korea, 1950, was like this for Marines exhausted by their harrowing retreat from Changjin Reservoir.

DAVID DOUGLAS DUNCAN

Terrified Captives

Surprise entries in the Korean War, Chinese troops flushed from cover wordlessly ask mercy from their GI captors.

HANK WALKER

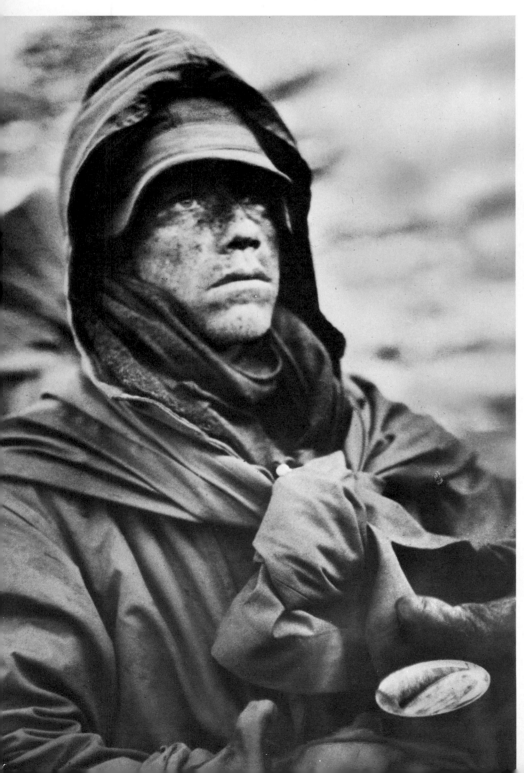

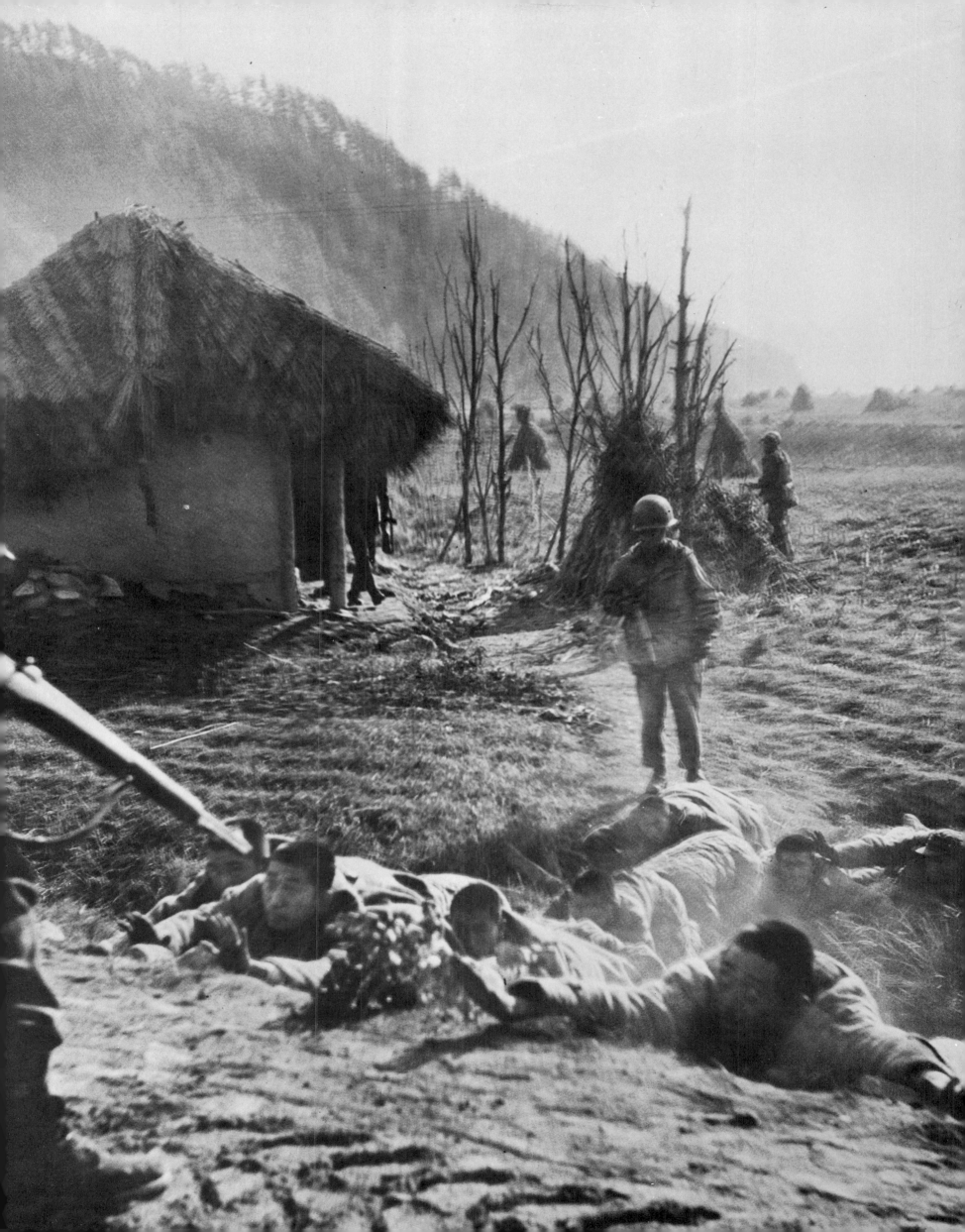

MARK KAUFFMAN

The Making of a Marine

A notoriously tough drill instructor confronts a scared recruit he hopes to turn into a Marine.

The Happiness of a Popsicle

An American officer's one-man foreign aid program wins a numb grin from a Korean boy.

CARL MYDANS

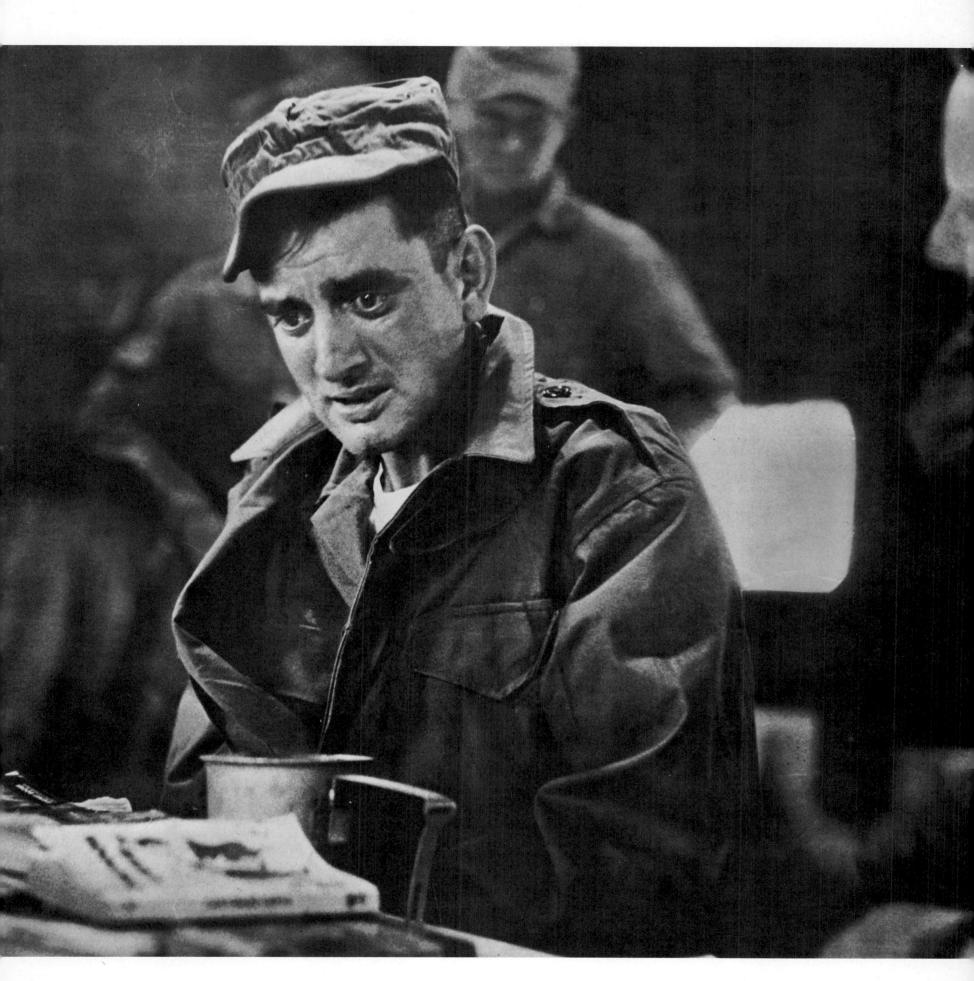

The Shock of Freedom Freed from a POW camp after 10 months, Pfc. John Ploch sits unbelieving, his eyes brimming with tears, in Panmunjom's Freedom Village. "I can't help it," he said. "It's too good to be true."

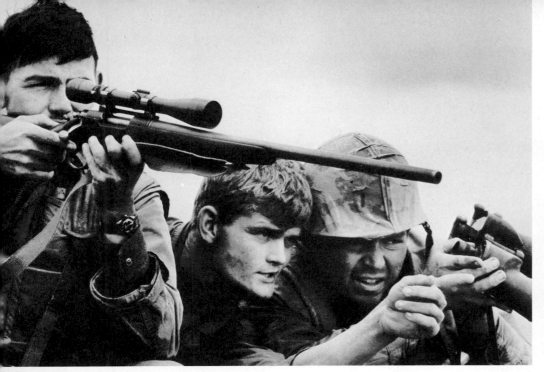

DAVID DOUGLAS DUNCAN

Death at a Distance With binoculars, scope and old-fashioned Kentucky windage, a three-man sniper team picks off the enemy at Khe Sanh.

Solace from an Old Song In a brief respite from the tension in besieged Khe Sanh, Pfc. Joseph Marshall takes comfort in a soothing spiritual.

DAVID DOUGLAS DUNCAN

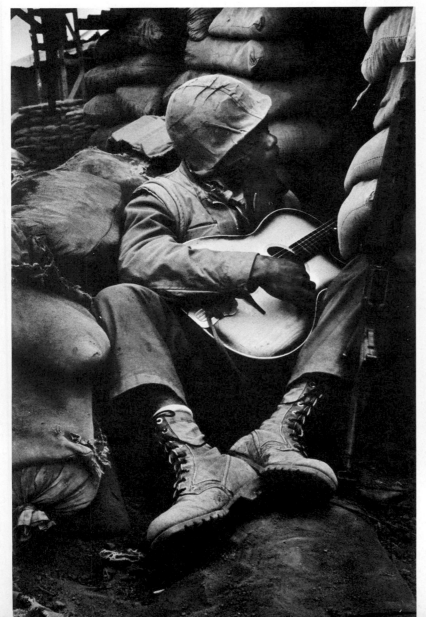

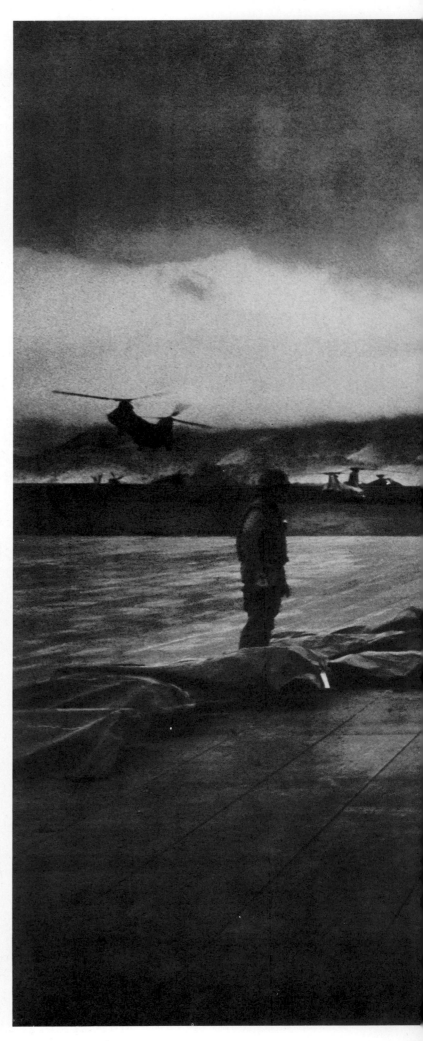

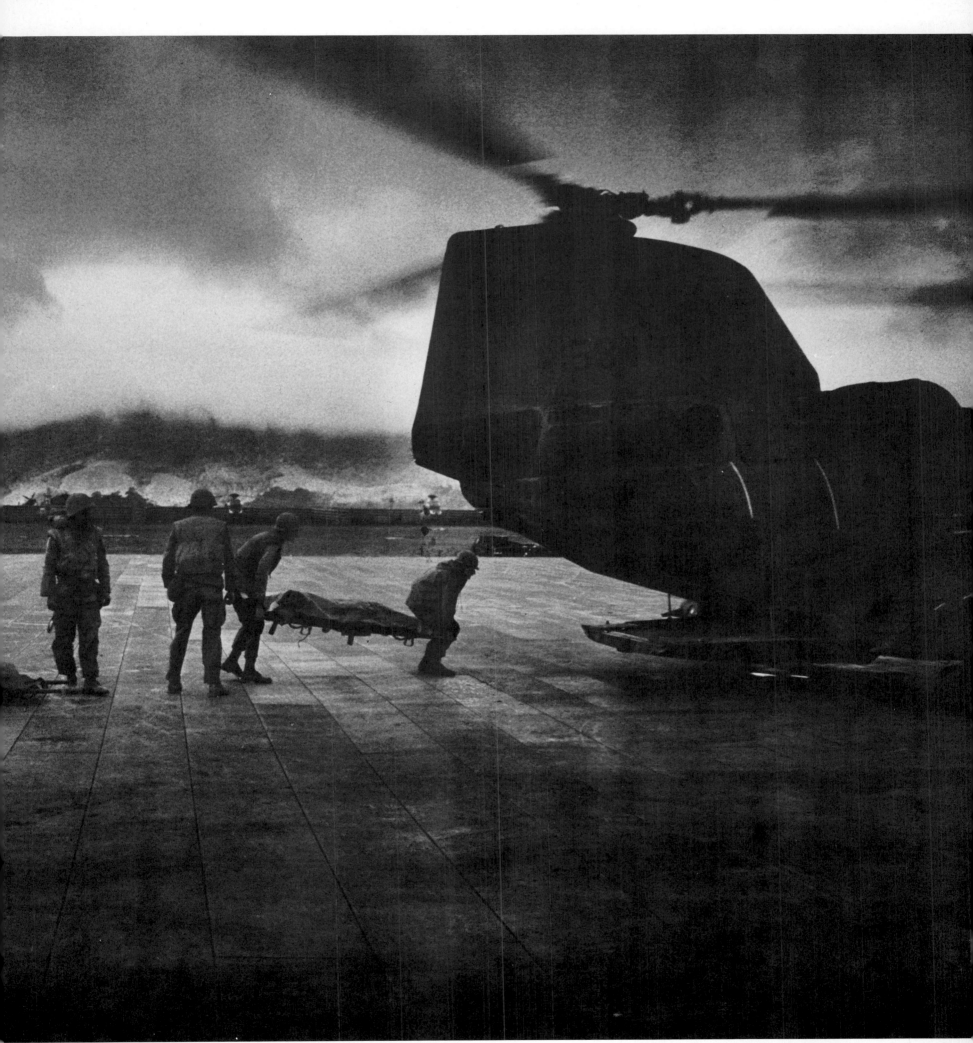

Requiem at Khe Sanh Marines load slain comrades onto a chopper for the trip home. The only way in or out of Khe Sanh was this metal-plate airstrip.

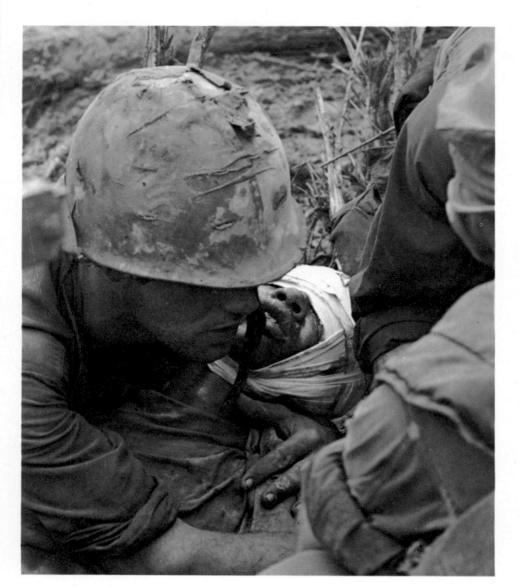

Help for a Hurt Marine

During fighting to hold the "Rock-pile" south of the DMZ, a helmeted Marine in Vietnam supports a bandaged comrade being treated in a sodden shell crater.

LARRY BURROWS

Tank-Turned-Ambulance

In a poignant tableau of the battle for Hué, wounded from forward positions are returned by armored tank, the only vehicles that could approach the Citadel.

JOHN OLSON

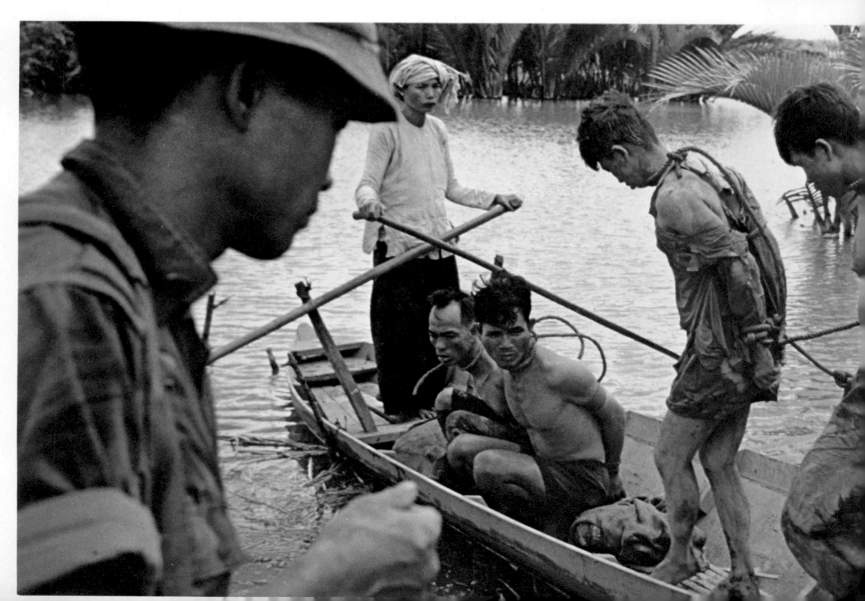

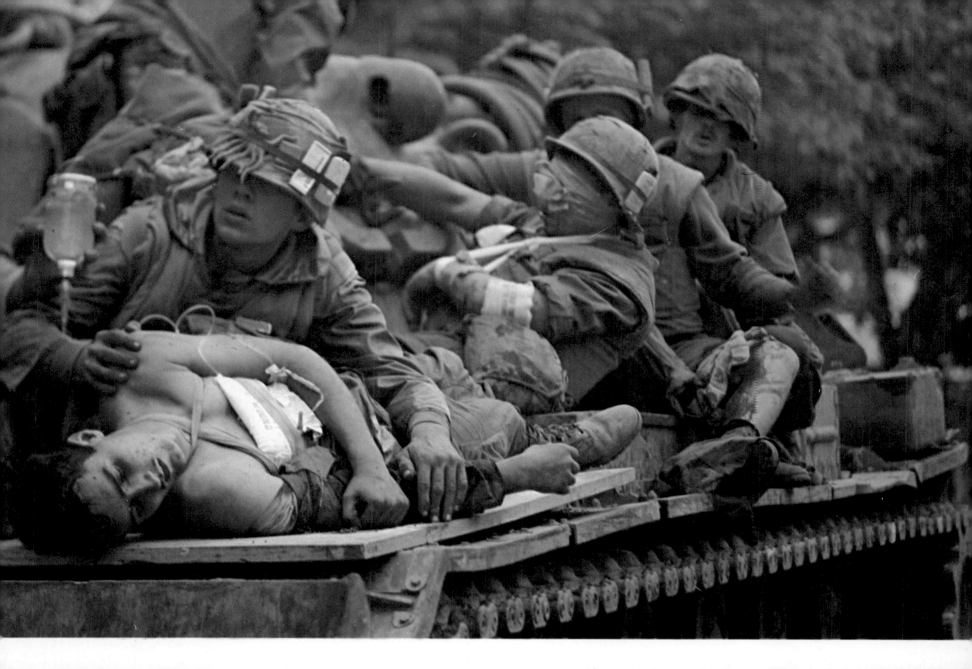

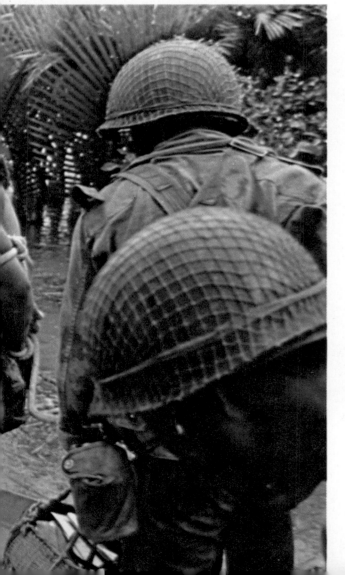

Boatload of Viet Cong

South Vietnamese soldiers load tautly bound Viet Cong and a wicker sack of documents into a peasant canoe for the trip to headquarters and prison.

LARRY BURROWS

Mother and Dying Child

A Vietnamese mother, wild-eyed with grief and terror, stumbles through the area of a fire fight at Cape Batangan with her dying child, struck by strafing runs before U.S. Marines landed.

PAUL SCHUTZER

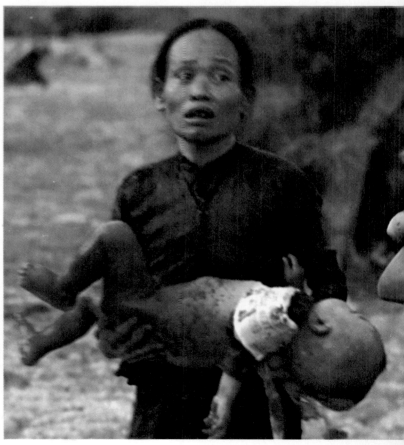

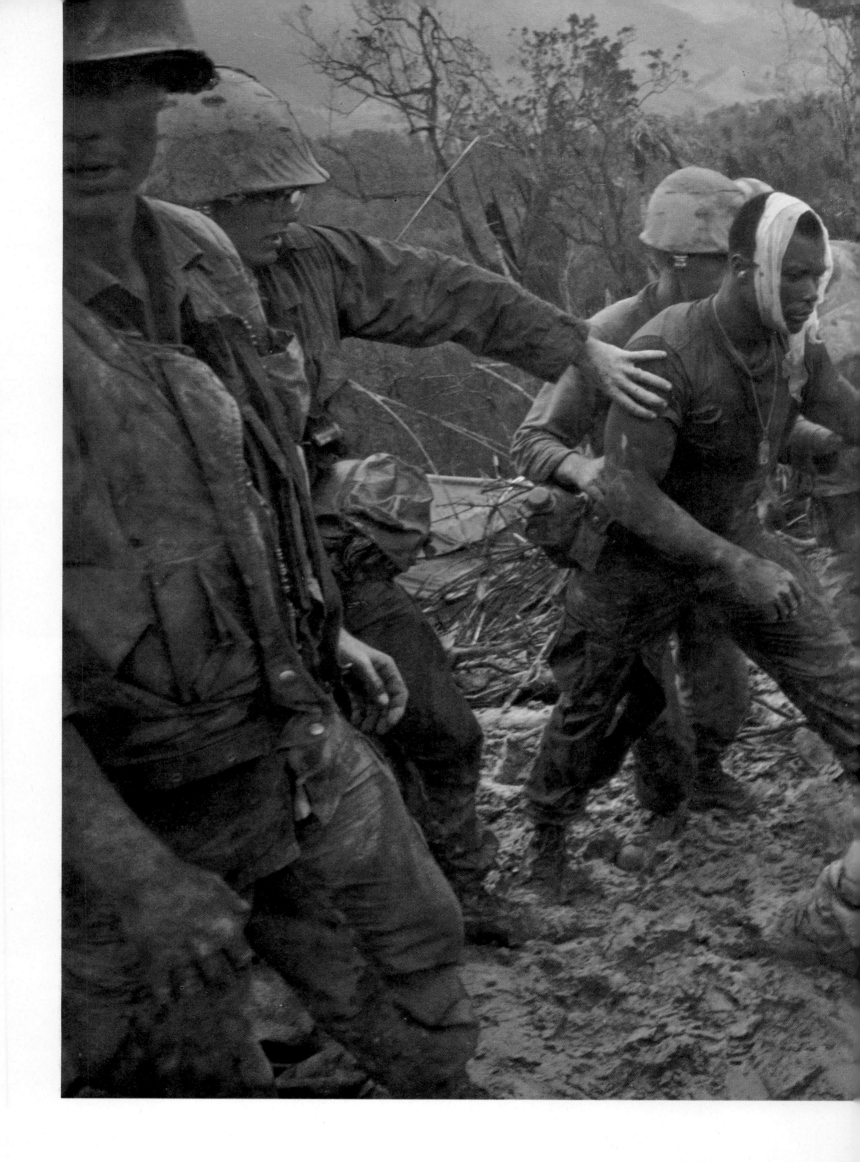

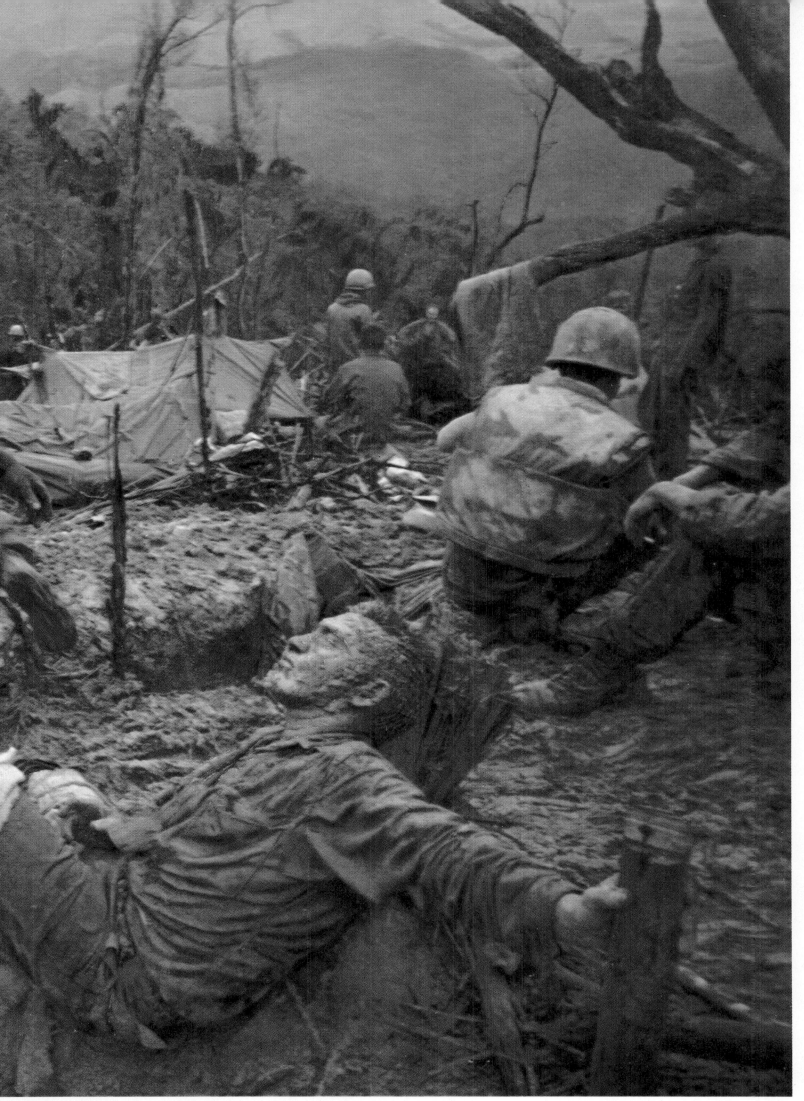

Compassion in a Muddy Hell Wounded in head and knee, a Marine is helped by corpsmen to a makeshift aid station carved out of a Vietnam hilltop. Despite his own pain, he reaches to help another stricken comrade.

THE CHILDREN

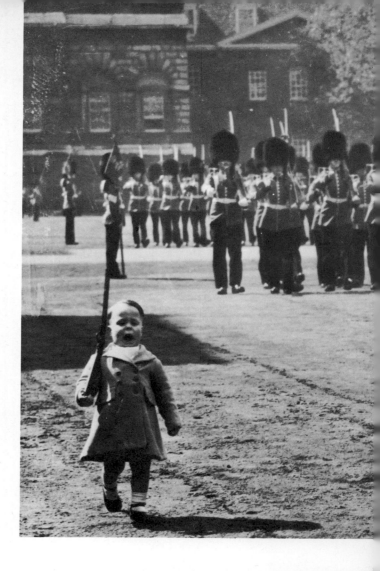

Peter Jackson, 2 *(right),* struts with the guards at Whitehall.

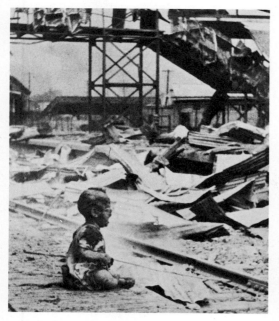

H. S. WONG

This photo from Japan-bombed Shanghai became historic.

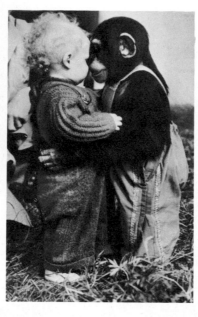

An English circus baby, 2, and his chimpanzee pal rub noses.

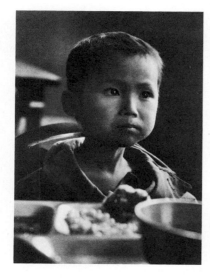

A grim-faced Korean boy *(left)* awaits his first U.S. meal.

MICHAEL ROUGIER

A pied-piper drum major leads a crew of young followers.

ALFRED EISENSTAEDT

They frequently stole the show

Children, as every actor knows, are the great scene-stealers. LIFE's photographers kept discovering this too. Before the camera prankish youngsters could upstage even the flashiest uniform. As victims, they pre-empted scenes of tragedy: "Newsreel" Wong's photograph of a baby in a Shanghai station *(far left)* aroused the world against Japan for bombing the civilian quarter.

Understandably, the photographer of children often lost his heart to them: after meeting refugee Kang Koo Ri *(bottom left),* Michael Rougier simply could not forget

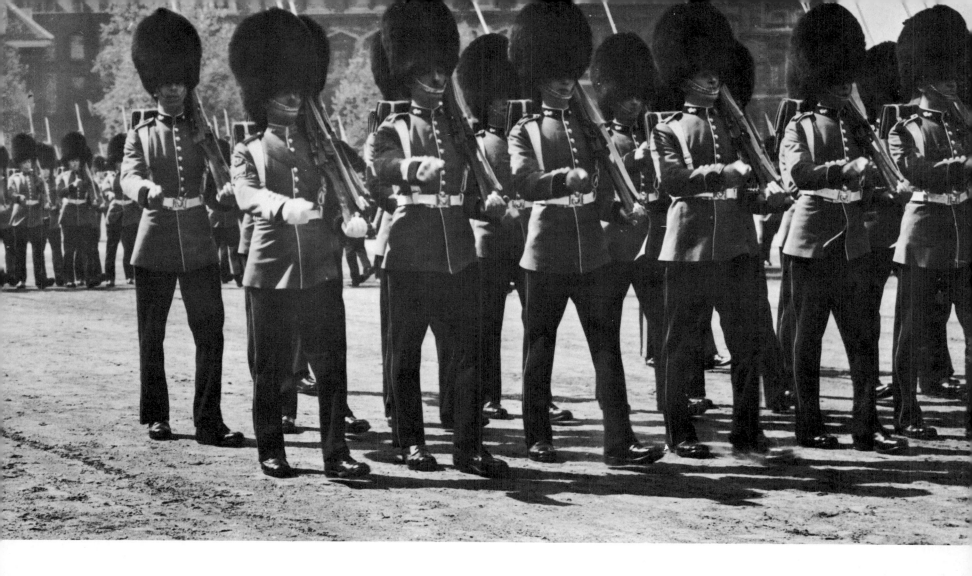

—and the photographer's heart

him. Rougier used the money that came in from LIFE readers to help support the orphanage where Kang lived; and one U.S. family was moved to adopt the young refugee. When Gordon Parks's essay made a Rio slum child named Flavio da Silva *(page 199)* famous, there was such a flood of donations from LIFE readers that the photographer went back and brought Flavio to the U.S. A Denver hospital treated the boy for his asthma and malnutrition. His family was housed and set up in business. Flavio, back in Brazil, is now married and working.

Dionne quints at 6

Young angler

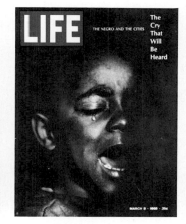

Tearful Harlem boy

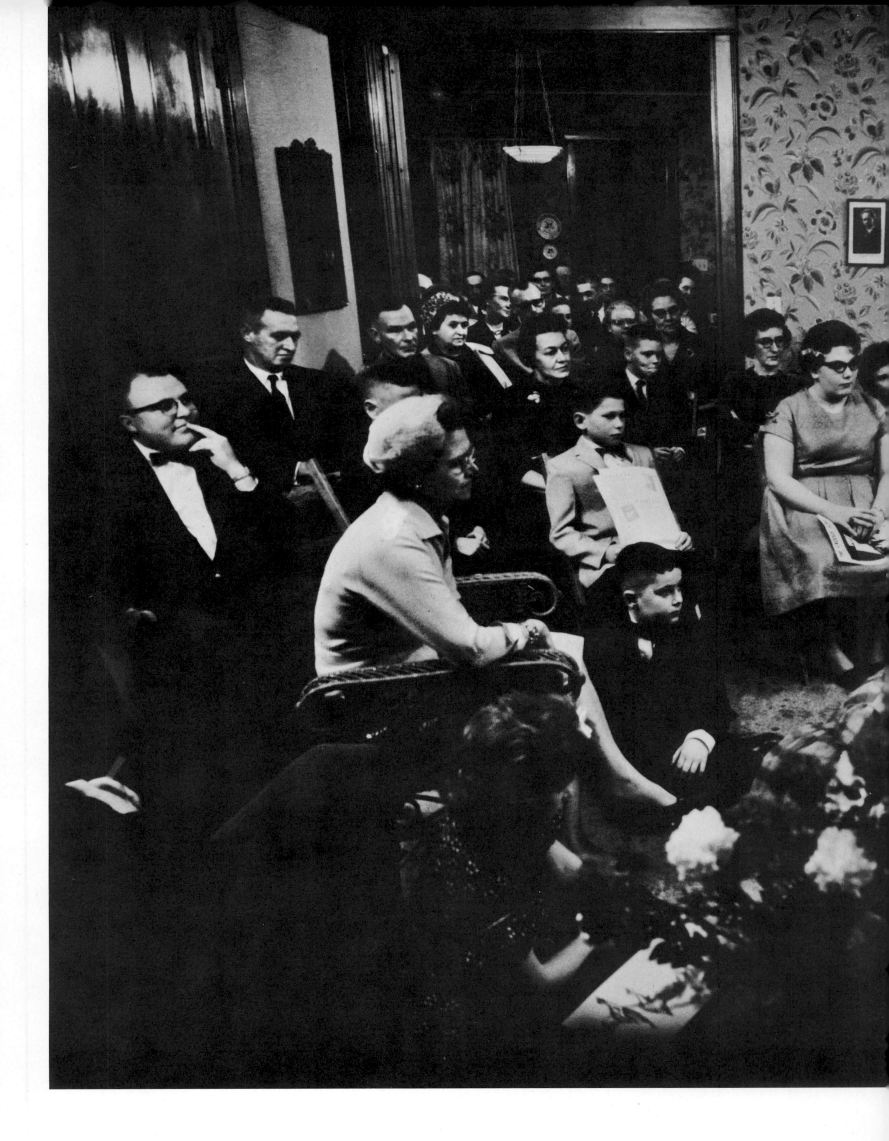

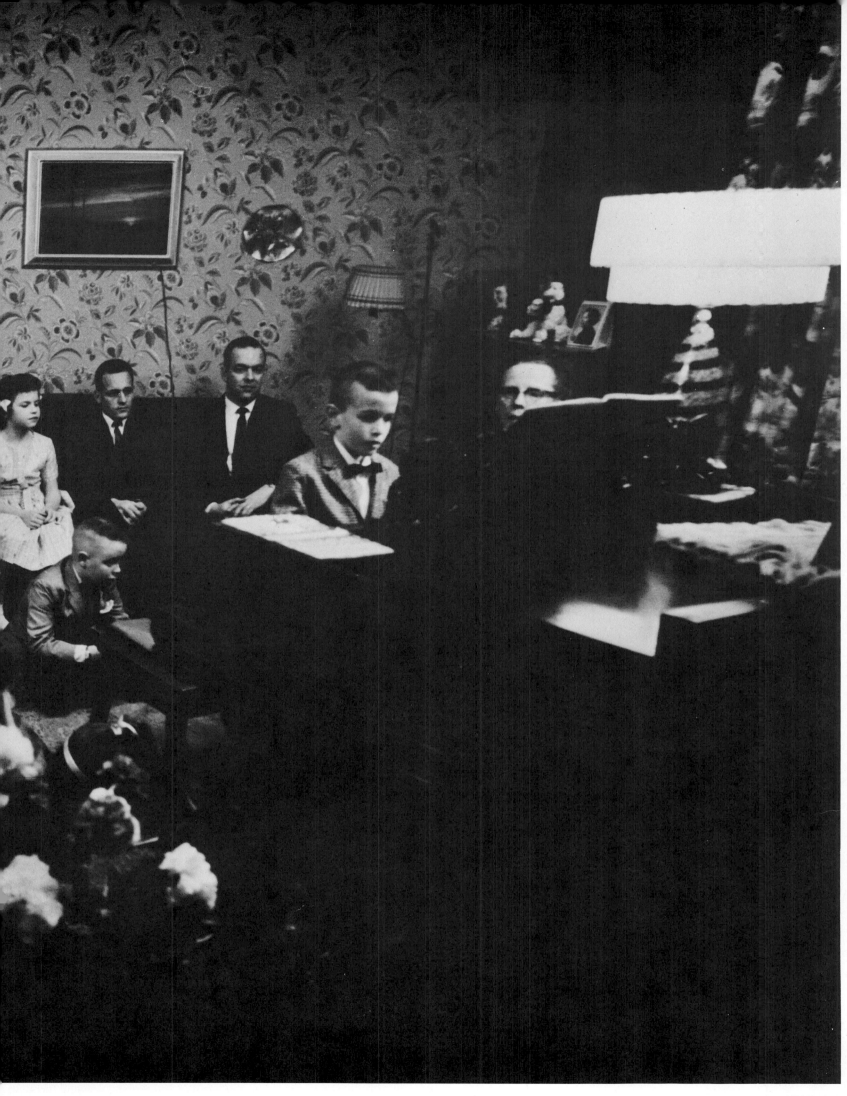

YALE JOEL

The Piano Recital What made this picture an American classic was that everyone could see himself in that Iowa parlor, as nervous parent, soloist at the point of no return or, worst of all, the terrified next-in-line.

Junior Gunslinger

Blissfully gunned down while at play in boyhood's favorite role, a vested badman clutches at his hammy heart and topples onto the New Jersey prairie.

Minor Mime

The remarkable acting ability innate in children enabled this little boy *(below)* to mimic exactly his babysitter's stern expression and help avert sterner discipline.

Sans Culottes

With all the persuasive earnestness of a major leaguer arguing for a better-paying contract, a Little League spokesman voices the players' demand for pants.

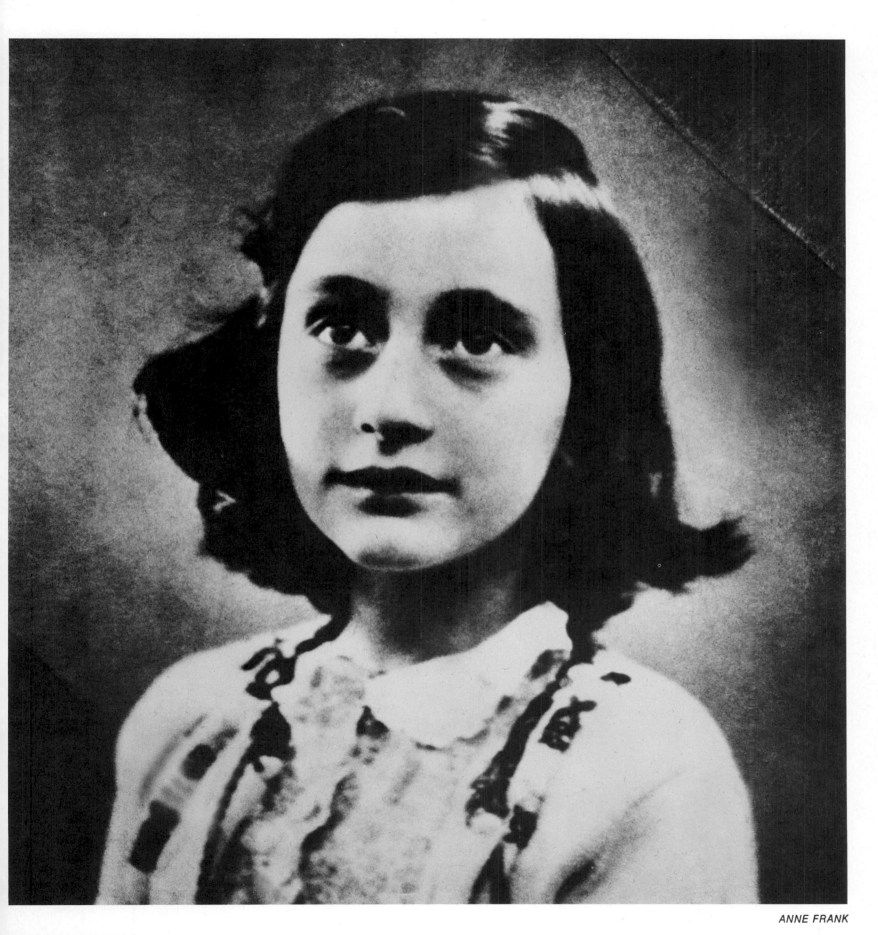

ANNE FRANK

Spectators of War Engrossed, and only partly terrified, English children *(left)* watch from a trench as airplanes fight in the Battle of Britain.

Victim of the Holocaust Anne Frank took this poignant portrait of herself in an automatic photo booth before hiding out and beginning her famous diary.

JOHN TOPHAM

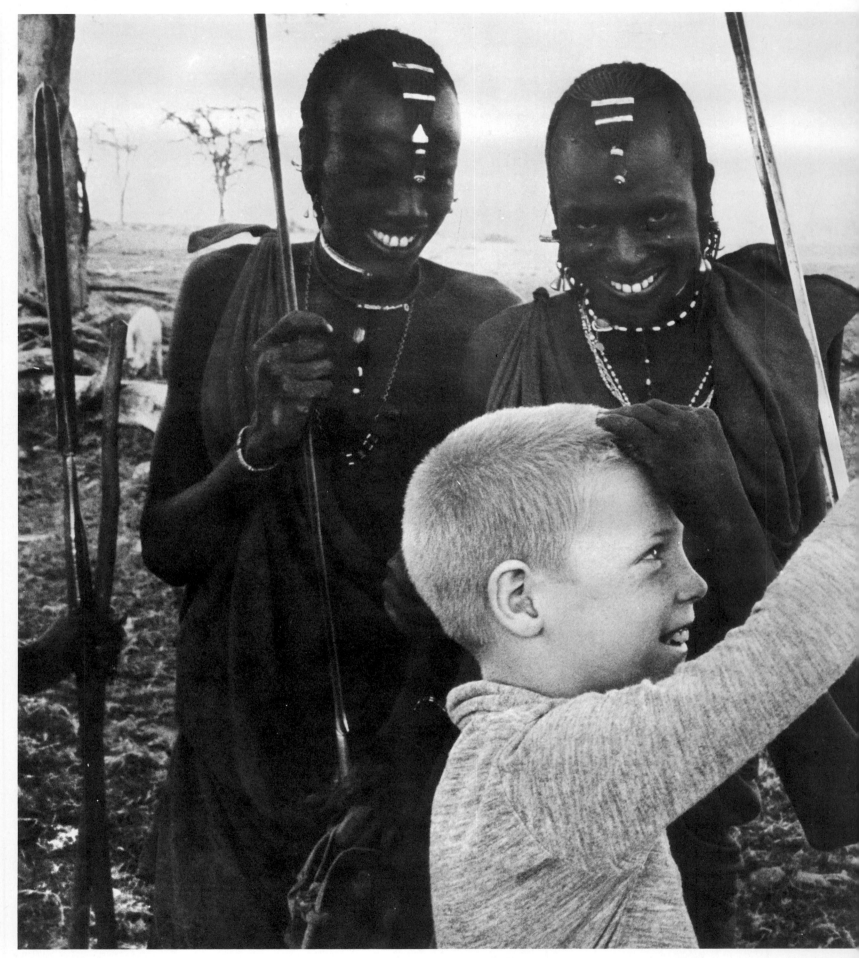

ROBERT HALMI

Mutual Curiosity An American guest of a Masai tribe and his temporary girl friend engage in mutual laying on of hands to compare hair texture.

Princely Awe Shy but fascinated, Prince Mash-ur of Saudi Arabia peers at the pomp of a Washington welcome.

HANK WALKER

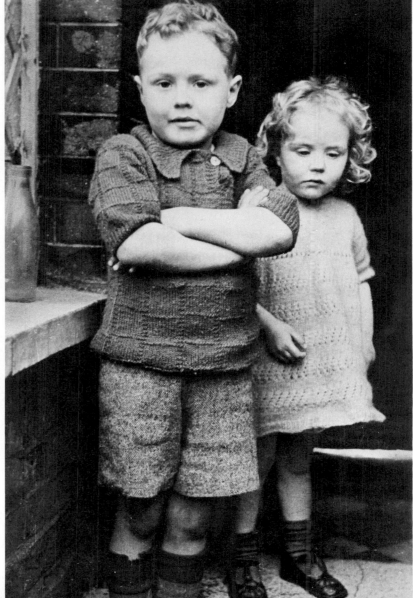

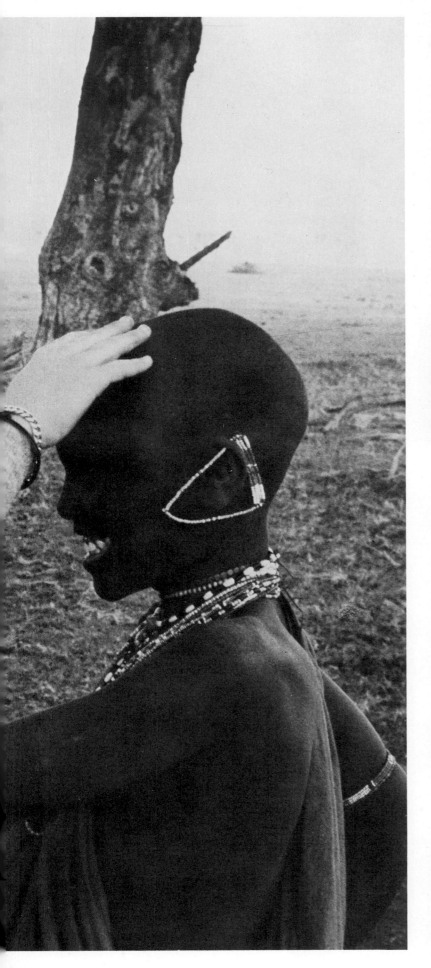

British Aplomb A young Londoner *(right)* who saved his sister from Nazi bomb wreckage registers modest calm.

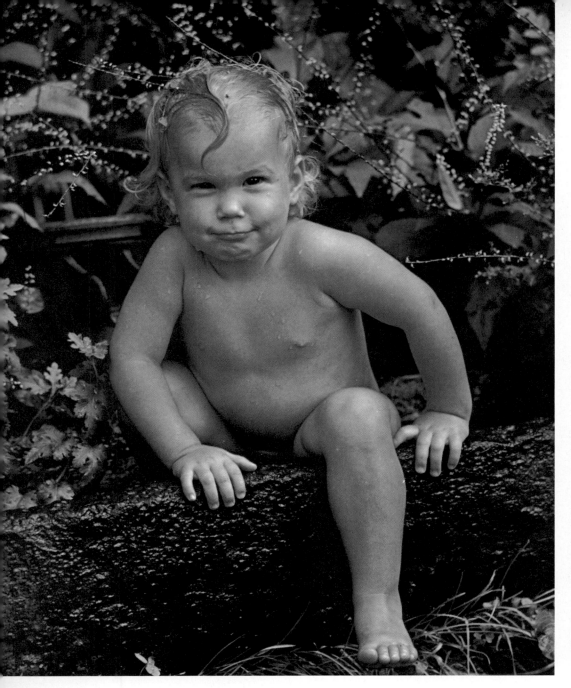

DOUGLAS FAULKNER

Concentration

Showing tongue-punishing dedication, a down-to-earth marbles player draws a very careful bead.

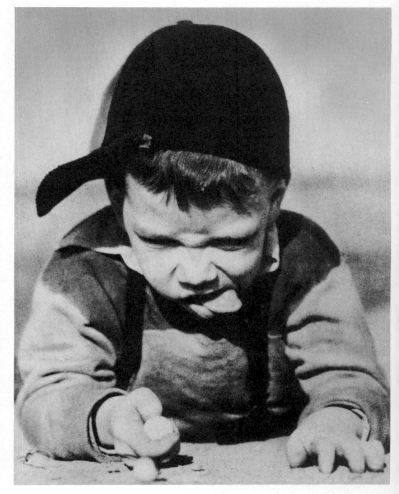

Self-Possession

The photographer's own daughter, 2½, brazens it out *(above)* when caught taking an illicit hot-weather dip in the bird bath.

Precipitation

While protecting his little sister from a summer shower, the good Samaritan savors a drop or two.

CARROLL SEGHERS II

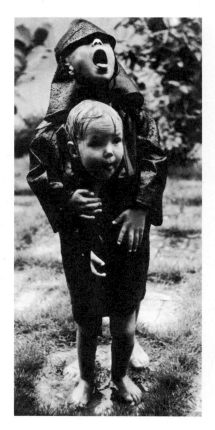

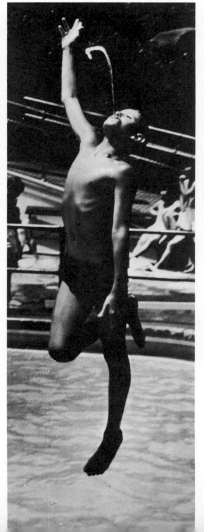

Demonstration

A young swimmer *(left),* nicely primed with a mouthful of water, mimes a fountain sculpture as he leaps off the diving board.

MARK KAUFFMAN

Delectation

A little girl *(right),* careful about the cleanliness of her cone if not her hands, struggles with the problems of melting ice cream.

MICHAEL MAUNEY

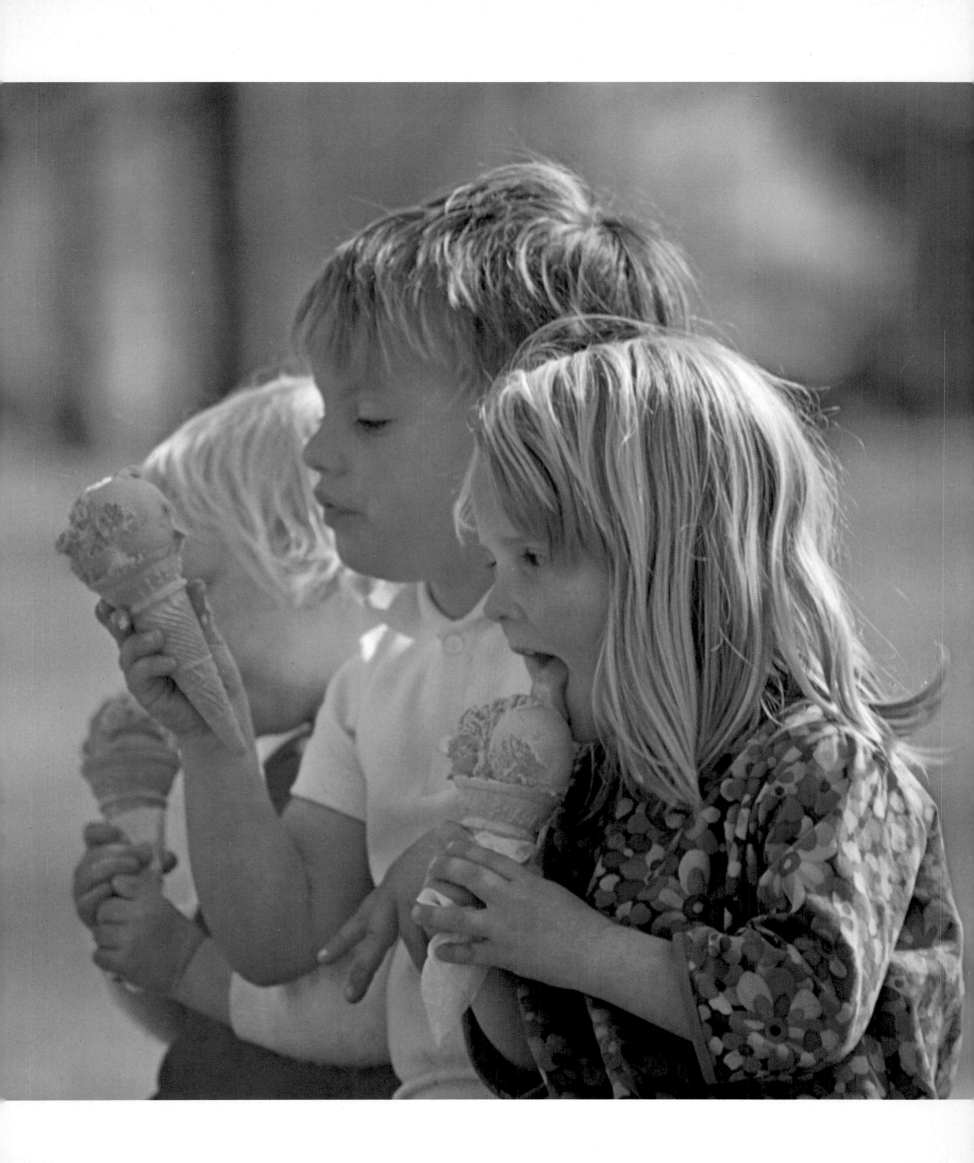

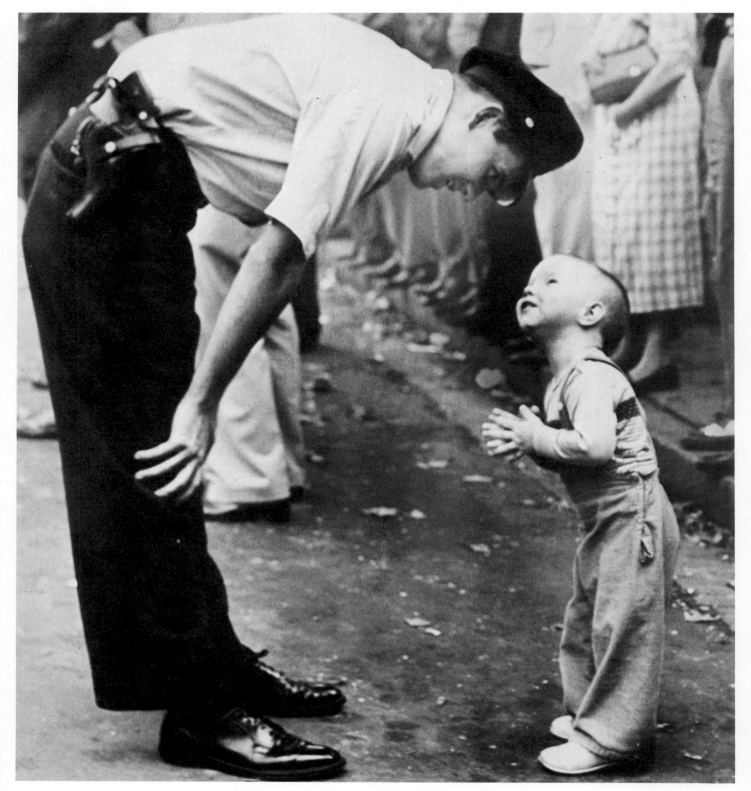

BILL BEALL

Official's Greeting

This picture of a helpful policeman won a Pulitzer Prize. Actually the cop was politely asking the kid to leave the path of a parade.

Puzzled Meeting

A curious toddler gives a careful inspection to one of her grandmother's dolls, just encountered at an outdoor children's party.

ELIOT ELISOFON

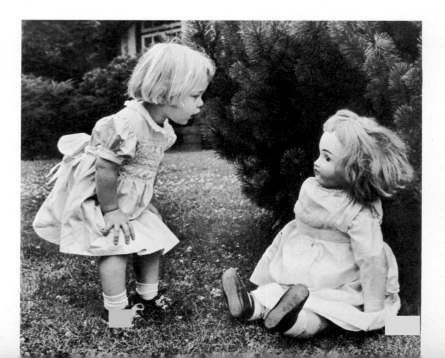

Runaway Fleeing

A frightened youngster dashes down the dark corridors of a children's home, attempting to run away. This haunting photograph, made at high speed in difficult light, was part of a memorable LIFE essay on a bad boy.

RALPH CRANE

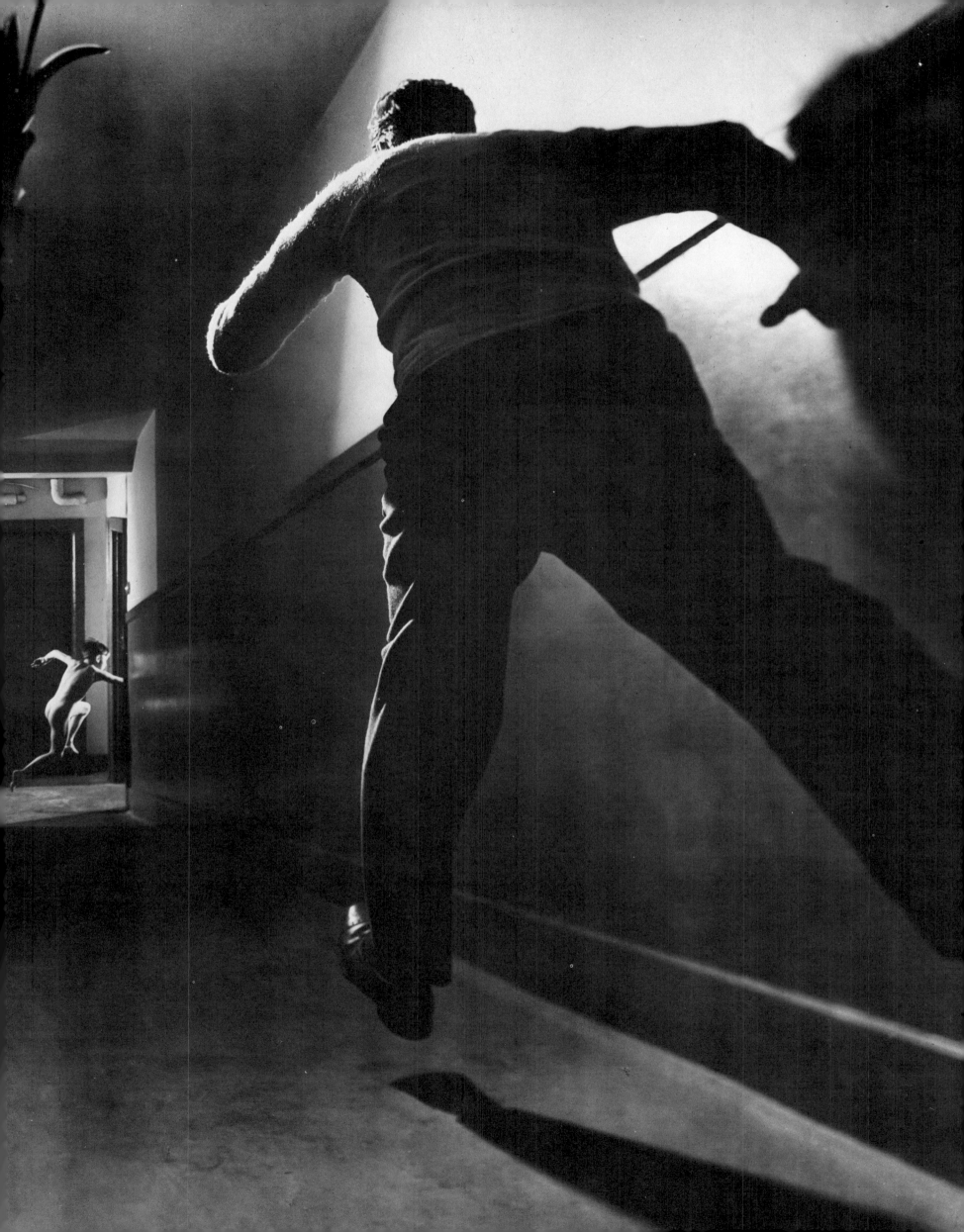

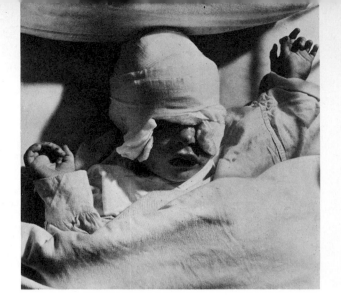

Victim of Nazis

A 2-year-old girl lies dying of the wounds she suffered when a German plane terror-bombed her small Welsh town. Her mother, father and grandmother also died.

WILLIAM VANDIVERT

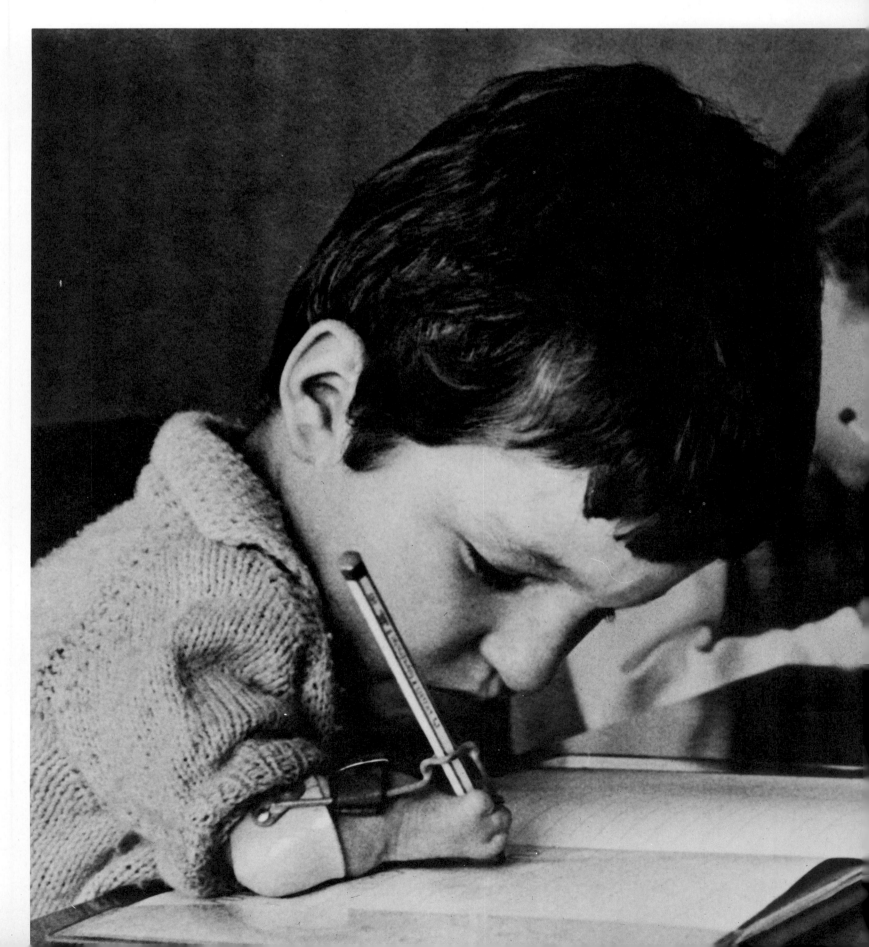

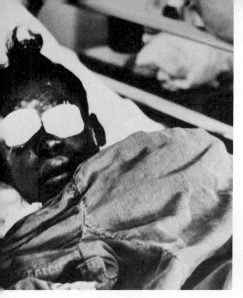

FRANK DANDRIDGE

Victim of Prejudice

Patches covering eyes that were seared by a racist's bomb loosed in a Birmingham, Ala., church, Sarah Jean Collins, 12, fearfully clutches her robe in the hospital.

Victim of a Drug

A 5-year-old boy *(left),* one of 10,000 children born deformed at birth by thalidomide in the 1950s and 1960s, learns to write in a West German kindergarten.

LEONARD McCOMBE

Victim of Poverty

Flavio da Silva *(right),* 12, the boy hero of Parks's essay on a slum family in Rio de Janeiro, rests on Sunday after a week of caring for his brothers and sisters while his parents work. The story made *favela,* Portuguese for slum, a familiar word in North America.

GORDON PARKS

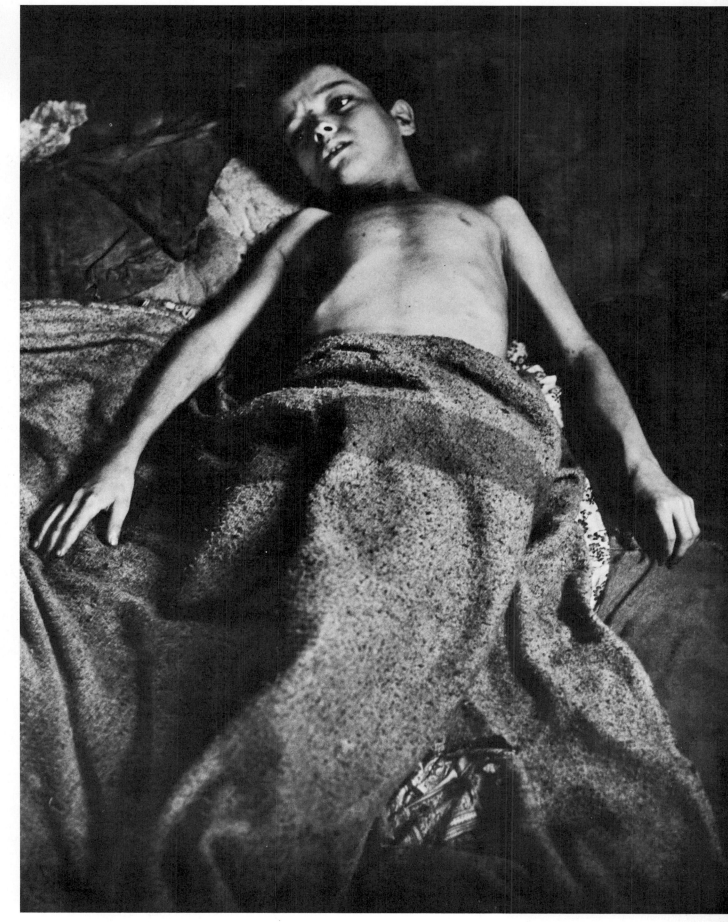

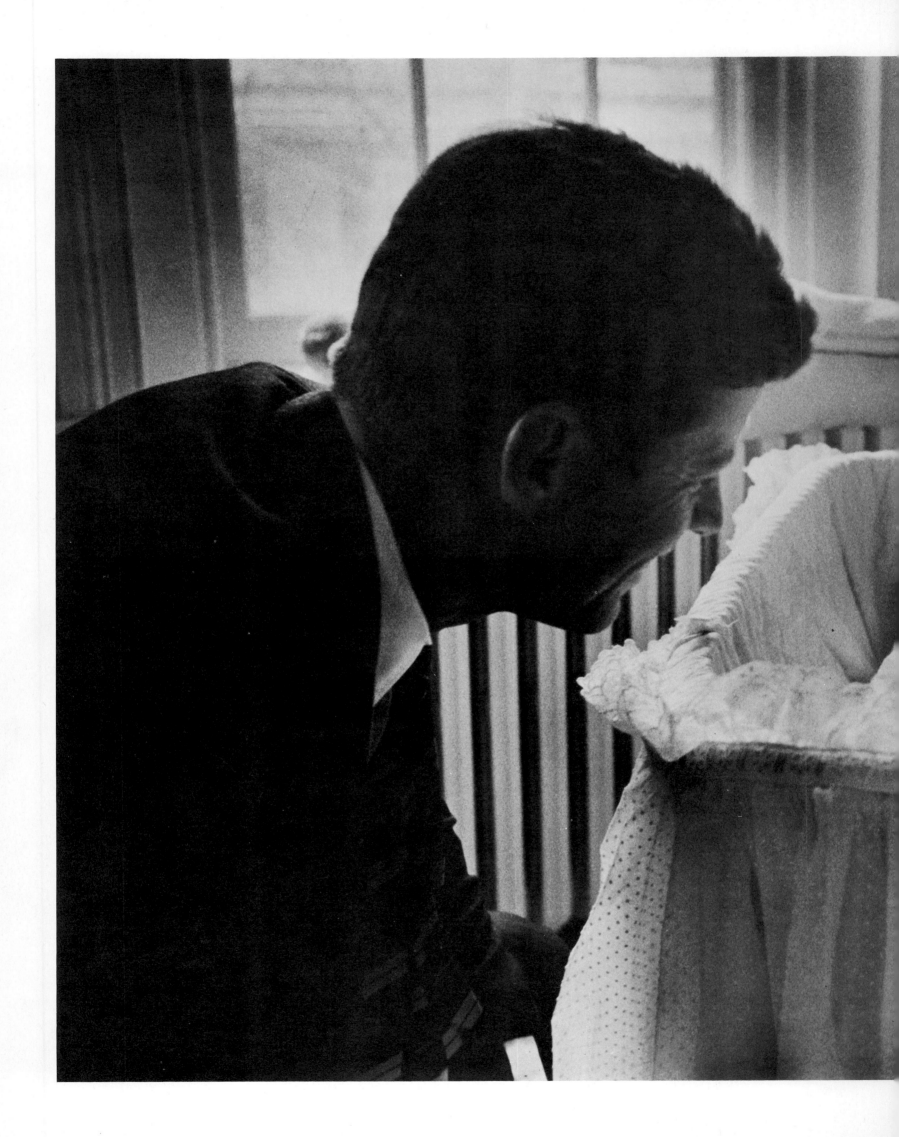

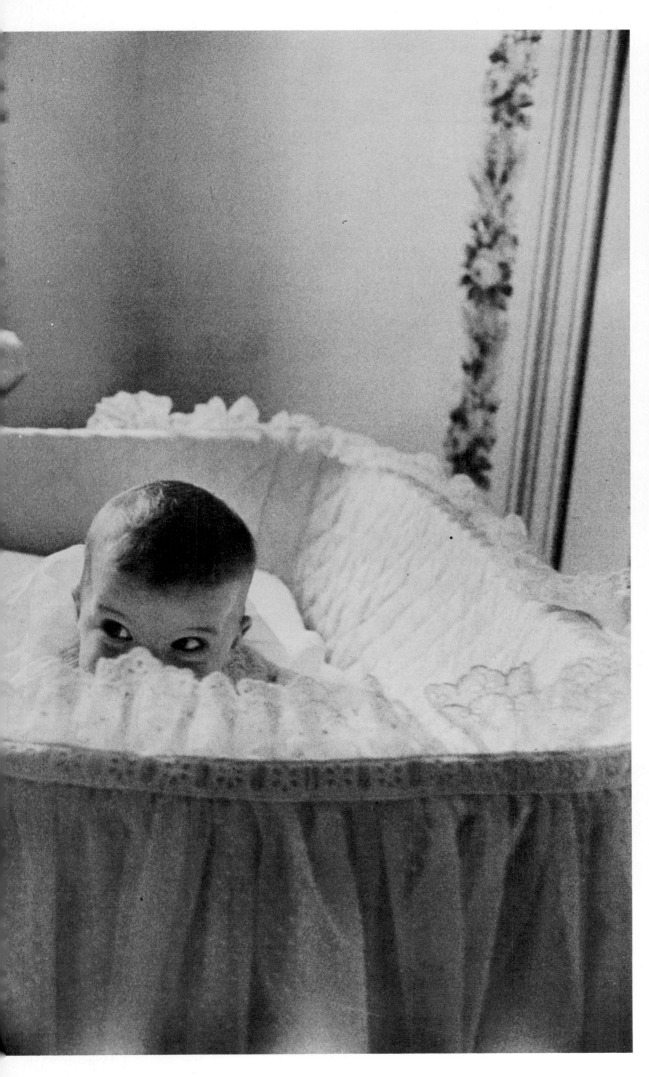

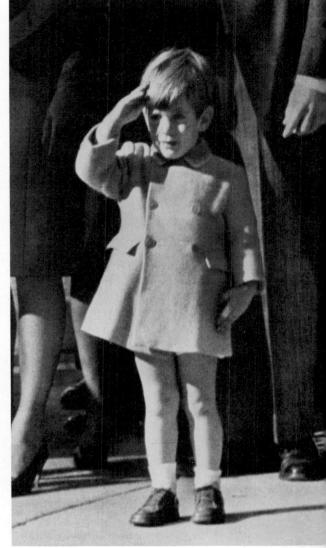

Young Soldier

In one of the heart-clutching moments of President Kennedy's funeral, his 3-year-old son John salutes the coffin as it leaves the cathedral in Washington.

Winsome Infant

A true Kennedy even in the bassinet, Caroline demonstrates her presence before the camera at only 4 months as she greets her father, then-Senator John Kennedy, with this photogenic peek.

EDWARD CLARK

Independence With the confident expression of a champion horseshoe pitcher— and matching form—a 3½-year-old Michigander lets one fly.

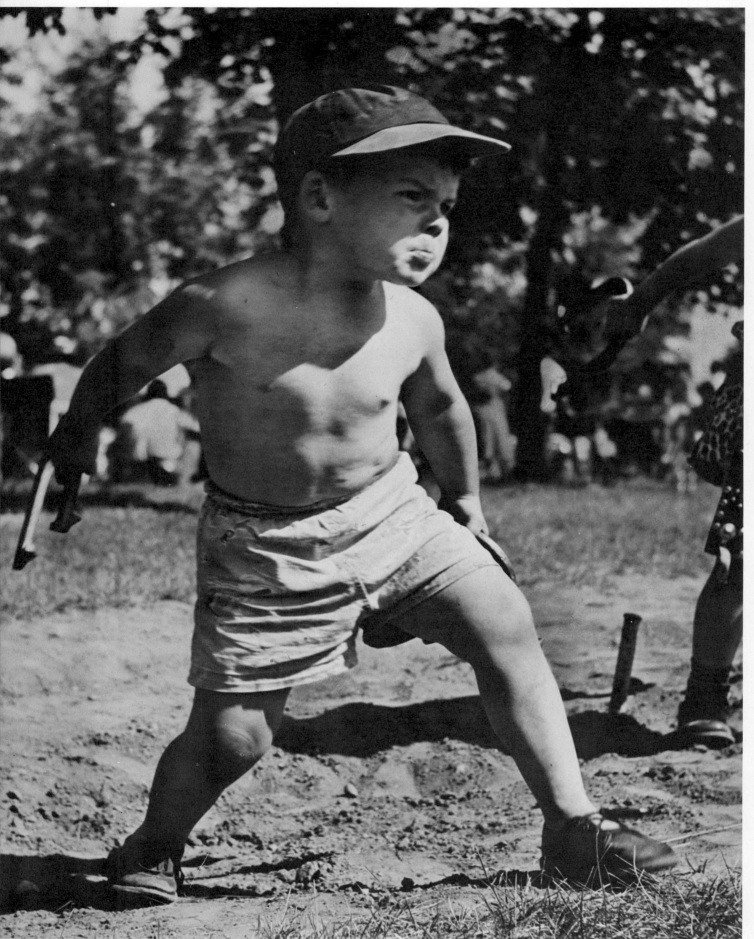

Dependence By popular response, one of the best-loved brother-sister portraits in LIFE's history was this one, of Pat Smith, 4, leading his sister Juanita, 2, along a woodland trail. It was taken by their father.

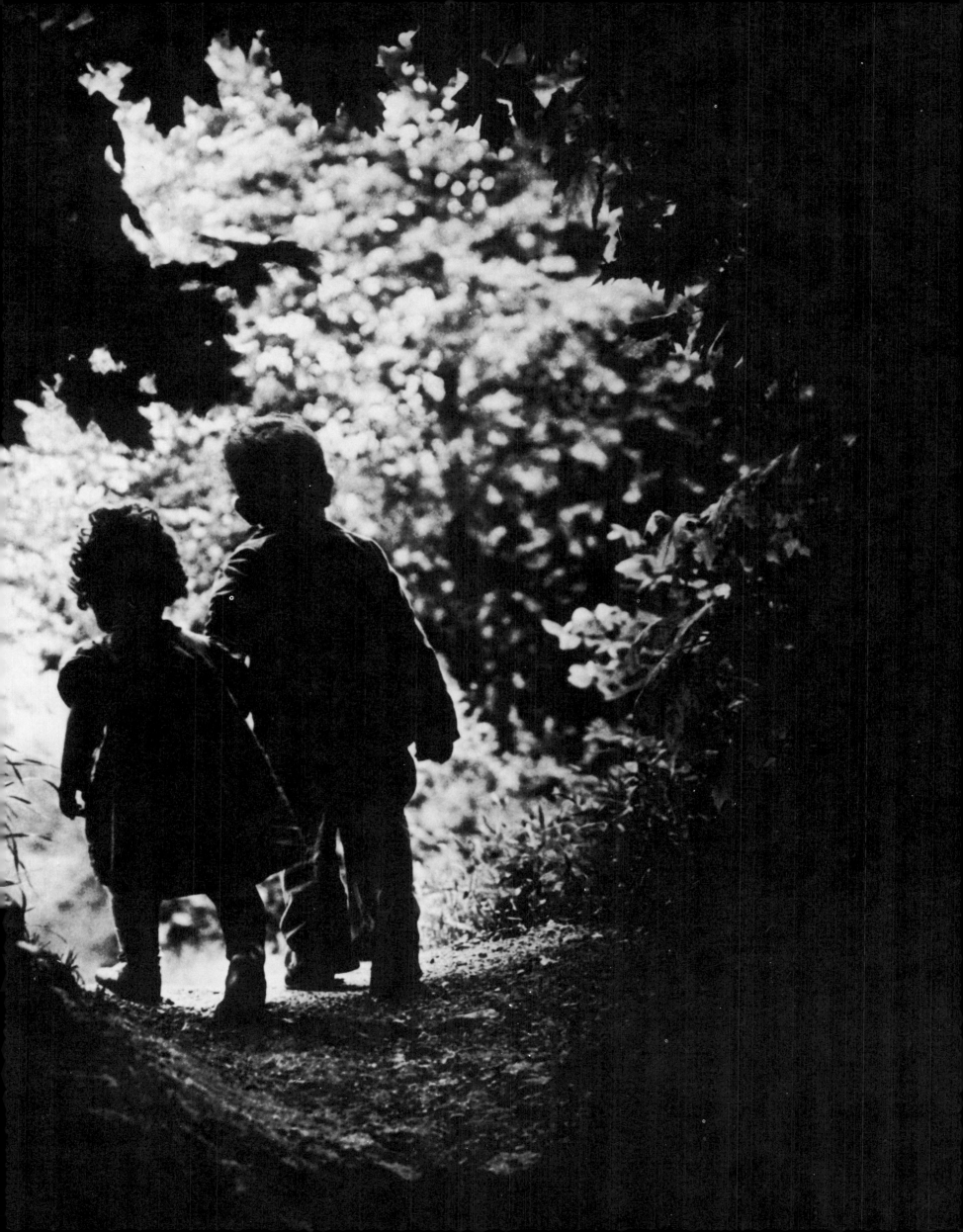

THE
ANIMALS

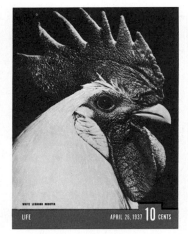

LIFE's only nameless cover

A fascination with all species from the spider to the whale

Animals forever intrigued LIFE. The first issue carried a photographic study of the life cycle of the black widow spider; the last reported on the world's smallest horse. In between, the magazine's editors studied just about every species that walks, crawls, swims, flies, skitters or jactitates, and found animals cute or ugly or comical, according to standards that no one thought to call human chauvinism. It was in respect for a lower species that LIFE omitted its logotype from the cover at left: it would have obscured part of the rooster's glorious comb.

LIFE's photographers followed the zoologists all over the world to study animals in their own environment. John Dominis spent months in Africa stalking the big cats that were his specialty. Stan Wayman, on a photographic expedition to India, spent a fear-filled night in a blind while tigers prowled around him—and then, in broad daylight and using a telephoto lens, got one of his best pictures of a tiger in the distance. Co Rentmeester chased a troop of Japanese snow monkeys through the icy wastes of Honshu Island; not long before that he had been in the steaming heat of Sabah chasing orangutans. Other LIFE photographers climbed cliffs after eagles and hawks and descended into the sea to observe whales and other creatures of the deep.

Not least of the hazards of animal photography was that the photographer often grew even more infatuated with the subject than the editors. By the time he had finished photographing terriers *(left),* Leonard McCombe had become such a canine lover that he found he could not resist bringing dogs home from the local pound.

A merry wire-haired fox terrier performs a dancing leap.

LEONARD McCOMBE

A male baboon displays his teeth during a feeding altercation.

TERENCE SPENCER

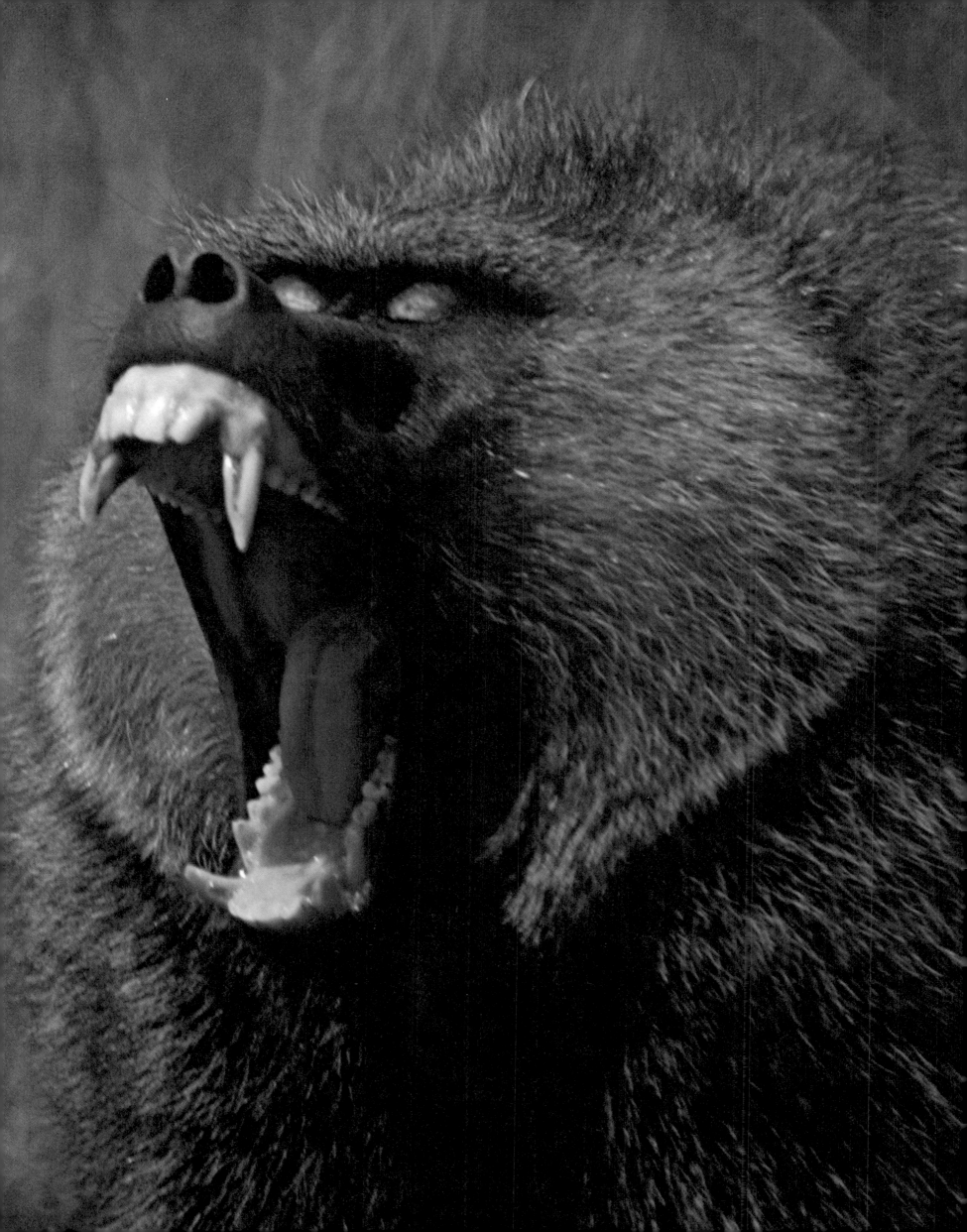

Winged Lion Fish

Looking more winged than finned, a brightly colored reef dweller that is cousin to the poisonous stonefish drifts over the coral.

FRITZ GORO

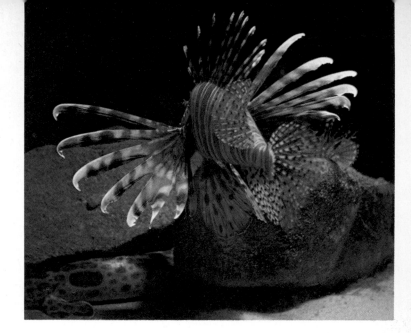

Flying Whale

Some 30 tons of humpback bursts from the sea off Bermuda during spring migration when the humpbacks move north for calving.

JOHN DOMINIS

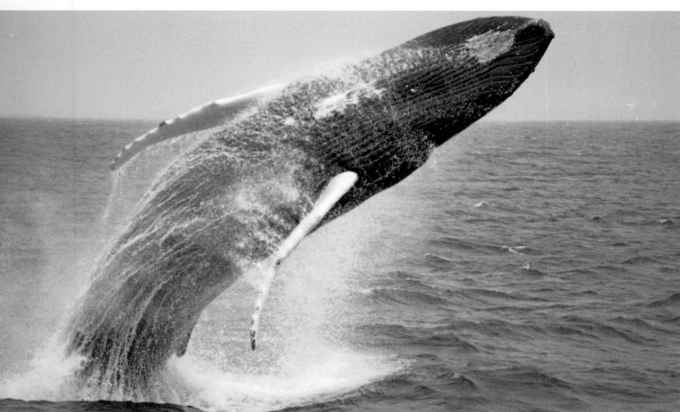

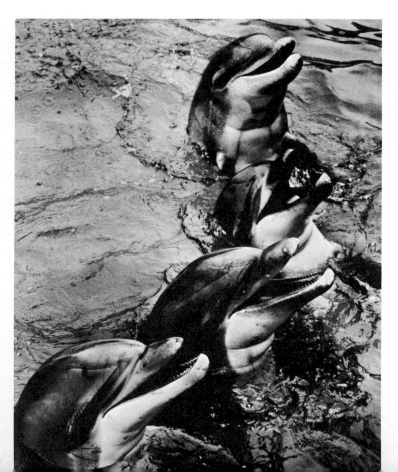

Hungry Dolphins

Showing almost human anticipation, four of man's lovable fellow mammals await the fish course at California's Marineland.

PETER STACKPOLE

Attacking Shark

This heart-stopping view of a 16-foot white shark, its jagged teeth at the ready, was made from inside a submerged cage.

VALERIE TAYLOR

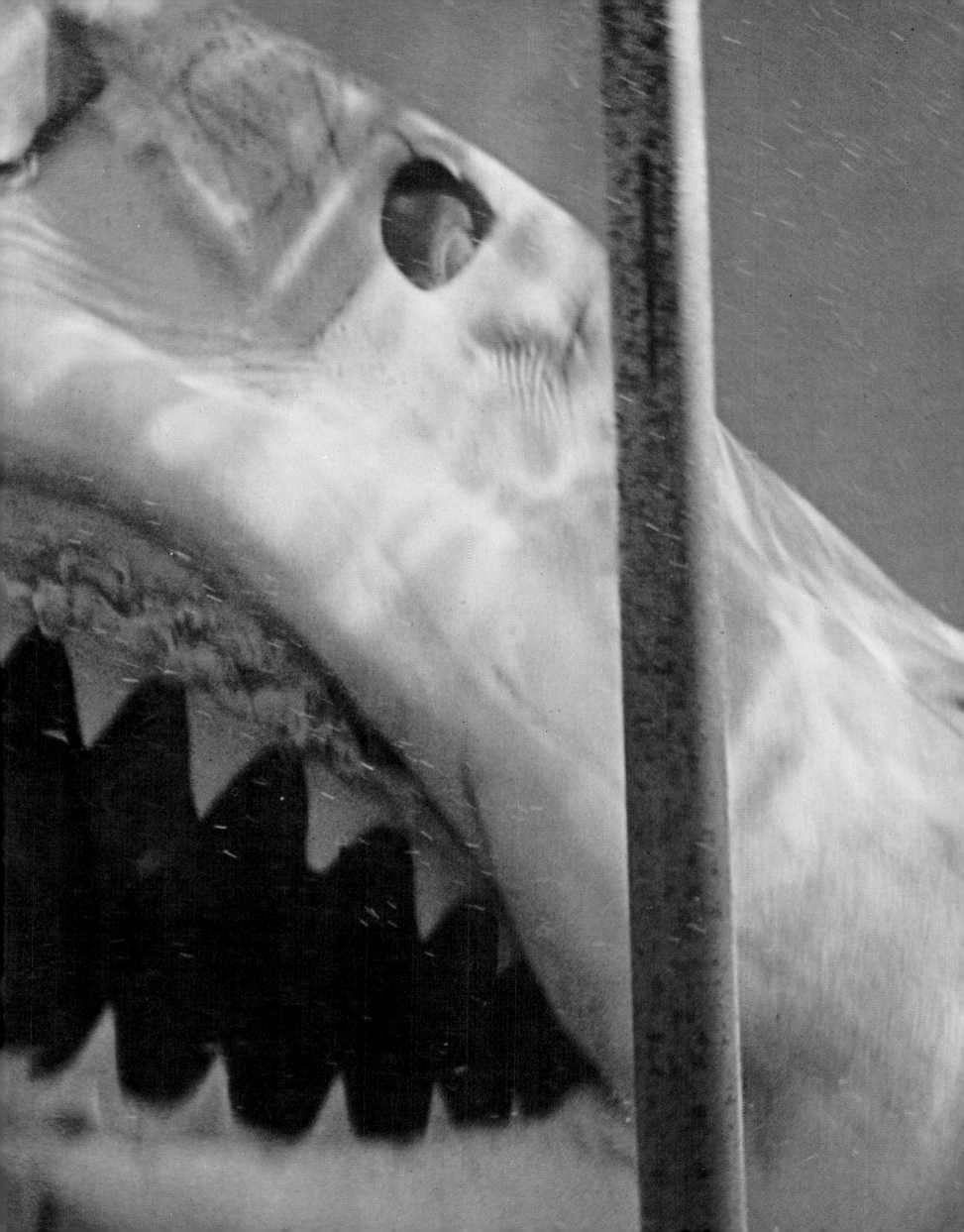

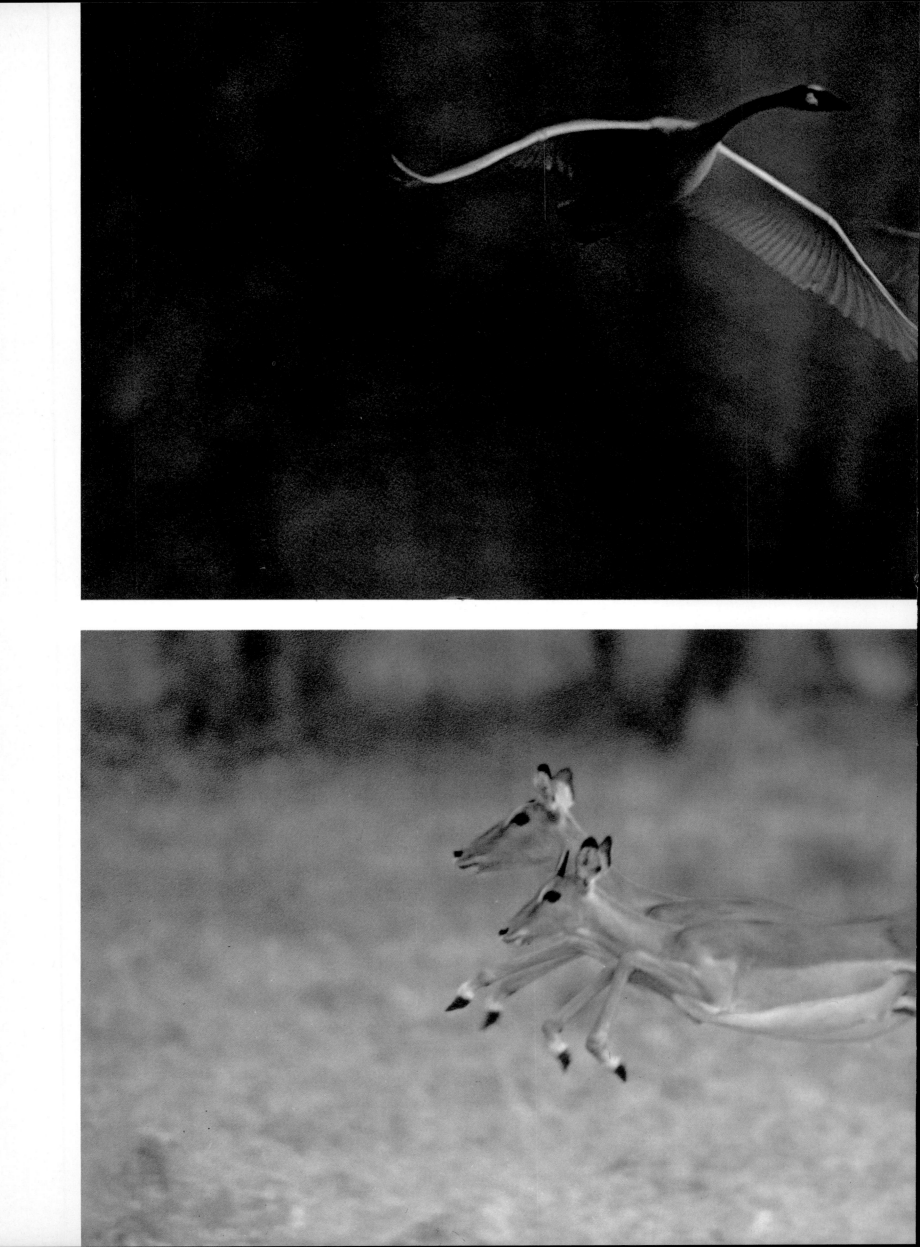

Trumpeters in Flight

Wings beating in synchronism, two trumpeter swans fly over their Canadian winter habitat in this rare close-up of a species that was saved from near extinction.

VERNON MERRITT III

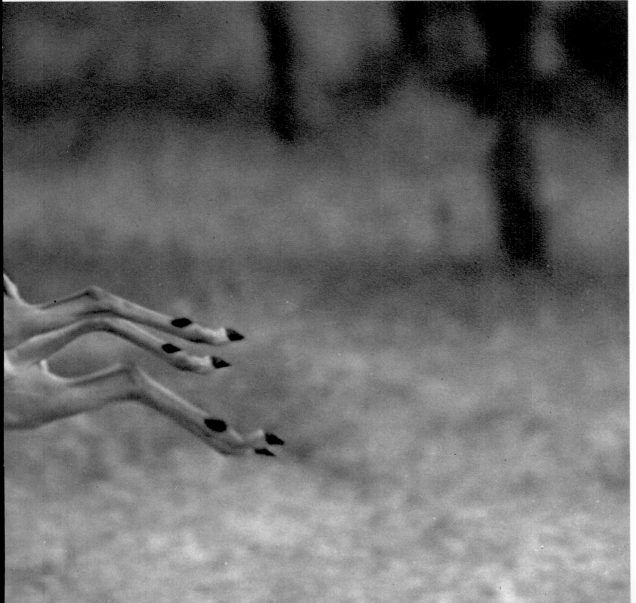

Impala in Mid-Leap

Two of Africa's most prodigious leapers—they can clear 35 feet at a bound—are caught with a 600-mm. lens, making their hurtling resemble formation flying.

JOHN DOMINIS

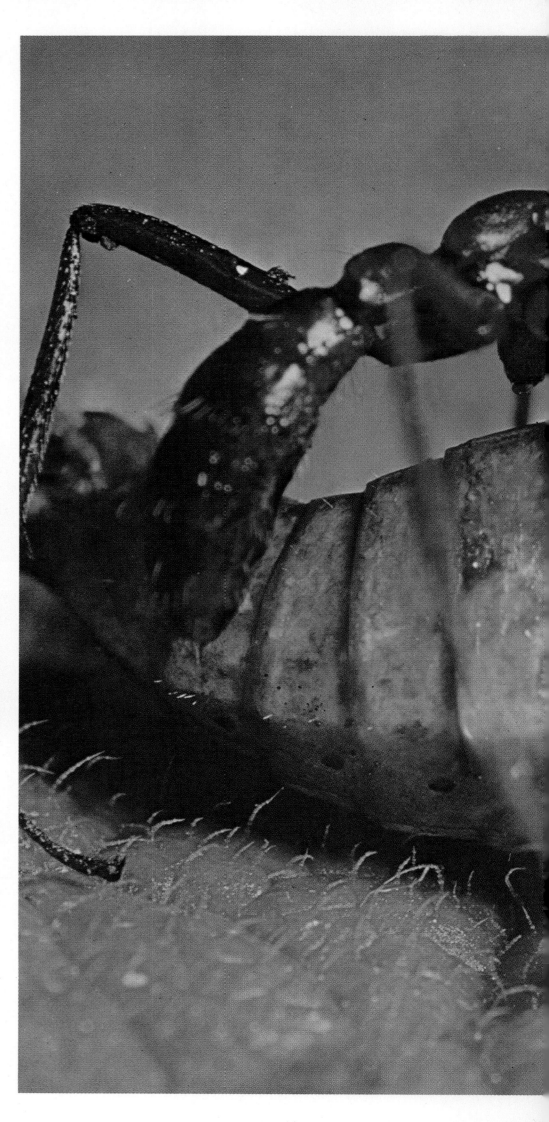

Insouciant Elephant

This jaunty African pachyderm perfectly illustrated the thesis of author Romain Gary, who wrote an accompanying "love letter" bemoaning the threat of oblivion to this noble creature. Gary concluded: "You are, dear Elephant, sir, the last individual."

PETER BEARD

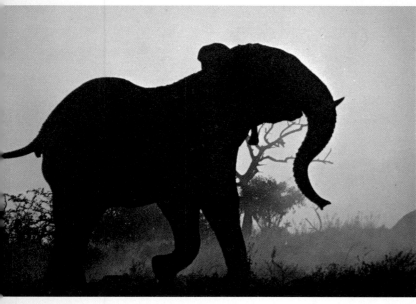

Voracious Ant

To get this close-up of an African driver ant killing a grasshopper, the photographer wore a skin-diving suit and gloves in 98° heat. But some ants got to him anyway.

CARLO BAVAGNOLI

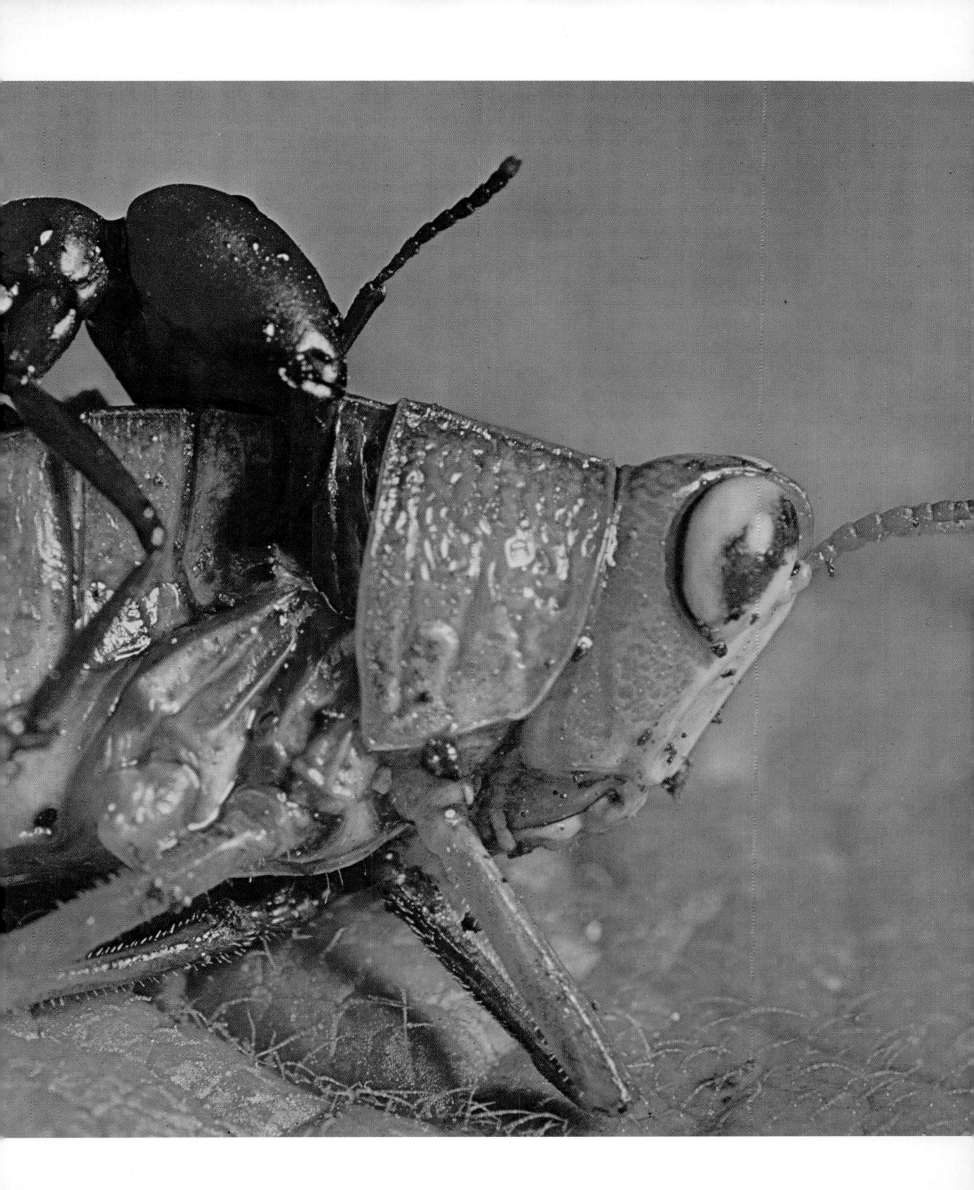

Lazy Lion

This picture of the king of beasts napping in the Serengeti provides beguiling proof of the fact that, despite their bellicose reputation, male lions actually spend some 17 hours of the day sleeping.

JOHN DOMINIS

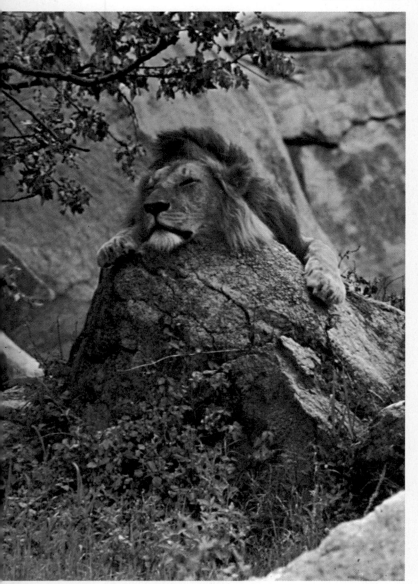

Lurking Tiger

What at first looked to the photographer like a tuft of sunrise-gilded Indian grass proved, when shot through a 600-mm. lens, to be this almost perfectly camouflaged cat.

STAN WAYMAN

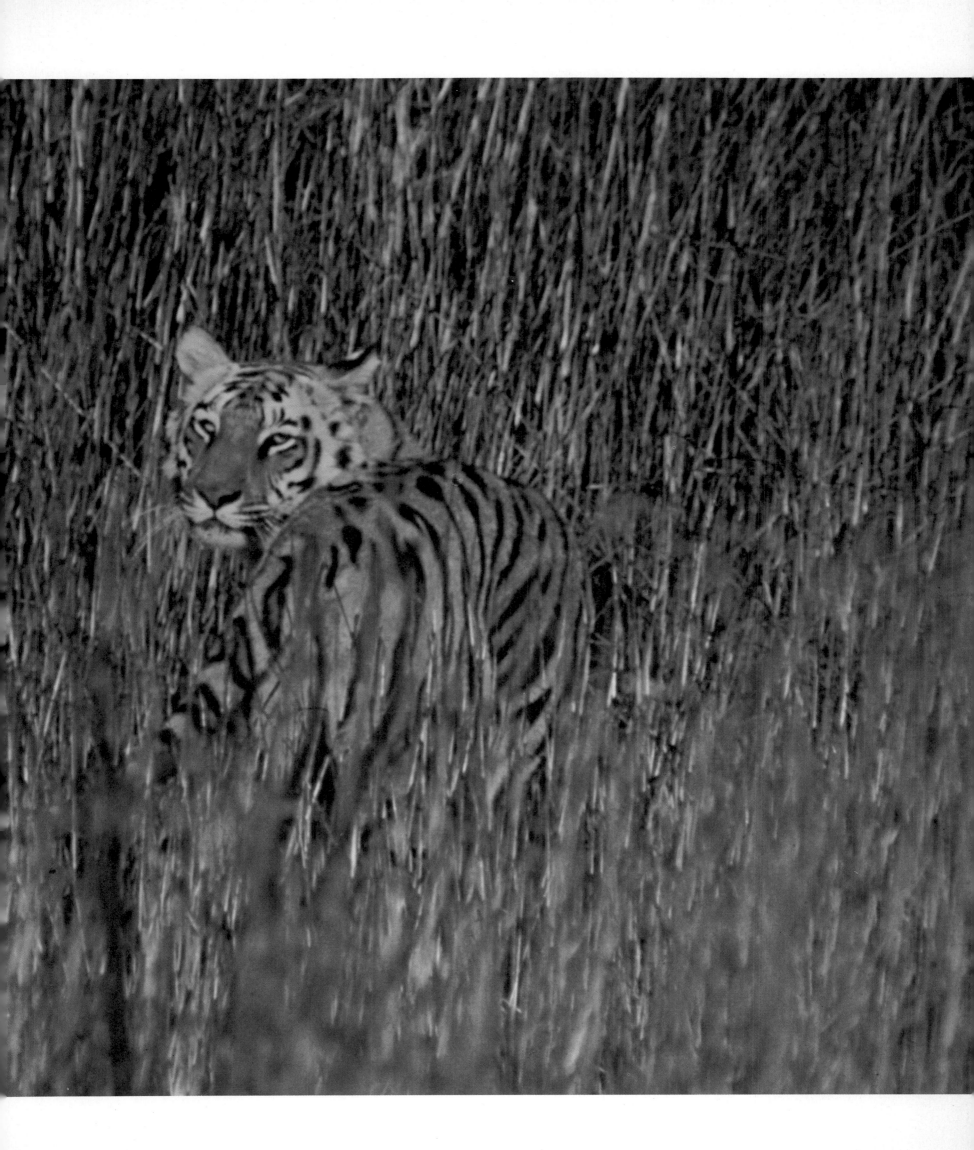

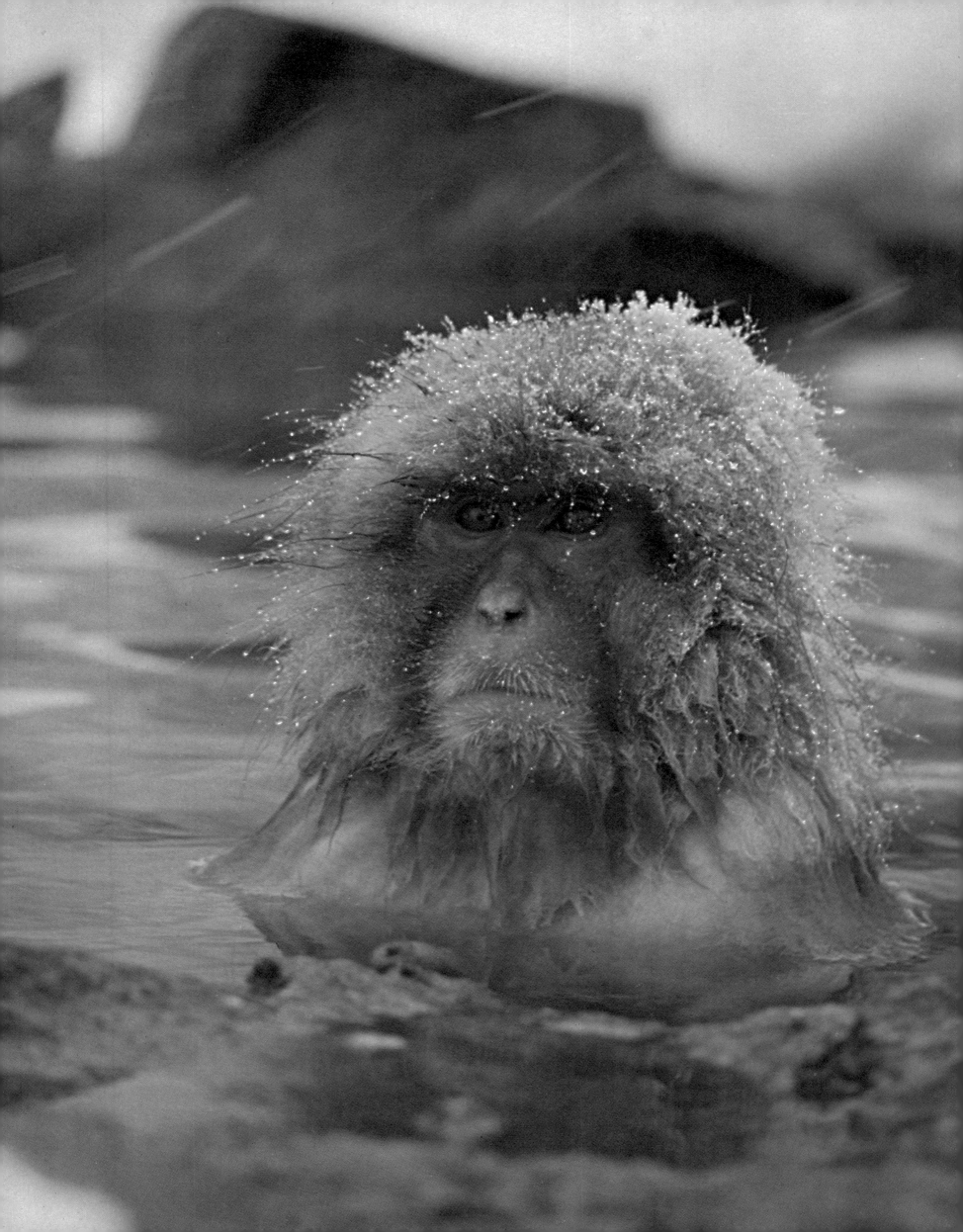

Steaming Simian

On the Japanese island of Honshu, the matriarch of a troop of Japanese snow monkeys sits out a snowstorm in a warm spring.

CO RENTMEESTER

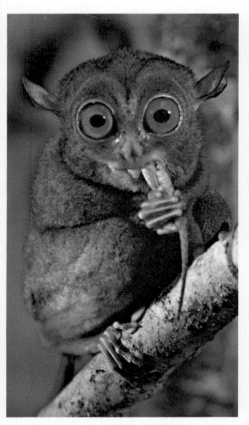

LARRY BURROWS

Sharp-eyed Tarsier

A swivel-headed Southeast Asian relative of the lemur chomps on a lizard which it has detected with its sharp eyes and sensitive ears.

Manly Mandrill

A West African mandrill is resplendent in the brilliant facial color indicating that he is a male adult and a formidable fighter.

NINA LEEN

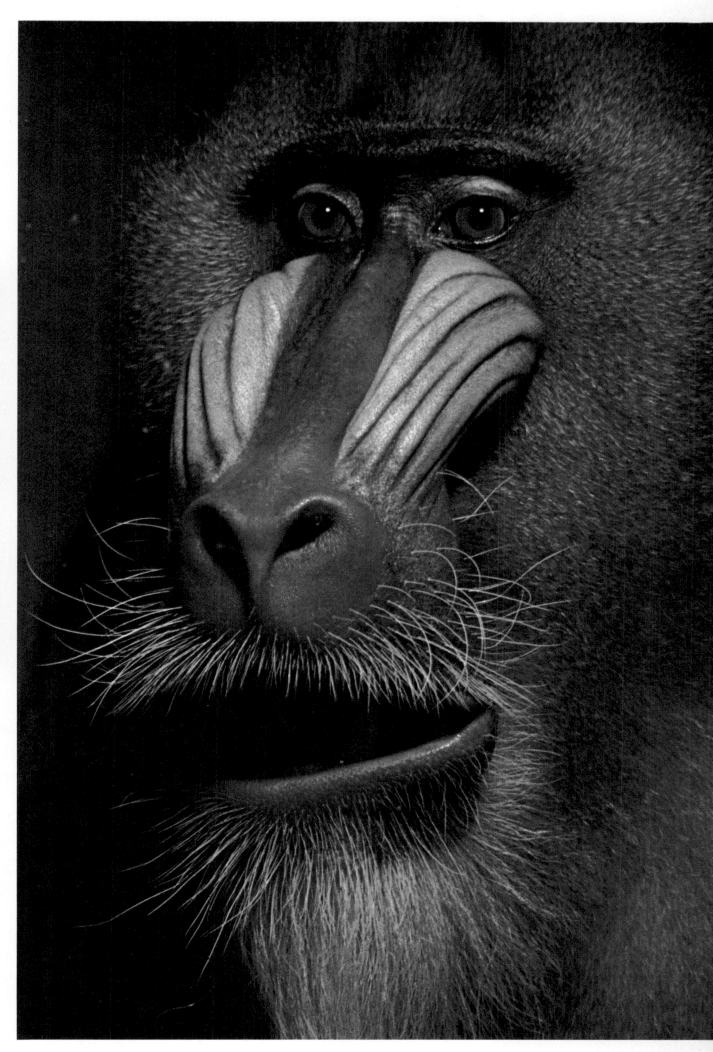

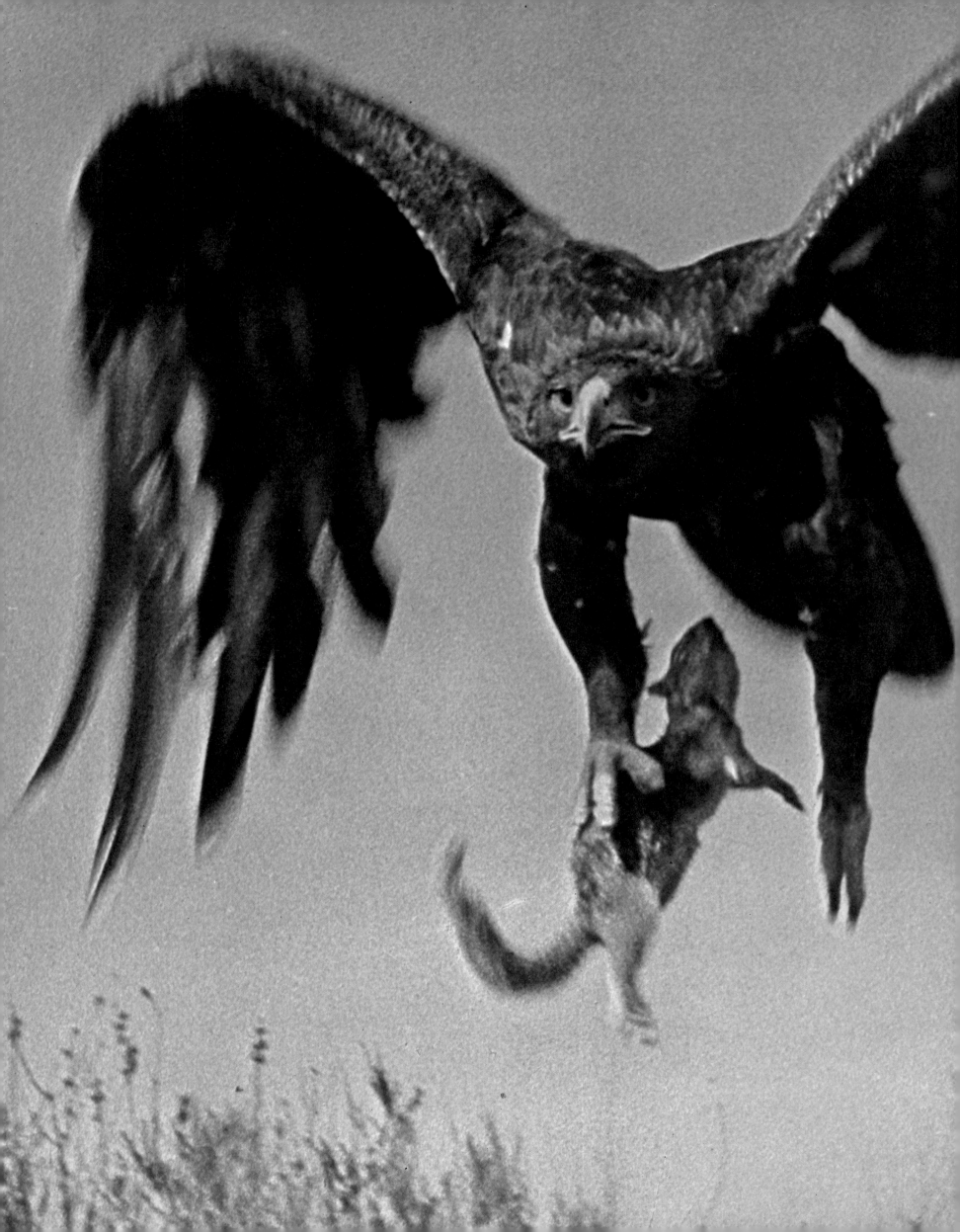

An Eagle's Swoop

Nature's ruthless law is captured in this photograph as surely as the ground squirrel in the talons of the California golden eagle.

GEORGE SILK

A Bat's Defense

Nina Leen's photographic study of bats included this close-up picture of a South American vampire bat defending its family.

NINA LEEN

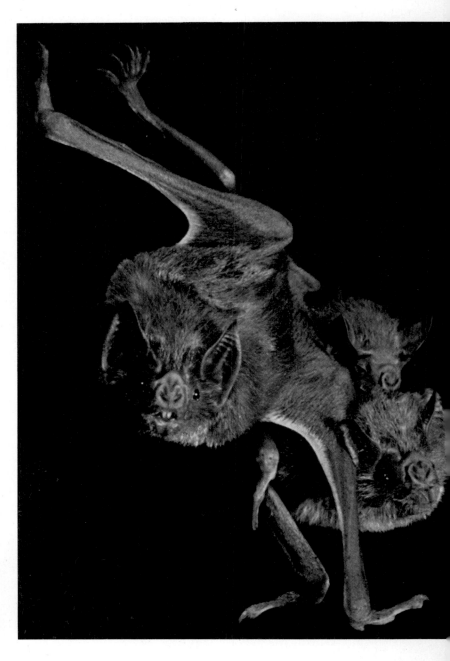

A Frog's Smile

Eisenstaedt found and immortalized this placid amphibian when he met it at its own level while he was photographing the fauna of a pond from a child's viewpoint.

ALFRED EISENSTAEDT

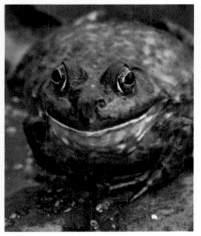

Snakes' Birth

To be sure she would not miss the hatching, Miss Leen kept a vigil over these corn snake eggs for 10 days, and then photographed the emergence of two 15-inch infants.

NINA LEEN

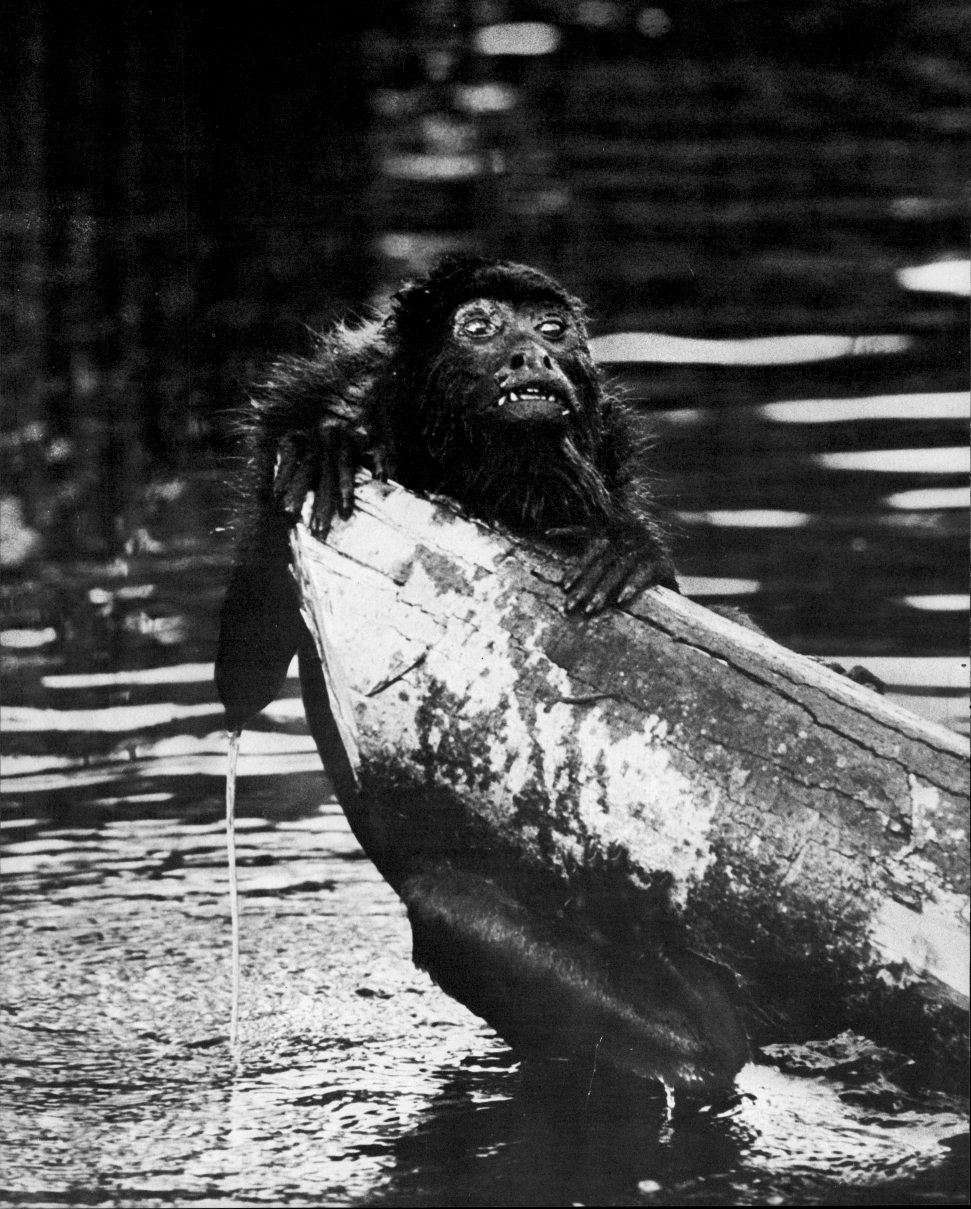

A Monkey's Panic

With a piercingly human expression of terror, this howler monkey is trapped between approaching rescuers and death by drowning in a flood in the Surinam jungle.

STAN WAYMAN

A Panda's Peek

In 1941, Mme. Chiang Kai-shek sent the Bronx Zoo two baby pandas. When the crates were opened, a bowl of milk helped to produce this bashful portrait.

JOHN PHILLIPS

An Orangutan's Stance

In an unconscious human imitation, a red-haired orangutan in a Sabah rain forest seems to pose like The Man with the Hoe.

CO RENTMEESTER

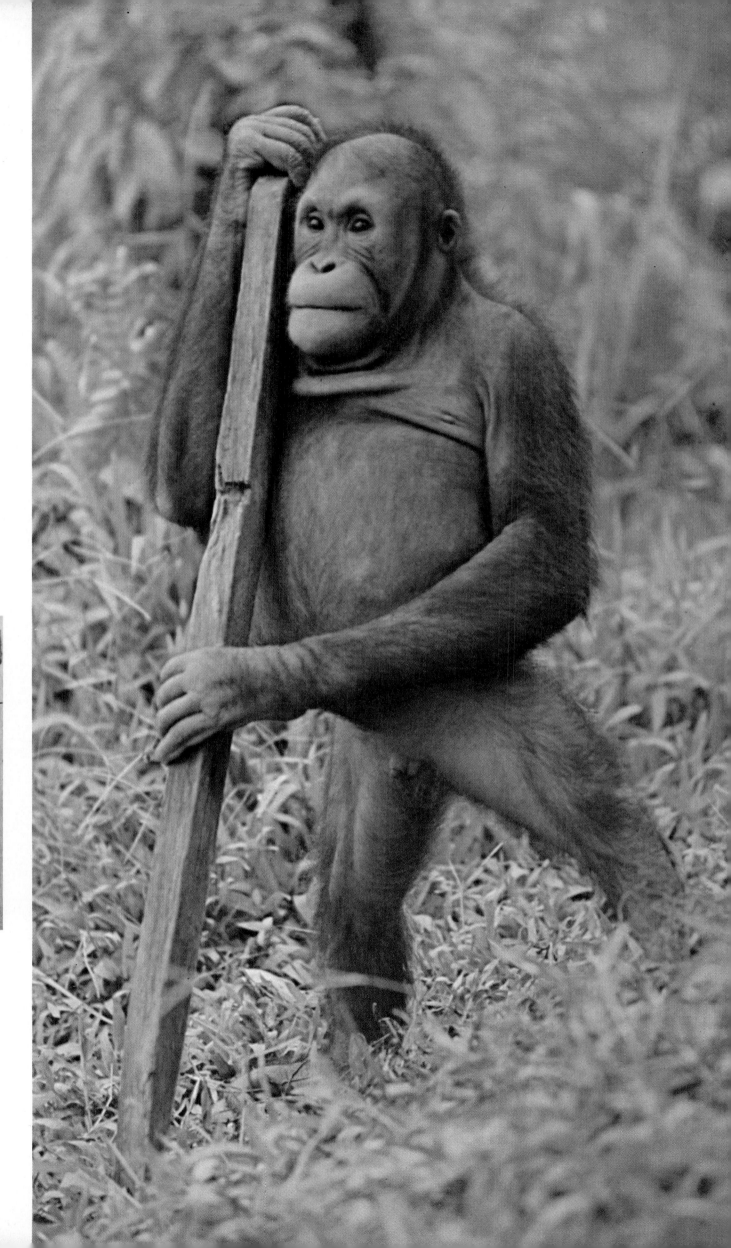

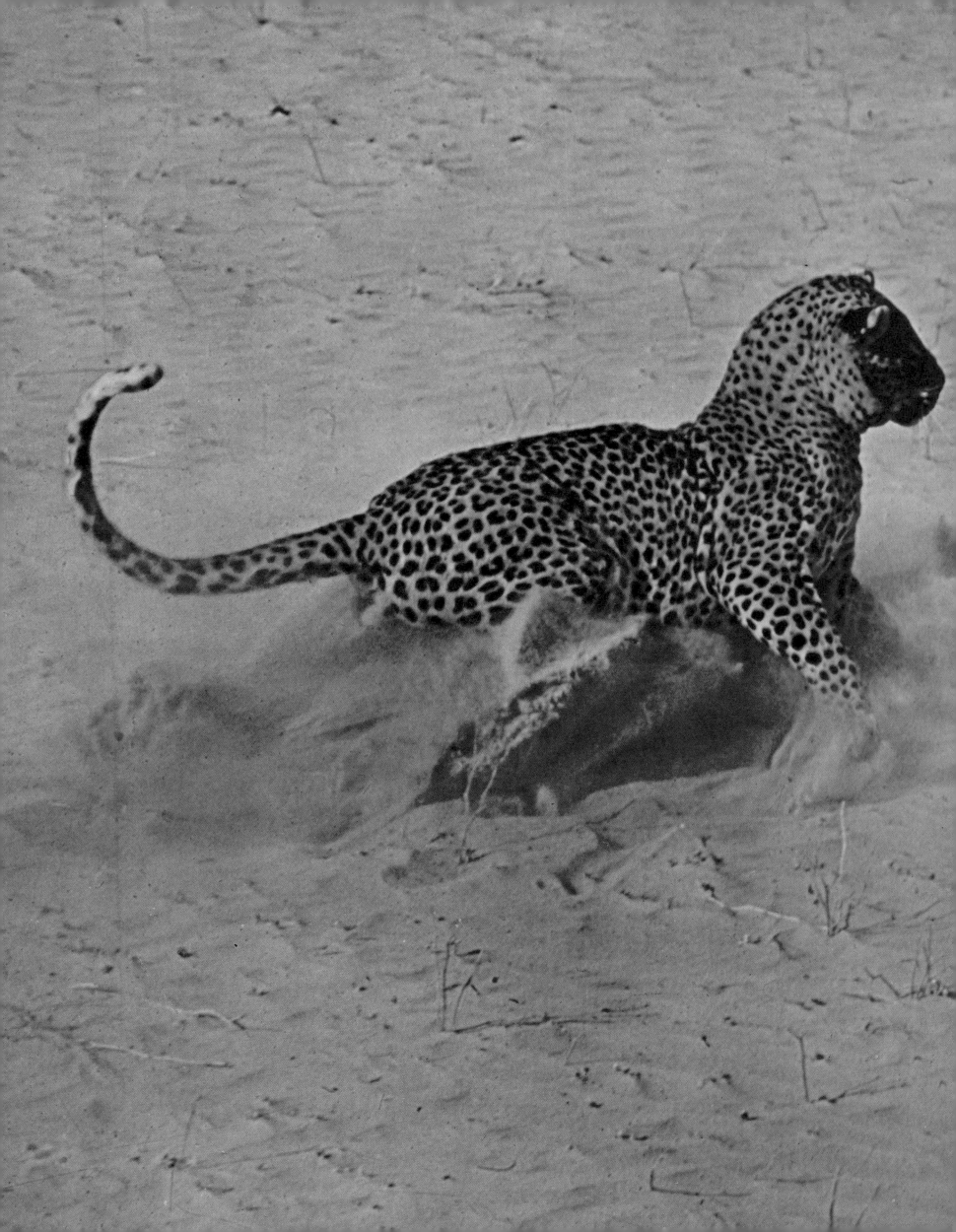

A Leopard's Kill This climactic moment, in which a terrified baboon makes a desperate last stand against the most ferocious of cats, is considered by many to be the best picture of such a confrontation ever made.

THE FADDISTS

Pictures that reported–and often abetted–the nation's silly season

Americans could seldom resist the latest fad, no matter how zany, undignified or downright dangerous. Neither could LIFE. The magazine not only reported each new mania but also helped to launch more than one. The craze that came to symbolize the silly side of pre-World War II college life was born early in 1939 when LIFE published a picture of Harvard freshman Lothrop Withington Jr. about to swallow a goldfish. Almost before Withington Jr. could hiccup, collegians everywhere were gulping little fishes—and sending their pictures to LIFE.

When an Ohio flagpole-sitter married his girl friend atop a 176-foot pole in 1946, LIFE (with tongue only half in cheek) called it "a return to peacetime normalcy," and covered the nuptials by helicopter. Vibrations ruined the pictures. But later photographer Allan Grant talked the couple into repeating the wind-blown ceremony *(page 226).* He borrowed a more stable platform to shoot from: a Goodyear blimp. In 1959, a later generation of collegians competed zealously to see how many of them could squeeze into a phone booth. When the stuffing nonsense faded, LIFE introduced an equally senseless import from Canada: marathon bed-pushing.

Some fads, like saddle shoes, make periodic comebacks. Most disappeared as abruptly as they came and an unwary manufacturer could be stuck with a warehouse full of Hula Hoops, Super Balls or 3-D glasses. A few, like the desperately exhausted 1937 "walkathon" dancers *(upper right),* became telling landmarks of the age that spawned them.

Covering such stories sometimes inspired serious progress in photography. For a LIFE essay in 1943, Gjon Mili used his then-new technique of silhouetting dancers with high-speed strobe lights to capture the airborne exuberance of the jitterbugs.

Jitterbugs dug the Lindy Hop,
named for Lindbergh's flight.

GJON MILI

FRED P. PEEL

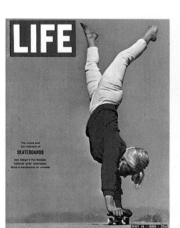

Acrobatic skateboarder

From the sagging marathon dancers *(top)* and goldfish gulpers of the '30s evolved the skateboard nut of the '60s.

223

"Dav-ey Crockett"

Dealers in coonskin caps enjoyed a brief bonanza in 1955 when millions of kids like this one imitated "the king of the wild frontier," as he was popularized by Fess Parker in a TV series.

RALPH MORSE

The Zoot Suit

A true hepcat's 1942 "threads" featured six inches of shoulder pad, a knee-length jacket and balloon trousers hitched chest high —until the War Production Board ruled out such wasteful clothes "for the duration."

MARIE HANSEN

MARTHA HOLMES

Rhyme without Reason

Histrionics like these accompanied a 1947 fad in which collegians talked in outlandish rhyme. She: "What's the deal, McNeal?" He: "Got no tale, nightingale."

Wrong Number

This phone booth crammed with 22 undergrads of St. Mary's College looked like the ultimate example of stuffing people into tight places. But the record was 34.

JOE MUNROE

ALLAN GRANT

Flagpole Wedding The craze for flagpole-perching reached a new high when an Ohio couple was married aloft in 1946.

Hula-Hoop Horde

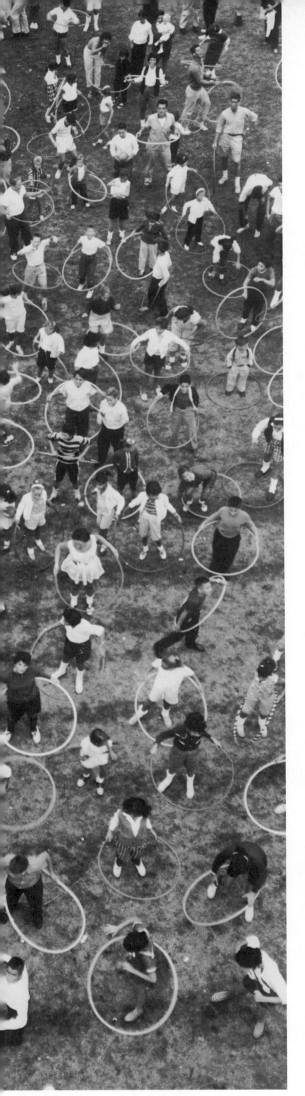

It was a circuitous field day when hip-twisters assembled to twirl hoops in Union, N.J., in 1958.

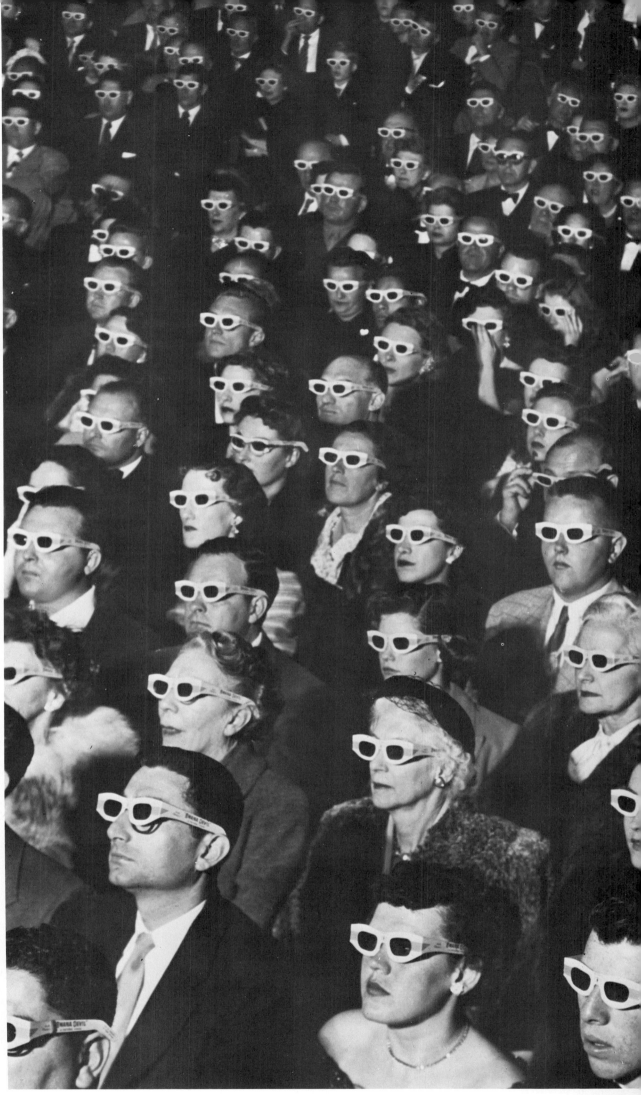

3-D Movies These 1952 movie-goers saw a film in three dimensions. But filter glasses lasted only briefly.

Cross-Country Bedlam Spawned in Canada, the dubious urge to set speed and distance records for pushing a bed cross-country went Hollywood in 1961. This University of Southern California squad had starlet Paula Lane aboard for their push across the desert to Las Vegas.

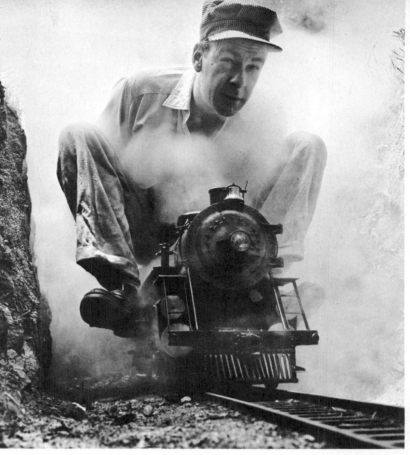

RICHARD HARTT

Tiny Iron Horse Steam locomotives were already an endangered species in 1952 when Californian Ollie Johnston built himself a 16-inch-high working model and chugged around his own backyard.

"Chicken" at the Wheel To test their youthful nerve, postwar hot-rodders raced jalopies at 70 mph with "no hands" until somebody "chickened out" and grabbed the steering wheel.

RALPH CRANE

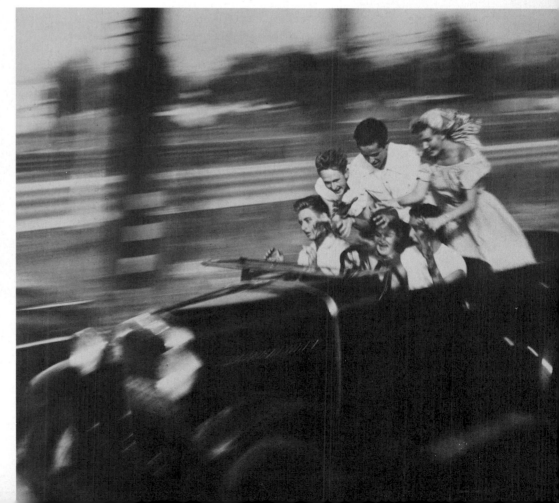

Two-wheeled Terror

The single picture below told the story of a motorcycle club's riotous invasion of a California town on Fourth of July, 1947. Six years later the episode inspired a memorable movie, *The Wild One*.

BARNEY PETERSEN

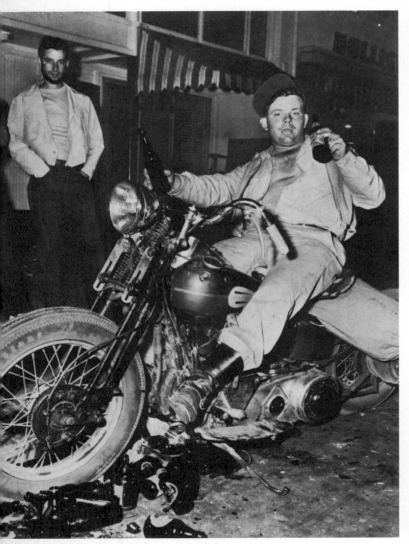

Masked Riders

Their faces protected against the storm of dust, part of an army of 650 motorcyclists zzroooms past the camera on a race across the Mojave Desert in 1971.

BILL EPPRIDGE

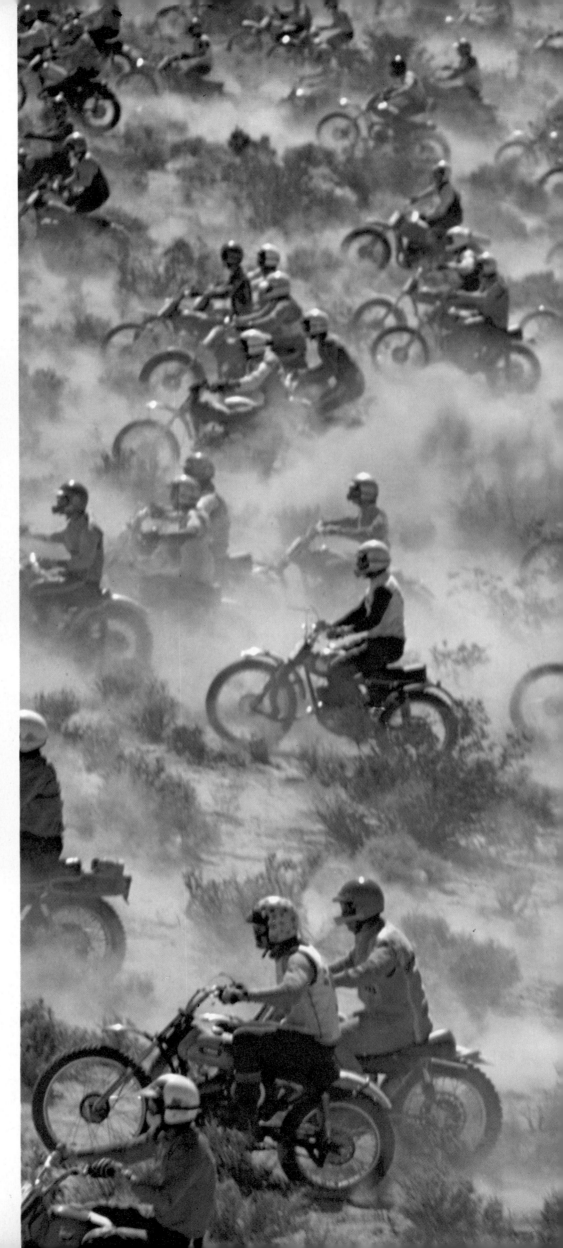

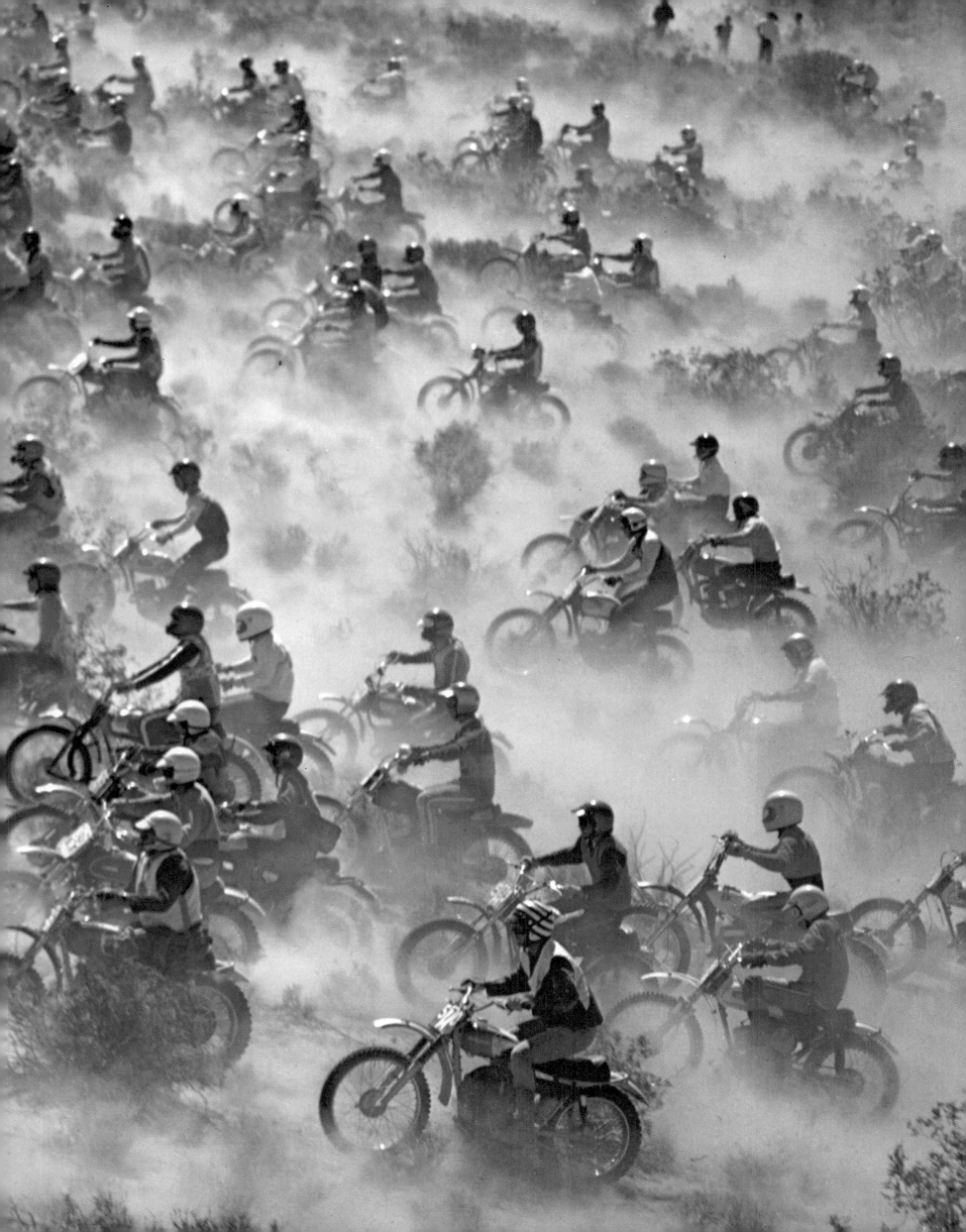

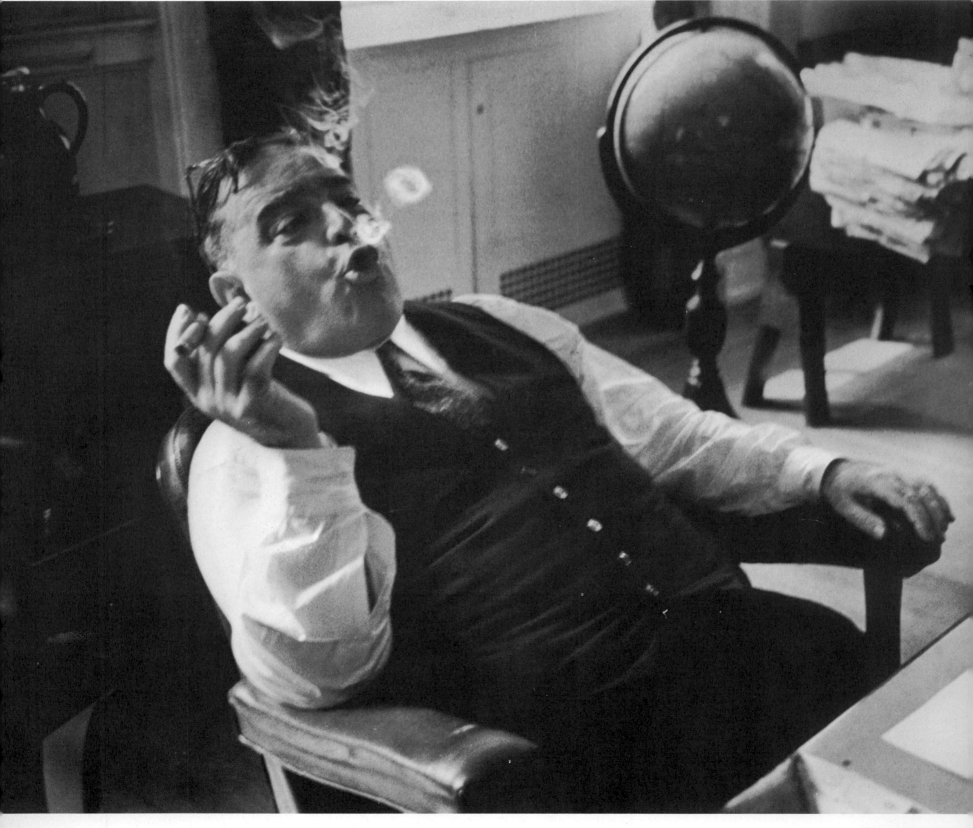

WILLIAM C. SHROUT

No mayor did a better job running New York than Fiorello LaGuardia. And none put on so good a show—the "Little Flower" could make a theatrical production out of just blowing smoke rings.

famous—sometimes shy, often hammy—who sat for posterity

Glamor deb Brenda Frazier

George Bernard Shaw at 87

A photographer on assignment had to be many-faceted when he came up against a reluctant subject. He had to be part con man and part impresario. But often enough, he found that people who professed to be camera-shy turned into arrant hams once they faced the shutter. It was expected that flamboyant Fiorello LaGuardia, who once did a radio stint reading Sunday comics to New York kids, would put on a vaudeville show *(left)*. But it was surprising that so many others turned into character actors or simply turned on.

For John Bryson, Ernest Hemingway made himself into the irrepressible figure of eternal youth and called the result "the best picture of me ever taken." Dame Edith Sitwell, without prompting, got herself up as if for a part in an Elizabethan drama. For Gjon Mili, Pablo Picasso squatted in the dark waving a flashlight before an open lens. A flash of strobe revealed the artist beginning to draw a wild beast in thin air. Frank Costello, that mysterious underworld figure, met Leonard McCombe and apparently assumed the typecast role he had seen in movies. "His clothes were sharp and he acted in a refined way," recalls McCombe, "and when he puffed out the smoke, I felt he was reminding me of George Raft."

Henry II, Ford boss

Painter Grandma Moses at 100

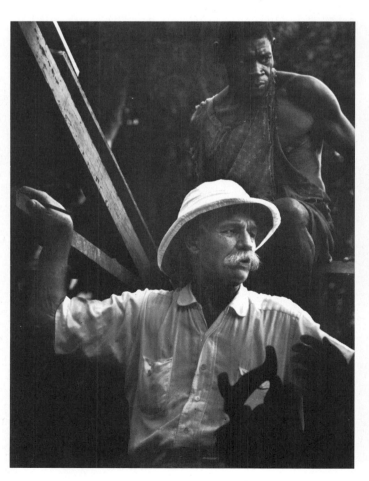

No man came closer to sainthood in his lifetime than Dr. Albert Schweitzer, missionary in Africa.

W. EUGENE SMITH

All-round writer Norman Mailer

The P.M. Steps Out

Clement Attlee and wife Violet *(below)* perform a prime ministerial chore: dedicating stepping-stones across the River Mole.

Mr. Speaker Gets the Word

In his N. Attleboro, Mass., newspaper office, Joseph W. Martin hears a G.O.P. sweep will make him Speaker of the House.

A Candidate Runs Thin

His shoes, like his energies, badly worn by the 1952 Presidential campaign, Adlai Stevenson *(below)* reveals a hole in his sole.

A Hand Pulls Votes

"I'm Estes Kefauver," he'd murmur, and reach for a handshake *(above)*. This approach won so many votes that for a while the Senator led in the 1956 Democratic Presidential primaries.

Patients Please the Doctor

"I whoop it up too much with children," confessed Dr. Benjamin Spock *(left)*, pediatrician turned politician, whose book helped to raise millions of babies.

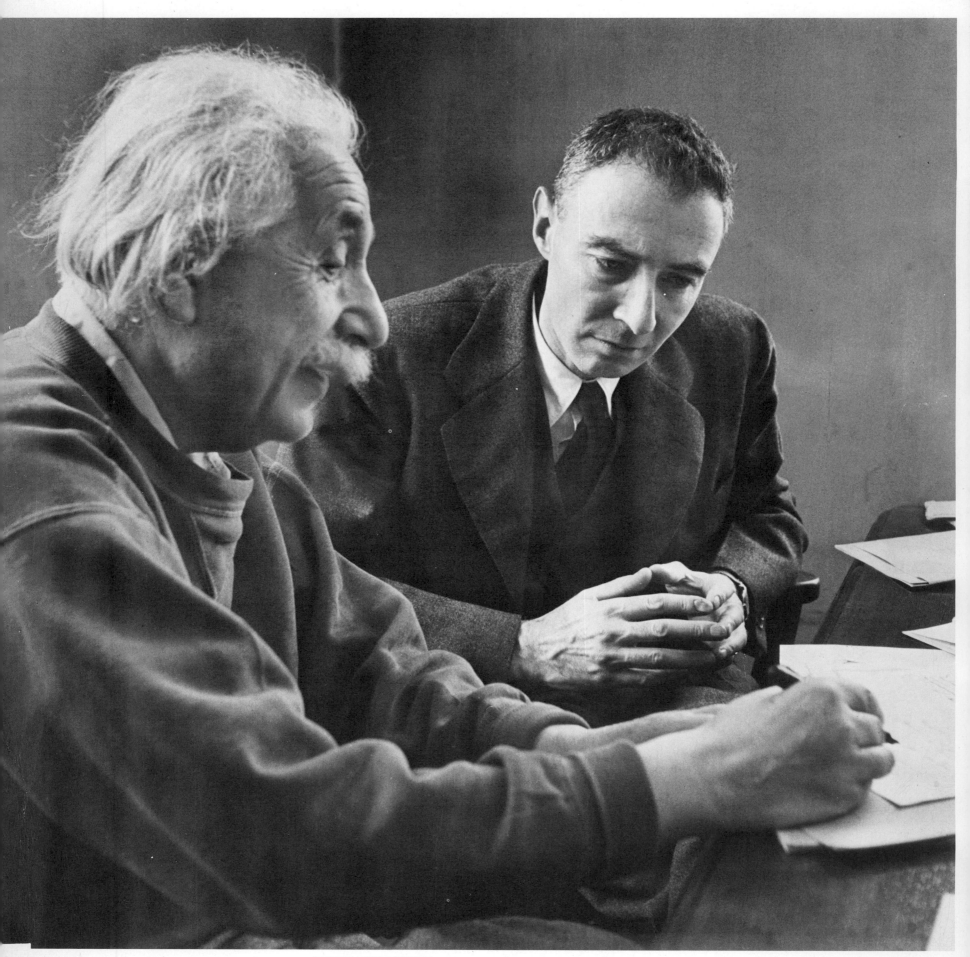

ALFRED EISENSTAEDT

Massive Minds Atomic scientists Albert Einstein and J. Robert Oppenheimer compare notes at Princeton's Institute for Advanced Study.

Contentious Philosopher Philosopher, mathematician, political gadfly, Bertrand Russell died at 97 after what he called a "life of disagreements."

LARRY BURROWS

DOMINIQUE BERRETTY

20th Century Sage In an exegesis of existentialism, LIFE described Jean-Paul Sartre as "the walleyed little man who figured it all out."

Atom-minded Admiral Hyman Rickover, the intellectual admiral who fathered the nuclear sub, climbs the ladder inside a power plant's reactor.

YALE JOEL

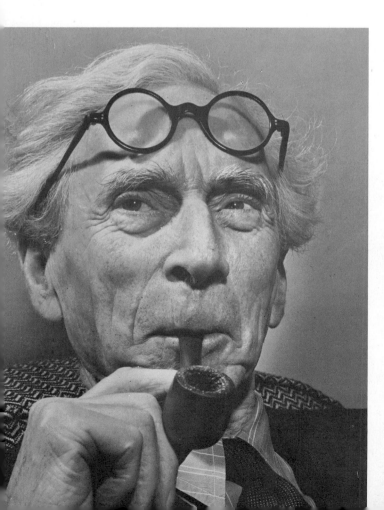

Lending an Ear

Archkibitzer of the age, Walter Winchell overacts his role as Vice President John Garner whispers to FBI's J. Edgar Hoover.

Exit by Chair

Defying a federal order on labor arbitration, Sewell Avery *(above)*, president of Montgomery Ward, achieves what LIFE described as his "synthetic martyrdom" as soldiers cart him from his office.

Weighty Fare

Herman Kahn *(left),* 300-pound solver of heavy problems affecting world civilization, describes himself as "one of the 10 most famous obscure Americans."

JOHN LOENGARD

LEONARD McCOMBE

An Innocent Air

Frank Costello, powerful underworld boss, permits a portrait, disclaiming influence and insisting, "I can't fix a traffic ticket."

Working Playboy

Hugh Hefner *(above, with pipe)* —publisher of *Playboy*, builder of a $70 million empire preoccupied with sex, inventor of the Bunny —studies a comely creation.

Golden Eagle

Before he became a billionaire recluse, Howard Hughes *(left)* was a daredevil pilot. In 1935, he flew his H-1 plane at 325 mph, setting a record for land planes.

Nuzzled Master

Bobby Fischer *(left),* who has an affinity for animals as well as chessmen, gets away from the board during his epic match with Boris Spassky to rub noses with an Icelandic pony.

HARRY BENSON

Rotund Majesty

After being bounced from Egypt and his throne, Farouk *(right)* gets his well-rounded royal figure into trunks on the Isle of Capri and settles down to being an ex-king.

PAUL CHILD

Culinary Wallop

Julia Child, a six-foot-two Bostonian, uses public television to teach inhibited Americans about French haute cuisine.

BURK UZZLE

Pugnacious Party-giver

Elsa Maxwell, hostess nonpareil, dons gloves for a movie short.

BERT SIX

Brave Symbol

Jill Kinmont, a ski champion as a young girl and now almost totally paralyzed after a bad fall, exults in the new life she has made for herself as a high school teacher in Seattle, Wash.

Art in Thin Air

At 68, Pablo Picasso *(left)* turns on a flashlight and creates an evanescent, priceless centaur.

GJON MILI

Artist in the Desert

At 80, Georgia O'Keeffe ponders the parched New Mexico region whose spirit her art distills.

JOHN LOENGARD

Design in Water

At 85, Walter Gropius, prime mover in architecture and in design, arcs a graceful spurt of water.

BOB PETERSON

245

Author and Alter Ego

In Paris, Gertrude Stein *(at far right)* is accompanied by her inevitable shadow, Alice B. Toklas.

CECIL BEATON

Pensive Author

William Faulkner latches his stable in Oxford, Miss., the real locale of his greatest novels.

MARTIN J. DAIN

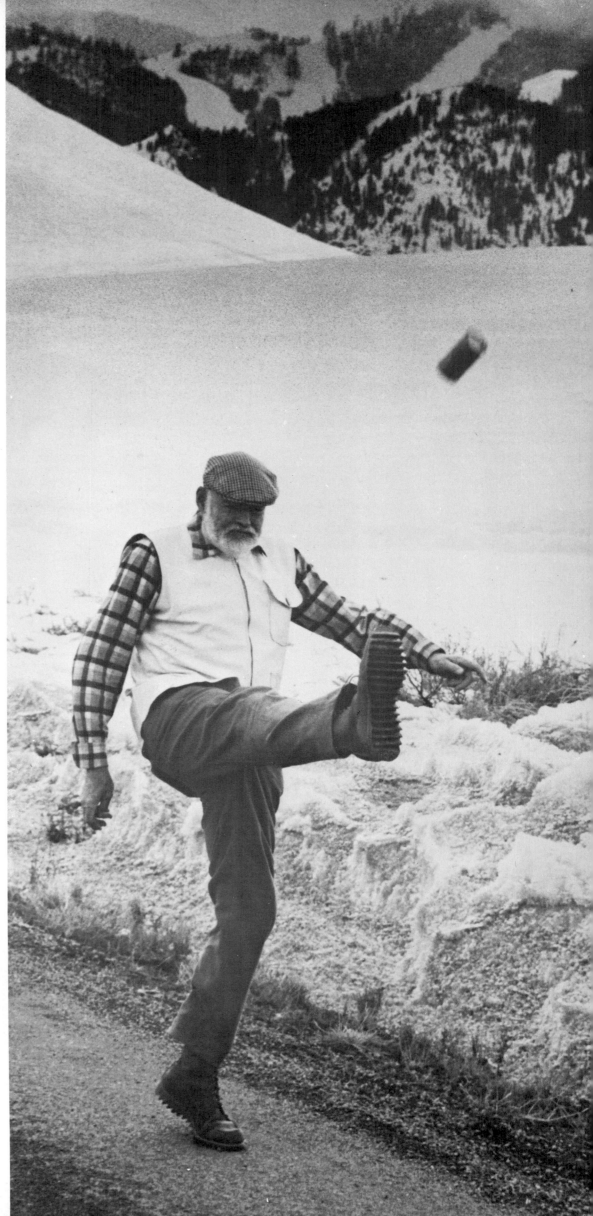

Exuberant Author

Ernest Hemingway at 60 kicks a can along a road in Idaho two years before he shot himself.

JOHN BRYSON

Guru of a New Generation

Engulfed in cigarette smoke, poet Allen Ginsberg, cult figure of U.S. youth, intones his views.

JOHN LOENGARD

Imperious Lady of Letters

In queenly costume, Dame Edith Sitwell *(right)* prepares for a reading of her own poetry.

LOOMIS DEAN

Poet of Whiskey and Ink

John Berryman, the hard-writing, hard-living bard from the Midwest, shouts into the wind.

TERENCE SPENCER

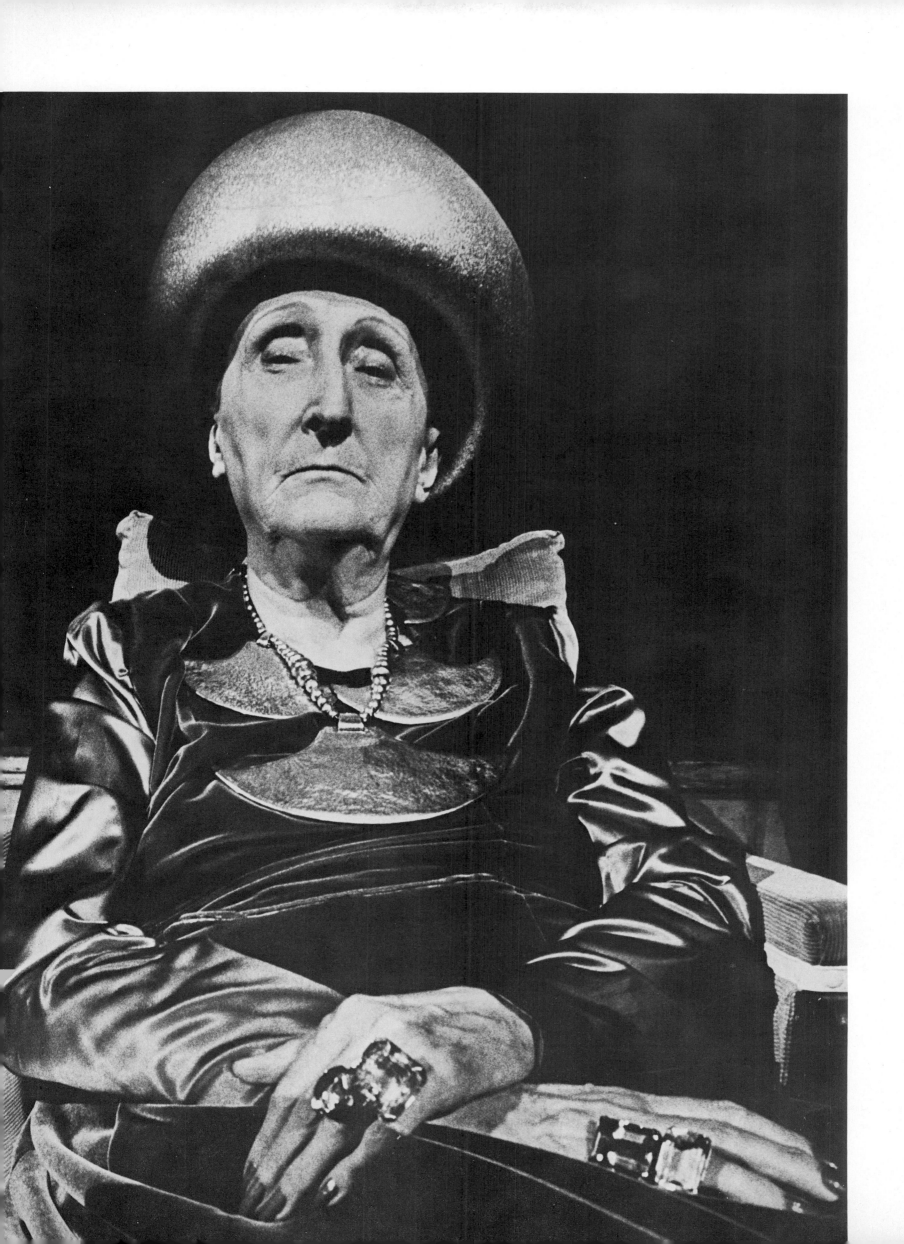

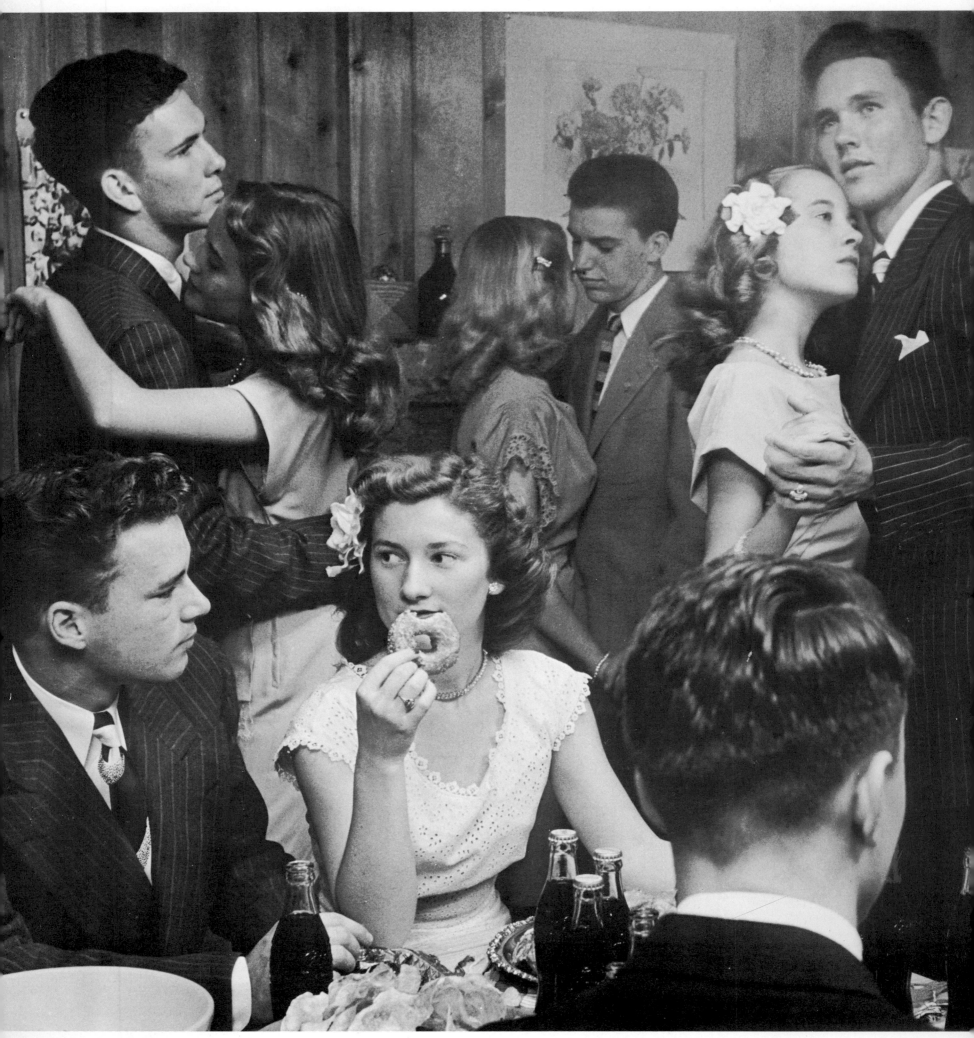

NINA LEEN

Teenagers at a 1947 Tulsa party munch doughnuts, sip Coke and dance, as LIFE said, to "dreamy tunes like *Night and Day*."

GROWING UP

The challenge of youth-watching: following the kids into "The Gap"

From the starry-eyed young dancers at left to the calorific couple at right, there is clear evidence of a quantum jump. And in that distinct difference lies the measure of one of LIFE's most challenging long-range assignments: youth-watching. It began when young people's activities were looked on with affectionate approval by nostalgic parents and ended with the era of the Generation Gap.

When Nina Leen photographed the Tulsa teenagers' party in the '40s, her chief concern was to bounce her flash off the ceilings so the lighting would not be harsh on those nice kids. But about the time the Silent Generation of the Eisenhower years gave way to the Beatlemaniacs, the changes in youth escalated exponentially, not without effect on the photographers. Bill Ray described his technical problem this way: "The whole trick in covering rock fans is getting the picture before you get knocked down. And obviously the same goes for student riots and scenes like Chicago 1968." As he worked, North Carolina-born, Northwestern-educated Michael Mauney, an exceptionally sensitive photographer, agonized over the possible post-publication consequences to be endured by the subjects of his essay on interracial dating.

In general, the photographers were all for the new look in youth. Leonard McCombe remembered that "in 1949, at the end of Hell Week at the University of Wisconsin, when I was on the Sigma Chi story, they threw the Hellmaster into the ice-filled lake, then they did the same to me. And that's what they did if they *liked* you."

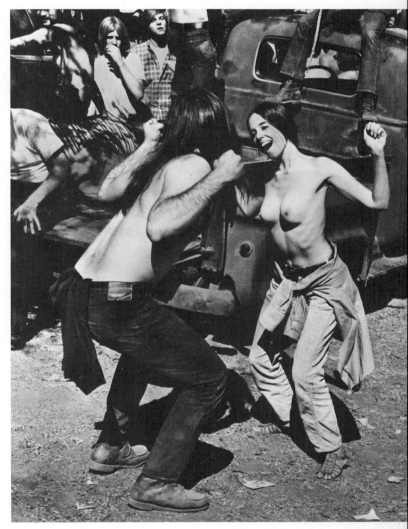

ROBERT GARRO

An uninhibited couple cavorts at a 1969 California rock festival.

Indiana sub-deb

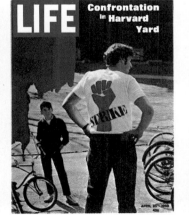

Battle of Cambridge

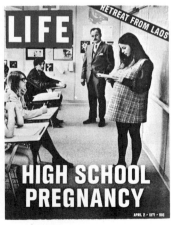

New morality (cont'd)

LEONARD McCOMBE

Fraternity Initiates

Sigma Chi members at Missouri's
Westminster College sing out for
the girl of their 1949 dreams.

Fraternity of Veterans

Ex-GIs on unemployment pay of $20 a week for 52 weeks take it easy a year after World War II.

LEONARD McCOMBE

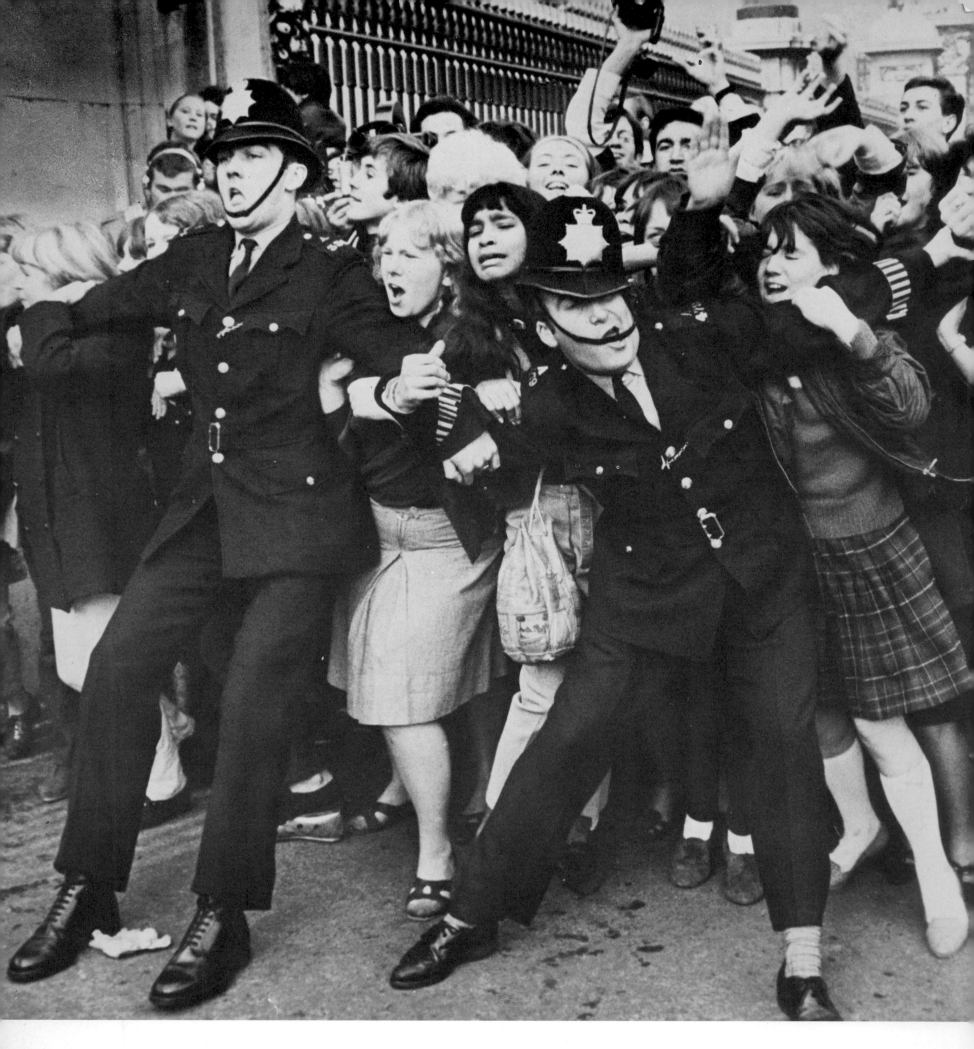

Beatlemania East The reserve of British bobbies is severely tested by Beatle-lovers, who register a range of emotions from agony to ecstasy as they storm Buckingham Palace, where the singers were guests.

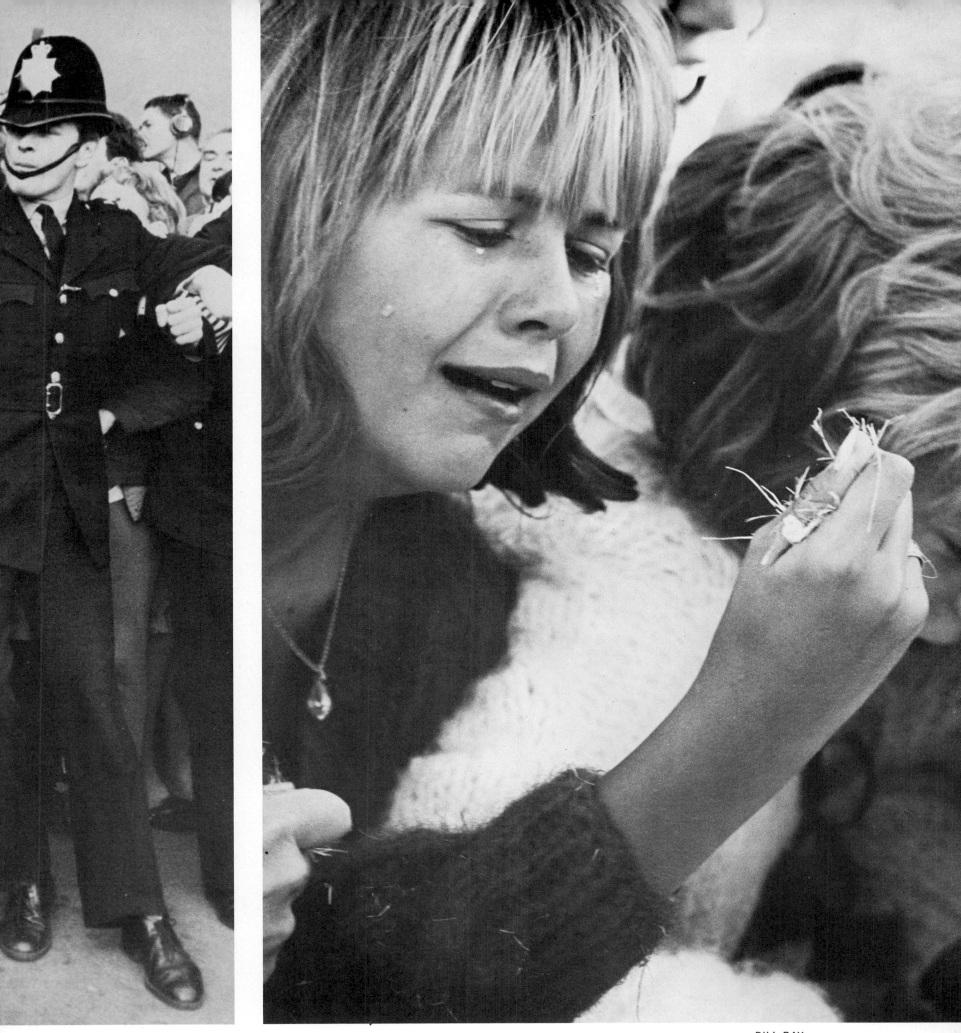

Beatlemania West Overcome at possessing a genuine relic, a devout Beatle fan at the San Francisco airport tearfully clutches a handful of sod that had lately been trod upon by drummer Ringo Starr.

255

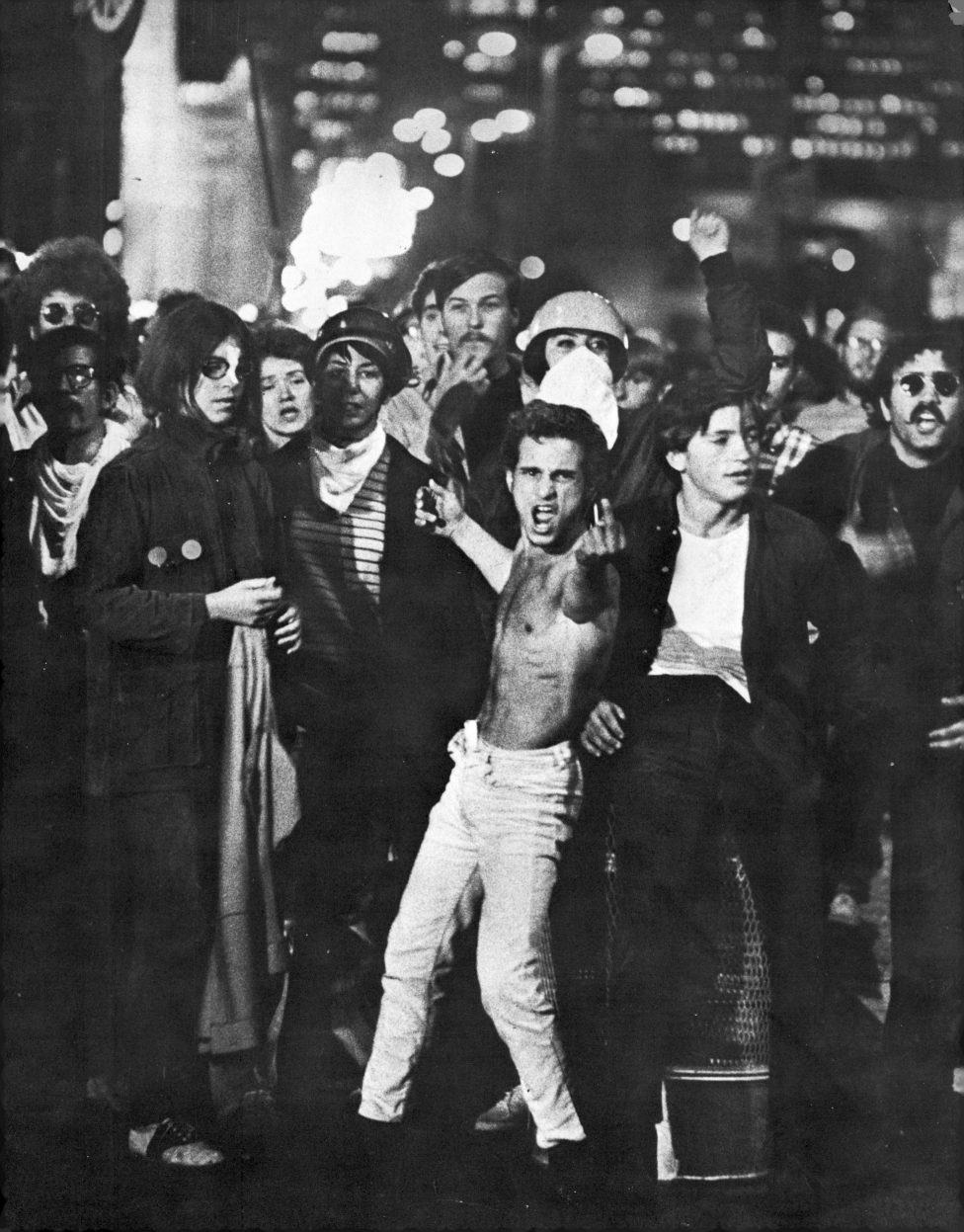

Youth Power

In a picture *(left)* that became the symbol of the street violence attending the 1968 Democratic convention in Chicago, young people on Michigan Avenue provoke police with obscenities and taunts.

PERRY C. RIDDLE

Student Power

A Columbia senior *(right)* at the desk of President Grayson Kirk enjoys a presidential cigar during the 1968 student takeover at the university. Behind him fellow rioters watch for police, who eventually drove them out.

GERALD S. UPHAM

Flower Power

A young antiwar marcher *(right)*, in a symbolic gesture, places pink carnations in the rifle barrels of Army guards on the steps of the Pentagon in a 1967 confrontation.

BERNIE BOSTON

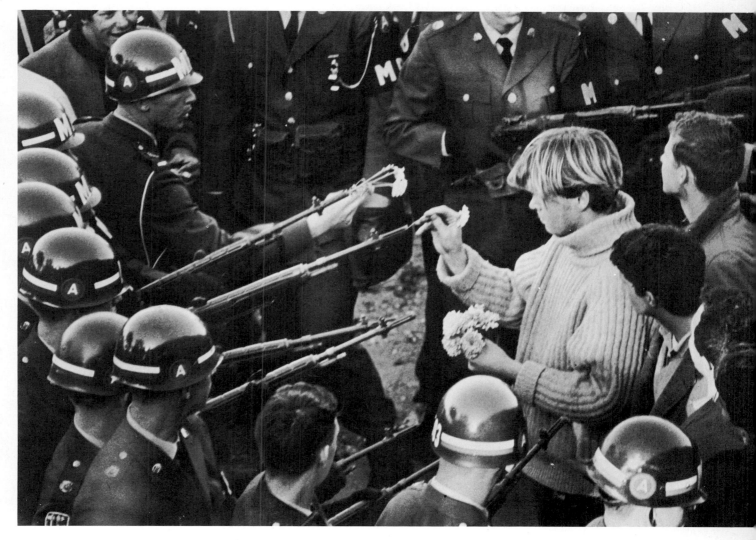

257

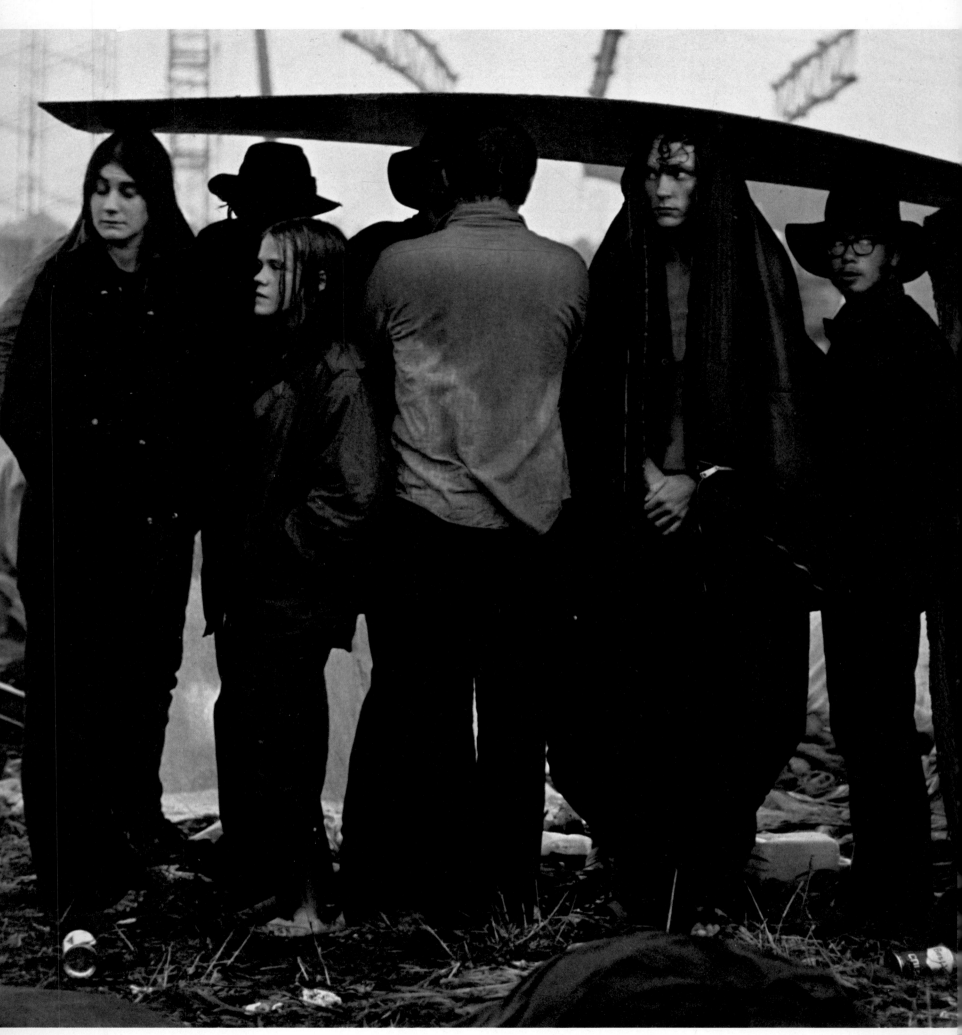

Impromptu Shelter Damp but determined, fans at Woodstock, N.Y.'s gigantic rock festival perch a piece of plywood on their heads for shelter during a downpour that turned the alfalfa-field site into a quagmire.

Impromptu Service A young convert, the embodiment of the Flower Child turned Jesus Freak, ecstatically awaits baptism in the Pacific.

Impromptu Appearance Wearing only handcuffs, a modern seeker of relief from a heat wave is ushered out of Central Park to the cooler.

BILL RAY

Double-up Biking

Still in their academic gowns, Mitchell Toll and Marilyn Ackerman *(right)* roar off into the world after graduation from Temple.

Coed Living

Enjoying that popular innovation, the coed dorm, Oberlin's Rob Singler and Cindy Stewart listen to music in his room.

Interracial Dating

On the University of Minnesota's campus, Faye Becker and Dexter Clarke ignore old barriers as they hold hands while leaving class.

MICHAEL MAUNEY

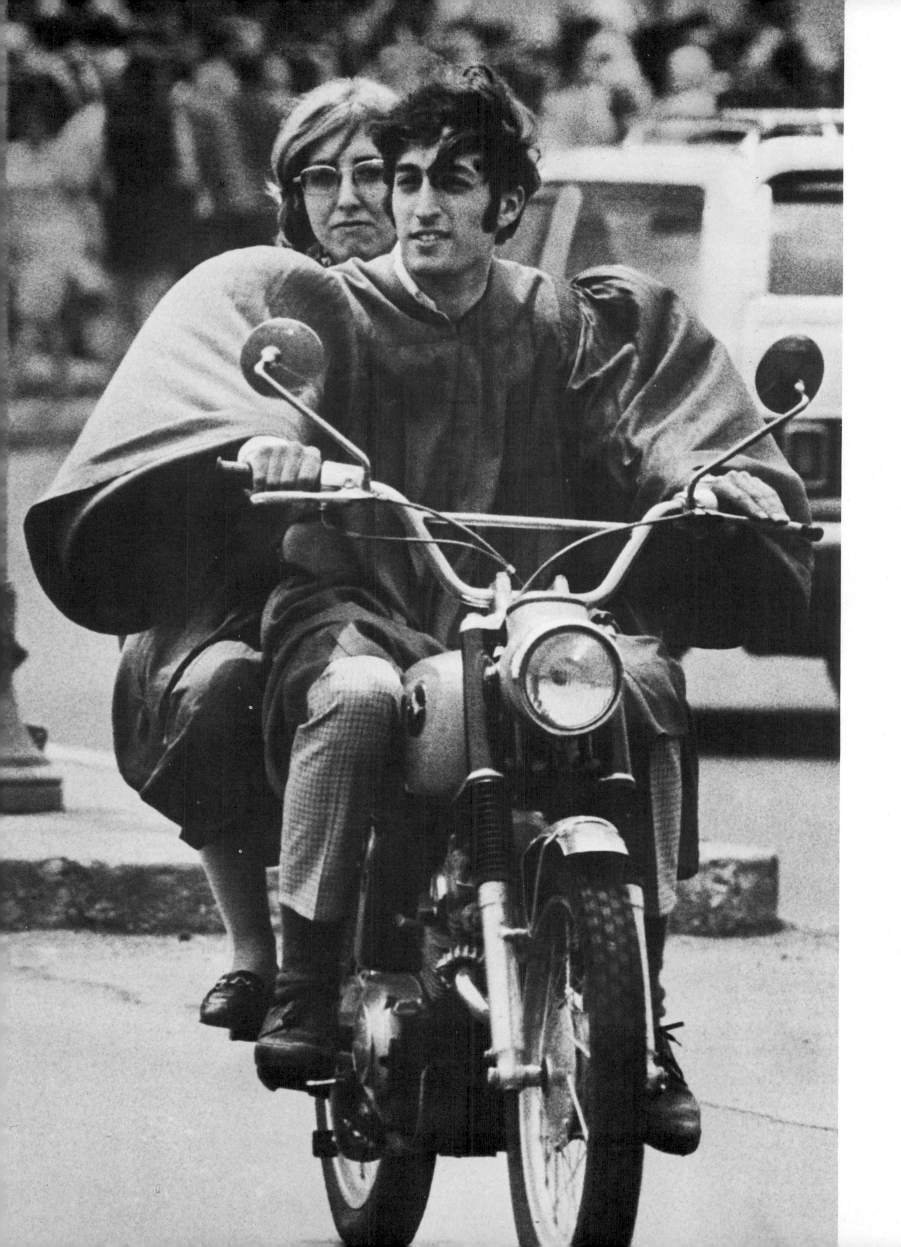

Garbo

Flynn

Rogers and Astaire

Lombard

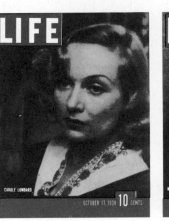
Martin

Davis

Hope

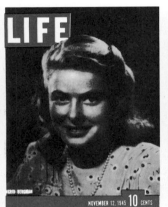
Bergman

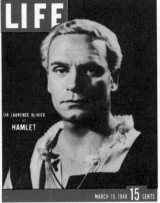
Olivier

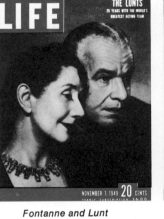
Fontanne and Lunt

Peck

Wynn

Monroe

Loren

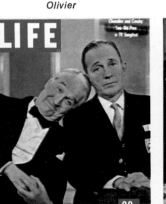
Chevalier and Crosby

Ball

Burton and Taylor

Beatles

THE ENTERTAINERS

A procession of stars, extending from Garbo to Diana Ross and back to Charlie Chaplin

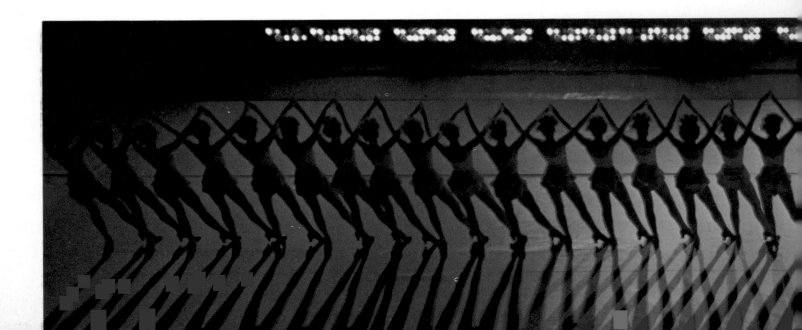

Shearer

Colbert

Grable

Cooper

Hepburn

Turner and Gable

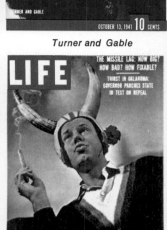

Dandridge

Kelly

Garland

Tracy

Hudson

Paar

Sinatra

Wayne

Davis, Belafonte, Poitier

Carson

Brando

Ross

Of the 1,864 LIFE covers, 392 were devoted to entertainers—more by far than to any other single subject. (Only 174 statesmen, for instance, made it—and only one dam.) The array on these pages is just a small sampling: 36 covers, one for every year of LIFE's existence. The numerical symbolism is circumstantially repeated in the wide-angle picture *(below)* of the Radio City Rockettes, who, as every show-biz fan knows, always total a neatly tapered three dozen. Elizabeth Taylor alone accounted for 12 covers, making her the show-business champ. And LIFE was such a movie buff that it couldn't stand losing all those marvelous images of the silent era—Keaton, Lloyd, Langdon, Turpin, et al.—that it had not been around to publish. So the editors assigned James Agee to write an essay on the great Hollywood clowns, and LIFE ran them all to illustrate it.

YALE JOEL

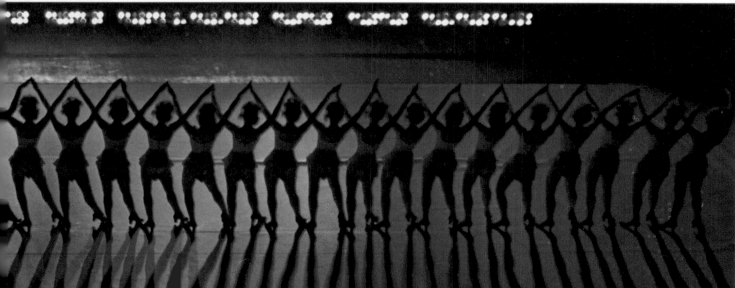

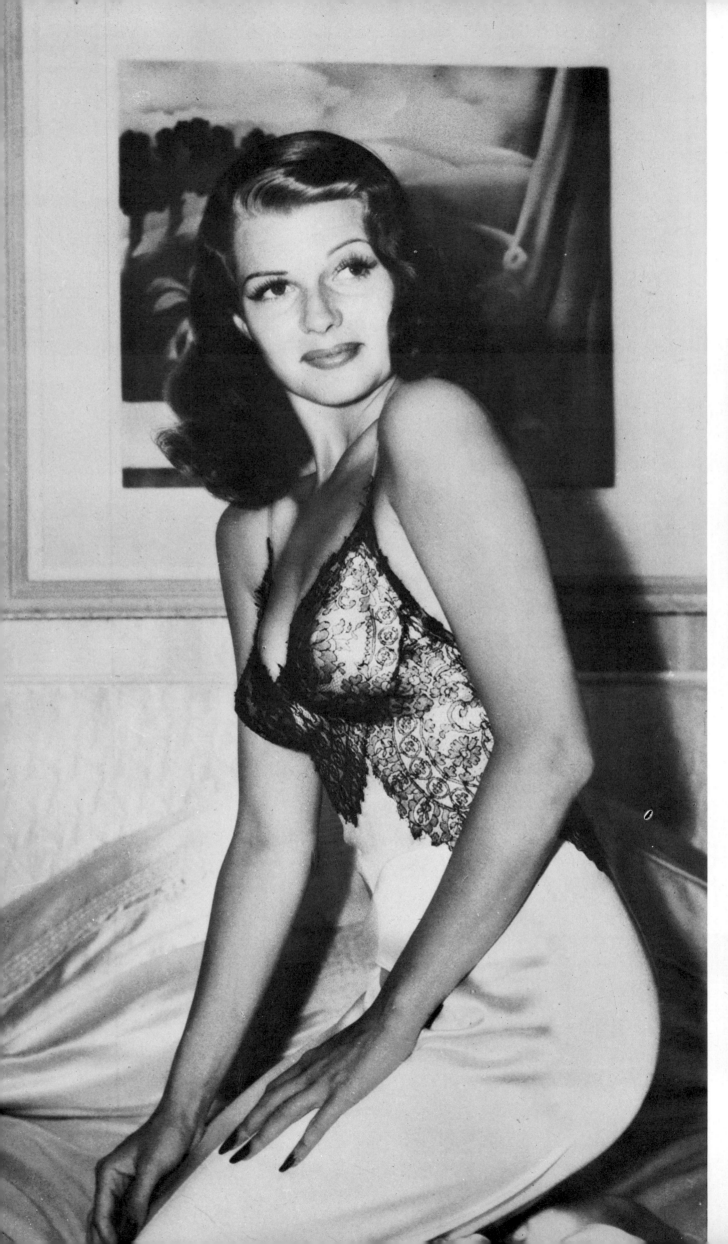

Dream Girl

Rita Hayworth kneels on a bed in the classic 1941 pin-up picture.

BOB LANDRY

Bubble Trouble

Jeanne Crain *(below)* takes a bath in bubbles pumped up by helium.

PETER STACKPOLE

EWING KRAININ

All-Time Pin-up

Chili Williams clutches a prop oar in a 1943 photograph that drew 100,000 feverish letters.

Retiring Type

Carole Landis combs her hair in comfort. She had caused a stir by protesting her press agents' plan to dub her "Ping Girl."

Early M.M.

In her first LIFE cover portrait *(right),* taken in 1952, Marilyn Monroe offers the inviting smile that became her trademark.

Plain Jane

Out from the shadow of that all-American hero, her actor-father Henry, Jane Fonda *(below)* sits nude on an Italian beach.

Gay Nineties Belle

As Lillian Russell, Marilyn Monroe becomes one of five period sex symbols, in a tribute photographed by Richard Avedon.

"It" Girl

As Clara Bow, the movie redhead with the bee-stung lips and Charlestoning feet, Marilyn radiates flapper sex appeal.

PHOTOGRAPHS BY RICHARD AVEDON

Blond Bombshell

As platinum-haired Jean Harlow *(right)*, Marilyn dons the requisite skin-tight white dress against a white-on-white backdrop.

Continental Siren

As Marlene Dietrich, Marilyn becomes the cabaret singer of *The Blue Angel,* going back to the perennial beauty's early years.

Original Vampire

As Theda Bara *(below)*, Marilyn mimics the screen's first great temptress, for whom the slang abridgment "vamp" was coined.

Slattern

Bette Davis flashes cheap jewelry as Mildred, the waitress in *Of Human Bondage,* her greatest role.

MARTIN MUNKACSI

Groundling

Katharine Hepburn tries the look of eagles amid 1938 rumors she'd fly off with Howard Hughes.

GEORGE KARGER

EDWARD STEICHEN

Enigma

Greta Garbo frames that unforgettable face with her hands in this best-known portrait of her.

Hellcat

Tallulah Bankhead demonstrates that she can spit like a puma. She could also, she said, coo.

Swinger

Beatrice Lillie twirls her six-foot string of pearls, a bit of business she made uniquely hers.

WALLACE LITWIN

Brawler

Disheveled Marlene Dietrich aims a six-gun after the epic barroom dust-up in *Destry Rides Again*.

SHERMAN CLARK

Veteran Pair

Shirley Temple, an old hand at 7, dances with Bill (Bojangles) Robinson in *The Littlest Rebel*.

PETER STACKPOLE

Model Secretary

Ginger Rogers sips a soda as Kitty Foyle. Many details of set and costume were based on a story LIFE had staged about the Christopher Morley novel.

Young Enchantress

Elizabeth Taylor, 13, stands with her favorite horse, Peanuts. Liz's equestrian skill helped her win the widely coveted leading role in *National Velvet*.

PETER STACKPOLE

New Star

Kim Novak, riding the 20th Century Limited, becomes the focal point if not of the photographer, of every other man in the diner.

LEONARD McCOMBE

TV Reunion

Judy Garland and Mickey Rooney, 41 and 42, wait on a TV stage 22 years after Andy Hardy days.

Dapper in the Desert

Noel Coward, the musical Englishman, goes out in the midday sun of Las Vegas before a 1955 nightclub appearance.

LOOMIS DEAN

N. R. FARBMAN

Protean Prince

Laurence Olivier, coifed and costumed for the title role, directs the 1947 filming of *Hamlet* in England.

Crusty Salt

Spencer Tracy, stubborn fisherman of *The Old Man and the Sea*, winces during his ordeal.

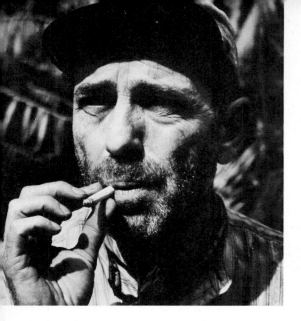

Skeptical Skipper

Humphrey Bogart plays a grudging hero who, commanding *The African Queen,* is led on a crazy expedition by Katharine Hepburn.

ELIOT ELISOFON

Sure-Fire Sheriff

Gary Cooper, six feet three of law, heads alone down the main street for a *High Noon* shoot-out with a gang of villains. He won.

EVE ARNOLD

Rugged Range Hand

Clark Gable has trouble controlling a wild horse he has lassoed in *The Misfits* (1961), his last film.

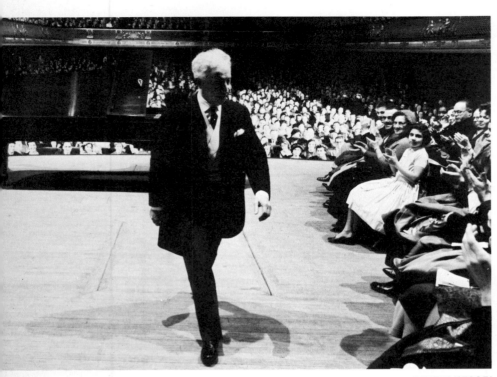

Jaunty Virtuoso

Artur Rubinstein, at 70 the world's most popular pianist, strides from an audience-lined Boston stage.

Symbolic Solo

Marian Anderson, denied use of a D.A.R. hall, gives a 1939 Easter concert at the Lincoln Memorial.

274

Humanized Maestro

That musical martinet, the great Arturo Toscanini, frolics *(at left)* with his granddaughter Sonia, 5. In another unprecedented picture *(above),* he falters while conducting his last concert at age 87.

Calisthenic Conductor

Batonless Leonard Bernstein, 38, the first U.S.-born principal conductor, rehearses the New York Philharmonic in 1957.

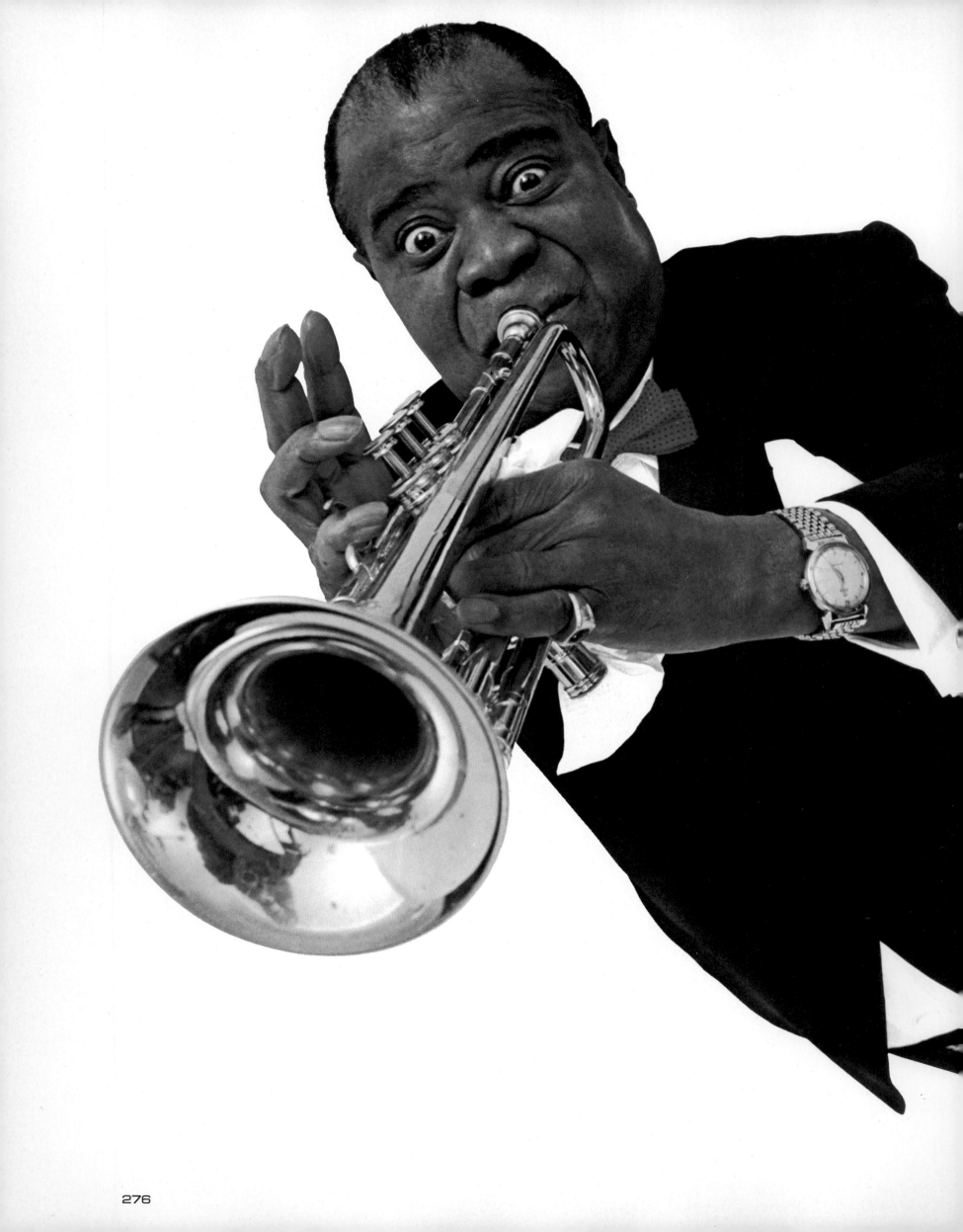

Sleepy GI

Irving Berlin dresses for a World War II reprise of 1918's *Oh, How I Hate to Get Up in the Morning.*

GEORGE KARGER

Gaudy Latin

Carmen Miranda lends an exotic Brazilian touch to the musical *Streets of Paris.*

W. EUGENE SMITH

ALLAN GRANT

Early Bopper

Dizzy Gillespie, before affecting a bent-up horn, plays bebop.

STAN WAYMAN

Non-Red Non-Square

Benny Goodman swings in Red Square on 1962 good-will tour.

Genuine Pops

Louis Armstrong and his horn, business end accentuated by a wide-angle lens, blast off.

PHILIPPE HALSMAN

HERBERT GEHR

Hail and Farewell

Frank Sinatra, going solo at 25, sings *As Time Goes By.* Right, 28 years later, he waves goodbye at a Los Angeles farewell concert.

MICHAEL ROUGIER

Rubber Mouth

Bert Lahr, a comedian bred in burlesque, mugs characteristically in a 1947 revival of the 1927 Broadway play, *Burlesque.*

RALPH MORSE

Sour Puss

Fred Allen, asked for his opinion of television upon retirement from radio in 1949, mimes his reply.

HERBERT GEHR

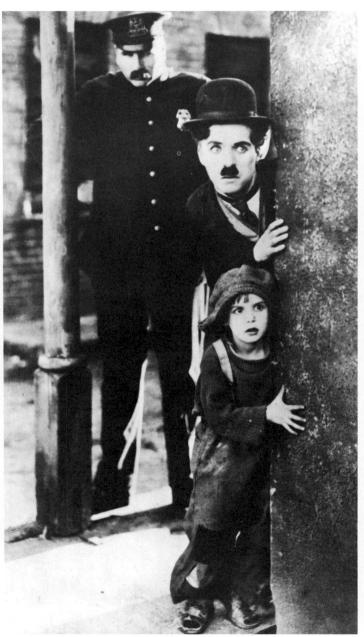

Look of Alarm

Charlie Chaplin and Jackie Coogan dodge cops in *The Kid.* This picture illustrated a 1949 article.

Put-on Smile

Jack Benny, 39 for many years, laughs at the idea of turning 40 on his 64th birthday in 1958.

LEONARD McCOMBE

Poker Face

W. C. Fields plays his cards close as phony oilman Cuthbert Twillie in *My Little Chickadee*.

ROBERT W. KELLEY

Gallic Grin

Maurice Chevalier, in America for one of his many farewell tours, flashes his *Louise* smile.

Stand-up Comic

Bob Hope, atypically reclining on stage at Oklahoma State, gets off a string of one-liners.

ALLAN GRANT

Lean-to Comedian

Buster Keaton, still up to his old tricks in 1950, lists perilously on his way to a TV-show fall.

RALPH CRANE

Walk-on

Ed Sullivan, silhouetted in a familiar attitude, enters to celebrate his 20th anniversary on TV.

ARTHUR SCHATZ

Light-up

Etched against the stucco of his California home, Bill Cosby savors a first puff on his cigar.

JOHN LOENGARD

TERENCE SPENCER

Write-in

David Frost sits in an Eero Aarnio "ball chair" while autographing a book in his London apartment.

Roll-up

To lure a laugh from his talk-show audience, Jack Paar hikes his pants above the knees.

CORNELL CAPA

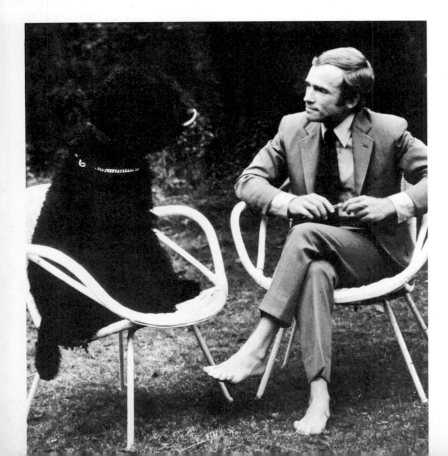

Put-on

Dick Cavett, barefoot at his Long Island retreat, mocks his own talk-show-host posture with the help of his poodle Louis.

MICHAEL MAUNEY

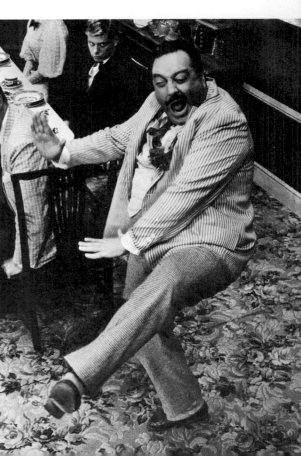

Cut-up

As the tipsy uncle in *Take Me Along,* the musical version of *Ah, Wilderness!,* Jackie Gleason breaks up dinner.

MARK SHAW

GJON MILI

Fleeting Grace

In an impressionist multiple-exposure study of motion, members of the New York City Ballet company perform Jerome Robbins' *Dumbarton Oaks.*

BILL EPPRIDGE

Vaulting Power

Muscles taut with the effort of one of his athletic leaps, the New York City Ballet's Edward Villella is caught at his apogee.

Spidery Suppleness

Her pliant limbs bend around like those of a spider as Judith Jamison, of Alvin Ailey's American Dance Theater, performs an interpretative dance.

HERBERT MIGDOLL

283

Smoke Screen

Unshaven and unkempt Bob Dylan puffs a cigarette. "I mean," he once said, "are all those people paying to see me look neat?"

DAVID GAHR

Liverpool Sound

The four Beatles—from the left, Paul McCartney, George Harrison, John Lennon and Ringo Starr —burst into melody in a Miami Beach swimming pool.

JOHN LOENGARD

All-out Effort

Exhausted after her performance at the 1969 Woodstock festival, Janis Joplin closes her eyes and rests on the microphone.

TUCKER RANSON

Seaside Recital

Joan Baez *(left),* in burlap blouse and jeans expressive of her Gandhian philosophy, strums her guitar on a beach near Big Sur.

RALPH CRANE

CHARLES TRAINOR

Lift-off Thrust

Elvis Presley, caught in mid-bump in 1956, rocks his way toward an annual income of $500,000 two years after giving up his job as a truck driver.

First Stone

Unlaced and shaggy-maned, jewelry ajangle, Mick Jagger *(right)* howls out a number during the Rolling Stones' 1972 U.S. tour.

JIM MARSHALL

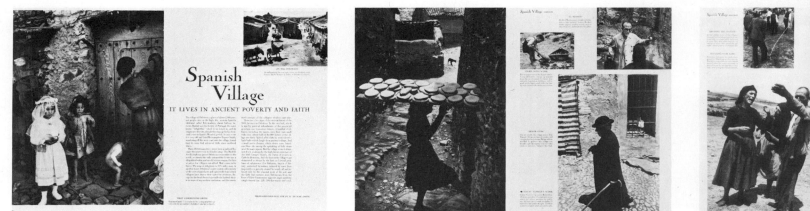

First Communion in an ancient hamlet　　　　　The unending chores of daily life　　　　　Scratching a cro

THE PHOTO

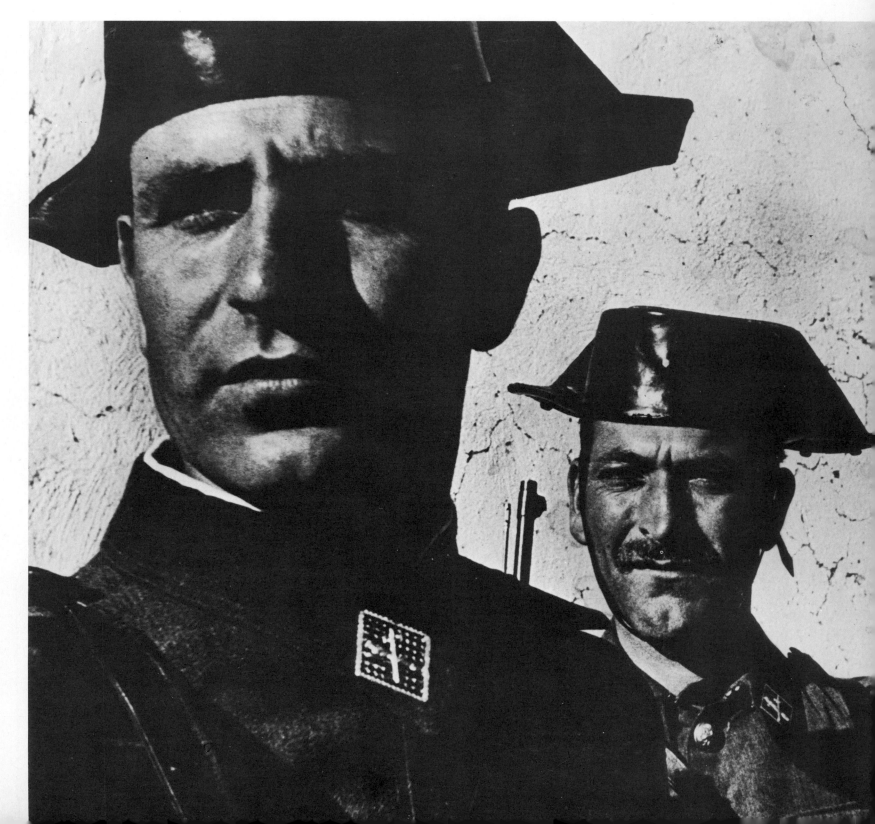

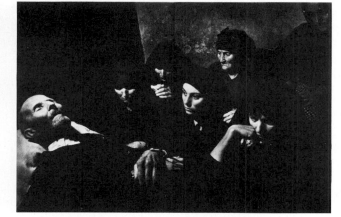

om the soil A somber frieze of grief at an old man's death

The new art form: pictures edited so that they tell a complete story

Small fast cameras, photographers with what Cornell Capa called the "chameleon ability to live in many worlds," and LIFE, all conjoined to develop a new art form. Until then single images had sufficed. But now groups of photographs were selected and arranged to tell a complete story, and the picture essay flowered. Gene Smith produced a classic of the new form in 1951. For his subject he chose the ancient village of Deleitosa, after driving 7,000 miles through Spain to find it.

GRAPHIC ESSAY

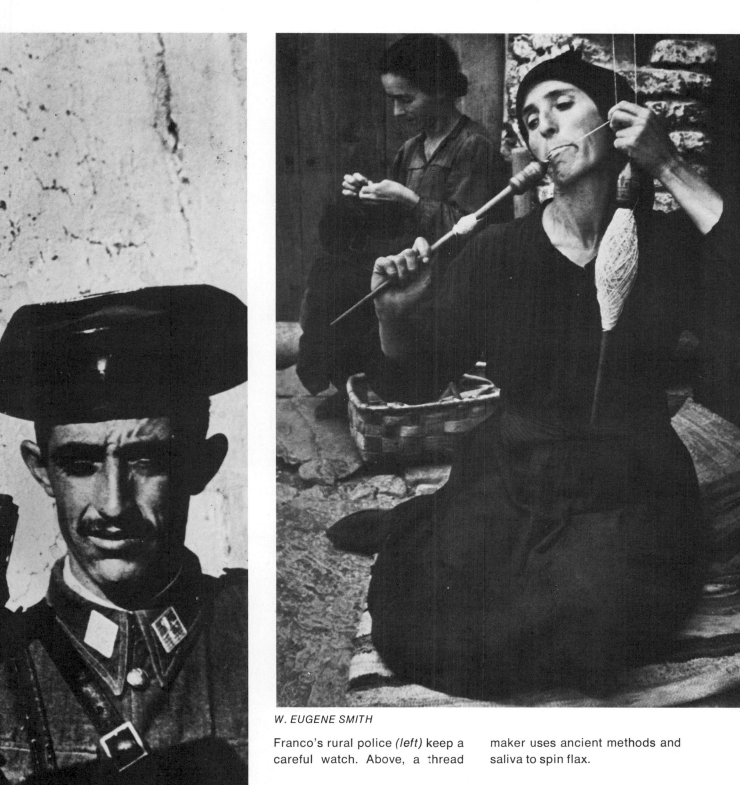

W. EUGENE SMITH

Franco's rural police *(left)* keep a careful watch. Above, a thread maker uses ancient methods and saliva to spin flax.

Starting Out on Her Own

A pretty girl comes to conquer the big town—and to find romance *(below).* A lesser eye might have turned in an illustrated cliché. But Leonard McCombe pursued his subject "like a kind of detective," and with the sequence at right caught both her winsome vulnerability and gritty ambition.

LEONARD McCOMBE

New girl in town—a cover and a heroine Long hours in t

Ending Up Dependent

She was "old-world," recalls Cornell Capa, "and irascible—like the old-world, irascible mother I had." And the tiny house where the old woman lived with her son's family—trying to settle children's fights *(above, right),* loving, mostly alone—was "like a stage set." From inside the narrow quarters *(right),* Capa offered this wrenching look at life at 80.

CORNELL CAPA

An age when only the little ones listen Eavesdroppi

288

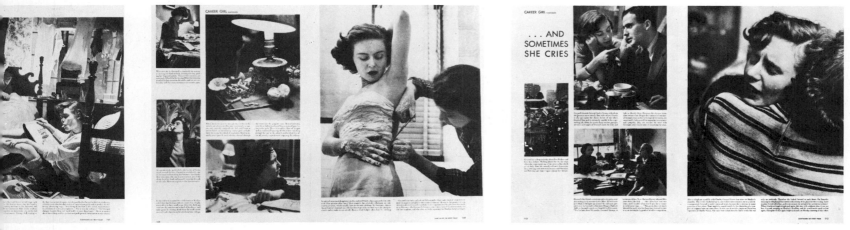

office and at home

Roommates for fighting and dressmaking

Boyfriends for fighting and having fun

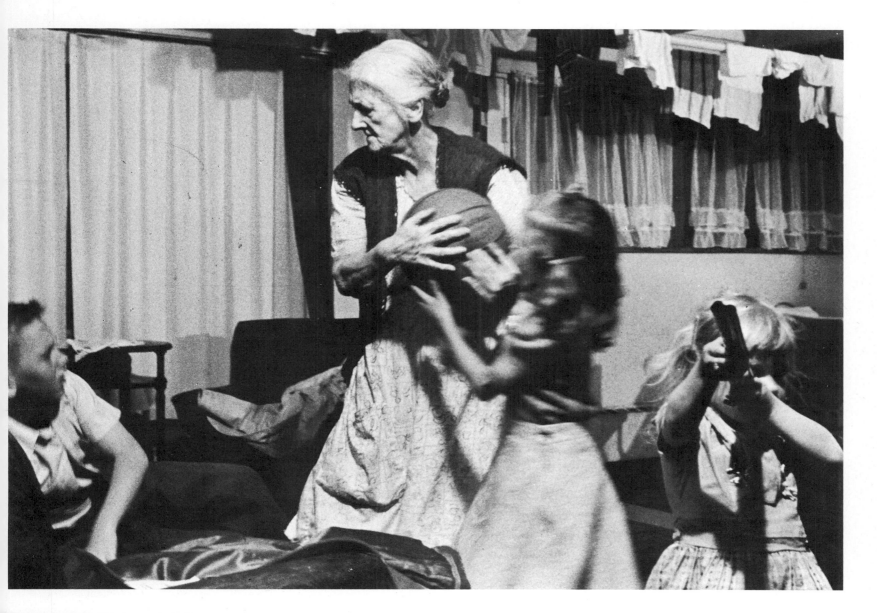

a family joke

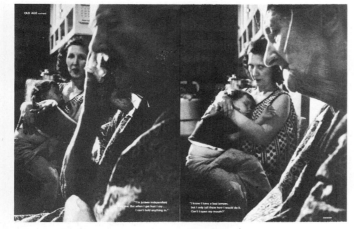

Squabbling with her daughter-in-law

Preserving a prickly independence

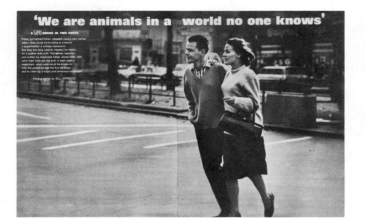

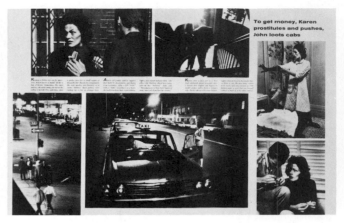

Young lovers in Needle Park

Buying, stealing, streetwalking to get heroin

Kicking the habit—

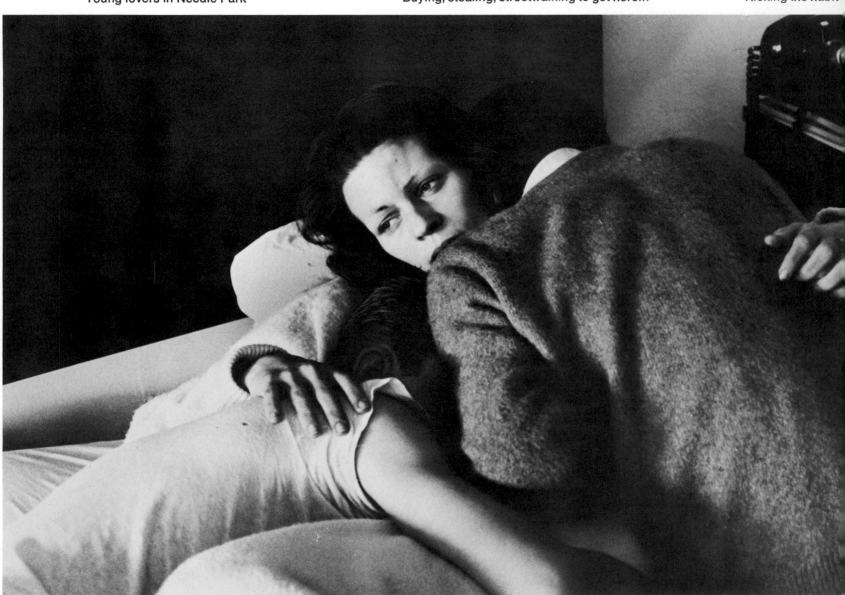

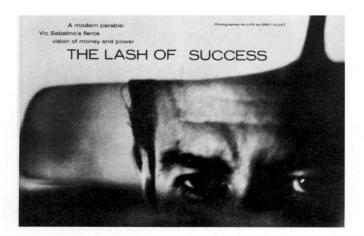

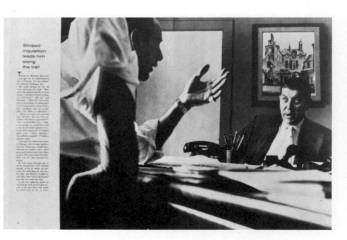

Tired and intense, a man bent on making it

Chewing out a worker who did a job his own way

Dapper scion of

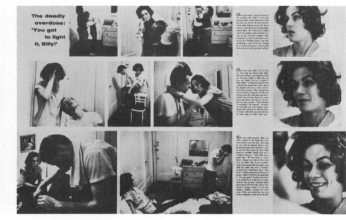

The deadly overdose: 'You got to fight it, Billy!'

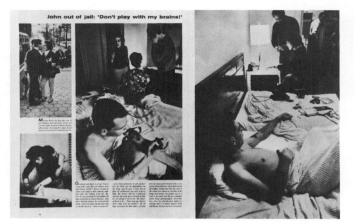

John out of jail: 'Don't play with my brains!'

to start again

A harrowing struggle to remedy an overdose

Five minutes after leaving prison, another fix

Hooked on Drugs

A young woman desperately tries to comfort her husband and his brother—all three hooked on heroin—in one scene *(left)* from an unprecedented look at the lives of drug addicts in the Manhattan area known as Needle Park. Photographer Bill Eppridge and writer Jim Mills spent two months on the assignment. During that time, both Eppridge and Mills carried electronic beepers virtually every waking hour so that their trusting subjects could reach them.

BILL EPPRIDGE

Hooked on Success

Working with his wife Barbara (a former LIFE writer), Grey Villet studied the yearning for money and power that shows in the face of a foam-rubber wheeler-dealer *(right)*. The result *(below)* was a strikingly frank case history of a driven man's travail in the marketplace and in his home.

GREY VILLET

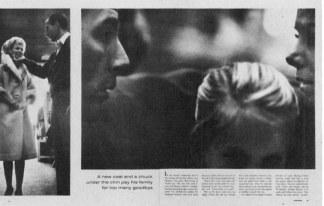

A new coat to assuage a family's loneliness

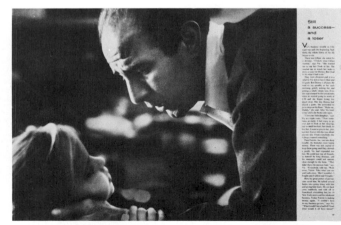

A rare chance to wake his daughter with a kiss

diligent grandpa

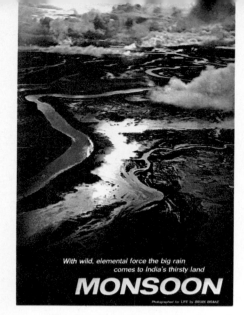

With wild, elemental force the big rain comes to India's thirsty land

MONSOON

Photographed for LIFE by BRIAN BRAKE

The Malabar Coast bathed in rain

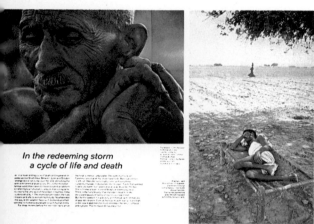

*In the redeeming storm
a cycle of life and death*

Parched villagers waiting for the storms

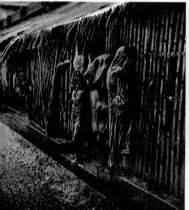

A drenching of blessed coolness

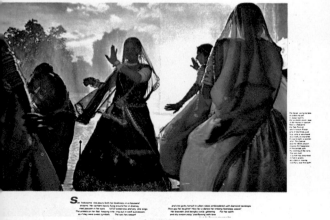

In honor of the weather, a festival

A season of sensuousness reflected in the rain-beaded face of a lovely girl

Loveliness of India

A globe-roaming soldier of photographic fortune, Brian Brake felt a yen to do a story not just on a place he loved—India—but in a season that deeply shapes its terrain and its life. During one year he researched the monsoon's impact and the next he captured it.

BRIAN BRAKE

292

A village of the Willigiman-Wallalua people

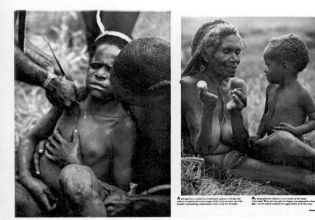
Common sights: battle wounds and ritual maimings

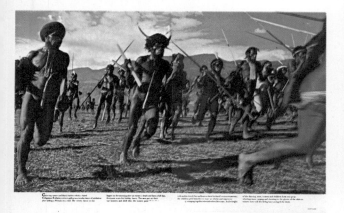
A day-long dance to celebrate a killing in battle

Wild Joy at an Enemy's Death

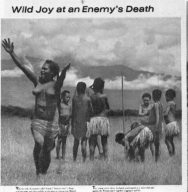

Hail to the victors from cheering women

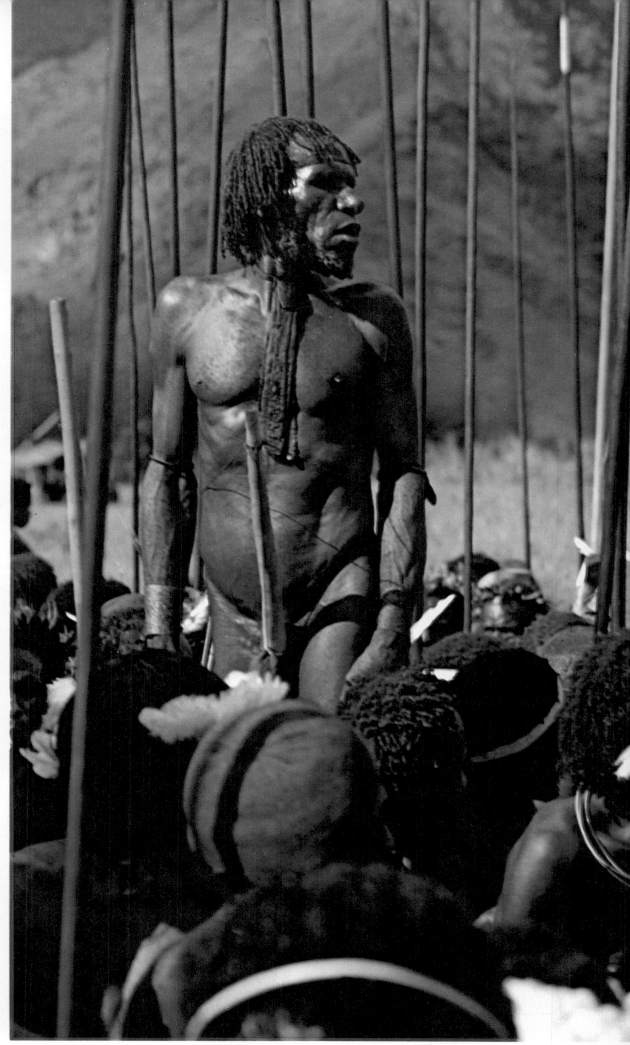
Amid a forest of spears, a glowering war leader

Savagery of New Guinea For six weeks in 1961, Eliot Elisofon joined Michael Rockefeller and a museum expedition studying savage tribesmen, who accepted their presence grudgingly. While on a field trip in the same area just two months later, young Rockefeller was to drown.

ELIOT ELISOFON, SAMUEL PUTNAM, MICHAEL ROCKEFELLER

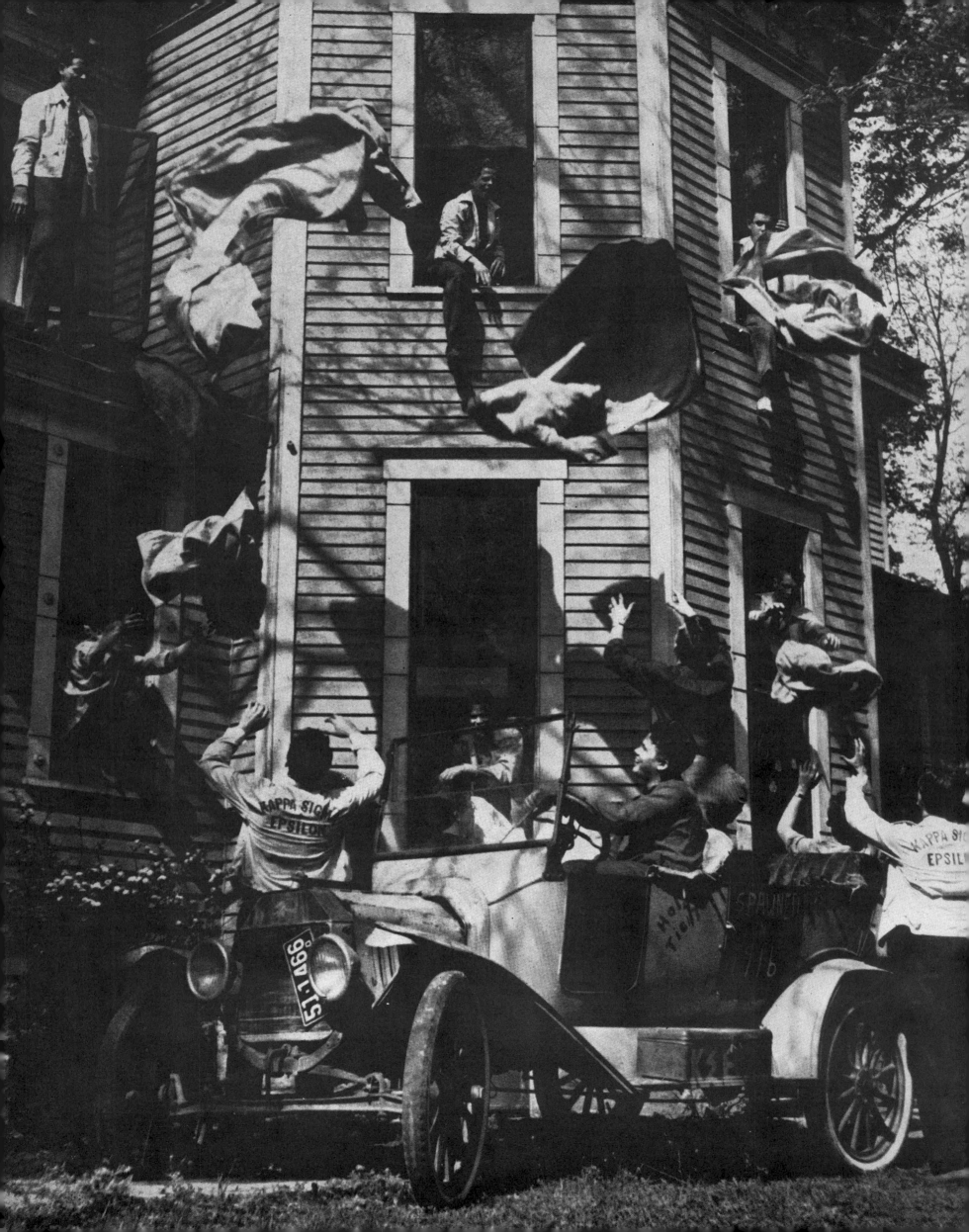

An antic sampling in which people share the top billing with animals

LIFE never stopped having fun. LIFE Goes to a Party became such a popular weekly feature that Harry James and Benny Goodman wrote a 1937 jump tune with that title. In all, LIFE went to 855 parties in 25 years (it gave up party-going in 1961), including debuts, picnics, reunions, blanket parties, a snail race and a snowball fight. It partied while migrating with Persian tribesmen, sailing up the Amazon with Brazil's president and ascending Mt. Washington on the cog railway.

LIFE also institutionalized the single funny picture in a feature called Miscellany, creating a category of fans who automatically opened each new issue to the last page. Inventing funny captions for these zany end papers wore out scores of writers. More often than not, Miscellany pictures were of animals, caught in attitudes that prompted viewers to exclaim, "Aren't they just like us!" Appropriately, Hansel Mieth's alienated monkey is the last well-remembered image in this book.

Venetian costume party

Capacious cup

FUN OUT OF LIFE

Pasta-garlanded, a rash but unrepentant kitten is ladled out of cold leftover spaghetti.

RON LAYTNER

Kansas fraternity men assemble the second-most-important ingredient for a spring blanket party.

WALTER SANDERS

A mischievous Brownie boots a rapt Girl Guide at a 1958 honors ceremony in Toronto.

PETER STACKPOLE

Birthday High Jinks

A guest on a swing at Jane Withers' 13th birthday party gets an overenthusiastic push.

Kronberg Conga

Students at a U.S. high school in Frankfurt *(below)* start a rakish conga line at Kronberg Castle.

JAMES WHITMORE

PETER STACKPOLE

Skyscraper Ball

A six-foot girl dances on tiptoe with her six-foot-six partner at a party of the Tip Toppers' club.

GEORGE KARGER

Canteen Caper

Ray Bolger referees a 1942 game between Dorothy McGuire and a GI at the Stage Door Canteen.

Opera Gala

A disgruntled bystander glowers at Mrs. George W. Kavanaugh and Lady Decies as the Metropolitan Opera opens.

WEEGEE

Classical Bash

Mr. and Mrs. Gilbert Orcel, hosts of the Classical Ball in Paris, clutch His and Hers tridents.

N. R. FARBMAN

A Situation Well in Hand

A girl who can't say no and a couple of unusually compatible boyfriends give a new significance to the old expression "All for one and one for all."

ANTHONY BRUCULERE

A Suit That Sold Itself

A gamely blase customer is greeted by a suit on a rack in a Memphis clothing store. The idea originated with the news photographer assigned to cover the opening of the store.

BARNEY SELLERS

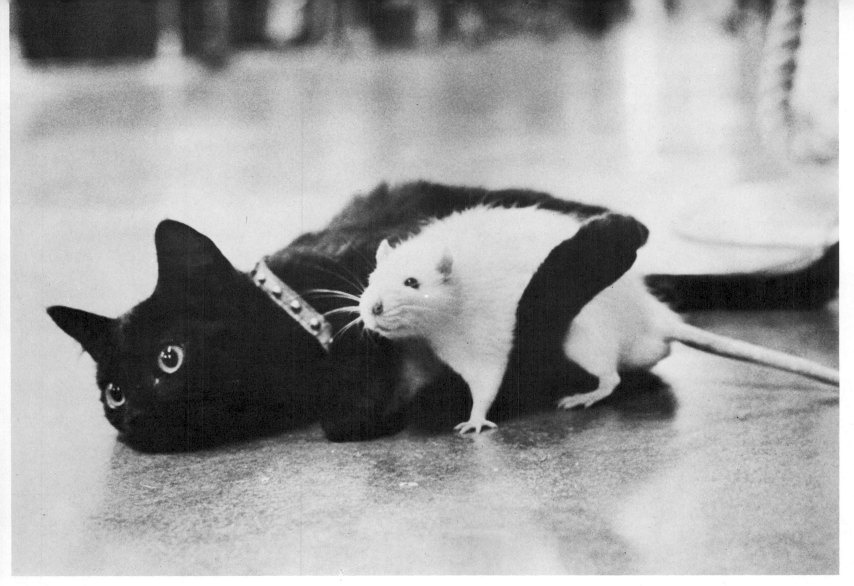

PRIYA RAMRAKHA

A Lesson in Coexistence

A pair of unlikely pals, a cat and a white rat, hobnob at a Los Angeles hobby show. Whose hobby was what no one knew, including the photographer.

A Friendship Uncemented

A mason *(left)* looks up from his labor to discover, with emotions happily not visible to the camera, that he has acquired a small sidewalk superintendent.

CLAYTON V. PETERSON

Melancholy Dane

A prince of pets ponders whether 'tis nobler in the mind to suffer the slings and arrows of outrageous fortune or to shove that kid out of there and eat.

MICHAEL LIEBERMAN

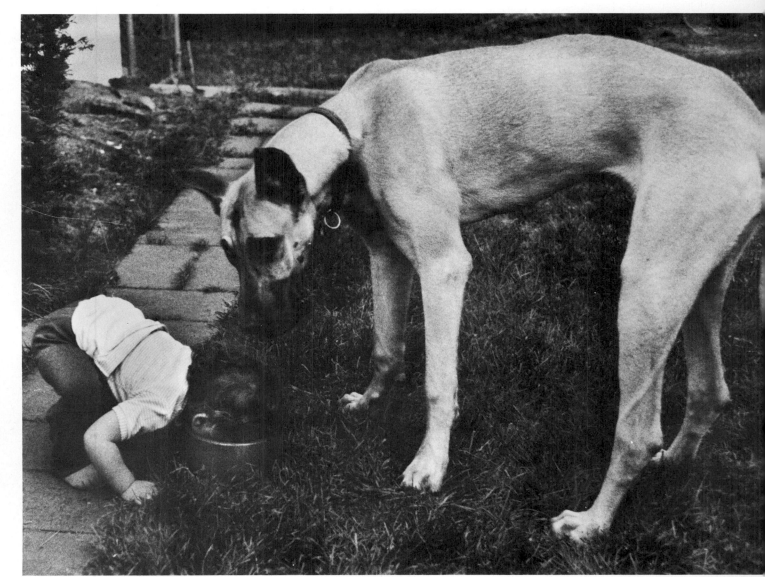

Hare-raising Ceremony A bunny trained by Jacksonville, Fla., school kids stands erect during the Pledge of Allegiance.

ROCCO MORABITO

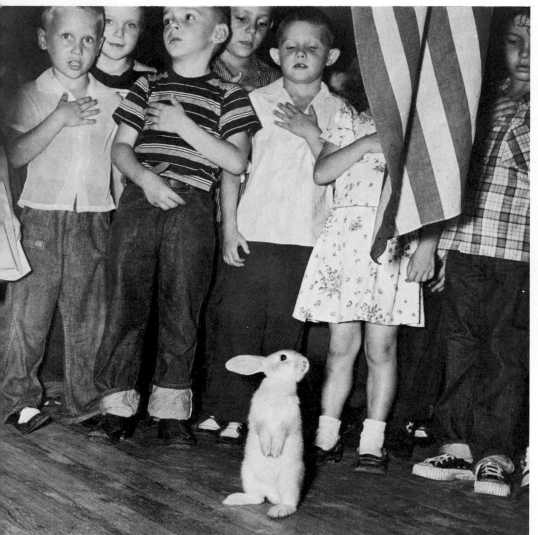

JOHN G. HOREY

Cool Babe An 8-month-old sybarite in a Texas pool curls his toes, lies back and luxuriates in the sun.

Old Dog Tray The 1954 writer couldn't resist that headline for this Miscellany picture of a canine juggler.

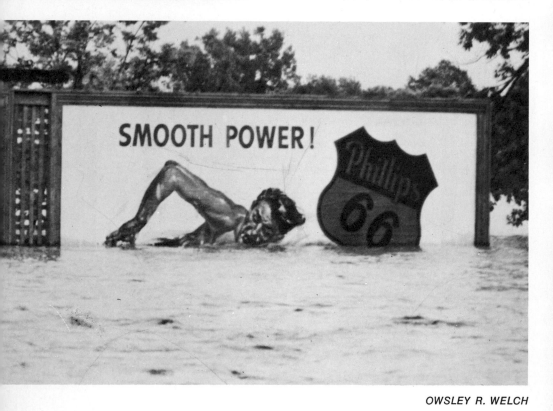

OWSLEY R. WELCH

Stroke of Fortune Missouri's Grand River in flood provides an oil firm with a "tie-in" beyond an adman's dreams.

Oversized Itch A worker washing down a billboard apparently draws a reaction from the insurance-ad model.

Fateful Plateful Looking like something out of *The Mikado* as staged by the Three Stooges, a baby wears her dinner.

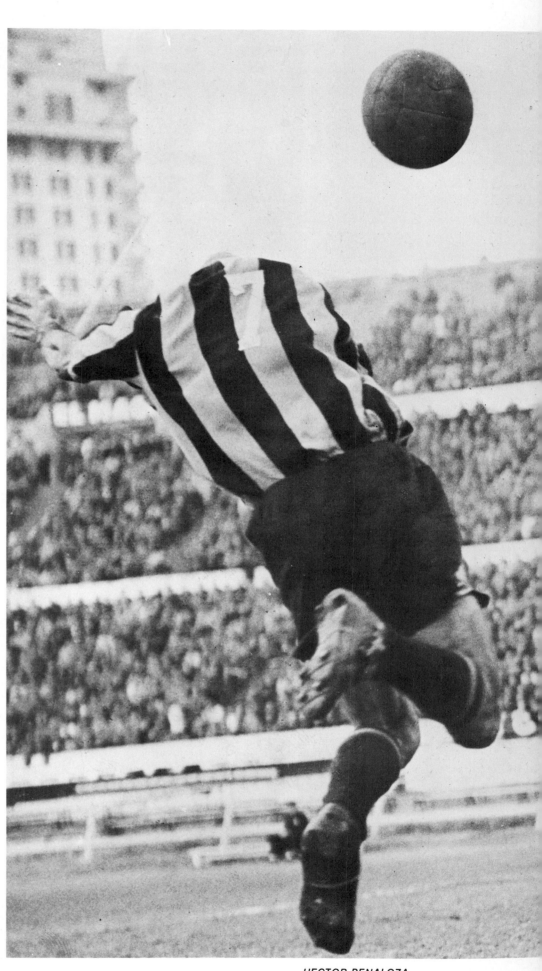

Heady Fling A Uruguayan soccer player, aloft after butting the ball, appears to have given his all.

301

Self-satisfied Seal

A sly seal in the Copenhagen zoo gets an obvious kick out of having his picture taken.

Lazy Dog

Not to be outdone by his best friend, an enterprising dog *(left)* nonchalantly climbs a fence.

ELAINE WILSEY

Misogynist Monkey

An unhappy rhesus monkey (his chilled cousin is on view on page 214) glowers from a sand bar after escaping chattering females.

HANSEL MIETH

Cap-sized Turtle

An octogenarian in a Wales zoo finds that a young fellow inmate makes a fine derby.

HAROLD F. TENNEY

Uncouth Cat

Clearly liberated from outmoded ideas of feline grace, Kitty enjoys a session with the juke box.

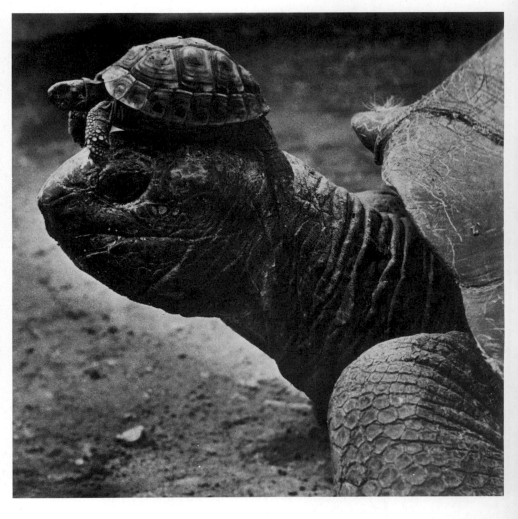

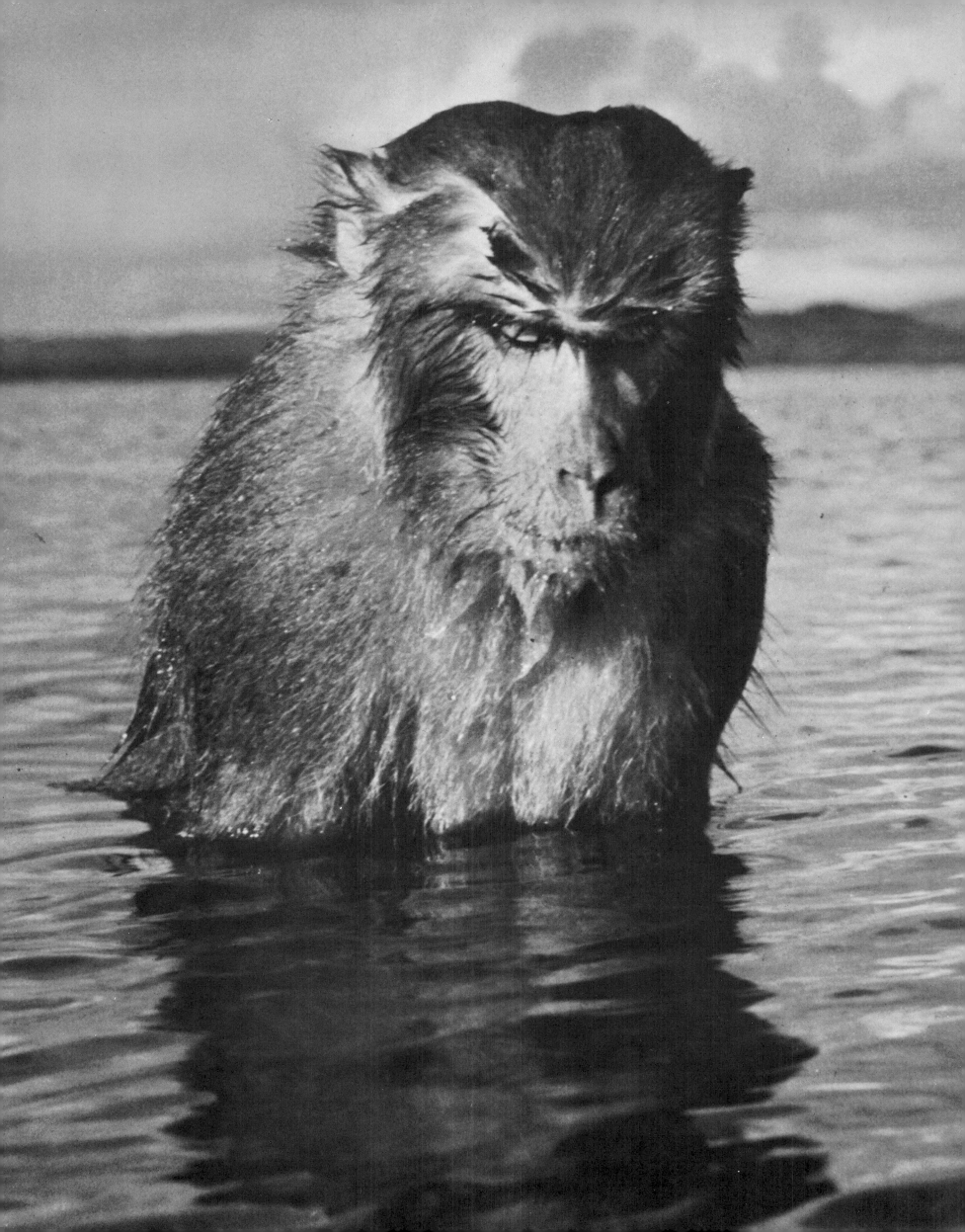

PICTURE CREDITS

Sources for the photographs in this book appear below. Credits are grouped by pages and are listed left to right, in repeated sequences.

INTRODUCTION 4,5—Margaret Bourke-White; Burt Glinn © Curtis Publishing Co.; William J. Sumits.

THE MOMENT PRESERVED 6,7—Margaret Bourke-White; WW; Fred Ward, BS; UPI; Paul Schutzer 8,9—Margaret Bourke-White; Sam Shere, UPI 10,11—UPI; AP; William Vandivert; Interphoto; WW 12,13—Ralph Morgan, UPI; John D. Collins, WW 14,15—Movietone News; U.S. Navy; no credit 16,17—UPI; Movietone News 18,19—Bob Landry; Robert Capa; Henri Cartier-Bresson 20,21—Carl Mydans; Johnny Florea; William Vandivert; Margaret Bourke-White 22,23—Edward Clark 24,25—Joe Rosenthal, AP; Alfred Eisenstaedt 26,27—Margaret Bourke-White 28,29—Henri Cartier-Bresson, Magnum; George Silk 30,31—Carl Mydans; Walter Sanders 32,33—AP; Ronald Case, Keystone 34,35—David Douglas Duncan; Edmund P. Hillary, British Mt. Everest Expedition 1953 world © The Times, London 36,37—John Sadovy; Mainichi Shimbun 38,39—Charles Moore, BS 40,41—Hank Walker; Abraham Zapruder © 1963 Time Inc., all rights reserved; Bob Jackson, Dallas Times Herald © 1963 AP 42,43—Joseph Louw, Public Broadcast Laboratory; Bill Eppridge 44,45—Larry Burrows; AP; Ronald L. Haeberle; Eddie Adams, AP; Nick Ut, AP 46,47—Donald McCullin © Sunday London Times 48,49—Howard Ruffner; Frederick H. Stires 50,51—W. Eugene Smith and Aileen Smith.

THE ATHLETES 52,53—Arthur Rickerby; George Strock; J. R. Eyerman; Yale Joel; John Dominis; Ralph Morse 54,55—Joe and Frank Scherschel; Don Rice, New York Herald Tribune; Hy Peskin; John Dominis 56,57—John Zimmerman 58,59—UPI (2); New York Daily News; Matthew Zimmerman, AP; Harry Coughanour, Pittsburgh Post-Gazette; New York Daily News Photo from Gilloon 60,61—Arthur Rickerby; Ken Regan, Camera 5; Bob Doty, Dayton Journal Herald; no credit 62,63—George Silk; Co Rentmeester 64,65—George Silk; Co Rentmeester (2) 66,67—George Silk.

SPEAKING OF PICTURES 68,69—© Philippe Halsman; Gjon Mili; Ralph Morse; Lilo Hess 70,71—Fernand Fonssagrives; Milton H. Greene; Marc Foucault, RG 72,73—Howard Sochurek; Mrs. Frank H. Chadwick; U.S. Navy; Henry Rox 74,75—Yale Joel; Ralph Steiner and Leo Hurwitz; George Silk; A. Y. Owen.

THE LEADERS 76,77—David E. Scherman; John Phillips; Yale Joel; © Arnold Newman; Charles Bonnay, BS; U.S. Army Signal Corps 78,79—WW; Walter Sanders, BS; Thomas D. McAvoy; UPI 80,81—© Karsh, Ottawa; PI; Charles James Dawson, UPI; © Philippe Halsman; Fox Photos-Pictorial Parade; no credit 82,83—European (2); Interphoto; Alfred Eisenstaedt 84,85—Sovfoto; Carl Mydans; Paul Schutzer (2); Hank Walker; Grey Villet; Sovfoto 86,87—W. Eugene Smith; Francis J. Grandy, Stars & Stripes; Cecil Stoughton, AP; Charles Cort, UPI; AP; Carl Mydans 88,89—Nick de Morgoli; James Whitmore; Margaret Bourke-White; UPI 90,91—Lisa Larsen; Bill Beebe © Los Angeles Times; Mark Shaw; Paul Schutzer 92,93—Bill Eppridge; Paul Schutzer 94,95—AP; Paul Schutzer; UPI; Harry Benson.

THE VARIETY OF LIFE 96,97—Nina Leen; Harry Benson; Perry Cragg; Alfred Eisenstaedt; Co Rentmeester 98,99—Special Pictures Inc.; Peter Stackpole 100,101—Wallace Kirkland; Ralph Crane 102,103—Albert Fenn; Mark Kauffman; Gordon Parks; Arthur Schatz 104,105—Robert C. Wiles; Walter Kelleher, New York Daily News 106,107—John Olson; Ralph Crane; George Silk 108,109—W. Eugene Smith; George Strock, Leonard McCombe 110,111—George Strock, Los Angeles Times; John Muller.

THE SCIENCES 112,113—Drawing by R. F. Zallinger; Painting by Carroll Jones; Fritz Goro; Lennart Nilsson; Fritz Goro 114,115—Fritz Goro; Yale Joel; Andreas Feininger 116,117—Lennart Nilsson 118,119—Lennart Nilsson 120,121—Ralph Morse (2); Neil Armstrong, NASA 122,123—Ralph Morse and NASA 124,125—James A. McDivitt, NASA; Edwin Aldrin, NASA 126,127—NASA.

FASHION 128,129—Greene-Eula courtesy Fogg Art Museum; Greene-Eula (2); Norman Parkinson 130,131—Raymundo de Larrain; Milton H. Greene 132,133—Howell Conant; Bill Ray; Douglas Kirkland; William Claxton, Globe Photos 134,135—Alfred Eisenstaedt; Milton H. Greene; Philippe Halsman; Gordon Tenney, BS; Nina Leen 136,137—Leonard McCombe; AP; Vernon Merritt III 138,139—Vernon Merritt III; Co Rentmeester; Yale Joel.

THE BLACK CAUSE 140,141—Gordon Parks; John Loengard; David Dornlas; no credit; AP 142,143—Joe Postiglione, Anniston (Alabama) Star; Gordon Parks; Bill Reed 144,145—Bud Lee; Co Rentmeester; AP 146,147—Jim Kean, San Rafael Independent-Journal © Time Inc.; Bill Eppridge.

THE LAND 148,149—Dorothea Lange; William A. Garnett 150,151—Ernst Haas, Magnum; Ray Manley, Shostal Agency 152,153—Andreas Feininger; Arthur Tress; J. R. Eyerman 154,155—Margaret Bourke-White; Robert A. Isaacs 156,157—Laurence R. Lowry 158,159—George Silk; Ralph Crane 160,161—Eliot Elisofon 162,163—Eliot Elisofon; John Dominis.

THE SOLDIERS 164,165—Bob Landry; Carl Mydans; Robert Capa, Magnum; Henri Huet, AP 166,167—Paris-Match; Robert Jakobsen, Los Angeles Times; News Chronicle; AP 168,169—Robert Capa; George Silk; Ralph Morse 170,171—George Strock; Ralph Morse; George Strock; George Silk 172,173—W. Eugene Smith (2); Johnny Florea 174,175—David Douglas Duncan (3); Hank Walker 176,177—David Douglas Duncan 178,179—Larry Burrows; John Olson; Larry Burrows; Paul Schutzer 180,181—Mark Kauffman; Michael Rougier; Carl Mydans 182,183—Larry Burrows.

THE CHILDREN 184,185—H. S. Wong, UPI; London Daily Mirror; UPI; Hansel Mieth; Rue Faris Drew; Gordon Parks; Michael Rougier; Alfred Eisenstaedt 186,187—Yale Joel 188,189—Ralph Morse; Yale Joel; John Dominis; Leonard McCombe; Mildred Totushek 190,191—Gerald Waller, American Red Cross Photo; Cornelius Ryan; Anne Frank courtesy Otto Frank; John Topham, BS 192,193—Robert Halmi; Hank Walker; London Daily Mirror 194,195—Douglas Faulkner; PI; Michael Mauney; Carroll Seghers II; Mark Kauffman 196,197—Bill Beall, Washington Daily News; Ralph Crane, BS; Eliot Elisofon 198,199—William Vandivert; Frank Dandridge; Gordon Parks; Leonard McCombe 200,201—Edward Clark; UPI 202,203—C. E. Westveer; © W. Eugene Smith.

THE ANIMALS 204,205—Leonard McCombe; Torkel Korling; Terence Spencer 206,207—Fritz Goro; Valerie Taylor, from the Peter Gimbel film expedition, "Blue Water, White Death"; John Dominis; Peter Stackpole 208,209—Vernon Merritt III; John Dominis 210,211—Peter Beard; Carlo Bavagnoli 212,213—John Dominis; Stan Wayman 214,215—Co Rentmeester; Larry Burrows; Nina Leen 216,217—George Silk; Nina Leen; Alfred Eisenstaedt; Nina Leen 218,219—Stan Wayman; John Phillips; Co Rentmeester 220,221—John Dominis.

THE FADDISTS 222,223—Gjon Mili; Fred P. Peel; Bill Eppridge; UPI 224,225—Ralph Morse; Marie Hansen; Joe Munroe; Martha Holmes 226,227—Allan Grant; Ralph Morse; J. R. Eyerman 228,229—Bill Bridges; Richard Hartt; Ralph Crane 230,231—Barney Petersen, San Francisco Chronicle; Bill Eppridge.

PEOPLE 232,233—William C. Shrout; W. Eugene Smith; UPI; © Karsh, Ottawa; Alfred Eisenstaedt; Cornell Capa, Magnum; Bob Peterson 234,235—UPI; Allan Grant; Bob Gomel; Grey Villet; AP 236,237—Alfred Eisenstaedt; Dominique Berretty; Yale Joel; Larry Burrows 238,239—AP; UPI; John Loengard; Leonard McCombe 240,241—UPI; Burk Uzzle, Magnum; AP; Harry Benson 242,243—Paul Child; Bert Six, Warner Brothers; Burk Uzzle, Magnum 244,245—Gjon Mili; John Loengard; Bob Peterson 246,247—Martin J. Dain; Cecil Beaton © 1938, 1966 Condé Nast; John Bryson 248,249—John Loengard; Loomis Dean; Terence Spencer.

GROWING UP 250,251—Nina Leen; Robert Garro; Nina Leen; Leonard McCombe; Ralph Crane 252,253—Leonard McCombe 254,255—Central Press, London; Bill Ray 256,257—Perry C. Riddle, Chicago Daily News; Gerald S. Upham; Bernie Boston, Washington Evening Star 258,259—John Dominis; Jack and Betty Cheetham; Larry Bazel 260,261—Bill Ray; UPI; Michael Mauney.

THE ENTERTAINERS 262,263—Clarence Bull, MGM; Scotty Welbourne; Rex Hardy Jr.; Alfred Eisenstaedt (3); Willinger, MGM; Alfred Eisenstaedt; W. Eugene Smith; Peter Stackpole, MGM; Clarence Bull, MGM; Peter Stackpole; © Philippe Halsman; N. R. Farbman; © Philippe Halsman; W. Eugene Smith; © Philippe Halsman (3); Bob Willoughby, Globe Photos; J. R. Eyerman; Sanford H. Roth, RG; Cornell Capa, Magnum; Richard Avedon; Emil Schulthess, BS for Paramount; Allan Grant; Ralph Crane; Bert Stern; John Dominis (2); John R. Hamilton, Globe Photos; © Philippe Halsman (2); Steve Schapiro, Consolidated Diamond Minds, Ltd.; James B. Wood; Yale Joel 264,265—Bob Landry; Peter Stackpole; © Philippe Halsman; Peter Stackpole; Ewing Krainin; Jean-Pierre Lagarde for Camera Press, Transworld Feature 266,267—Richard Avedon 268,269—Culver Pictures; Martin Munkacsi; George Karger; Edward Steichen © Condé Nast; Wallace Litwin; Sherman Clark, Universal Pictures 270,271—20th Century Fox; Peter Stackpole; Leigh Wiener; Peter Stackpole; Leonard McCombe 272,273—Loomis Dean; Eliot Elisofon; United Artists; N. R. Farbman; Eve Arnold, Magnum; Warner Brothers 274,275—Dmitri Kessel; Edmund B. Gerard; Sy Friedman, NBC; Alfred Eisenstaedt; Thomas D. McAvoy 276,277—© Philippe Halsman; George Karger; Allan Grant; Stan Wayman; W. Eugene Smith, BS; Edmund B. Gerard; Michael Rougier 278,279—Ralph Morse; Edmund B. Gerard; Leonard McCombe; Culver Pictures; Robert W. Kelley; First National courtesy Museum of Modern Art; Allan Grant; Ralph Crane, BS 280,281—Arthur Schatz; Terence Spencer; John Loengard; Cornell Capa, Magnum; Michael Mauney; Mark Shaw 282,283—Gjon Mili; Bill Eppridge; Herbert Migdoll 284,285—David Gahr; Ralph Crane; Jim Marshall; John Loengard; Charles Trainor, Miami Daily News; Tucker Ranson, Pictorial Parade.

THE PHOTOGRAPHIC ESSAY 286,287—W. Eugene Smith 288,289—Leonard McCombe; Cornell Capa 290,291—Bill Eppridge; Grey Villet 292,293—Brian Brake; Michael Rockefeller, Samuel Putnam and Eliot Elisofon for Film Study Center, Peabody Museum, Harvard University.

FUN OUT OF LIFE 294,295—Walter Sanders, BS; Photo Ferruzzi; Burt Glinn; Ron Laytner; © Rex Features from Galaxy 296,297—Peter Stackpole (2); George Karger; James Whitmore; Weegee; N. R. Farbman 298,299—Anthony Bruculere; Priya Ramrakha; Barney Sellers, Memphis Commercial Appeal; Clayton V. Peterson; Michael Lieberman 300,301—Rocco Morabito, Jacksonville Journal; John G. Horey; Garry A. Watson; Hector Penaloza; Owsley R. Welch; Keystone; George G. Trabant, St. Petersburg Times 302,303—IFOT from BS; Elaine Wilsey; Hansel Mieth; Harold F. Tenney; Camera Press from Transworld Feature.

Abbreviations: © copyright AP, Associated Press; BS, Black Star; PI, Pictures Inc.; RG, Rapho Guillumette; UPI, United Press International; WW, Wide World. Every effort has been made to ascertain the names of the individual photographers deserving of credit in this book. In the absence of this information, credit has been given to the agency or publication that provided the photograph.